FOR HEARTH AND ALTAR

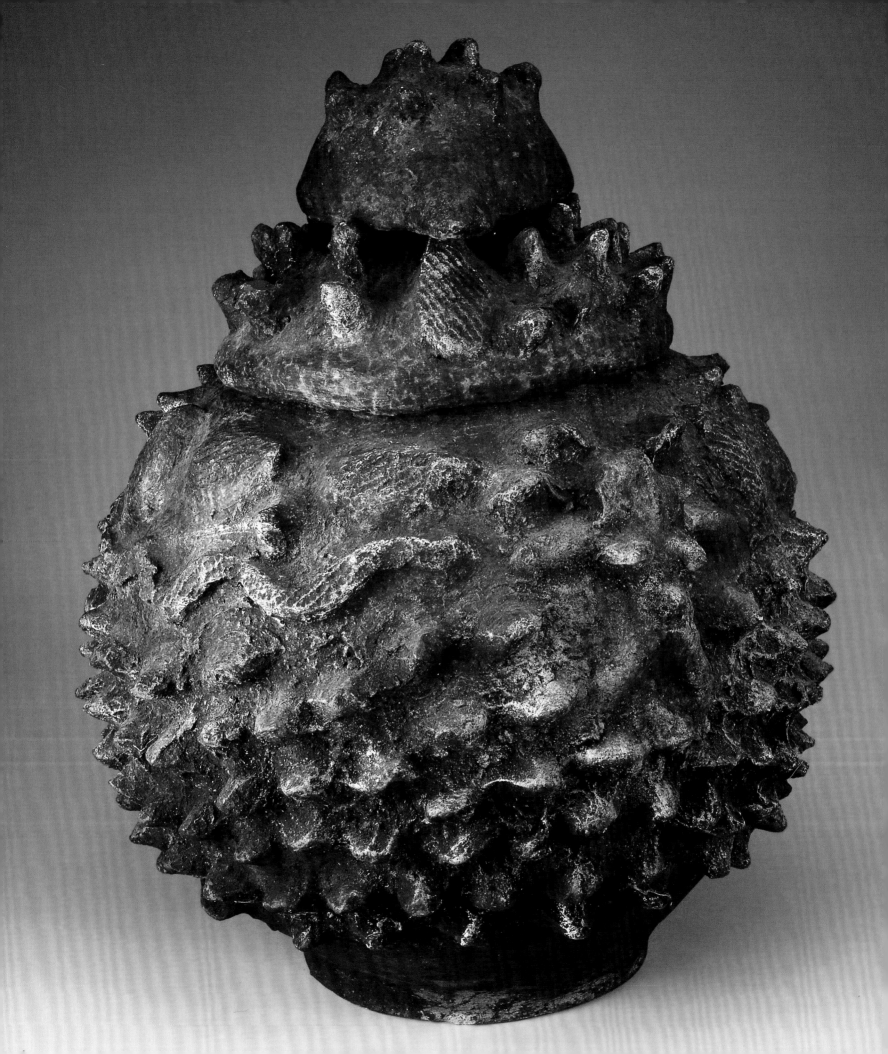

FOR HEARTH AND ALTAR

AFRICAN CERAMICS FROM THE
KEITH ACHEPOHL COLLECTION

Kathleen Bickford Berzock

THE ART INSTITUTE OF CHICAGO

YALE UNIVERSITY PRESS, NEW HAVEN AND LONDON

This book was published in conjunction with the exhibition *For Hearth and Altar: African Ceramics from the Keith Achepohl Collection*, organized by and held at the Art Institute of Chicago from December 3, 2005, to February 20, 2006.

Published by
The Art Institute of Chicago
111 South Michigan Avenue
Chicago, Illinois 60603–6110
www.artic.edu

Published in association with
Yale University Press
New Haven and London
www.yalebooks.com

Produced by the Publications Department of the Art Institute of Chicago, Susan F. Rossen, Executive Director
Edited by Robert V. Sharp, Associate Director of Publications, and Gregory Nosan, Associate Editor
Production by Sarah E. Guernsey, Production Coordinator
Photography research by Sarah K. Hoadley, Photo Editor
Designed and typeset by Joan Sommers Design, Chicago
Principal photography by Robert Lifson, Department of Graphic Design, Photographic, and Communication Services
Separations by Professional Graphics, Inc., Rockford, Illinois
Printed and bound by Butler and Tanner, Ltd., Frome, England

ISBN 0-300-11149-5 (hardcover)
ISBN 0-86559-221-7 (softcover)

Library of Congress Control Number: 2005930065

Front cover: *Bowl* (detail). Mambila; Cameroon. Early/mid-20th century. Cat. 85, pp. 140–41.
Back cover: *Container for Water or Beer* (Inongo). Gwembe Tonga; Zambia. Mid-/late 20th century. Cat. 119, pp. 184–85.
Frontispiece: *Altar Vessel*. Gur-speaking peoples, possibly Lobi; Burkina Faso. Early/mid-20th century. Cat. 31, pp. 73–74.

CONTENTS

FOREWORD

The antiquity and longevity of Africa's ceramic traditions make them an indelible part of any history of the continent's artistic heritage. Yet their significance has been recognized only sporadically through research, collecting, and exhibitions. Perhaps this neglect is due to their pervasiveness—for as the title of this catalogue amplifies, in Africa pottery appears across the domestic and ritual spheres. Or perhaps it is due to their remarkable functionality—for their basic forms are intended to serve the most essential of human needs, even as they touch everyday life with beauty and the grace of aesthetic contemplation. Pottery from Africa is also remarkable for its simplicity of materials and techniques. Using terracotta clay fired at low temperatures in the open air, potters have engaged in a seemingly endless exploration of forms and embellishments. At their best these wares compel us by means of the same visual language that we know from other, more vaunted forms of three-dimensional art, among them, the handling of volume, the shifting of vantage point, and the interplay of interior and exterior space. These, indeed, are the aesthetic qualities that have long intrigued and held the attention of Keith Achepohl, whose collection we present here. Like all private collections, Keith's is on one level a reflection of personal taste. A working artist, he has selected each piece of pottery for the unique way that it has stimulated his own sense of aesthetics. But Keith's collection has also transcended such personal significance. Because of its size and comprehensiveness, and the irreplaceable quality of many of its individual works, the collection is worthy of much broader recognition.

When Keith Achepohl decided to share his collection of African ceramics with a wider audience, the Art Institute seemed a natural choice of venue. From the time he was a young man growing up in Elmhurst, this museum has been a place of wonder and exploration for him. It was the stage for some of his earliest experiences with original works of art, and it initiated a passion that eventually led to his life as an artist and a collector. His early visits also opened his eyes to the generosity of benefactors—those philanthropic individuals who give works of art to museums so that they can be shared with the public and held in trust for future generations. Such acts of civic goodwill likewise captured his imagination. Thus it is with great pleasure that we announce that almost half of the vessels illustrated in this catalogue have been promised as gifts to the Art Institute and will place us squarely at the forefront of art museums displaying African ceramics. We express our deepest gratitude to Keith Achepohl for his extraordinary generosity, and applaud curator Kathleen Bickford Berzock for her exemplary and illuminating treatment of these works in the essay and entries that follow. As part of our permanent holdings, this pottery will also be seen in dialogue with other world-class collections of ceramics on view from China, Japan, Korea, and the ancient Americas, and will enhance our visitors' experience of another of the world's great cultural traditions.

JAMES CUNO
President and Eloise W. Martin Director
The Art Institute of Chicago

ACKNOWLEDGMENTS

This catalogue and the exhibition it accompanies, as well as the remarkable gift that they celebrate, have been in development for over a decade, and in that time numerous people have brought their energy and talents to bear on our success. The foremost thanks must be reserved for Keith Achepohl, whose world-class collection has set the parameters for this project. Since Keith first entered into conversations about an exhibition of his collection and a substantial gift of pottery to the Art Institute of Chicago, he has been a true and inspiring partner. Over the years he has worked with us with enthusiasm, dedication, and patience, and he has graciously shared with us his vision and his process as a collector. He has also graciously extended the hospitality of his beautiful home, his considerable talent in the kitchen, and his stimulating conversation to myself, my family, and members of the Art Institute's staff. His warmth and humanity, his passion for life, his visual focus as a working artist, and his deep love of the arts have gently molded every stage of this process.

My research on the Achepohl collection brought into sharp relief the many gaps that exist in the literature on African ceramics. In an attempt to fill some of these voids, I relied heavily on the personal accounts of numerous individuals. I also depended on colleagues to provide personal and archival photographs. The inclusion of contextual photographs that help us visualize the work of potters and the place of ceramics in African life has greatly enriched this effort. I am deeply indebted to the many colleagues who endured my repeated inquiries and willingly shared their research, insights, opinions, and photographs with me in a spirit of generosity and openness. I extend sincere thanks to Nicolas Argenti, Cynthia Becker, Marla Berns, Aimee and Mark Bessire, Suzanne Blier, Jean-Paul Bourdier, Elisabeth Cameron, Amanda Carlson, Julia Charlton, Jan Cocle, Herbert M. Cole, Karl Cole, Susan Cooksey, Nic David, Douglas Dawson, Bill Dewey, Michael Dietler, David Doris, Henry Drewal, Nnamdi Elleh, C. M. S. Eisenberger, Knut Felberg, Marc Felix, Hermann Forkl, Silvia Forni, Barbara Frank, Phyllis Galembo, Christraud Geary, Genesis Ghasi, Anita Glaze, Ivo Grammet, Robert Hart, Fr. Hermann Gufler, Nessim Henein, Ingrid Herbich, Lindsay Hooper, Carolee Kennedy, Zachary Kingdon, Hans-Joachim Koloss, Chris Mullen Kreamer, Anne Mayor, Anders Lindahl, Karen Milbourne, Andrea Nicolls, Clara Oliveira, Joaquim Pais de Brito, John Pemberton III, Nii Quarcoopome, Fiona Rankin-Smith, Judy Rosenthal, Doran Ross, Klaus Schneider, Laurie Shaman, Christopher Slogar, Fred Smith, Ryan Smith, Carol Spindel, Judy Sterner, Barbara Thompson, Robert Farris Thompson, Gary Van Wyk, Marie-France Vivier, Jerome Vogel, Susan Vogel, Maude Wahlman, John Watson, Henny Weima, Birt Witkamp, David Zeitlyn, and Beatriz Zengotitabengoa and the institutions with which they are affiliated.

I offer particular thanks to Douglas Dawson, who has been an invaluable and generous resource for all manner of information on African pottery and its trade, ranging from the mundane to the esoteric. Doug has also been a consistent sounding board over the years that I have worked on this project. I greatly value his friendship and

have benefited enormously from his expansive knowledge and discerning eye. My thanks also go out to his highly professional staff at the Douglas Dawson Gallery: Wally Bowling, Nancy Bender, and Armando España.

Staff past and present in the Art Institute's Ryerson and Burnham Libraries were critical in facilitating my research. I extend thanks to Director Jack Brown, Peter Blank, Hannah Bennet, Lauren Lessing, Marcy Neth, Amy Bendler, and Nancy Ford, for their assistance in locating interlibrary loans and, when possible, for purchasing critical publications. My research was also greatly enhanced and facilitated by the outstanding collections of the Melville J. Herskovits Library of African Studies at Northwestern University, under the direction of Curator David L. Easterbrook, who extended to me every courtesy and eased my access to materials in diverse ways. Through David I was fortunate to meet Matthew Teti, who became my research assistant during the most intense period of research and writing. His enthusiasm for the arts and his openness to the topic of African ceramics were gratifying and his knowledge of and ease within libraries were extremely helpful. There were many times when he went the extra yard to provide me with materials, and I am very grateful to him for his assistance. In addition I wish to thank Leah Boston, Monique Fowler-Paul, and Cherise Smith, each of whom researched pottery in the Achepohl collection at various times.

At the Art Institute of Chicago, it was curator Richard F. Townsend, head of the Department of African and Amerindian Art, who initiated this project, passing it on to me in 1995. I thank him for his encouragement, friendship, and considerate and insightful council, and for the confidence he has invested in me these many years. He has guided my development as a curator and set a standard of excellence that I can only hope to attain. Thanks are also due to James N. Wood, former director of the Art Institute, who saw the potential of this project and supported it from the beginning. Likewise, upon his arrival, President and Director Jim Cuno embraced our work-in-process with enthusiasm and commitment, and he has unfailingly seen it through to fruition.

Also in the Director's Office Dorothy Schroeder, Associate Director for Exhibitions and Museum Administration; Jeanne Ladd, Vice President for Museum Finances; and Dawn Koster, Museum Fiscal Coordinator, were instrumental in making our plans a reality.

It would be impossible to enumerate all of the contributions made by the staff of the Department of African and Amerindian Art: Barbara Battaglia, Departmental Secretary; Ray Ramírez, Departmental Specialist; and Elizabeth Pope, Special Projects Research Assistant. I am grateful for their professionalism, their can-do attitude, and their good humor under duress. It is a sincere pleasure to work with such excellent people.

Special recognition is also due to the outstanding staff of the Publications Department, under the direction of Susan F. Rossen, without whom this project could not have been realized. For their work on the catalogue I am particularly indebted to Associate Director Robert V. Sharp; Scholarly Publications Associate Editor Greg Nosan; and Coordinator of Production Sarah Guernsey. With consummate skill and great sensitivity they helped to mold the form and refine the embellishment of this volume, making my passion their own in a true spirit of partnership. Photo Editor Sarah Hoadley oversaw the compilation of images for the text and pursued the rights to publish them with dedication and resourcefulness, while Department Assistant Shaun Manning offered help on many levels. I am doubly indebted to Robert Sharp for editing the labels included in the exhibition, in which task he was ably assisted by Labels Editor Elizabeth Stepina. The Publications Department also brought on board Joan Sommers, who designed and laid out this beautiful catalogue. Joan listened to my initial, broadly articulated thoughts, and to subsequent comments from myself and others, and magically transformed them into an elegant and cohesive work that highlights the magnificence of the containers in the Achepohl collection.

Like the production and layout of the catalogue, the photography of the pottery itself was a multifaceted job deserving of recognition and

thanks. Robert Lifson made the trip to Iowa City to digitally photograph over one hundred pots in Keith Achepohl's home (with the assistance of Ray Ramírez and, from the University of Iowa, Christopher Lahti), while Robert Hashimoto photographed still other pots in the Art Institute's studios. Together with Chris Gallagher, they then manipulated the digital files to arrive at the final product. Lisa Deichmann, Loren McDonald, and Caroline Nutley also helped facilitate the photography and other matters.

I wish to draw special recognition to those individuals and departments at the museum that have had an ongoing involvement in the project. These include Joe Cochand, Senior Exhibition Designer in the Department of Design and Construction, who designed the exhibition's installation with a masterful touch, and the talented staff of the Department of Graphic Design, and Photographic and Communication Services, under the direction of Lyn DelliQuadri, who designed and produced labels and other signage. In the Department of Museum Registration, Executive Director Mary Solt, Darrell Green, and John Molini skillfully processed the loans and gifts and arranged for the packing and transportation of objects to and from the museum, while Craig Cox and the art installation crew diligently assisted with the exhibition's installation. In the Department of Objects Conservation, Senior Conservator of Objects Barbara Hall, Suzy Schnepp, and Emily Dunn Heye analyzed and restored selected works. In the Legal Department, Vice President, General Counsel and Secretary Julie Getzels, Maria Simon, and Sara Gellen were dedicated to provenance research and oversaw contractual matters. In the Department of Museum Education, Executive Director Robert Eskridge, Mary Sue Glosser, Nenette Luarca, Maria Marable-Bunch, Jeff Nigro, Robin Schnur, and Jean Sousa developed innovative programs to engage our audiences; and in the Department of Public Affairs Chai Lee promoted the exhibition. I also gratefully acknowledge the hard work of Executive Director William Caddick of the Department of Physical Plant, Executive Director Ray Van Hook of the Department of Protection Services, and the members of their respective staffs. Many other museum staff participated in various aspects of this project; they are too numerous to name here, but their contributions are warmly appreciated.

Three final colleagues deserve special recognition for their help and support during this project. Erin L. Haney, a post-doctoral fellow at the National Museum of African Art, Washington, D.C., stepped in on short notice to work on the interleaf sections of the book. I am grateful for her diligence and focus. My friend and mentor Kate Ezra offered support, advice, and sound counsel at many stages in this work; likewise, my Art Institute colleague Martha Tedeschi gave welcome practical advice along the way.

I must also acknowledge the sacrifices made by my family. My daughter, Lou, whose life mirrors in so many ways the duration of the most intense phase of this work, has been a gift to me in countless ways. She has poured joy into my life and some of it has found its way onto these pages. My son, Sol, did not choose to have this strange sibling called the Achepohl Show, yet he has had to put up with all the ways that it has disrupted his environment and distracted his mommy. While my husband Cary did choose me, he could not have anticipated the realities of life under the pressures of this project. I thank him warmly for his nurturing love, unflagging support, and patient understanding. Finally, this work is dedicated with love and gratitude to the memory of my mother, Nancy Suedmeyer Webster (1939–2004).

KATHLEEN BICKFORD BERZOCK
Curator of African Art
The Art Institute of Chicago

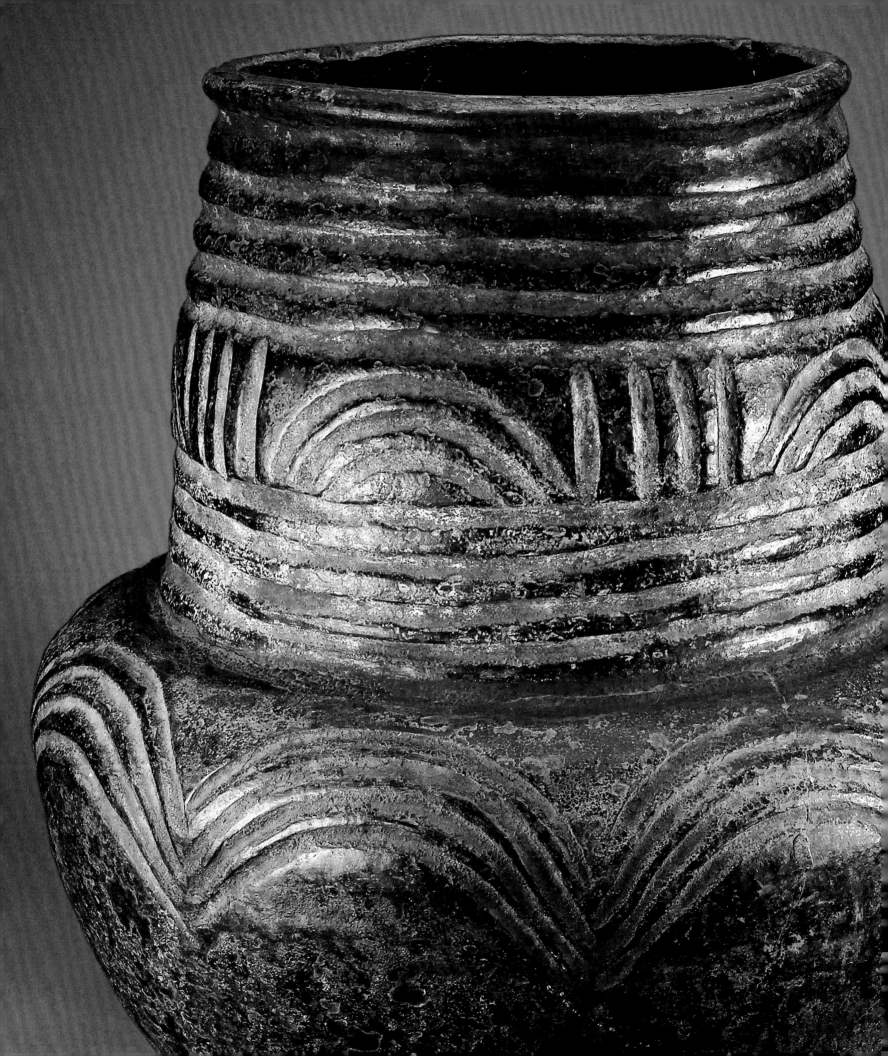

A CONVERSATION WITH KEITH ACHEPOHL

KEITH ACHEPOHL is a noted printmaker and an emeritus professor of printmaking at the University of Iowa. He has been a working artist for more than four decades and has collected African ceramics for nearly twenty years. Here he sits down with Art Institute of Chicago curator **KATHLEEN BICKFORD BERZOCK** to discuss his passion for African pottery.

KBB How did you start collecting African ceramics?

KA I acquired my first pots in Egypt in 1977. While wandering around Aswan and Luxor, I saw great quantities of new pots in markets, and having seen pottery in the museums in Cairo and Luxor, the similarities between old and new interested me. When bicycling through villages in Upper Egypt, I spotted a bowl (cat. 16) that stood out, and I was able to buy it. I bought it because it did not look like any other pot I saw in Egypt, and I loved it—its incredibly crude nature, in terms of the way it's made. A mound of clay was scooped out and the artist just simply took a knife and sliced away chunks on the sides, putting holes into the handles to hang it out of the way. Its heft and utilitarian nature were all so evident. I bought two other pots on that trip and carried them home in my luggage. That experience began a process that has continued for almost thirty years: looking at all that is in front of me and deciding what is the most beautiful.

KBB What sparked your interest in pottery originally?

KA I started thinking about the beauty and importance of pottery in high school. I attended York High School in Elmhurst, Illinois, west of Chicago, and studied with the most important and influential teacher I have ever had. Lois Ashton Larson was my Latin teacher, and her classroom was in effect a little sanctuary representing the classical world. For four years I sat in a room that was filled with replicas of the Parthenon and Greek and Roman statues, which left me profoundly aware of the Mediterranean world. We didn't just learn Latin—we learned about classical art and literature, too. I remember there were quite a few illustrations of Greek pottery because she talked about how the Greek myths, all the great tales, were told in pottery. I must have been struck by the power of the pottery to be useful and be a record of the time in so many ways. The shapes of pottery, and what those shapes could convey through drawing and painting, also left a profound impression. On top of that, my maternal grandfather was born in classically rich Southern Italy.

Ms. Larson traveled every summer, and besides teaching me how to make marzipan, she instilled in me the need to spend my life traveling as much of the Mediterranean as I could see. I traveled the region for years—I lived in Italy in the early 1960s, visited the Villa Julia in Rome, and saw the collection of great Etruscan pots there. I've gone to Crete, Malta, and Athens, and the pottery from that part of the world has always been something I've really loved.

OPPOSITE: 99 (DETAIL)

KBB In my mind there's quite a lot of difference between Mediterranean pottery and African pottery. Do you see relationships?

KA Well, I think the great Cameroon pot (cat. 87) looks very, very much like something I saw in a museum on Crete, so I see more and more similarities. There are profound differences, of course, mostly because of how they were made: in most of Africa they did not use the potter's wheel. I think that one of the great things about African pottery is that it looks so profoundly handmade—the object is not about perfection. With Greek pottery it *was* about perfection, because the pot had to be made as beautifully and as carefully as possible before it was given to someone to decorate. So it was more of a two-person process, whereas making African pottery is generally a one-person process, and that one person has more control over how they're going to use that surface. It's always much more individualistic. I think we sense more of the artist's personality in African pottery than we do in classical Greek or Roman pottery.

KBB So is that difference what fed your interest in African pottery? Did you ever really start collecting Mediterranean pots?

KA Actually, it was probably a decade after I bought my first African pots before I started thinking more about them. In between I had been collecting American art pottery, which I got tired of very quickly. It was in part the issue of personality or individualism that led me to dispose of all of my American art pottery; beautiful as that is, it relies more on just a glaze, and some of the shapes are beautiful, but you realize that you see the same shapes over and over again.

Although this is somewhat true of African pots, too, the variations are more interesting to me —it's more how the pot is decorated and the slight things that the individual potter can bring to it to make it a very special piece. One of the things I've always liked is when dealers pull up in my parking lot, open up their van, and show me ten or twelve Nupe or Zulu pots. They're all basically the same shape, but I have really loved being able to make great comparative judgments, determining, "Whoa, this one really is super, and that one is not."

KBB In your collection, I think the idea of endless variations on a theme emerges through the groups that you put together, like the Nupe or Zulu pots (cat. 68–75, 122–25).

KA It's wonderful to see that variations on a theme do say a great deal. Even though I've taught art for so long, I'm still struck by the fact that when students make art or study it, textbooks give them only one example of an artist's work. They don't let them know that the artist made perhaps fifty drawings, paintings, or prints based on one idea. And all of those objects are worth looking at, to find out how an idea bloomed from the small seed of an inception to something grand and wonderful only through lots of trial and error. I think that by looking at many pieces we start seeing the variations, and that those become beautiful and let us know that variations in life are pretty wonderful.

KBB In the 1980s, when you first began collecting African ceramics, they were not well known either in public or private collections.

KA That was at a time when the American art market was absolutely insane. I was hearing from the dealers who handle my work that people would come in and say "I need a painting in the $5,000 to $6,000 range for my new apartment." It hardly mattered what the artist's name was— they had to have a piece of a certain value. To me this was a kind of corporate interior decorating, with astronomical prices being given to work that didn't really merit them. And here were these very beautiful objects, African pots, that didn't cost very much. They were anonymous—we know a few of the potters by name, very few—and I loved the idea that this anonymity was present.

KBB What do you like about that?

KA I like it because I knew I was always going to be looking at these things for what they were as objects, not for "who did it," because all the rest of the art world is about "who did it."

KBB So it's sort of a response to the egocentricity of the Western art world?

KA Right—to me it was a relief that I did not have to think about who made them, which means that we are forced to think about the things that are really important: their value to us as gorgeous objects. The major question to me is whether on the simplest terms I believe it's a beautiful object. This was very much the case with the first pot I bought after the Egyptian piece from Aswan—the great big Songye pot (cat. 99). In a sense that turned out to be the model for what I was going to be doing for quite awhile.

KBB Where did you get the Songye pot?

KA It came from the Chicago dealer Doug Dawson, who supplied me with so many pots over the years. I think the wonderful thing about walking into his gallery, way back in the mid-1980s, was how I saw the pot and thought immediately that it was such an incredible form. The wedding of that form to what the artist did, in terms of decorating or embellishing, was just astonishing. It's just a simple container, and yet the two basic forms—the great bulbous bottom and thick neck—and then the simple decoration around it, all combine to make a truly heroic piece of sculpture. So I thought, "Here is pottery that's sculpture." It had great patina and obviously was a pot that was much used. It carried so much with it that I wanted to have it with me, as a way to experience what sculptural forms coming out of Africa could be. Within a month I returned and acquired two more, and with those six African pots a collection began. It was wonderful to be able to trust a dealer like Doug, who possesses great integrity and a knowing sensibility, to help guide me in the quest.

Our discussions about pottery have been inspiring. As I became more serious, I wanted to assemble something more comprehensive that represented as much of African pottery making as I could.

KBB What do you look for in a piece?

KA I'm not an anthropologist or an art historian, so my approach to the collecting of all these pots has always been to look at them as an artist. I want to live with these things because I can be moved by them. I've encountered a lot of dealers and have to get them to understand that I really don't initially care about all the information they can give me, except the important stuff—where it's from, since the exact dates are something no one knows for sure—so I'm left to my own devices in terms of what I can bring to it. The itinerant dealers who come around often don't have correct information, so one must be self-reliant in making decisions. Over time, I've developed a self-honed, comparative eye, which lands on objects with a strong, beautiful surface and a sense of decoration that seems appropriate. All that means is that there seems to be some sort of comparative chip in my head, linked to my heart, which says in front of a great pot, "Yes—get that one!" Often, my mind zips around to pots I've seen somewhere else and tells me that the neck, shoulder, body, and foot are all put together in an interesting way. When looking at pots for the first time, I have the feeling my mental Rolodex is zipping back to all the pots I've seen in museums around the world for comparisons.

KBB I keep thinking about the Songye pot, because one of the things that I think is so attractive about it is how much the embellishment is in harmony with the shape.

KA I think that's true about a lot of the pots I like the most, even those that couldn't be more different from each other. The Songye pot has very thick walls of clay, while the Zulu pots are some of the thinnest there are. The Zulu pots in the show have a completely different handling of the clay on

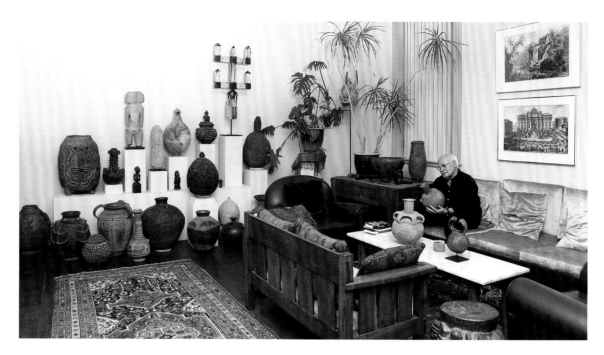

Keith Achepohl at home with his collection, Iowa City, Iowa, 2004.

the surface. There are often geometric shapes, but in this case each is produced with distinct tools. The decoration on one (cat. 125) is probably just simple scribing with a comb in a zigzag pattern; the other two (cat. 123–24) have those beautiful shapes that were simply pinched out of the clay. There are a lot of Zulu pots out there and I've looked at many, but these three typify how different they can be, and I love that difference. Then there's the Cameroon pot (cat. 88), which has almost a necklace of ribbon hanging from the shoulder, that is so beautiful. There's a kind of rhythm that the potter used, and that's grand. You almost have the feeling that if you turned the pot it would move. There's great feeling there. The neck is so elegant, with the shoulder of ribbon, it's magic.

KBB How has what you've looked for changed over time?
KA When I first started collecting, there were very few pots available. When those first Songye pots came out of Africa in the 1980s, there weren't many other kinds of pots, then all of a sudden there were no more Songye pots. Then another kind of group would start arriving into the American market, so it became quite interesting. I think that as different objects became available, I changed my own feelings about what I was looking *for* partly because what I was looking *at* was different. But I also believe that there's been a broader pattern in my own approach: even from that first Songye pot I started noticing that there's a sense of drawing in African pottery that's very special. By this, I mean "drawing" in a general way—how a potter uses her hand to put clay down, uses a tool to scribe, or uses anything to make a kind of mark. The hand is at work on all these pieces, and as the collection grew I think I looked more keenly for that sense as a key ingredient of a unique piece. It became wonderful to see how animals or figures would be drawn out of or onto clay. With a few pots I had the feeling that if the pot could be laid out flat it could be read as a picture.

KBB You are an accomplished printmaker. Has your experience or vision as an artist influenced your collecting, or vice-versa?

KA Most of my own work in art has been made on paper, but in the last ten years I've usually worked on handmade papers, which have beautiful textures. The surfaces of the pots are an important part of what I look at, texture, color, and what gets added to the surface. In a broader way, both paper and pottery are fragile yet resistant—both survive centuries of use. I have come to think that I like the balance between fragility and whatever it takes to keep an object intact. As a collector and as a maker of objects, I'm attracted to the idea that what must survive does survive.

It's impossible to look at many of these pieces and not be encouraged to make a bold statement in my own work, whether it is through heroic form or exquisite decoration. I have probably been encouraged subconsciously to be braver in making art, to think more before doing. Certainly I have thought a good deal about the idea of variations on a theme. So much of the utilitarian pottery is about a certain need to perform a specific function—to hold grain, water, beer. Even with these simple needs the potter plays with the shape, the creative juices flow, and we get the occasional special piece. The ritual objects are probably more idiosyncratic and allow the maker a freer attitude.

KBB When did you first begin to think about your pots as a "collection," and how did this change the way you made purchases?
KA Much has been written about collecting—the need for it, the neurosis of it, and so forth. And there are those people to whom two or three of something becomes a collection. I had been collecting African art of various sorts since 1970, but even then collecting important pieces of traditional African art was expensive. To find that great pieces of pottery were affordable in the 1980s, even when the art market was crazy otherwise, was encouraging. As the great pots became available and I continued to look, it became impossible not to acquire. At some point it seemed logical to try to make a significant collection representing as much of

African pottery as possible. There may be gaps, but I have been fortunate in generally being able to get what I wanted when the pieces were available. Living with these works and looking at so much pottery over the decades has of course been thought provoking. Every time I look closely at a piece I have neglected for a while I'm reminded of why I bought it: the form—the decoration—the use of tools to embellish—the subtleties—the bravery or finesse in the making. More and more I see an individual at work making a statement.

KBB What inspired you to donate your collection to the Art Institute, after having lived with it for so many years?
KA When I was growing up, there were no art works in our house to live with, but there was the Art Institute, which my grandmother took me to visit often. From these first visits I remember thinking how wonderful it would be to live with great works of art. I made pictures from a very early time in my life—I knew it was what I had to do.

I remember on a visit to the Art Institute I asked my grandmother about the little placards beside works of art—information on donors, acquisition dates, and so on. She explained to me that so much of what was there was donated, that people built collections and eventually gave the works to the museum for the public to see. I remember the names Helen Birch Bartlett and Regenstein from these years, and they left an impression on me.

Only later of course, long after being able to live with works that I would acquire and absorb, could I begin to conceive of giving them to an institution. There is a point when you simply want to share. Perhaps it is a matter of thinking a collection belongs where people can learn from it. I've been a teacher for almost half a century; if not teaching, exactly, building a collection and giving it to the public is another form of teaching. It's all about revelation—allowing others to benefit from something that has been of great value to me in my own life.

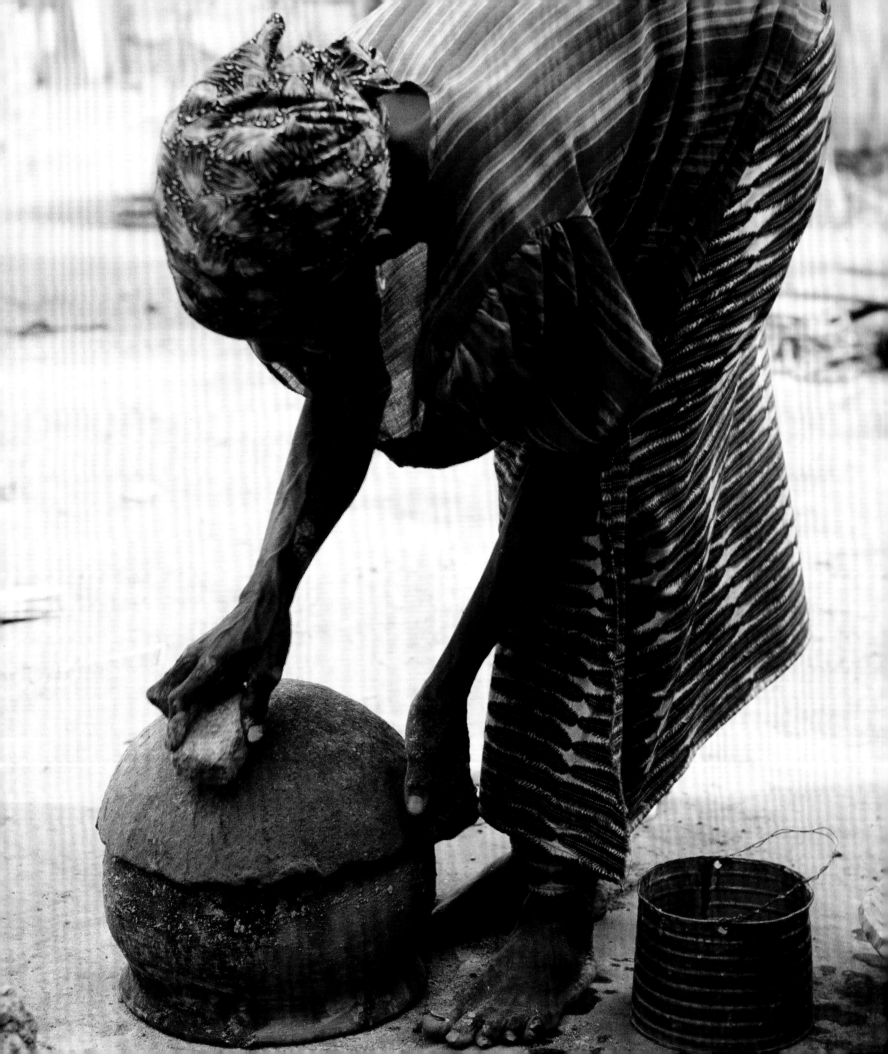

CERAMICS IN AFRICA

Kathleen Bickford Berzock

Pottery is among the most ancient of human endeavors, and its basic processes and forms have changed little over time. Even today the essential elements of a potter's work—the tempering, forming, embellishing, and firing of clay—link us to our distant ancestors. On the African continent, where ceramics are predominantly built by hand and fired at low temperatures in the open, this is particularly true. African potters preserve technologies that are so refined in their steps and so fitting for their purposes that they have been passed down from practitioner to practitioner for centuries and in some cases millennia.[1]

The history of pottery in Africa can be traced back many thousands of years. By 8000 B.C. hunters and gatherers in the central Sahara, then a verdant land of lakes and rivers, formed and fired clay to make vessels for cooking and storing food.[2] As the area became increasingly arid, some adapted to a life of pastoralism while others migrated southward seeking more fertile lands. By 1600 B.C. people on the edge of the forest, in what is today northern Ghana, began to practice agriculture, and with this settled lifestyle their ceramics grew in abundance and complexity.[3] Pottery was also being practiced elsewhere on the continent. To the east, in Egypt, fine ceramics can be dated as far back as 4000 B.C., with marked changes in style over subsequent centuries.[4] In the region of the Great Lakes, in what is today Rwanda, Burundi, and Uganda, dimple-based pottery was being made by 500 B.C.[5] Along the east coast of Africa, archaeologists have found works that they associate with the migration of Bantu-speaking

people from the Great Lakes beginning in the third century B.C.; they have also uncovered a locally derived style, called triangular incised ware, which developed not long afterward.[6] In southern Africa, conical-based examples associated with herders can be dated to the first centuries A.D., while migrations from the north brought populations who cleared land for farming and produced works in a contrasting style beginning in the fourth century A.D.[7] By the first centuries A.D., pottery was practiced throughout the African continent, and many potters were engaging in their craft as a form of aesthetic expression, shaping and embellishing their work in ways that transcended mere necessity.

Archaeology also reveals the symbiosis of pottery and ironworking. These technologies often appear hand in hand, heralding settled life and the development of complex societies.[8] Each uses the earth's raw materials and is dependent on the transformative power of fire. Scholars speculate that experiments with firing ceramics may have led to the discovery of metallurgy.[9] Across a large expanse of West Africa, from the westernmost edge of the Sahel to the mountains of western Cameroon, this intimate connection is woven into the social fiber of the many cultures that contain a separate, hereditary social group composed of male blacksmiths and their potter wives and mothers. The Achepohl collection includes examples of pottery made within this tradition from the Bamana, Maninka, and Somono of Mali, the Bobo of southern Mali and western Burkina Faso, the Jerma of Niger, and the Mafa of west-central Cameroon. Among these

FIG. 1
Maninka potter Nakani Kanté forms the bottom of a vessel over a convex mold. Photo by Barbara Frank, Kangaba, Mali, 1992.

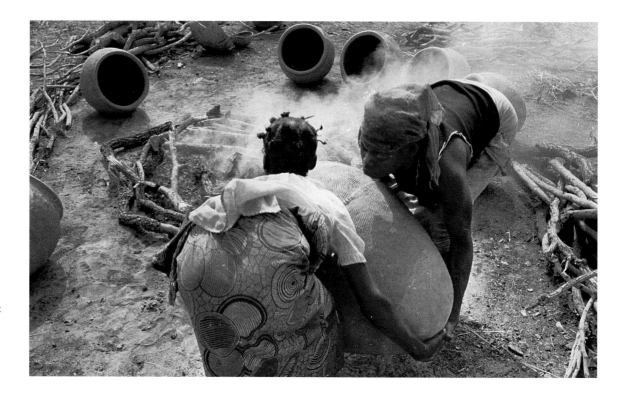

FIG. 2

Bobo potters work together to lift a heavy jar onto a bed of fuel, where it will be fired. Photo by John Watson, Koro, Burkina Faso, 1996.

societies ironworking and pottery are more than professions—they are a birthright that contributes to a sense of identity, whether an individual takes up a craft or not.[10] This practice, however, is not universal. In those instances where potters and blacksmiths are not fundamentally linked, for instance among the Senufo, we can see alternate histories of cultural development.[11]

Given the primacy of pottery in human society, its intimate connection with the earth, its almost magical relationship to fire, and its close association with the dangerous and powerful technologies of ironworking, it is not surprising that its ritual use can also be traced through Africa's archaeological record. In the Middle Niger region of Mali, for instance, the rise of cities and trade increased the demand for decorative pottery containers, which appear to have been made exclusively for inclusion in elaborate burials (see cat. 9–10).[12] The same is true in the area of the Upemba Depression, in present-day Democratic

Republic of the Congo. There potters working in the eighth to tenth century A.D. made a wide range of wares, some in elaborate shapes and with distinctive incised rims, and included them in the graves of important members of the community.[13] In South Africa's Eastern Transvaal, pottery shards have been found along with elaborate clay sculptures of human heads that date to the sixth century A.D.[14] The region north and south of the confluence of the Niger and Benue rivers in present-day central Nigeria was one of the richest centers of ritual pottery production. There the ancient sites of Nok (800 B.C.–A.D. 600), Igbo-Ukwu (tenth century), and Ile-Ife (eleventh through fourteenth centuries) have all revealed ritual contexts for figural sculptures and containers in clay.

The pottery chips and fragments that litter archaeological sites today bespeak a thriving ancient industry. It is more than likely that the same skilled potters made wares for a variety of secular and ritual purposes and that they were

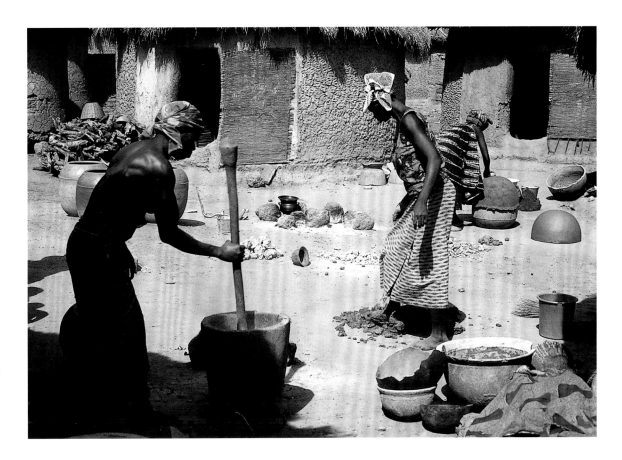

FIG. 3

Kpeenbele Senufo potters at work. One woman pounds broken pieces of pottery into temper, while another mixes temper into wet clay with her foot. In the background a third potter forms the bottom of a large water container over a mold. Photo by Anita Glaze, Diegon village, Dikodougou district, Côte d'Ivoire, 1970.

women, just as women dominate contemporary ceramic production across the continent.[15] It is important to note, however, that women's ownership of the technology and craft of pottery is not universal in Africa, and that exceptions to this rule can be found in all major regions. In the cities of Algeria and Morocco, for instance, Berber men make vessels using the wheel, while in rural areas Berber women build their works by hand. Among the Mossi of Burkina Faso the gender of potters varies from region to region, with men controlling the craft in some areas while women predominate overall. This is true as well for the Hausa, where men are the primary potters in parts of northern Nigeria. Among the Bëna of Nigeria, the Nsei of Cameroon, the Chokwe of Angola, and the Lozi and Mbunda of Zambia, women produce the bulk of domestic pottery, while men focus on ritual or

luxury wares, which are highly specialized and also, arguably, more lucrative.

Equally significant is that even among cultures in which both sexes can be potters, they usually practice their craft separately and may even use fundamentally different techniques.[16] This reflects an overall trend across Africa of keeping the responsibilities and occupations of men and women largely distinct. Other tasks that are often, although not universally, taken up by women include basketry, beadwork, body decoration, calabash decoration, cloth dyeing, embroidery, hairstyling, leatherwork, wall painting, and weaving. These jobs often have a domestic function at their root and are easily practiced at or near home, making them convenient for women who must also look after children, prepare meals, and keep house.[17] The same is true of pottery,

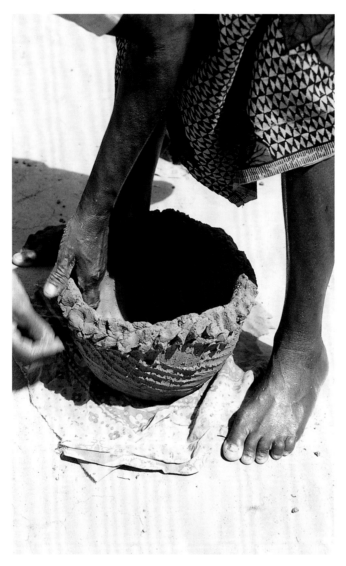

FIG. 4
Pare potter Mamsifueli Nyeki
begins a pot by pulling clay
upward with her fingers. Photo
by Barbara Thompson, Lushoto
district, Tanzania, 1997.

who conducted an in-depth study of ironworking
and related technologies in Africa, argued that,
in its processes and forms, pottery offers a power-
ful means of reflecting on human procreation and
reproduction.[20] As Herbert described it, the potter
"provides the pots in which water is stored for
drinking and for rainmaking, she transforms raw
food into meals and raw clay into finished forms
through the medium of heat, and in so doing she
provides a way of thinking about the most central
aspects of human life."[21]

THE TECHNOLOGY OF POTTERY
IN AFRICA

In Africa, the ancient processes used to make
ceramics have been streamlined through trial and
error; highly efficient, they are well suited to
varying environments.[22] Pottery is a conservative
craft, and changes to its essential steps are intro-
duced only gradually. It is this conservatism that
has led Barbara Frank to observe of Mande pot-
tery, "The ways potters make pots reveal more
about the origins of different traditions than the
styles of the finished products. Pottery produc-
tion reflects specialized knowledge transmitted
from one generation to the next and augmented
by individual experience."[23]

Before pots can be created, raw clay must be
obtained and prepared. The mining of clay—
which is widely distributed across the continent
and often located in secondary alluvial deposits—
takes place mainly during the dry season.[24] In arid
regions such as the Sahel and savanna, clay is exca-
vated from deep pits that must be free of standing
water in order to be accessed. In forest regions it
is commonly mined from the banks and beds of
rivers or ponds, which may be under water during
the rainy season. Digging clay is physically
demanding work, and men often participate even
in areas where women are strictly in control of all
other aspects of pottery making. Because clay is

which is primarily made in villages, fired nearby,
and used in the home.[18] Group cooperation also
characterizes much of the work traditionally done
by women in Africa.[19] The arduous steps entailed
in making ceramics—digging clay, collecting fuel,
transporting and organizing pots for firing, and
transporting the finished product to market—
are all accomplished more easily when done
together (see fig. 2). Tackling these tasks collec-
tively optimizes resources and labor. In a more
metaphysical vein, the scholar Eugenia Herbert,

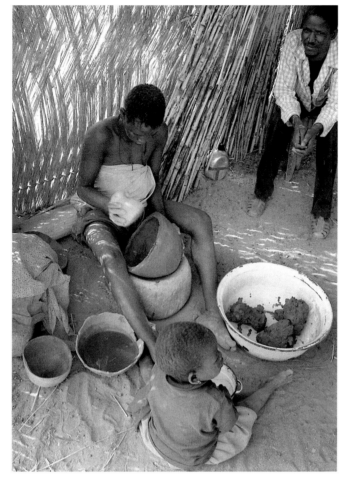

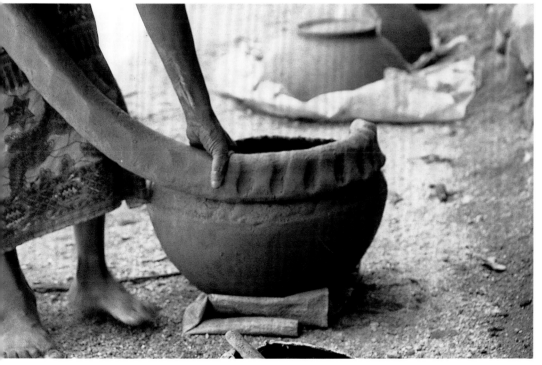

derived from the earth and is closely linked to it, prohibitions and rituals are sometimes associated with its excavation. This is also true for the dangerous activity of firing ceramics. In both instances invocations may be said and offerings made to spirits of the earth or wilderness. Individuals may be banned from these activities if they are considered particularly vulnerable to supernatural harm or if their state of being could hinder the process. In Mali, for instance, Mande people speak of raw clay as having a vital energy, or heat, that can be dangerous if not handled properly, and they view clay pits as the domain of spirits called *jinew*.[25] Before they dig clay, Mande women and men must first bathe in a solution specially prepared to offer protection; menstruating women are barred from participating. Menstruating and pregnant women are likewise strongly advised to avoid the clay pits in the Babessi chiefdom of Cameroon, where volatile and potentially dangerous spirit forces inhabit the landscape.[26] These forces can threaten both a woman's reproductive abilities and her ability to produce pottery, an act that is conceptually likened to childbearing.

Once mined, fresh clay must be transported back to the village, sometimes miles away, to be processed. Various steps are involved in preparing it for use. Most commonly it is dried in the sun and impurities are removed; the dry clay may then be pounded into small chunks or even a fine powder for storage. When potters are ready to use it, they soak it in water from one to as many as several days. They then knead the reconstituted material to consolidate the clay particles, removing air bubbles that could expand and burst during firing. If necessary, they then add a temper such as sand, ground-up pebbles, finely chopped plant fibers, or grog, a fine substance that consists of fired pottery reduced to a powder (see fig. 3).[27] Tempering with such an inert material—one that will not expand and contract—reduces the plasticity

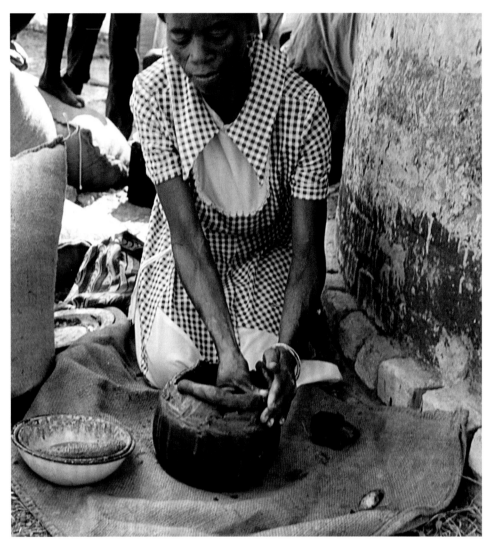

FIG. 7
This Shona potter has turned the leather-hard upper half of a vessel upside down and is completing the bottom by adding coils.
Photo by Anders Lindahl, Gutu, Northern Mashonaland, Zimbabwe, 1988.

pounding a flat slab of clay over a rounded form, often an old pot (see fig. 1). Potters may also use a concave mold, pressing clay into it to create only a small part of the base; they may use a variation of this technique that allows them to build a much larger portion of the container.[29] In this second method, the potter hammers clay into a mold, which is either a shallow bowl or a specially prepared indentation in the ground, while progressively tipping and rotating the resulting form (see fig. 5). With each turn, she thins and gradually shapes the mass of clay into a rounded, at times almost perfectly spherical, container. Because this technique requires very little water, it is particularly well suited to dry regions. Coiling, in which rolls of clay are adhered by pressure to the upper edge of a form in a spiral fashion, is frequently used as a complement to each of these techniques (see fig. 6). Coils can be used to build or greatly increase the height of a pot's walls or, more minimally, to fashion a neck or a simple lip.

Some interesting variations exist among these techniques. When making large vessels, for instance, Shona potters in Zimbabwe and southern Mozambique complete the upper body and neck, allow it to dry to a leather hardness, and then turn it over to complete the bottom (see fig. 7).[30] The Ekiti-Yoruba practice another unusual method whereby the walls and rim of a pot are built up from a hollowed-out but unformed lump of clay.[31] When hardened, the completed portion of the vessel is inverted and the outside of the base is scraped until it, too, is evenly thin and smooth. And in the pottery centers of Babessi and Nsei, in Cameroon, potters begin mid-sized and large pots by forming a low dome. Once leather hard, this is turned over to become the pot's base, and coils are added to complete the walls and lip.[32]

If fashioning a small container, a potter usually works from a seated position while rotating the pot on a roundel, often a piece of broken pottery or a shallow wooden dish made especially for the

of clay, allowing it to dry more evenly and making it less likely to crack during firing. This process also renders the clay body stiffer so that it holds its shape more readily as the potter works.

The vast majority of potters in Africa make their works by hand, using a limited repertoire of techniques.[28] The most widespread of these is the direct pull or pinch pot method, in which a potter punches or gouges directly into a lump of clay, widening, thinning, and shaping the base with her fingers (see fig. 4). Also widely employed is the convex mold technique, which involves pressing or

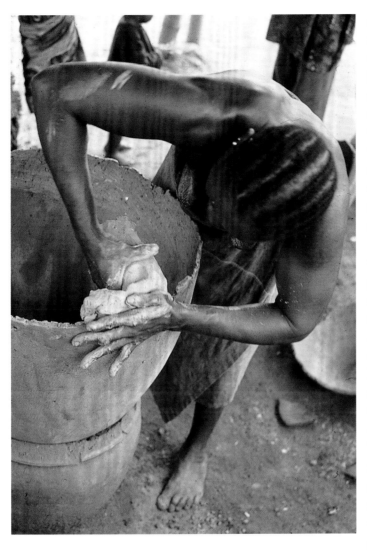

With her large, unfinished vessel standing on a raised base, Rachele Bamide, a Yoruba potter, adds a coil by walking backwards around it. Photo by Maude Wahlman, Moro, Nigeria, 1970.

dipped in water is used to smooth the body and rim. A stone or beads are sometimes rubbed over the pot when it is leather hard in a process called burnishing that strengthens clay particles and gives the surface a smooth, shiny appearance. And a corncob or a specially fabricated roulette—whether a twisted or plaited fiber or a carved wooden dowel—may be rolled over the surface of the wet clay (see fig. 9). The resulting texture makes a fired pot easier to grip and increases its surface, improving heat absorption in cooking and evaporation in cooling.[33]

African potters most commonly fire their wares in the open, using fuels such as dung, grasses, millet shafts, straw, and wood. The size of a firing may vary from one very large pot to several dozen or even hundreds of smaller ones. Arranging the vessels in these joint firings is an exacting task, for a mistake can put everybody's hard work at risk. Like other facets of pottery making, the various options are dictated by tradition. Pots may be stacked mouth down, mouth up, or mouth on edge, leaning against the pot in front. They may be positioned atop an initial layer of fuel or on top of stones that allow heat to move around and inside them. The completed pile is crowned with fuel, creating a massive mound. Once ignited, the burn is watched and carefully gauged by experienced potters who are experts in this critical art (see fig. 10). They may instruct younger members of the group to add fuel at various locations to keep the fire burning evenly and with proper intensity for a sufficient period of time. Even so, the fire spends itself relatively quickly, often being reduced to ashes in no more than one or two hours.

There are traditions in which a low-walled, roofless kiln is used to fire ceramics, as, for instance, among some Yoruba and Hausa potters in Nigeria and Mossi practitioners in Burkina Faso (see fig. 11).[34] Access holes around the bottom of the kiln allow air to circulate, or at times fuel to be

purpose. This makes it easy for her to work on all sides evenly and can create centrifugal force that helps her shape and smooth the clay body. When crafting larger wares, she often works upright, placing the vessel on an elevated base if necessary and walking backward around it to create the motion and at times the rotating momentum necessary to achieve symmetry (see fig. 8). Potters are assisted in their work by a small number of additional tools. An easily gripped rib, whether a piece of gourd, wood, or a seedpod, is good for scraping. A leaf, a small patch of cloth, or leather

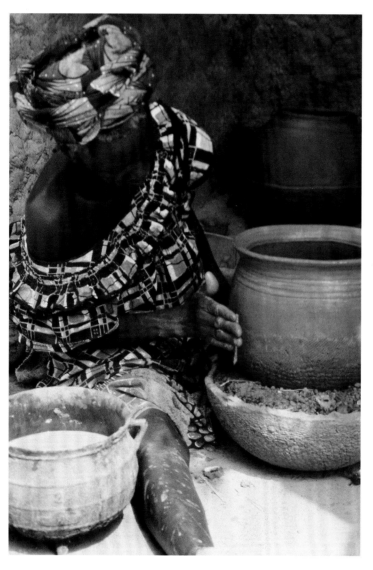

transformation of the clay into a material that will not disintegrate when it absorbs water and is able to expand and contract easily.[36] These qualities mean that African pottery sweats, keeping liquids cool, and can withstand sudden changes in temperature, known as thermal shock, without cracking. This makes it ideal for cooking over an open fire, which may produce uneven heat, or for easily integrating ingredients of varying temperatures, such as a cool liquid into a boiling sauce. It also allows pots hot from the fire to be splashed with or dipped directly into a liquid solution of water-soaked bark or leaves, which gives them a shiny appearance and colors them in shades varying from reddish brown to a deep brownish black (see fig. 12). Other pieces may be smoked and blackened in a pile of dry shavings—whether of grass, locust seed pods, or millet chaff—that is ignited by the burning-hot vessels themselves.

THE ART OF AFRICAN POTTERY

African pottery is functional above all else. It is meant, for instance, to store grain or water, to cook and serve food or medicines, or to keep treasured possessions safe. These duties necessitate a strict set of requirements that must be met and maintained if a vessel is to fulfill its task. The craft of pottery lies in meeting its practical requirements well; the art of pottery lies in transcending them to create a vessel that is wholly useful while also pleasing and compelling to the senses. In Africa, where pottery is hand built, an important part of its aesthetic appeal lies in the physical immediacy and intimacy of the potter's touch. Very often a finished piece reveals the trace of the potter's hands and the highly individual way she manipulated her clay. Although the types of vessels that a potter makes may be repetitive, their forms are not mechanical. Each handmade pot possesses idiosyncrasies and asymmetries that

FIG. 9
Bamana potter Assitan Ballo rolls a roulette made from a twisted string around the belly of a cooking pot, creating a pattern of impressed diagonal lines. Photo by Barbara Frank, Kunògò, Mali, 1991.

added, to keep the fire burning strong. Pots are stacked to a height that reaches above the kiln's wall, and even more fuel is piled on top. The entire mass is then covered by large pieces of broken pottery that shelter the blaze and help retain heat. Firing pots in a shallow pit likewise helps to retain heat, though this technique seems to be used only rarely by African potters.[35]

The temperatures produced by these firing techniques are relatively low, achieving a complete

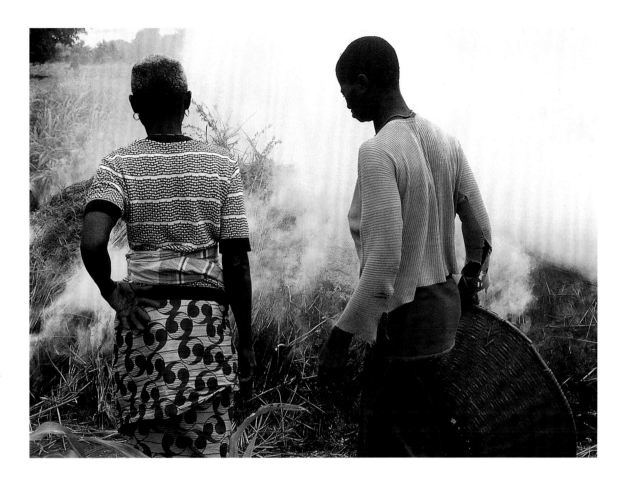

FIG. 10

Senufo potters watch as their pots are fired within a carefully constructed mound of burning grasses and wood. Photo by Kathleen Bickford Berzock, Dabakaha, Côte d'Ivoire, 1992.

make it unique. And because a potter usually decorates her own wares, there is often a strong accord between form and decoration.

Clay is formless and infinitely malleable. This quality, coupled with the seemingly elemental and unencumbered processes of hand building and low-temperature firing, helps make possible a wide variety of inventive shapes and embellishments. Vessels made by African potters range from the minimalist to the highly ornate, from the robust to the refined. The structures of many pots are naturally dictated by their uses. Containers for transporting liquids are light in weight and designed with capacious bodies that narrow at the neck or mouth to reduce sloshing and spilling (cat. 71). Because they remain stationary, those for storing grain are often heavier and have wide mouths that

allow for easy access. They are also frequently designed with short legs that help reduce infestation from rodents or insects (cat. 39). Cooking pots have round bottoms that conduct heat evenly and are given little surface embellishment since they will become sooty with use.

It seems almost simplistic to observe that the shaping of a vessel can fully engage a potter's aesthetic faculties. Yet, like sculpture, pots are three-dimensional objects, occupying space in a complex manner that shifts according to the viewer's vantage point. In her work, a master potter weighs the relative size of foot to neck to body, subconsciously playing out the balance between the swell of a belly and the inward turn of a shoulder. While some pieces have an exquisitely balanced form as their primary source of aesthetic interest,

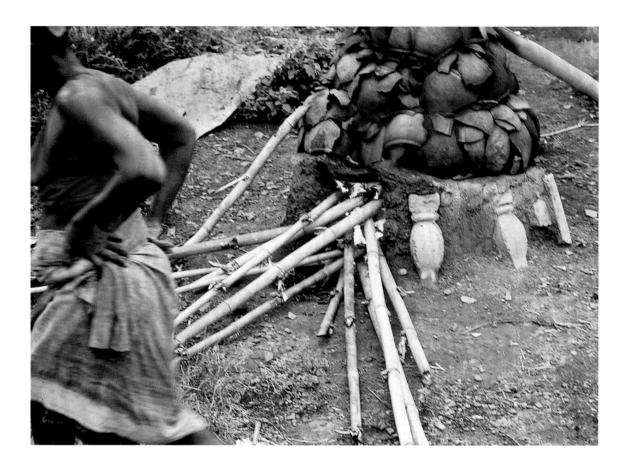

FIG. 11
A Yoruba potter adds bamboo
stalks to feed the fire in a low-
walled kiln. Broken pots are
stacked on top to help retain heat.
Photo by Maude Wahlman,
Yakoyo, Nigeria, 1970.

the vast majority of pots are also adorned, how-
ever minimally, with some type of surface embel-
lishment, whether impressed, incised, or applied
with clay or pigment.

Impressed patterns are introduced when the
clay is still soft. Even in the early stages of form-
ing a vessel, a potter can mindfully enlist her own
processes of production in the service of this type
of decoration. For instance, concave molds are
often lined with a mat or loosely woven cloth to
help reduce sticking. As the potter pounds her
clay into the mold, a texture appears that may be
carefully preserved later (cat. 19). A similar result
is achieved with a convex mold by covering the
block used to pound clay over the mold with a
roughly textured cloth (cat. 25). The roulette is
perhaps the most widespread tool used to impress

patterns and textures into wet clay.[37] While in
most regions of Africa roulette patterns are
applied in a broad, repetitive fashion that empha-
sizes texture more than design (cat. 37), in some
areas they are employed in highly distinctive
ways. For example, Turka potters in Burkina Faso
use roulettes to impress netlike, crisscrossing
bands around a container's body (cat. 28), while
in East Africa's Great Lakes region, dense and
complex roulette patterns are the most common
form of pottery decoration (cat. 111). The tines
of a comb (cat. 11–12), a notched metal bracelet
(cat. 29), a carved wooden stamp (cat. 21), and
even the maker's own fingers (cat. 17) can also be
used to impress patterns into clay. Potters fre-
quently heighten the visual impact of impressed
patterns by contrasting them with smoothly bur-

nished areas (cat. 101). If done vigorously enough, burnishing can also score shallow channels in the clay, creating a subtle texture of its own, as seen on the neck of the Hausa water container in the Achepohl collection (cat. 17).

Incising with a pointed implement or sharp-edged blade usually takes place when clay is leather hard. This technique is often used to outline large areas of a design, which may be filled in with further incising (cat. 39), roulette-impressed patterns (cat. 102–103), or pigment (cat. 120–21). Special tools and techniques may be used to render evenly incised lines, whether individually or in clusters. For instance, holding her stylus steady in one hand, a potter can rotate her vessel on a roundel to mark its circumference with a perfect circle. By applying multiple circles in this fashion, she can create the look of a wider band (cat. 47). Closely set and evenly spaced lines can also be added by pulling a comb across the surface of the clay (cat. 65). In contrast to these mechanical approaches, incising can also be employed to make very immediate, even gestural marks, including the fine, arcing lines on a ritual object from Mali's Inland Niger Delta (cat. 2) and the animals drawn freehand on an Ambundu or Chokwe bottle (cat. 98). Incised areas are often enhanced by rubbing kaolin, a white clay, into the crevices (cat. 117). In the chiefdom of Nsei, in central Cameroon, as well as among the

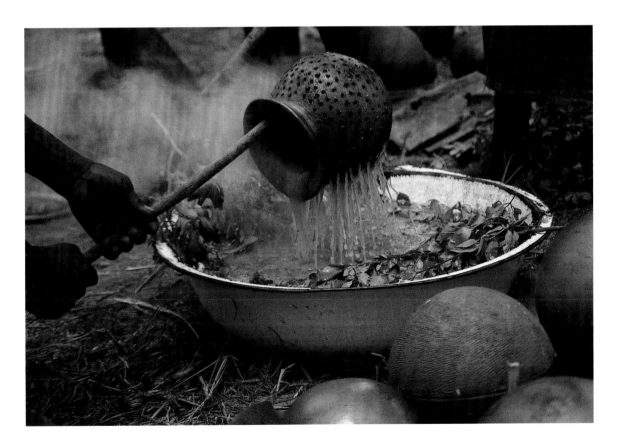

FIG. 12

A strainer still hot from the fire is immersed in a solution of water, bark, and leaves that will give it an attractively shiny appearance. Photo by Kathleen Bickford Berzock, Dabakaha, Côte d'Ivoire, 1992.

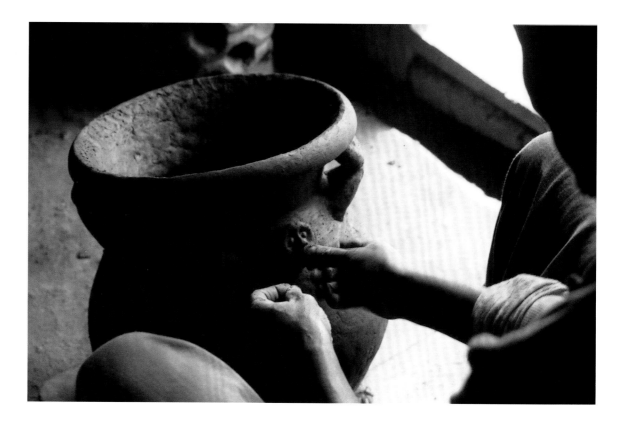

FIG. 13

Innovative Nsei potter Martin Fombah applies sculptural decoration to a palm wine container. He also made the palm wine pitcher in the Achepohl collection (cat. 95). Photo by Silvia Forni, Mbaghang quarter, Nsei, Cameroon, 2000.

Barambo and Zande of northwest Democratic Republic of the Congo, incising has been taken to another level. In these traditions potters intentionally construct their wares with walls that are thick enough to accommodate deeply inscribed patterns (cat. 89, 103).

The opposite of incising is the application of raised embellishment. Narrow cords of clay may be used to draw a design on the surface of a pot (cat. 63), or small clusters may fill in a pattern, as with the classic Zulu style of decoration evocatively called *amasumpa*, or warts (cat. 122). Shapes appliquéd in low relief can elegantly delineate an abstract motif or portray an image simply (cat. 36). As the relief becomes higher, it can be articulated in a very sculptural manner (cat. 95; see fig. 13). At times a container becomes a stage for an almost freestanding figure (cat. 23) or is itself transformed into a figural sculpture by the addition of a head or arms (cat. 107). Potters can apply

elements that add decorative flourishes to a vessel's overall form, as with the buttresslike handles on many Igbo bottles (cat. 65–66) and the arcade around the shoulder of the Ewe shrine pot in the Art Institute's collection (cat. 54). Some additions transform the surface of a piece almost completely, such as the spiky projections that bristle across the bodies of some medicine and altar pots (cat. 80). Applied patterns need not always be rendered in clay; pitch was used to draw stick figures on the side of a Bwa pot in the Achepohl collection (cat. 44), and thin, repoussé metal plates were adhered to a Nupe bottle (cat. 70).

While glazes are not traditionally part of the repertoire of African potters, pigment is used and can be applied before firing to create a permanent effect or afterward to produce a more transient impression. The most common method of adding color before firing is with slip— a fluid suspension of mineral-rich clay in water—

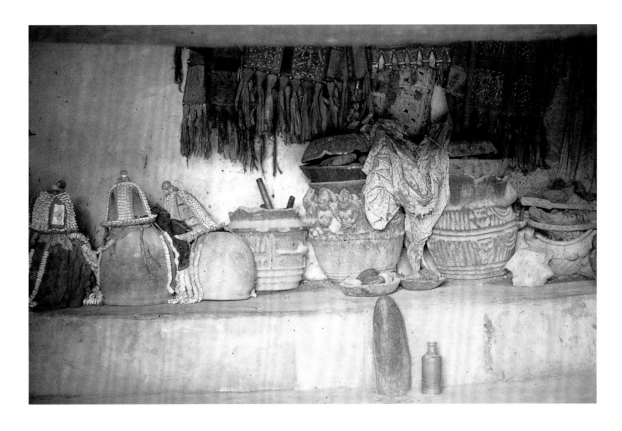

FIG. 14
Several ceramic containers are among the accoutrements on this shrine dedicated to the diety Sango and located at the compound of Baale Koso in Oyo, Nigeria. Photo by John Pemberton III, Oyo, Nigeria, 1971.

that is painted or rubbed onto a pot once it is leather hard. Slips can create subtle shifts in tone (cat. 119) or more extreme contrasts (cat. 22). If burnished before being fired, a slip takes on a lustrous quality that contrasts with matte or textured surfaces (cat. 26–27). After firing, a pot can be plunged directly into an herbal solution that varnishes the vessel deep brown or black (cat. 24). A vessel taken directly from the flames can be blackened entirely or marked only in spots, called flashes, if placed in a pile of millet chaff, sawdust, or other dense flammable materials; this process is called reduction firing and works by creating an oxygen-poor environment (see cat. 122–25). Once cool, a piece can be painted with natural pigments including iron oxide, kaolin, laterite, ochre, and soot. Jerma potters in southern Niger ornament water containers with elaborate but fleeting patterns that may later be refreshed by their owners (see cat. 18–19). Today enamel

paints sometimes replace slips and other natural pigments, as on a Shona water container in the Achepohl collection (cat. 118).

FOR HEARTH AND ALTAR

Pottery in Africa is abundant and accessible. It is made in almost every culture on the continent, usually in an open and public manner (see fig. 3).[38] This profound integration of pottery into the life of a community is also expressed in the multiplicity and blending of its uses. While the overwhelming majority of ceramics are made for the home, their uses may be secular or sacred and may move from one context to the other with fluidity.[39] The same bowl that cooks the family meal may also be used to mix medicines that promote contact with spirits or may become part of a diviner's kit (see "Engaging the World Beyond," figs. 1–2). A beer pot may pour a libation to the ancestors one

minute and be shared among wedding guests the next (see "Beer and Palm Wine," fig. 4). Most often it is not the form of the vessel, but rather the context of its use, that signals how it should be regarded. Among the Baule of Côte d'Ivoire, for instance, the same pot that is looked at openly when used to hold water, grain, or food, can only be glanced at surreptitiously when it is placed on a shrine.[40] Conversely, the relatively rare works that are made expressly for ritual use often mimic their more secular cousins, differentiated only by virtue of their size or elaborate embellishment. Thus a vessel intended for a shrine in the Yoruba region of Nigeria may still take the form of a water container (cat. 64), and a palm wine vessel reserved for use by a palace regulatory society in the Cameroon chiefdom of Nsei is signaled only by the looping handles and representational imagery around its shoulder (cat. 94). The settings for such ritual containers also at times evoke the domestic sphere. A Sango shrine like the one seen here, in the Yoruba town of Oyo, in some ways imitates a palace veranda, in essence establishing a stately human home for the deity (see fig. 14).

Whether secular or sacred, the most essential task of a vessel is to be filled. The symbolic association of pottery with containment is so strongly felt that even when ritual pots are completely dissociated from this role, they may continue to be given the outward form of a container. For instance, in the Inland Niger Delta region of Mali, ancient ritual objects made exclusively for burial were shaped like lidded jars, but with no functional opening at the top (cat. 2–4). When pots are given human attributes, the symbolic aspects of containment are extended even further. This is true in northwestern Nigeria and eastern Cameroon,

where pots used in rituals of healing and ancestor commemoration are made to look like people, metaphorically referencing the human body's role as a container of life force and spirit.[41] Among the Fon and related peoples of coastal Ghana, Togo, Benin, and Nigeria, where the Vodun religion is practiced, potters are commissioned to make shrine figures that take the form of pots turned upside-down (cat. 52–53; see "Pottery and the Body," fig. 4). It is interesting to note that such figures, while forsaking any practical application as containers, continue to retain an interior space, with all of its symbolic potential. Other pots may be embellished with the same motifs that are used to decorate the human form, as with the Kurumba storage container that bears women's scarification patterns (cat. 38) and the Berber milk jug or butter churn that is painted with motifs also used in tattooing (cat. 14; see "Pottery and the Body," fig. 3). These decorations not only make pots look like people but also give them an almost human sense of social character.[42] Following this line of thought, scholars have suggested that pots and people are alike in that both are irreversibly transformed—pots by fire and people by enculturation.[43] The embellishment of pots with patterns also used on human bodies seems to make this point tangible. The parallel between ceramics and the body is most fundamentally mirrored in the ways that we use language to humanize vessels by naming their parts in our own image—foot, belly, shoulder, mouth, lip. These practices force us to consider the long-standing presence of pottery in human life. In Africa, where hand-built pottery is still widely made and used, we can readily glimpse its profound connections to human experience from hearth to altar.

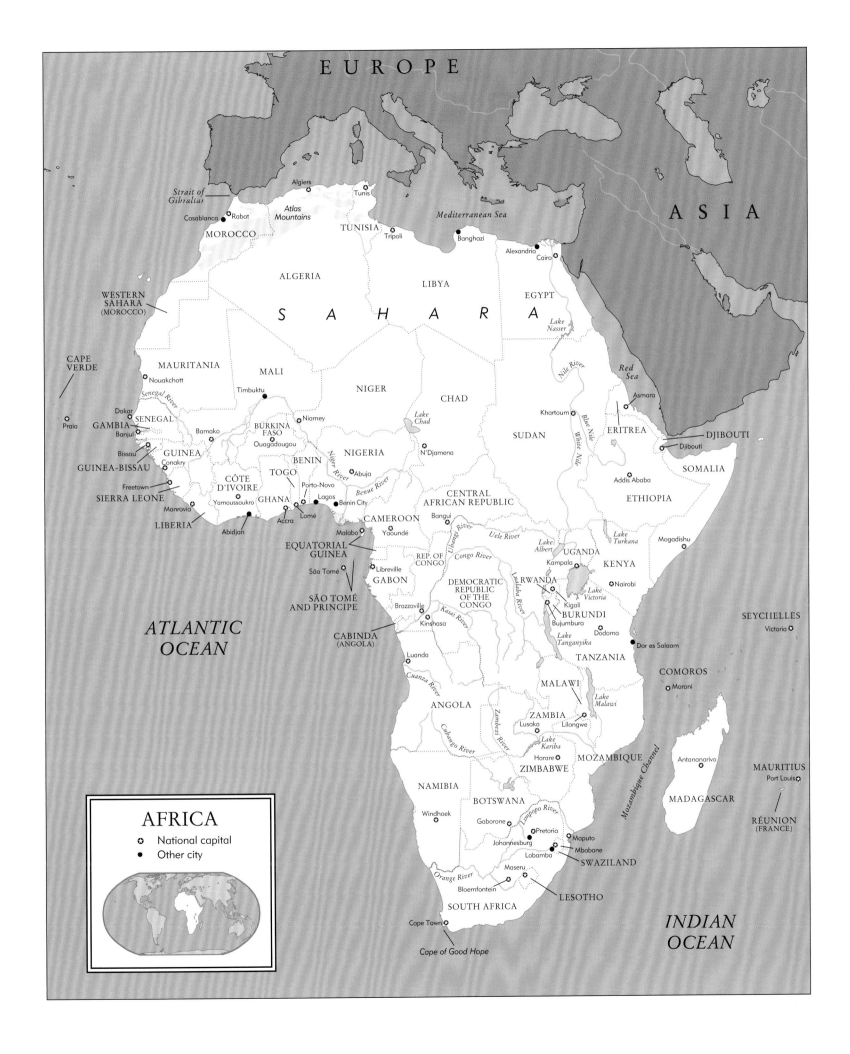

EUROPE

ASIA

Strait of Gibraltar

Algiers
Tunis
Casablanca ● Rabat
Atlas Mountains
MOROCCO
TUNISIA
Tripoli
Banghazi
Alexandria
Cairo

Mediterranean Sea

WESTERN SAHARA (MOROCCO)

ALGERIA
LIBYA
EGYPT

S A H A R A

Lake Nasser

Red Sea

CAPE VERDE

MAURITANIA
MALI
Nouakchott
Timbuktu
NIGER
CHAD

Nile River

Khartoum
Asmara
Blue Nile
ERITREA
DJIBOUTI
Djibouti

Senegal River
Dakar
Praia
SENEGAL
GAMBIA
Banjul
Bissau
GUINEA-BISSAU
Niamey
Bamako
BURKINA FASO
Ouagadougou
NIGERIA
SUDAN
White Nile

Conakry
GUINEA
BENIN
N'Djamena
Lake Chad
SOMALIA

CÔTE D'IVOIRE
TOGO
Abuja
Addis Ababa
ETHIOPIA

Freetown
SIERRA LEONE
Yamoussoukro
GHANA
Porto-Novo
Niger River
Lagos
Benin City
Benue River

Monrovia
LIBERIA
Accra
Lomé
CAMEROON
Bangui
Mogadishu

Abidjan
Malabo
Yaoundé
CENTRAL AFRICAN REPUBLIC
Ubangi River
Uele River
Lake Turkana

EQUATORIAL GUINEA
São Tomé
Libreville
REP. OF CONGO
Congo River
Lake Albert
UGANDA
KENYA

GABON
SÃO TOMÉ AND PRINCIPE
DEMOCRATIC REPUBLIC OF THE CONGO
Kampala
Nairobi

ATLANTIC OCEAN
Brazzaville
Kasai River
Kinshasa
Lualaba River
RWANDA
Kigali
BURUNDI
Bujumbura
Lake Victoria
SEYCHELLES
Victoria

CABINDA (ANGOLA)
Dodoma
Lake Tanganyika
Dar es Salaam

Luanda
TANZANIA
COMOROS
Moroni

Cuanza River
ANGOLA
MALAWI
Lake Malawi

Cabango River
ZAMBIA
Lusaka
Lilongwe
Antananarivo
MAURITIUS
Port Louis

Zambezi River
Lake Kariba
MOZAMBIQUE
RÉUNION (FRANCE)

NAMIBIA
Harare
ZIMBABWE
MADAGASCAR

Windhoek
BOTSWANA
Limpopo River

Gaborone
Pretoria
Maputo

Mozambique Channel

Johannesburg
Lobamba
Mbabane
SWAZILAND

Maseru

Orange River
Bloemfontein
LESOTHO

SOUTH AFRICA

Cape Town
INDIAN OCEAN

Cape of Good Hope

AFRICA

✥ National capital
● Other city

ANCIENT CIVILIZATIONS OF THE NIGER BEND

THE WINDING NIGER RIVER extends some 2,600 miles from its origins in the highlands of present-day Guinea to its immense delta in south-central Nigeria. It is one of the great river systems of the African continent and has provided the life-sustaining resources that have led to the development of major cultures.[1] In the northwest, the successive empires of Ghana, Mali, and Songhay all flourished around the Niger. Further southeast, Niger River sites include Nok, Igbo-Ukwu, and Ife.

The river's vast flood plain, known as the Middle Niger, traces a path from north of Timbuktu to south of Jenné-Jeno in present-day Mali. Archaeologists have revealed ancient cities scattered throughout the region that were once interconnected by trade and cultural exchange.

Although parts of the area show signs of habitation as early as 300 B.C., such urbanism flourished from approximately A.D. 500 to 1100 and continued in decline until approximately 1400. Archaeology paints a picture of a culturally diverse, economically independent, and cohesive region.[2] Its population included a wealthy elite and a highly skilled artist class of at least part-time specialists who produced and exchanged functional pottery, ceramic sculpture, and works of copper, gold, and iron.[3]

Further down the river, in the region extending north of Niamey in present-day Niger to the Malian border, lay the ancient sites of Bura. There, excavations have uncovered burial and ritual centers and areas of habitation dating from the third through eleventh centuries A.D.[4] As in the Middle Niger, material remains from these settlements include pottery and metalwork that, in their abundance, refinement, and intricacy, suggest sophisticated societies with highly structured social systems and trade networks.[5]

Many of the most distinctive styles from the Middle Niger, Bura, and other ancient sites can be found in multiple locations and associated with different uses. As it is impossible to determine the precise origins and function of pottery that has not been excavated under controlled circumstances, most of these ancient works—which have not been scientifically excavated—will never be fully understood. While their extraordinary forms speak to us from across the centuries, we must regret that the stories they might have told are lost when they are pulled out of context without care and study.

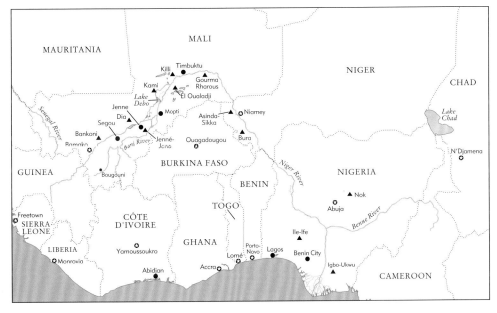

OPPOSITE: 13 (DETAIL)

FIGURAL VESSEL

Inland Niger Delta region, Mali
10th/14th century
Terracotta
36.8 x 29.2 cm (14 ½ x 11 ½ in.)

RICH IN NATURAL RESOURCES and arable land, the Niger River's inland delta has been a regional center of trade since the first millennium. The area's ancient cities, including Jenné-Jeno and Dia, were also centers for ceramic production from their earliest periods of settlement in approximately 250 B.C.[1] It is believed that potters practiced their art in organized groups, worked as specialists at least part of the time, and were women, as are the potters in the region today.[2] They created a wide variety of ceramic wares for domestic and ritual use, including quite possibly the masterful and at times fantastic figural sculptures in clay that have become so well known.[3]

This robust figural vessel clearly demonstrates that containers and sculpture cannot be separated in the ceramic traditions of the Inland Niger Delta. A sparely rendered human head pushes up from the top and is dwarfed by the pot's inflated body, which is hollow with a small hole allowing entry on one side.[4] Bumps like those on numerous figures from the region have been applied to one side of the vessel and may represent pustules or body decoration.[5] Likewise,

the raised herringbone and incised zigzag lines that cascade down from the shoulders suggest the snakes that enwrap many figures and ritual vessels. Combined with this figure's full form, the vessel's sprouting bumps and writhing snakes project a sense of ripeness and fecundity that has deeply human associations.

Though larger in size and more elaborate in form, this vessel is reminiscent of a group of almost spherical examples from the Inland Niger Delta that have been found in a variety of ritual settings. Those have round bodies and flat bottoms and are embellished with snake motifs that often meet in a topknot, dividing the form into quadrants.[6] During excavations at Jenné-Jeno, archaeologists unearthed a spherical pot that was intentionally buried along with a terracotta figure and other containers in the foundation of a house, leading to speculation that they were used in rituals directed toward ancestors.[7] At the site of Kami, north of Mopti, such a vessel was found in a funeral urn.[8] It is possible that this evocative object was used in one of these contexts.

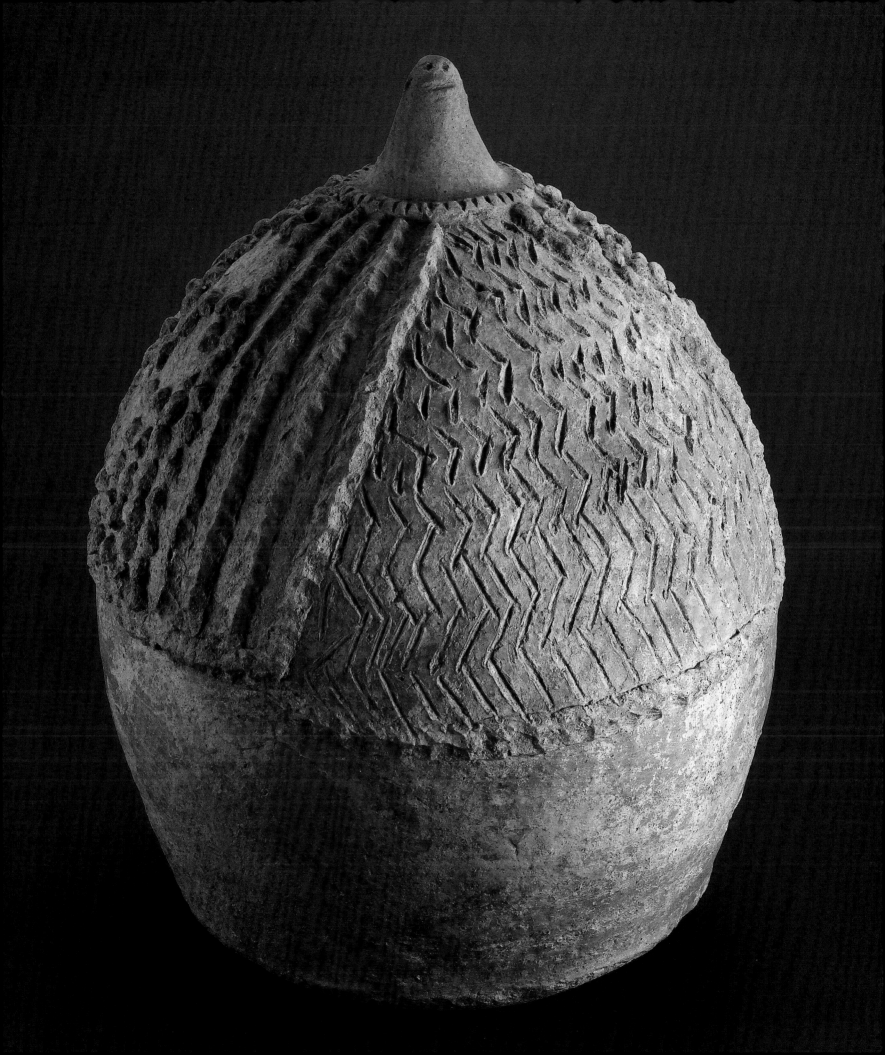

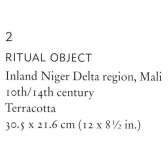

2

RITUAL OBJECT

Inland Niger Delta region, Mali
10th/14th century
Terracotta
30.5 x 21.6 cm (12 x 8½ in.)

3

RITUAL OBJECT

Inland Niger Delta region, Mali
10th/14th century
Terracotta
28.6 x 17.2 cm (11¼ x 6¾ in.)

4

RITUAL OBJECT

Inland Niger Delta region, Mali
10th/14th century
Terracotta
30.5 x 20.3 cm (12 x 8 in.)

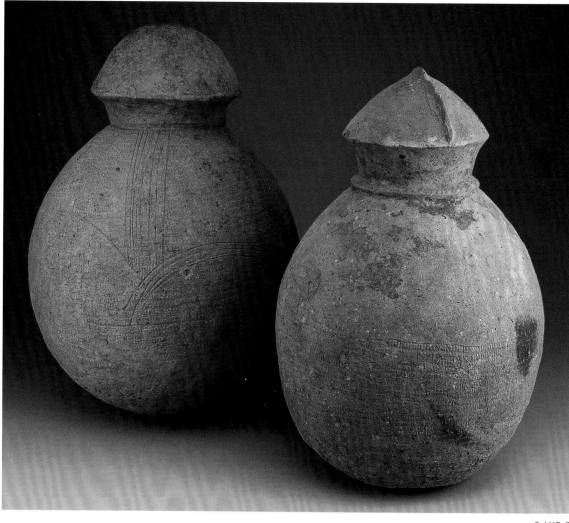

2 AND 3

LIKE THE SMALL, NONFUNCTIONAL POT from the same region (cat. 1), these objects take the outward form of containers but are not, which suggests that they were made for ritual use alone. Here, what appear to be jars with lids are in fact made of a continuous wall of clay that cannot be opened. While similarly shaped pieces have been found at sites in the Inland Niger Delta including the ancient town of Jenné-Jeno, the context of their original use is unknown.[1]

These three examples are alike in the particularly graceful formal relationship that exists between their ovoid bodies, slightly flared necks, and domed tops. All are hollow and were made with a hole at bottom, probably to encourage even drying and successful firing. While of the same type, each illustrates a slightly different approach to overall shape and ornament. The first (cat. 2), at left, has a high, round top and a body covered with a shallow, twisted-cord roulette pattern.[2] Working quickly, the potter drew a series of incised lines that extend in clusters from neck to mid-body and encircle the body in broad arcs.[3] The same staccato roulette pattern was applied to the lower half of the second example (cat. 3); a raised band surrounds its neck and a sharp ridge intersects the steeply sloping top. The roulette pattern is even more deeply impressed into the lower half of the third piece (cat. 4), while its top is rounder and gently flared at the edges, with a projecting button at its peak. Black patches appear in several locations on these objects; this characteristic is found with some frequency on pottery from Jenné-Jeno and results from a buildup of carbon during firing.[4] The blackening on the third example (cat. 4) has a precise quality that suggests it may have been not accidental, but intentional and controlled.

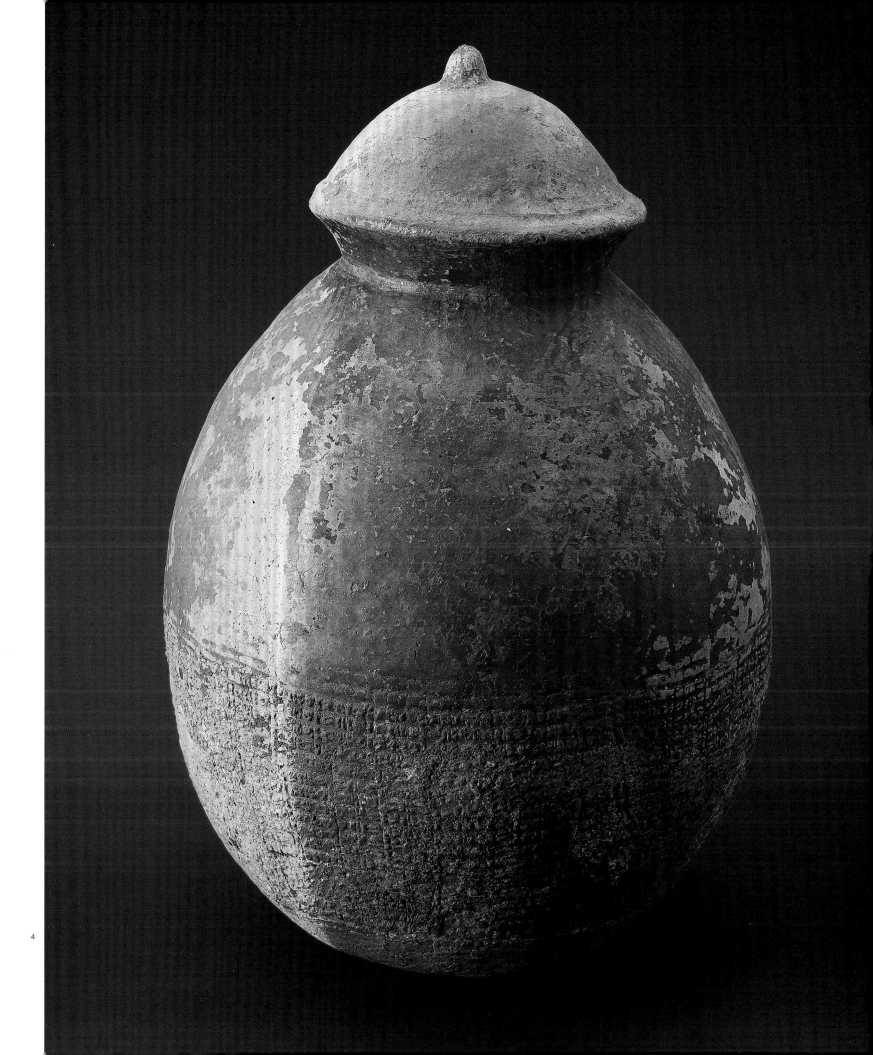

4

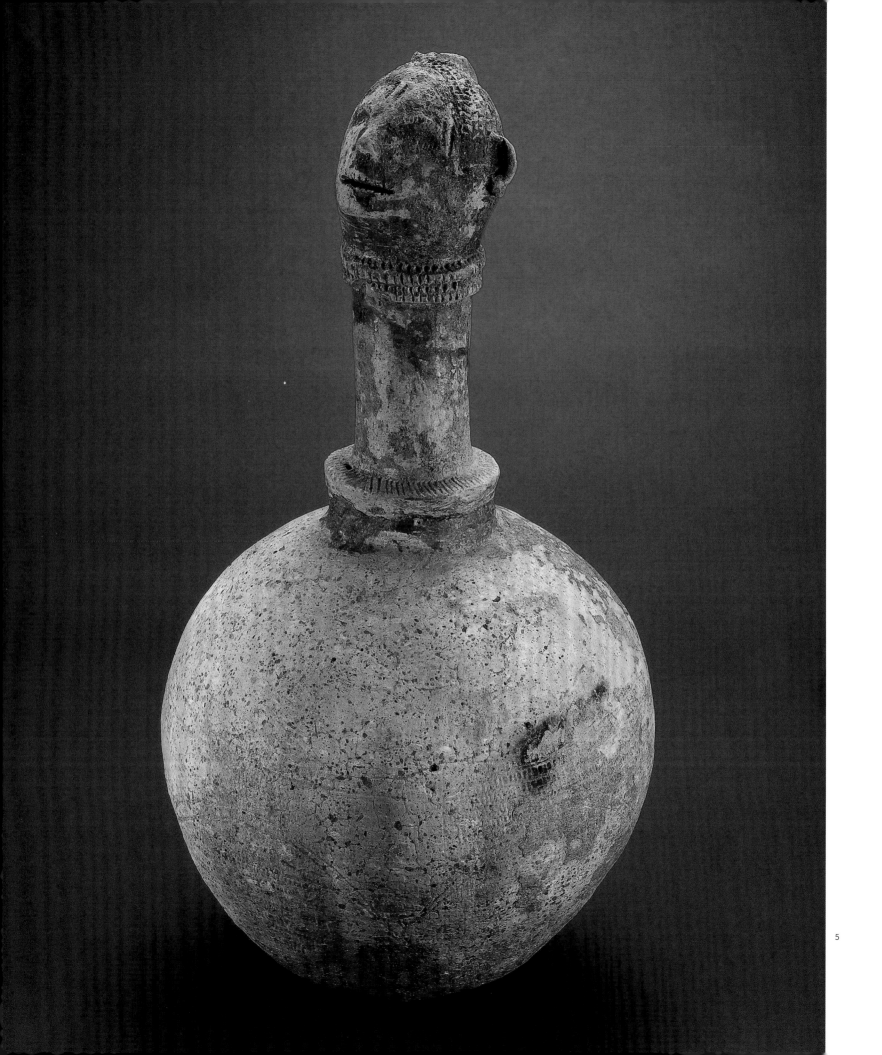

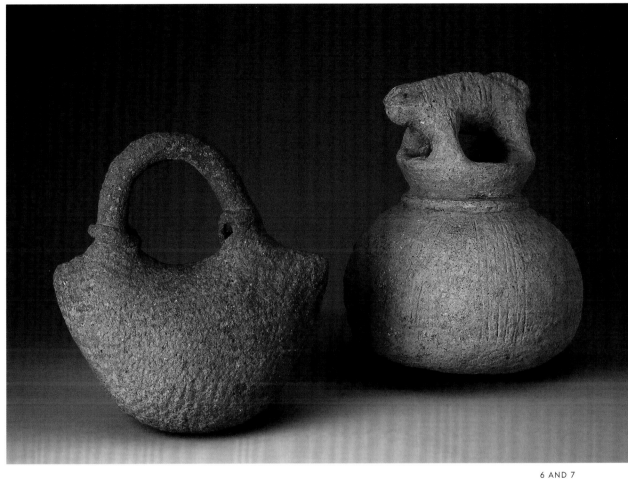

6 AND 7

5

RITUAL OBJECT WITH
HUMAN HEAD

Bougouni region, Mali
11th/13th century
Terracotta
38.1 x 21 cm (15 x 8¼ in.)

6

RITUAL OBJECT

Inland Niger Delta region, Mali
10th/14th century
Terracotta
14.6 x 14 cm (5¾ x 5½ in.)

7

RITUAL OBJECT WITH ANIMAL

Inland Niger Delta region, Mali
10th/14th century
Terracotta
16.5 x 14 cm (6½ x 5½ in.)

8

CYLINDRICAL VESSEL

Middle Niger region, Mali
8th/14th century
Terracotta
28.6 x 15.2 cm (11¼ x 6 in.)

DIVERSE FORMS OF ANCIENT POTTERY made for domestic and ritual use have been found in the Middle Niger region, where the history of settlement stretches back to before the first millennium A.D. Excavations at Jenné-Jeno, the most extensively studied site in the area, show that blacksmiths and potters were already engaged in a well-developed industry at the city's founding in approximately 250 B.C.[1] Differences in the fineness of the clay used at Jenné-Jeno, particularly before A.D. 400, suggest that there may have been two groups of potters at work in the town, each with its own ethnicity and technical practices.[2]

Like many similar works from the region, the first of these ritual objects in the Achepohl collection (cat. 5) takes the form of a vessel, but is non-

functional. The only access point is a small hole at the bottom, which facilitated its making, drying, and firing. While examples of bottle-shaped objects crowned by birdlike heads have been found at ancient sites in the region of Bougouni (most famously near the village of Bankoni), representations of human heads appear to be uncommon.[3] The distant, slightly upward gaze of the sensitively modeled head is reminiscent of many terracotta figures found throughout the Middle Niger. The object's round base is decorated with quickly sketched, arching lines.

The other ritual objects shown here (cat. 6–7) may date to the later phases of habitation in the region, when pottery was coarser in texture, population was rapidly increasing, and ritual practices

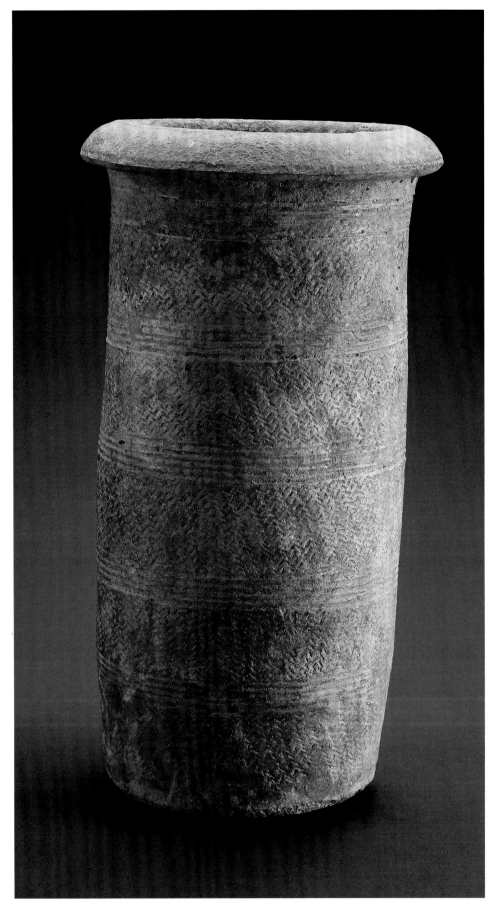

were becoming more homogenized.[4] Their unique shapes suggest they were made for ritual use. That on the left (cat. 6) is a small, pouchlike form similar to one excavated at the site of Feto-Kolé, near the town of Segou.[5] While ritual pottery—some of it associated with a burial—was found there, it is difficult to speculate on the use of this enigmatic piece.[6] That on the right (cat. 7) takes the form of a round jar with a flared mouth; the work is solid, however, and there is no entry hole at the top. A thick, raised band encircles its neck and incised lines run down its length at intervals, while a sturdy, four-legged animal stands astride its mouth.

The cylindrical vessel (cat. 8) was likely also made for ritual use, based on the close attention to decorative detail that it displays, and on the relatively rare occurrence of flat-bottomed containers among ancient pottery from the Inland Niger Delta.[7] Its ornament, though, is a classic combination: carefully executed incised lines, probably applied with a comb, alternate with a deeply impressed, zigzag pattern made with a plaited roulette.[8]

8

9

BOTTLE

Lakes region, Mali
8th/11th century
Terracotta and slip
38.7 x 22.2 cm (15 ¼ x 8 ¾ in.)

10

BOTTLE

Lakes region, Mali
8th/11th century
Terracotta and slip
40 x 19.1 cm (15 ¾ x 7 ½ in.)

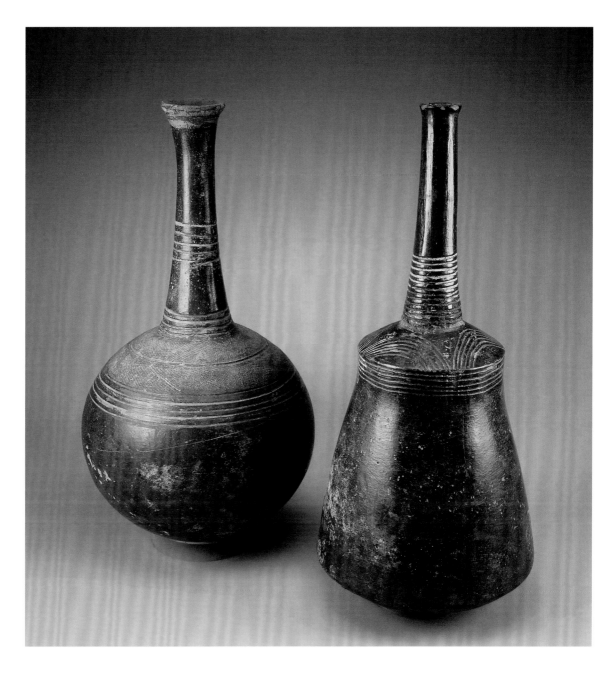

ELEGANT, SLIP-PAINTED BOTTLES with long necks and incised or impressed linear embellishment are widely distributed among archaeological sites in the Lakes region of Mali, along the Niger River between Timbuktu and Lake Debo.[1] They have been found in burial mounds at the sites of El Oualadji and Killi, among others, together with luxury goods such as copper-alloy jewelry; ironwork ornaments and weapons; and terracotta beads, containers, and figurines.[2] Bottles such as these may have been part of an emerging practice in the region of crafting pottery specifically for burial.[3] The large burial mounds, or tumuli, in the area were constructed for the elite, and their increasing elaborateness in the eleventh century may reflect a rise in wealth among those who controlled the flow of trade goods along the river.[4]

The bottle on the left (cat. 9) is covered in a red-brown slip, with alternating white and gray lines encircling its long neck and round base. Two wide, textured bands of roulette work further enhance the shoulder. The one on the right (cat. 10) is a deep, polished red, and its abrupt shifts in form—from the narrow neck to the flat shoulder to the slightly flared body— are emphasized by a rhythmic, tightly clustered series of finely incised white lines.

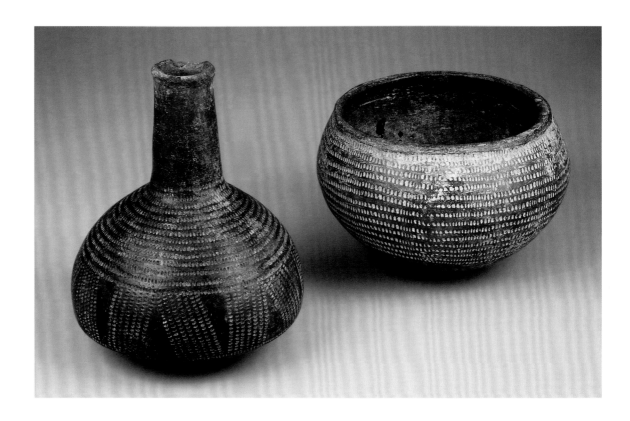

11

BOTTLE

Middle Niger region, Mali
8th/13th century
Terracotta
10.8 x 8.9 cm (4 ¼ x 3 ½ in.)

12

BOWL

Middle Niger region, Mali
8th/13th century
Terracotta
6.4 x 11.4 cm (2 ½ x 4 ½ in.)

THIS SMALL BOTTLE AND BOWL are similar to ones found at the sites of the ancient cities of Jenné-Jeno and Dia, in the Upper Niger Delta, as well as in the Lakes and Niger Bend regions, and as far north as Timbuktu and its vicinity.[1] They are embellished with distinctive, dotted lines that were pressed into the leather-hard clay, perhaps with the tines of a comb, and most often applied in horizontal rings that accentuate the circularity of the forms. Such pottery was made in a variety of colors ranging from burnished blacks and dark browns to slip-induced reds and red-oranges. Objects such as these appear to have been widely traded and may have been intended specifically for burial.[2]

Pottery fragments excavated at the burial mounds of Killi, and at a site near Gourma-Rharous in the region of Timbuktu, combine horizontal and angled lines in patterns much like that used on the bottle.[3] This example (cat. 11), however, is remarkable for the thoughtful and controlled manner in which the design was applied. A series of dotted circles brim just slightly up the bottle's neck, continuing downward along its quickly widening lower half. A zigzagging band of dotted lines dances across the broadest expanse, contrasting with smoothly burnished areas, and a single circle of dots accentuates the point at which the bottom begins a sharp inward slope.

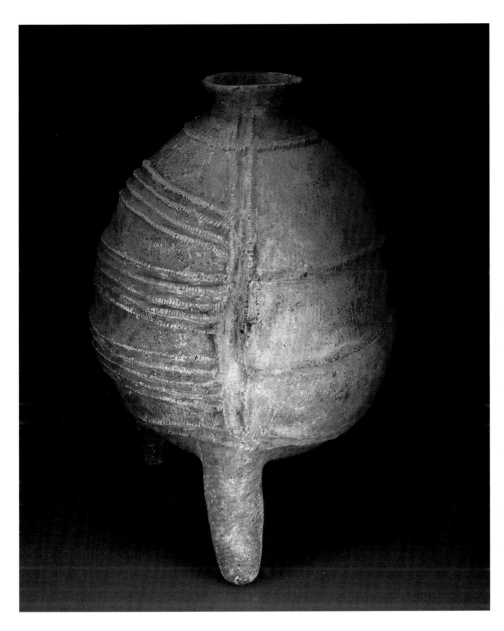

13

CONTAINER

Bura; Niger

3rd/11th century

Terracotta

55.3 x 41.3 cm (21 ¾ x 16 ¼ in.)

The ancient sites of Bura, located along the Niger River between Niamey, in Niger, and the border with Mali, have yielded findings that include burial and ritual centers and areas of habitation. Bura's most stunning revelations have been vast cemeteries such as that at Asinda-Sikka, where 630 large terracotta containers were uncovered. Buried with their mouths facing downward, most of these vessels held an iron arrowhead and fragments of teeth and bones, and marked the burial of human skeletons one to one-and-a-half meters below.[1] Scholars have argued that such objects functioned as effigies of the deceased or as a type of ritual sacrifice.[2] The most spectacular examples support this theory, since they are surmounted by stylized human heads, or, more rarely, by complete human figures, sometimes on horseback; both heads and figures are embellished with distinctive coiffures, jewelry, and scarification.

Excavations at Bura have also produced a variety of nonfigural containers, including three-legged vessels such as this one. These have been unearthed at ritual and domestic sites, which suggests that the form served multiple purposes.[3] Likewise, in many parts of Africa today, pottery moves fluidly from ritual to domestic contexts and back again. Regardless of its intended use, the special care that went into shaping and embellishing this piece suggests that it was valued. The potter's confidence is implied in the overall form, the intuitive positioning of the legs, and the crisp, spontaneous placement of the thick, striated bands that stretch across the body (see detail, p. 32). These raised bands create a dynamic contrast of positive and negative space as they wrap around the egg-shaped body; a more subtle texture, produced with a roulette, softens the underlying surface.

Pottery and the Home

The striking display of valuable ceramic containers in Sanmiko Hien's kitchen makes a strong statement of wealth and taste. Set on a raised platform behind the hearth, the richly embellished vessels are for storing and serving water; those stacked in towering tiers to the side are used for cooking. In this context, however, the pots are intended primarily for display and as a place to store valued possessions. When a Lobi woman dies, her female relatives inherit her pottery collection. Photo by Klaus Schneider, Siwera, Burkina Faso, 1990.

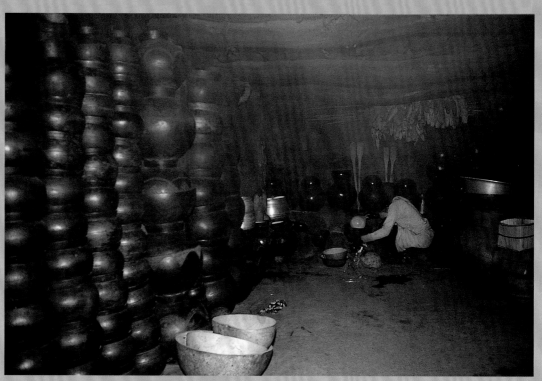

FIG. 1

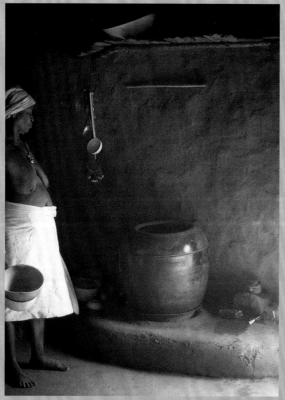

FIG. 2

Kolo Soro stands beside the large water storage container that she was given upon marriage. The vessel sits on an earthen platform that she fashioned especially for it and is the visual focus of her home's most sacred space. The platform also supports a small altar to her personal guardian spirit, making visible the close relationship between life-sustaining water and spiritual sustenance and protection, as well as the blending of domestic and ritual activities that is widespread in Africa. Photo by Anita Glaze, Poundya, Côte d'Ivoire, 1970.

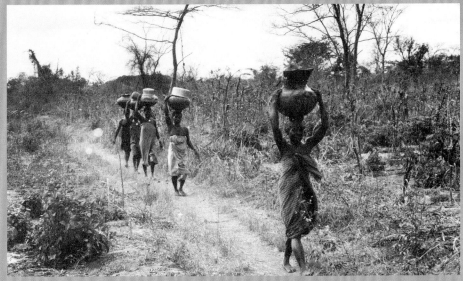

FIG. 3

These Makonde women of Mozambique's high plateau spent several hours each day transporting water to their homes. Makonde water containers are designed to be capacious and lightweight, and to minimize spillage. They are also a source of pride both for their beauty and for their deep connection to a woman's role in promoting the well-being of her family. Photo by Jorge Dias, Antupa, Dankali, Mozambique, 1957.

FIG. 4

Home-brewed beer is an integral part of Zulu life, providing nourishment, offered in hospitality to visitors, and attracting and sustaining the ancestors. This Zulu woman from the Sithole family has brought her *imbiza*—a large vessel used for brewing and storing beer—and a smaller beer storage vessel to the entrance of her home to show the photographer. Both containers are commonly kept at the back of the house in a sacred area called *umsamo*. The cool darkness of this space is inviting to the ancestors, who visit it in order to consume the beer that is regularly left for them in offering. Photo by Carolee Kennedy, Msinga, KwaZulu-Natal, South Africa, 1977.

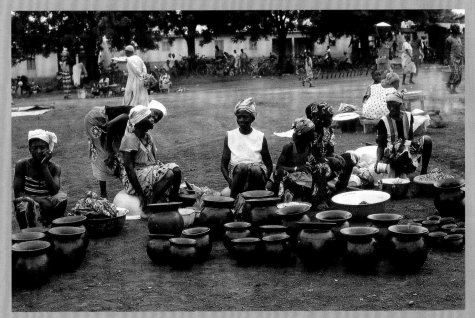

FIG. 5

Across Africa the vast majority of pottery is intended for use in the home and is sold at modest prices in markets large and small. Here Senufo potters present their wares, including large, flare-necked vessels for storing water and mid- and small-sized pots for cooking and serving food. Photo by Phyllis Galembo, Côte d'Ivoire, 1988.

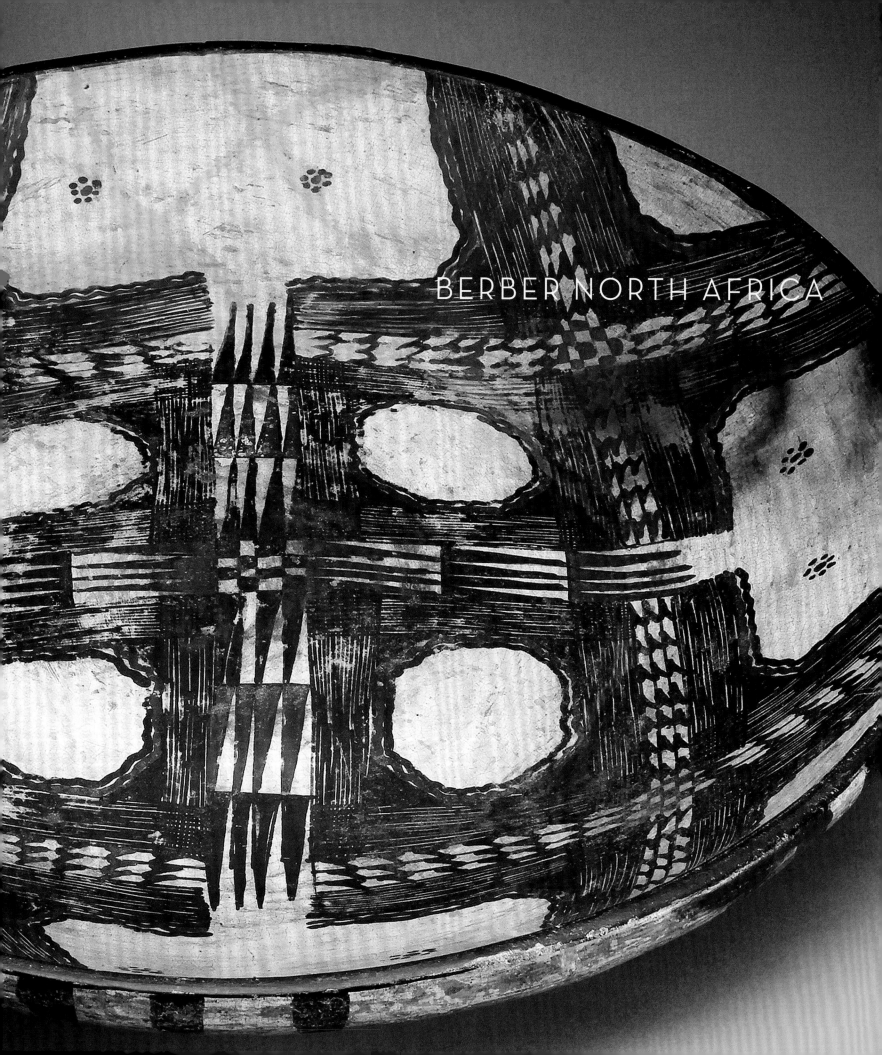

BERBER NORTH AFRICA

BERBER PEOPLE LIVE SCATTERED across Northern Africa in nations including Mauritania, Morocco, Algeria, Tunisia, Libya, and Egypt. They are widely considered to be the original inhabitants of the region, and historical references to them exist from as far back as ancient Egypt.[1] The Berber have also interacted with the Phoenicians, the Greeks, the Romans, and, beginning in the seventh century A.D., with Muslim Arabs. Although they eventually converted to Islam, the Berber maintained a large degree of autonomy by retreating from urban, coastal centers into more remote regions of the mountains and the Sahara Desert, where they continue today. Reflecting this independent temperament, their practice of Islam has at times incorporated preexisting beliefs and ritual.

While the Berber share ancient linguistic roots, their modern culture is highly diverse and distinguished by unique dialects, dress, jewelry, and art forms. This combination of commonality and difference is reflected in Berber pottery traditions. Among the rural Berber—as in so much of sub-Saharan Africa—women make pottery by hand, using coiling techniques and firing their work in the open or in shallow pits. Their efforts are community based, and the majority of wares are intended for family use, with the surplus being sold in small markets or, increasingly, tourist shops.

Berber potters produce vessels in a variety of forms, some of which are widespread. They usually leave cooking pots unembellished, but often paint with abstract designs those intended for storing, preparing, or serving food. Some of these forms and painted patterns may reach back to the ancient Mediterranean world, but Islam has also had an influence, particularly in the predilection for nonrepresentational designs. Regardless of their sources, many of the painted patterns on Berber pottery are associated with forces of nature and supernatural protection and are interpreted by potters in a highly personal way.

Distinctive regional approaches to form, manufacturer, and decoration are also readily apparent. The Berber potters of Morocco's Atlas Mountains are known for the sculptural quality of their pottery and for the subtle, highly abstract character of its minimally painted embellishments. In contrast, the potters of Algeria's rugged and mountainous Great Kabylie region are known for using elaborate painted patterns that reflect a strong sense of geometric design. Among Egypt's oasis communities, pottery is often less decorative and is made by men using a wheel.

OPPOSITE: 15 (DETAIL)

14

MILK JUG OR BUTTER CHURN
(CHKOUA)

Aït Ouaraïn; Taounate province,
Morocco
Early/mid-20th century
Terracotta and pigment
50.8 x 58.4 x 33.7 cm
(20 x 23 x 13 ¼ in.)

THE AÏT OUARAÏN are among the Berber peoples who make their home in the mountainous Rif region of northwestern Morocco. Like most inhabitants of the area, they maintain a primarily rural and agrarian lifestyle. While the vast majority of Berber today follow the Muslim faith, their culture developed long before the Arab invasion of the seventh century, and aspects of pre-Islamic practice are deeply integrated into their lifestyle. These include many of the forms, techniques, and underlying beliefs about pottery.

A calendar synchronized with the cyclical demands of farming and animal husbandry guides the making of ceramics. Pottery used for milk products, such as this jug or butter churn, is created in the autumn during the calving season.[1] The shape, with its tapered neck standing perpendicular to an oblong belly, is one of the standard pottery forms found in households across the wider Berber region.[2] Its distinctive look is reminiscent of the animal-skin bags that the Berbers' nomadic ancestors used to make butter; the handles on the jug's sides allow the milk within to be rolled back and forth, effectively churning it into butter. The painted motifs resemble stitching, recalling animal skins that are sewn together.[3]

Berber women make domestic pottery by hand, using coil techniques.[4] In the Rif region, much of their work has a strong sculptural characteristic and is ornamented with subtle patterns that are seemingly randomly placed. Potters fire their wares in the open and then paint them with organic pigments, sometimes using a second firing to fix the colors in place.[5]

For the Berber, pottery making is intimately connected with the spiritual realm. Dug from the earth, the abode of *djinn*, or earth spirits, clay is a medium associated with attaining blessings and protection from evil.[6] The use of fire and water in the production of pottery only adds to its supernatural resonance. Decoration is also part of this broad symbolic vocabulary. The painted motifs on this jug, for example, are part of a repertoire of signs imbued with spiritual and protective significance—as well as aesthetic appeal—that are applied to women's belongings including jewelry, leatherwork, and textiles. That their main association is with female tattooing and body painting, however, reveals the intimate connection between women's possessions and their bodies (see "Pottery and the Body," fig. 3).

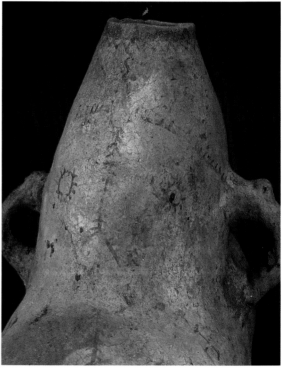

DETAIL

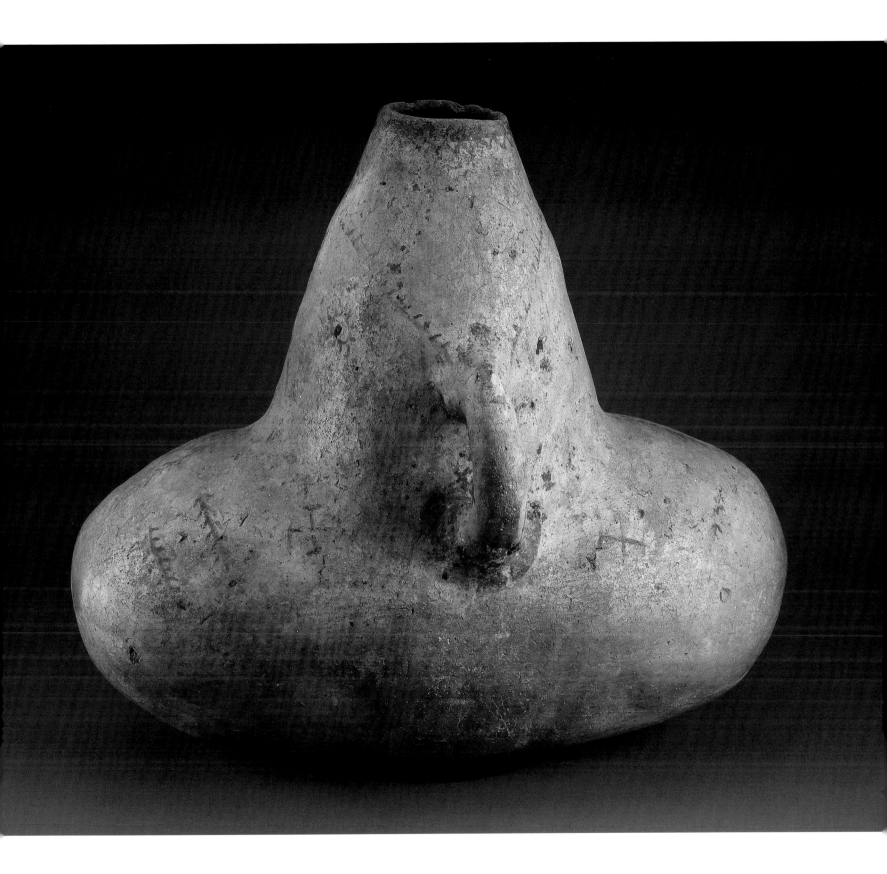

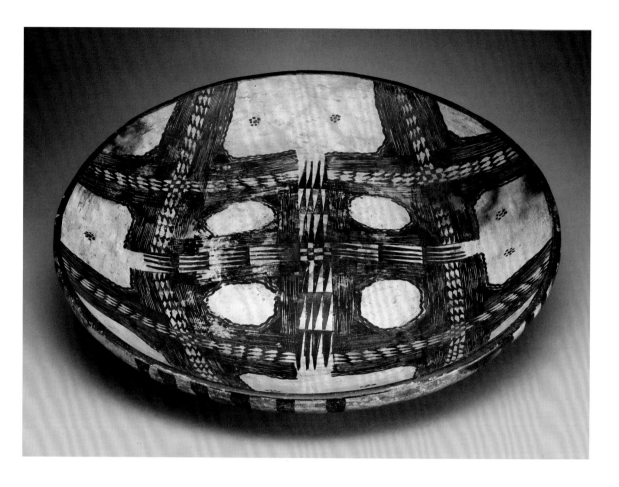

15

COUSCOUS PLATTER
Aït bou Addou or Aït Mendes;
Bezzit or Merkalla, Great Kabylie
region, Algeria
Early/mid-20th century
Terracotta and pigment
7 x 43.2 cm (2¾ x 17 in.)

SITUATED IN NORTH AFRICA's rugged Atlas Mountains, the Great Kabylie region of Algeria is home to culturally related Berber peoples, including the Aït bou Addou and Aït Mendes.[1] While in Algerian cities men make ceramics, using the wheel to fashion vessels for commercial sale, in rural regions pottery is women's work, a craft passed from mother to daughter. Pottery is usually practiced in the spring, when the weather allows for even drying.[2] Pots are made using coil building techniques and are then smoothed and polished.[3] Firing, a communal effort, is generally done in the open air, and painted decoration is usually added afterward.[4]

Pottery from the Great Kabylie is known for the variety and richness of its painted decoration. This boldly ornamented platter, enlivened by large, briskly hatched areas of black, is a classic example of the continuous play on geometric pattern that characterizes such wares. The potter created a symmetrical composition that moves outward from a central point, drawing on a vocabulary of motifs including checkerboards, crosses, circles, and triangles. Attention was paid to creating an overall design, as well as patterns within patterns, that incorporates alternating and opposing elements, instilling a sense of visual equilibrium.[5]

While Berber potters use conventional motifs, they apply and combine them in ways that reflect their own aesthetic sensibility.[6] The names and meanings given to these motifs are also open to personal interpretation, although they often highlight the importance of both supernatural protection and nature—particularly fecundity—in Berber tradition.[7]

16

BOWL
Berber peoples; Egypt
Late 19th/mid-20th century
Terracotta
11.4 x 27.9 cm (4 ½ x 11 in.)

ALTHOUGH THIS SHALLOW BOWL was formed on a wheel, it has a tactile muscularity that is more common in handmade vessels. This quality derives from the blocky projections running in an arcade around its rim, elements that are aesthetically compelling but that also contribute to the piece's functionality, providing convenient grooves for fingers to grasp. Two of the projections on opposing sides are also pierced with holes, which may have enabled the vessel to be suspended.

The bowl was made in one of Egypt's many oasis communities, where Berber men are the primary potters. Practicing in multiple-family workshops, they use techniques that date back to the pharaohs and firing technology that can be traced to medieval times.[1] It is the responsibility of boys to dig the clay, often from sources that have been used since antiquity; they then mix it with temper and knead it in preparation for throwing.[2] Adult men work the wheels, while older men clean the edges and make additions by hand, including embellishments like the projections encircling this bowl.[3]

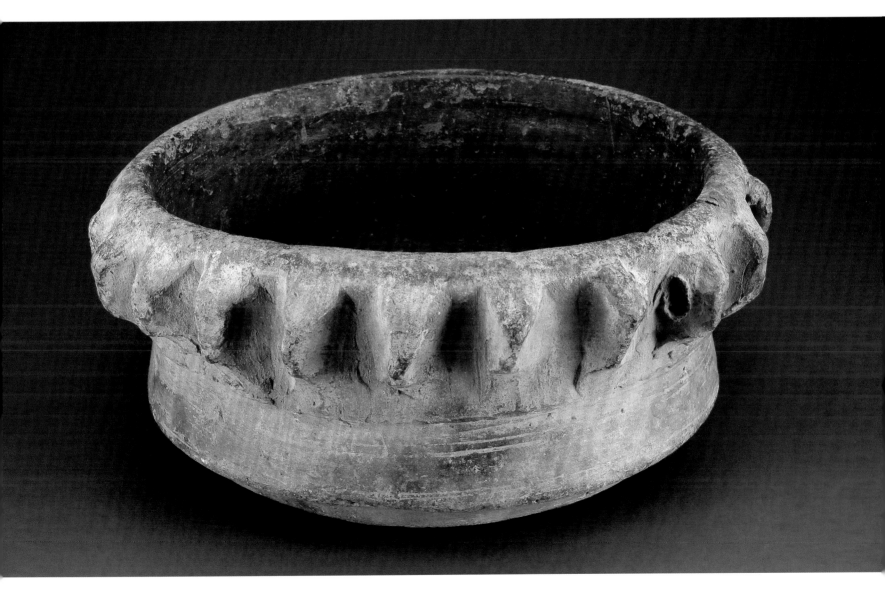

Granaries and Grain Containers

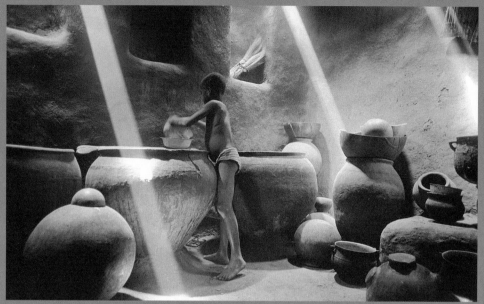

Throughout much of Mali and Burkina Faso, potters make enormous, wide-mouthed containers to store either dry grain or the sprouted kernels used in beer making. These vessels are often so large that they must be fired individually and are rarely moved once set into place in a home or outer courtyard. This Nuna girl is using a basin to scoop grain from one of the vast pots kept in the cool interior of a woman's living space, one of many rooms in a multistructured compound. Photo by Jean-Paul Bourdier, Pouni, Burkina Faso, 1978.

FIG. 1

There are noticeable differences in the style and use of women's and men's granaries among the Ga'anda of northeastern Nigeria. A woman's granary (seen at left) has a wide body and openwork patterns at its base, while a man's (at right) is smoothly rounded and organic in shape. Women use their structures to store various food-stuffs and valuables, accessing them by literally climbing inside. Men's hold only the staple crop, sorghum, which is removed with a scoop. Women commission men to make their granaries, while men decorate theirs with red slip designs that mimic women's scarification patterns. Such complementarity reaffirms the interdependence of both sexes in promoting human and agricultural fertility. Photo by Marla C. Berns, Kwanda, Nigeria, 1981.

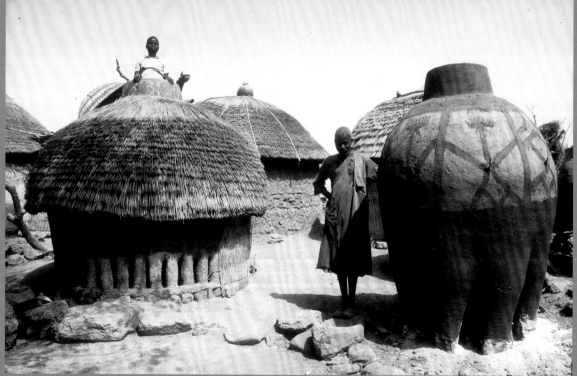

FIG. 2

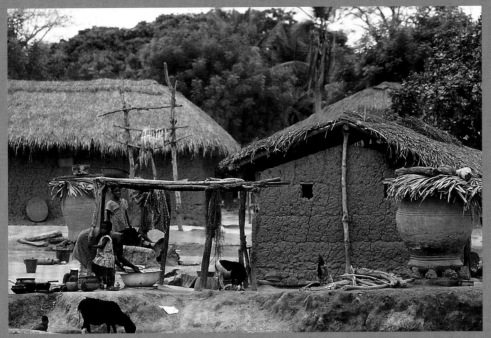

Across West Africa, staple grains such as maize, millet, and sorghum or guinea corn are stored in large, unfired earthen containers called granaries, which often echo ceramics In their shapes and embellishments. The squat, round-bellied granaries of this Baule village are a case in point, blurring the distinction between pottery and architecture. Photo by Susan Vogel, Warebo area, Côte d'Ivoire, 1978.

FIG. 3

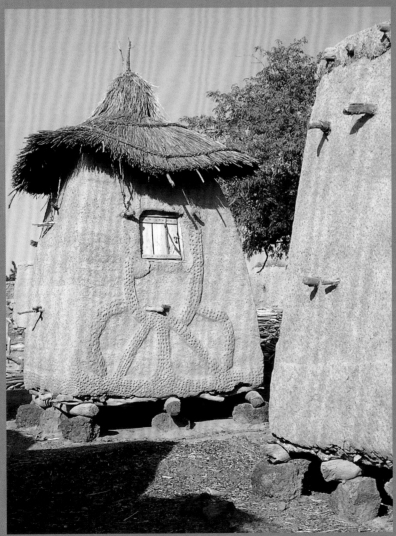

The powerful symbolic link between agricultural and human fertility is ripe with potential. The raised bands on this stately Bobo granary resemble the scarification patterns that once commonly graced a married woman's abdomen, themselves symbols of fecundity and renewal. Photo by Kathleen Bickford Berzock, Kanga, Mali, 1997.

FIG. 4

WEST AFRICA: SAHEL AND SAVANNA

WEST AFRICA'S EXPANSIVE savanna grasslands stretch from the upper reaches of the Senegal and Gambia rivers to Lake Chad. In the north the grasslands merge with the encroaching Sahara Desert, creating an arid zone known as the Sahel. To the south the open savanna is interrupted by forests that were once dense and lush, although intense deforestation in the twentieth century diminished their grandeur. At the heart of the region is the sweeping arc of the great Niger River, which has supported agriculture and, by extension, the development of complex societies for millennia. Clay deposits are plentiful across the savanna, and fuel for firing pottery, while dwindling, can also be found.[1] Islam began to take hold here as early as the tenth century, and it remains a strong influence today. From the eleventh through the thirteenth century, cities that were already centers of commerce and craft

production such as Jenne, Gao, and Timbuktu in Mali and Kano in Nigeria also became influential seats of learning.[2]

One common thread that runs through parts of this broad and culturally diverse expanse is the strong connection between ironworking and pottery. These ancient technologies, with their shared dependence on the transformation of raw materials by fire, often developed side by side. Among many cultures of the western Sahel and savanna, this commonality is reflected in a unique social structure in which blacksmiths and potters belong to a separate, hereditary, and intermarrying class of artisans. In this system blacksmith men and their potter wives carry their professions as a birthright and embrace them as an identity, whether they are active practitioners or not. This is true among the Mande-speaking cultures that dominate the Middle Niger River area, and it has been maintained by Mande and related groups that have migrated farther afield. Indeed, the practice stretches as far west as the Mandara Mountains of Cameroon, where it is found among the Mafa, Sirak, and other closely related peoples.

It is also interesting to take note of cultures in which blacksmiths and potters are not linked, because this suggests pottery practices that stem from different origins—as, for example, among the many interrelated Gur-speaking peoples of Burkina Faso, who were the region's first inhabitants, as well as the Lobi and the Senufo. Finally, the practice is not found among the Hausa, who live farther east in Niger and northern Nigeria and whose ancestors probably migrated from the region of Lake Chad.

OPPOSITE: 27 (DETAIL)

17

WATER OR STORAGE
CONTAINER

Hausa; Niger
Early/mid-20th century
Terracotta and slip
69.9 x 47 cm (27½ x 18½ in.)

BY THE SIXTEENTH CENTURY, the legendary and powerful city-states of the Muslim Hausa stretched across what is today south-central Niger and northern Nigeria. In the early nineteenth century, large portions of the region came under the control of the Fulani, and their culture and that of the Hausa have intertwined. Men dominate the production of ceramics throughout much of the area; in parts of Niger, however, only women are potters.[1] Regardless of their sex, Hausa potters use a convex mold to shape the base of their pots, adding coils to complete the form.[2] On this large and handsome container, a dimpled line indicates the seam where coils began to be joined with the molded lower half.

Hausa pottery is often noted for its straightforward, relatively unadorned appearance.[3] A potter's subtle finesse becomes evident in the volumes and proportions or his or her work, as here in the slight bowing of the columnar neck and its relationship to the rounded base. These forms are complemented by understated embellishment: spiraling, diagonal lines were applied by roulette at the shoulder, and a band of round indentations were impressed with the pad of a finger where base and neck meet.[4] The container's tall neck is scored with vertical grooves, the result of vigorous burnishing with a string of baobab seeds.[5] Shorter burnishing lines also mark the body. This action heightened the red color of the slip that was applied to the vessel before firing.

The nicks and abrasions that mark the surface bear witness to its many years of use. It is reportedly from Niger and may have served as a water container, possibly in a mosque, where it would have held water for washing before prayer.[6] Similar vessels are also used to store grain or other staples.[7]

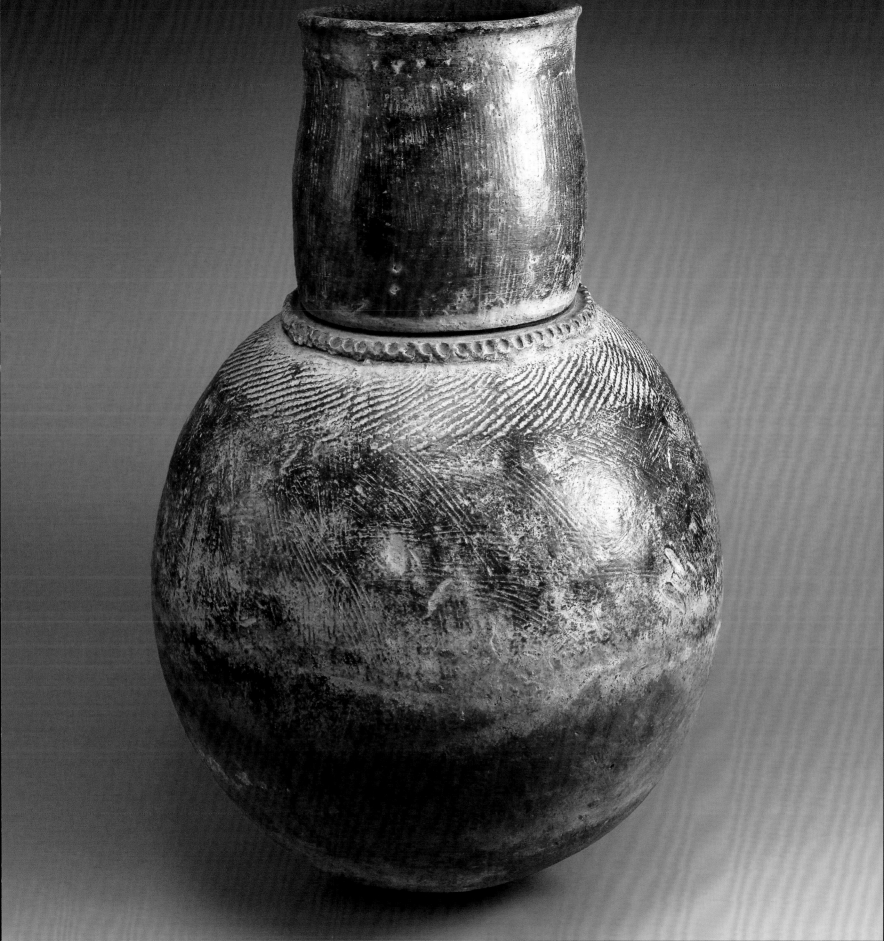

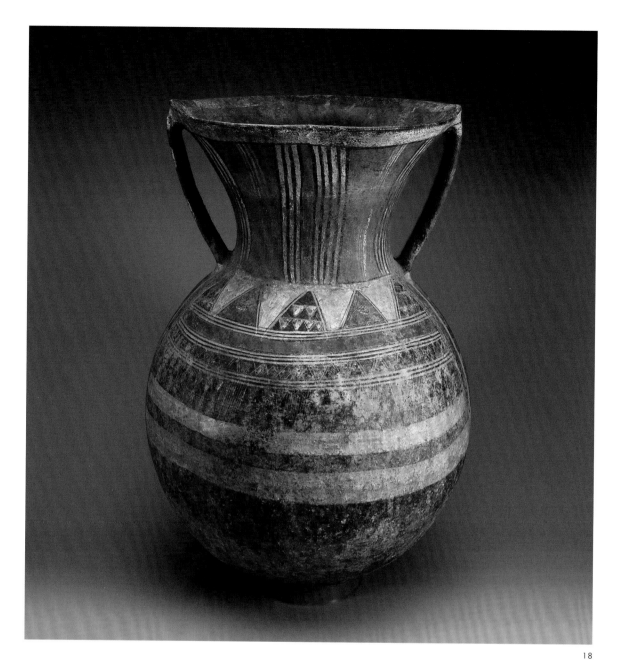

18

WATER CONTAINER

Jerma; vicinity of Niamey, Niger
Early/mid-20th century
Terracotta and pigment
50.2 x 34.9 cm (19¾ x 13¾ in.)

19

WATER CONTAINER

Jerma; vicinity of Niamey, Niger
Early/mid-20th century
Terracotta and pigment
64.5 x 44.5 cm (25½ x 17½ in.)

THE NIGER RIVER PASSES through the country of Niger far to the southwest, creating a fertile plain at the edge of the Sahara Desert. Despite the river's abundance, agriculture can be a tenuous activity. In such surroundings, it is not surprising that the task of collecting and storing water is of critical importance. The Jerma, who arrived in the region in the sixteenth century as exiles fleeing the Moroccan conquest of the Songhay Empire, are widely known for their gracefully shaped, delicately painted water containers of various sizes.[1] They remain closely related to the Songhay in language and culture, and, like the Songhay, Jerma potters use a concave mold technique to form the lower portion of a vessel, completing the upper sections with coils.[2] Also like the Songhay and many other peoples living along the Middle Niger, the Jerma regard pottery as a closed, hereditary profession that is closely aligned with ironworking. Jerma potters have even established separate villages from their non-potter neighbors, such as Saga, near Niamey.[3]

The urnlike form and intricately painted geometric patterns of Jerma water containers are

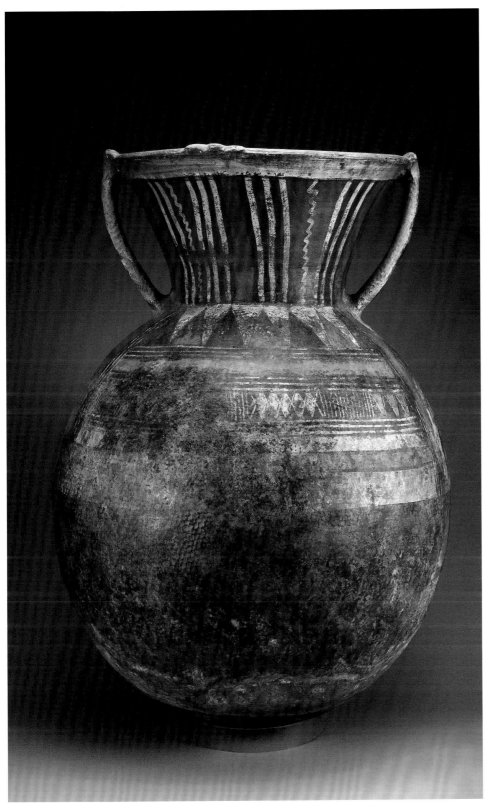

19

rarely seen south of the Sahara and suggest historic links with North Africa. The designs, closely related to those found on Jerma textiles, are applied after a pot has been fired, and are made using natural pigments such as iron oxide, kaolin, laterite, ochre, and soot.[4] Because these fleeting colors wear off over time, a valued container may be repainted periodically by its owner.[5]

These elegant vessels reveal two interpretations of the classic Jerma water container. The first (cat. 18) displays a long neck that is emphasized by the vertical stripes that descend its length, while the indrawn waist and curving body are complemented by patterns of triangles and horizontal bands. A shorter neck and larger basin give the second pot (cat. 19) a sturdier appearance. Its body is impressed with an underlying texture that results from the mat that was laid over the concave mold on which it was formed. With their refined patterns and muted colors, these containers can be compared with a similar vessel that was collected in 1930 or 1931 during Marcel Griaule's Mission-Dakar-Djibouti.[6]

20

BOTTLE

Somono; Mali
Probably 15th/17th century
Terracotta, slip, and kaolin
54.6 x 29.2 cm (21 ½ x 11 ½ in.)

21

WATER CONTAINER

Somono; Mali
Late 19th/mid-20th century
Terracotta, slip, and kaolin
59.7 x 41.9 cm (23 ½ x 16 ½ in.)

MALI'S INLAND NIGER DELTA region is well known for its widespread urbanism and abundant pottery, both of which can be traced to the first centuries A.D. The region is also home to a rich blend of cultures that have developed in relation to one another. Distinct ethnic pottery traditions exist and are mostly apparent in the techniques used for starting a pot—molding within or hammering onto a concave form, molding over a convex form, or pinching out a lump of clay.[1] Shared regional styles have developed, however, because potters of one ethnicity often work near potters of another, particularly in cities and towns.[2] Complicating matters further, among the Mande-speaking people of the region, including the Somono, the making of pottery is largely limited to women who have inherited its practice by birth or marriage. These individuals are very often, although not always, related to men who are blacksmiths by birthright.[3]

The Somono developed as a social group perhaps as early as the thirteenth century, when the ruling Bamana conscripted or recruited them from various ethnic groups and put them to work on the river. Today Somono are found across the Inland Niger Delta, and although some speak Bamana, many speak the Bozo language.[4] This may explain why the Somono are sometimes considered a subgroup of the Bozo and why scholars occasionally identify their pottery as Bozo.[5] To assist them in their work, Somono potters use a turntable that is made from a shallow bowl placed on an oiled surface.[6] This acts as a very slow wheel, allowing the potter to shape and smooth her vessel as it spins. A small saucer holds the clay in place on the turntable, and the potter uses this

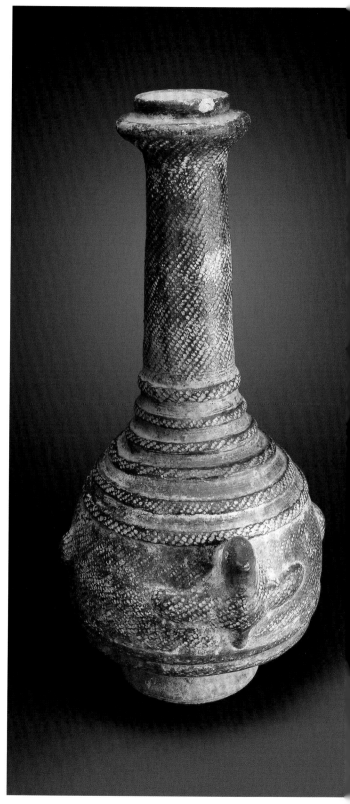

20

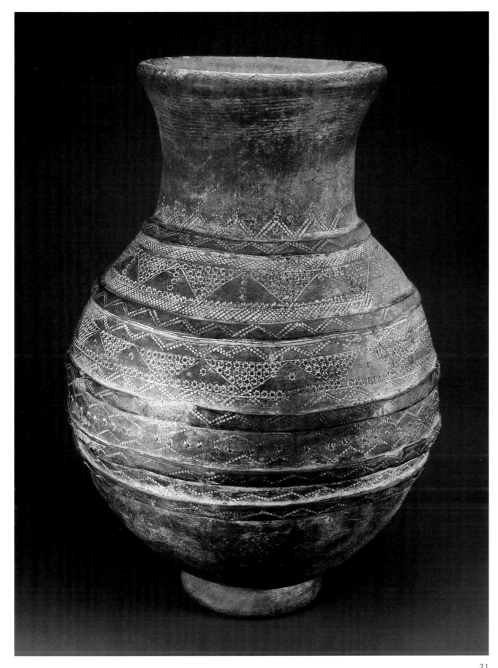

21

techniques that are seen today.[8] Some forms, however, have passed out of use. For instance, Somono potters no longer make bottles like the handsome example shown here (cat. 20), which is embellished with twisted-string roulette patterns and charming, immature birds with outspread wings, placed like handles on either side.[9] While the bottle's function can only be surmised, its large size and weight, and the smallness of its mouth, would make it quite difficult to use in a conventional manner.[10] The inset rim suggests that it probably had a lid at one time. The vessel may have been made to place in a burial; beautiful bottles were made for this purpose across much of the Middle Niger region in ancient times (see cat. 9–10).

Large decorative water containers such as the one illustrated here (cat. 21) continue to be made today. Throughout the region such pieces are intended for public display and are usually placed in a prominent location in a family's courtyard.[11] A Somono woman is often given a water container upon marriage, and it remains an important piece of her household furniture throughout her lifetime. The closely spaced lines and dots that make up the patterns on this jar have been incised with a metal comb and impressed with wooden sticks and stamps.[12] Red slip was applied to the pot before firing, and afterwards a white mixture of kaolin and water was rubbed into the patterns to enhance them. These time-consuming techniques were still in use by some older Somono potters in the 1990s, although slip-painted designs are presently gaining in popularity throughout the region.[13]

as a mold to first shape the base by pressing clay into it, then adding clay in coils to build up the walls and neck.[7]

Somono pottery is an ancient tradition that is distinguished by its detailed embellishment, which combines raised bands with impressed and incised patterns. Archaeological excavations have revealed pottery dating from the eleventh to seventeenth century, made in the same principal forms and employing the same basic building and decorating

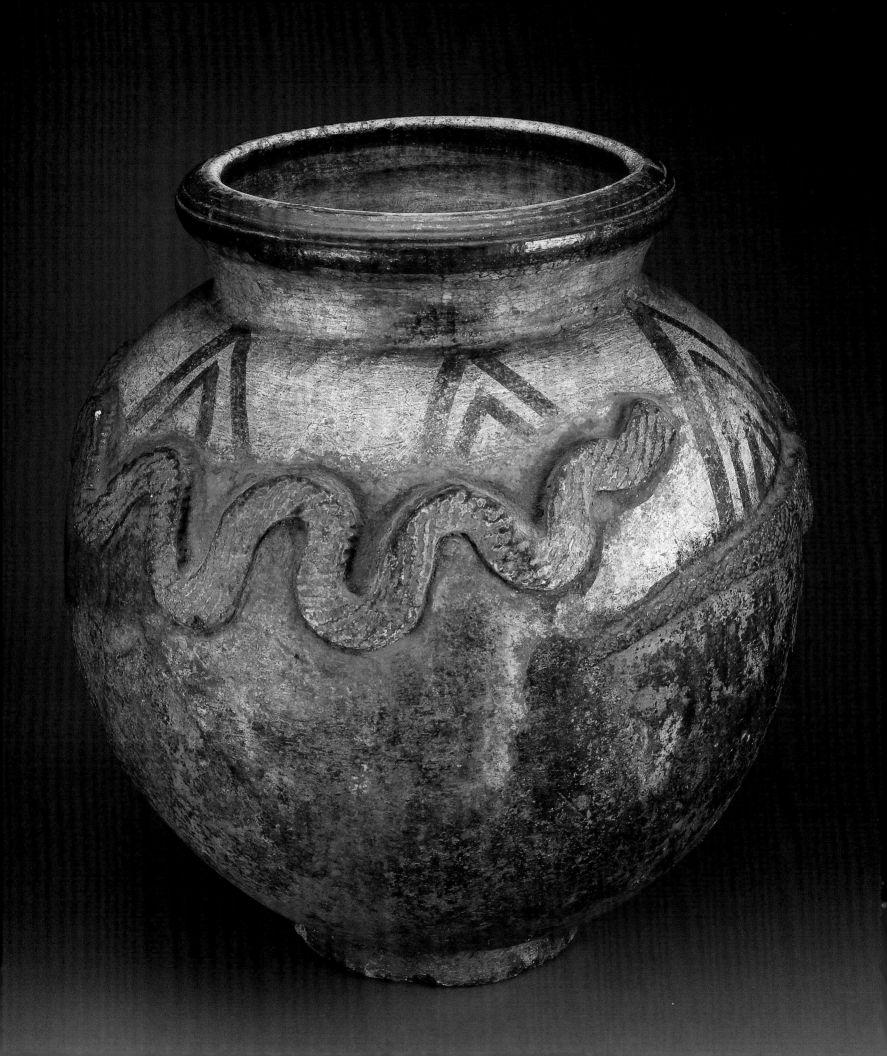

22

WATER CONTAINER

Possibly Somono or Bobo;
Mali or Burkina Faso
Early/mid-20th century
Terracotta and slip
45.7 x 45.7 cm (18 x 18 in.)

ON THIS CONTAINER, dynamic slip-painted and low-relief embellishment are combined in a unique manner. The vessel's round body sits on a low foot and is crowned by a slightly flared neck. An elongated lizard wraps around one side, chasing the tail of an undulating snake that likewise creeps up on the lizard's tail. Each creature's body was rendered in a flattened, schematized style and embellished with a diagonal texture applied with twisted-fiber roulette. The dull, cream color of the fired clay was left on the interior of the container, in a band around the neck and shoulder, and in a large patch on one side. Red-orange slip, derived from iron oxide, covers the animals' bodies and the bulk of the pot below them; it also rings the mouth and defines inverted Vs that sit in stacks of two and three around the shoulder.

The origin of this vessel is uncertain. Its basic shape—a plump body, short thick neck, and engaged foot—is typical of water storage containers produced by many potters among the Mande and related peoples across central and southern Mali and northern Burkina Faso, including the Somono and Bobo. While red slip painting is also common in these areas, raised and flattened imagery is not seen today. A related vessel has been published that is reputed to be Bozo.[1] Like this piece, it is constructed with a foot and painted with red slip, and features two snakes wrapping around it in opposite directions. The Bozo, who live in the region of the Inland Niger Delta, are not potters by tradition, although there are Somono potters who speak the Bozo language and are sometimes identified as Bozo by scholars.[2] They use a shallow saucer as a mold to form a pot's base and embellish their wares with complex incised patterns and, increasingly today, with painted designs in red slip (see cat. 20–21).[3] Red slip-painted vessels also are made by the Bobo, who live east of the Somono in Mali and Burkina Faso. Bobo potters use a direct pull method to form the base of a vessel, adding coils when necessary to increase the height.

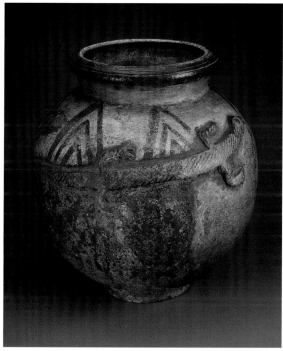

ALTERNATE VIEW

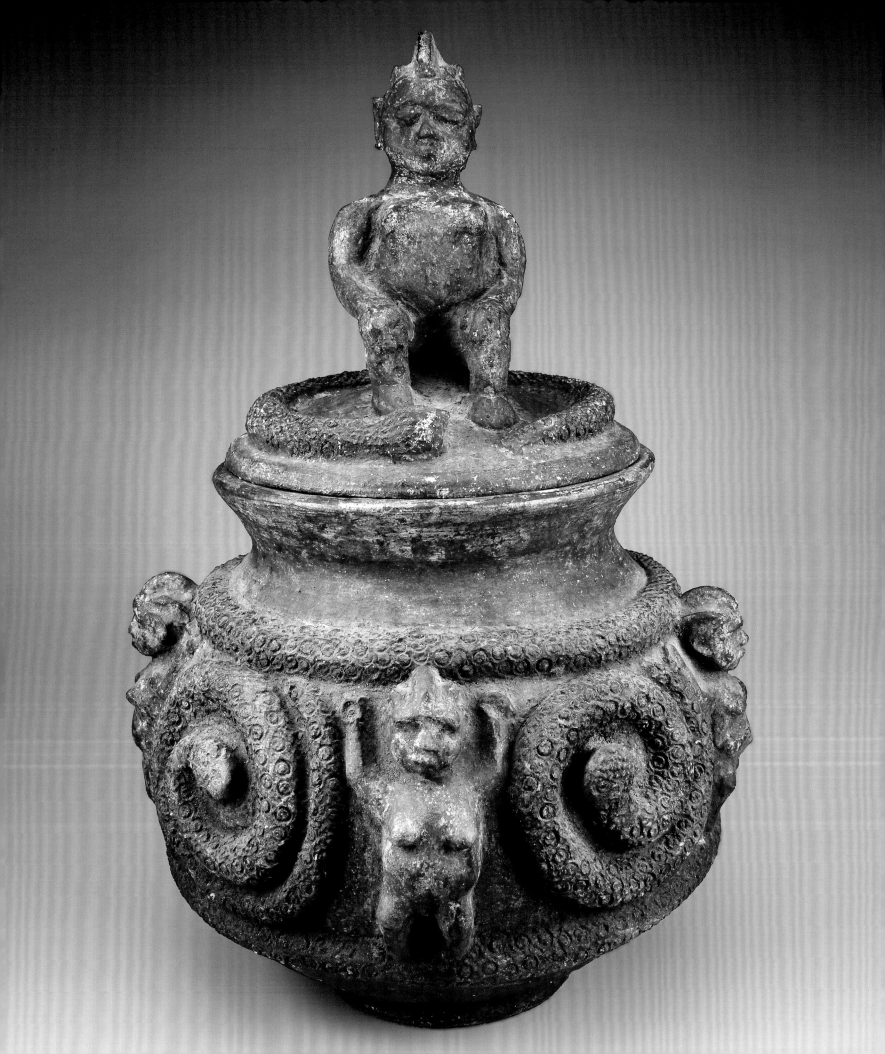

23

RITUAL JAR
Inland Niger Delta region, Mali
Early/mid-20th century
Blackened terracotta
43.8 x 28.6 cm (17¼ x 11¼ in.)

WHILE THE EXACT ORIGINS of this elaborate, lidded jar remain something of a mystery, its detailed embellishment, which is modeled in high relief, suggests that it was intended for ritual use. At center stage on the lid is a large, stately figure of a seated woman encircled by a snake; her hair is styled in a high crest flanked by shorter ones. On the jar's body, spiraling snakes, each covered with small circles applied by a wooden stamp, are interspersed with female figures, which appear with arms raised and legs apart, wearing identical crested coiffures. The jar is believed to come from Mali's Middle Niger region, where the pottery has a long history of stamped embellishment and snake imagery. Ancient terracotta containers and figures, dating largely to between the tenth and fourteenth centuries, are widespread in the region; they often feature circular stamps and modeled snakes, which are possibly associated with beliefs about ancestors or the founding of communities (see cat. 1).[1] The distinctive coiffures of the jar's female figures may also offer a clue to its beginnings. They are suggestive of the high crests worn by Fula women, who are prominent, prolific potters throughout the Inland Niger Delta.[2] The Fula were among the delta's original inhabitants, and jewelry found at sites such as the ancient city of Jenne, where pottery was a major industry, bear a strong resemblance to modern Fula styles.[3]

Two related pots have been published. One has been identified as originating with the Bobo, a people who live mainly on the southern and western fringes of the Inland Niger Delta.[4] Like the pot illustrated here, the body of that jar bears spiraling snakes and female figures with raised arms, wide stances, and crested coiffures, although its lid is topped by a looped knob.[5] The other related vessel, which is missing its lid, is attributed to the Bamana, who reside primarily in the north

of the delta.[6] It is embellished with a male as well as a female figure, who appears with arms held out from her body and hair styled with a short crest and long locks down each side. On this jar, the human figures are interspersed with a snake, a lizard, and other water animals.

Another close comparison is provided by an old water jar with a narrow neck and pouring spout, photographed in situ in a Maninka village southwest of the delta. The container stood discarded in a courtyard and, like the lidded jars, features a snake and other images modeled in high relief.[7] Such embellishment is rarely seen today, replaced instead by slip-painted decoration.[8]

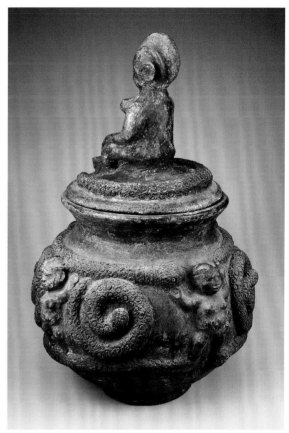

ALTERNATE VIEW

24

WATER CONTAINER (*JIDAGA*)
Bamana; Mali
Early/mid-20th century
Blackened terracotta
48.9 x 42.6 cm (19 ¼ x 16 ¾ in.)

25

WATER CONTAINER (*JIDAGA*)
Bamana; Mali
Early/mid-20th century
Blackened terracotta
51.4 x 38.7 cm (20 ¼ x 15 ¼ in.)

26

WATER CONTAINER (*JIDAGA*)
Maninka; Kangaba, Mali
Early/mid-20th century
Terracotta and slip
38.1 x 39.4 cm (15 x 15 ½ in.)

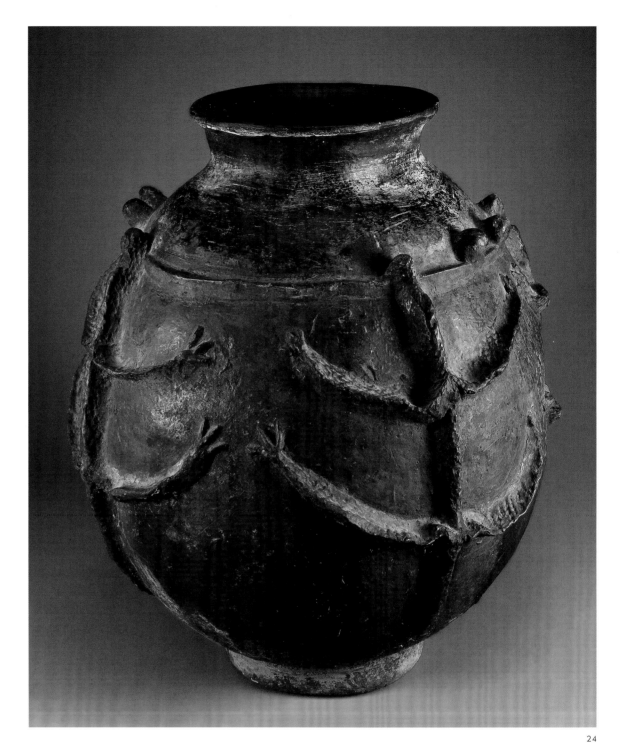

24

AMONG MANDE-SPEAKING PEOPLES such as the Bamana and Maninka, bards, blacksmiths, leather workers, and potters maintain a separate status within society that underscores their specialized skills and the critical services they perform. This practice has created a culture in which such artists are both respected and disdained.[1] Mande potters are known as *numumusow*, or blacksmith women, because tradition dictates that only the wives of blacksmiths have the right to make pots. Potters also take on other important responsibilities. Their presence is required at many rites of passage including childbirth, where they are often mid-wives. They likewise appear at baptisms, marriages, and funerals, and in the past were responsible for excising girls in a ritual that marked their

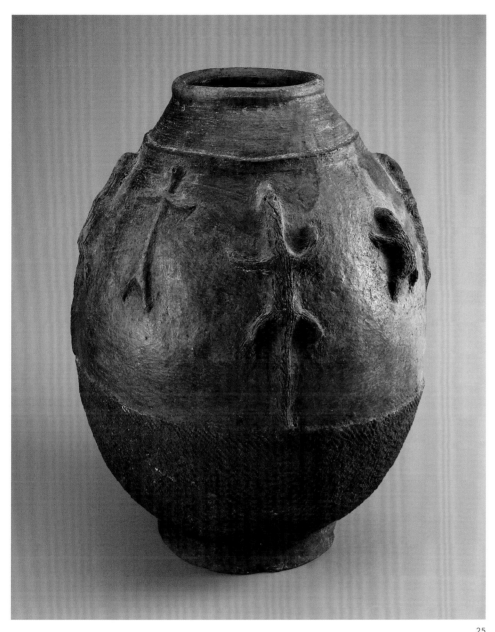

25

clay over a convex mold with a stone or fired-clay tamper; often, the mold is an old or broken pot that has been saved for the purpose (see "Ceramics in Africa," fig. 1).[4] If the vessel requires a foot, it is added to the base while it is still inverted. After it has dried enough to be self-supporting, the base is turned upright and placed on a turntable. (Among the Bamana, turntables are made from the bottom of a large broken water jar, which is set into a shallow impression on the ground and filled with sandy gravel that gently supports the pliable base and allows it to be rotated. Among the Maninka, turntables are specially commissioned wooden platters.[5]) The potter then scrapes the interior walls of the base before adhering coils to complete the vessel's form. She perfects the lip using a piece of wet cloth and may go on to burnish parts of the vessel to give it a smooth finish.

Because they are intended for public display, medium-sized water containers are among the most decorative and varied wares that Bamana and Maninka potters make. They are often placed prominently in a family compound, within easy reach under a tree or near the veranda.[6] Water containers such as these two Bamana examples (cat. 24–25), which are embellished with modeled imagery of animals and humans, are rarely seen in villages today.[7] The first (cat. 24) projects the strong, simple, and robust qualities that are hallmarks of pottery in the Mande heartland.[8] To achieve its rich, black coloring, the potter removed the vessel from the fire and immediately smoked it in a pile of sawdust, peanut shells, millet, or rice chaff.[9] She then plunged it, still burning hot, into a tree-bark bath in order to seal and further blacken it. Lizards, a common motif on Bamana water containers, are rendered in high relief, legs outspread and bodies draped as if suspended from the ridge that encircles the pot's shoulder. On the second piece (cat. 25), pencil-thin ridges define three distinct zones. The rough texture of the container's base was applied as the potter molded the clay over a convex form using a heavy block

transition into adulthood.[2] Potters are frequently healers, with mastery of a wide variety of herbal and medicinal cures, and until recently were renowned for their knowledge of the occult, although this waned as Islam became increasingly popular in the late twentieth century.[3]

Bamana and Maninka potters form the base of a work by gently pounding a flattened pancake of

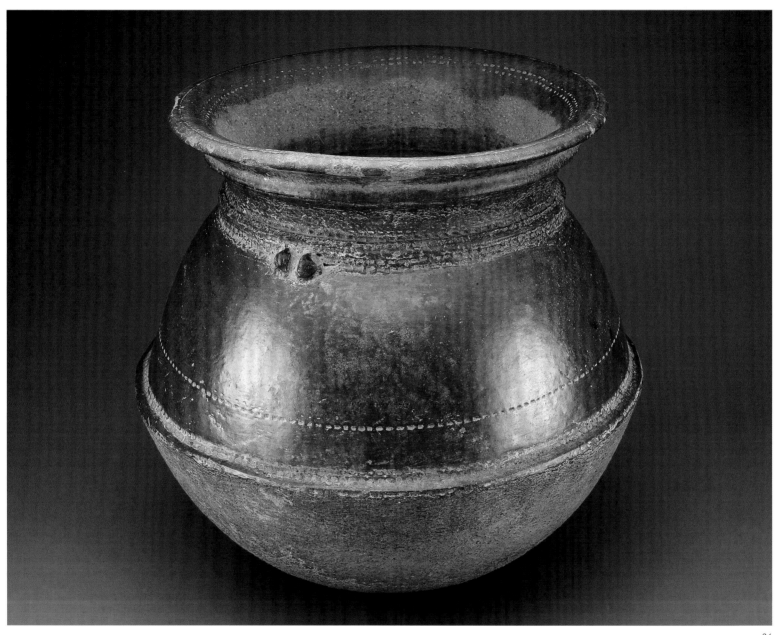

covered with a netted cloth. In marked contrast, the belly and neck were burnished and embellished with stick figures in low relief.

The third pot (cat. 26), a Maninka example, reportedly comes from the village of Kangaba.[10] Its carefully considered form reflects the process that was used to make it. The rounded base, formed in a convex mold, ends in a narrow ridge that visually separates it from the sloping upper body and short flared neck, which were formed by coiling. Contrasting areas of texture and burnished red slip accentuate these transitions. Thin dotted lines, achieved by carefully rocking a notched metal ring along the soft clay, lie like jewelry around the waist and just inside the lip, while two small raised pellets mark a focal point at the neck.

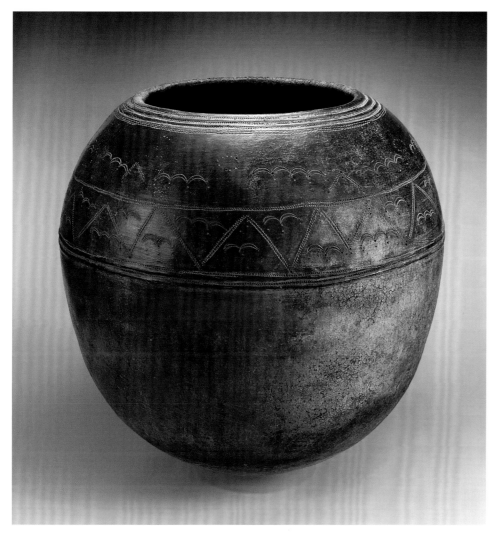

27

WATER CONTAINER *(FUNJOHO)*
Senufo; Côte d'Ivoire
Early/mid-20th century
Terracotta and slip
61 x 61 cm (24 x 24 in.).

SENUFO-SPEAKING PEOPLES live across a region that today includes parts of northern Côte d'Ivoire, southern Burkina Faso, and southeastern Mali. Their culture includes farmers and artisans who form distinct, hereditary groups that are economically dependent upon one another. Tyedunbele women, whose husbands are woodcarvers and gunsmiths, and Nafanra women, the wives of farmers, make pottery in a small way. But it is Kpeenbele women, the wives of brass casters and weavers, who make the majority of pots in the Senufo region.[1] According to Anita Glaze, pottery forms the crux of the interdependent relationship between the Kpeenbele and their farming neighbors. Characterizing this, one village chief told her, "When the Kpeenbele came they said, 'We are going to make pottery for your cooking; in exchange you cultivate the fields and we will eat together.'"[2]

Upon her marriage, a Senufo woman is often given a large, round, lipless water container like that pictured here. In the traditional two-chamber adobe home it is installed as the central feature in the main room, where it stands on a custom-made platform along with a small personal shrine (see "Pottery and the Home," fig. 2).[3] This handsome and capacious container was made by a Kpeenbele potter who was a master of her craft. The base was formed using a convex mold, generally an old pot that is placed upside-down on a turntable made from a shallow bowl filled with sand.[4] She then pressed wet clay against the mold with a block of fired clay (see "Ceramics in Africa," fig. 4). Once leather hard, the base was removed from the mold and the walls were scraped thin. Coils were then applied in fluid fashion to build up the walls. At this point the potter used a turntable—much like a mechanical potter's wheel—to help form the pot, thinning and shaping the rotating clay with the pressure of her hand.[5]

This container's refined embellishment was achieved with great skill and sensitivity. A shiny band of burnishing from waist to rim serves as the ground for the simply drawn decoration. Stippled lines define a zigzag band within and above which appear inverted Vs, the dotted outlines of circles, and, most prominently, crescents in groupings of two and three. These crescents are highly suggestive of birds in flight, which the Senufo strongly associate with important ponds and streams.[6] In his 1984 study of sub-Saharan ceramics, Arnulf Stössel illustrated several pots with similarly rendered crescents and stippled lines.[7]

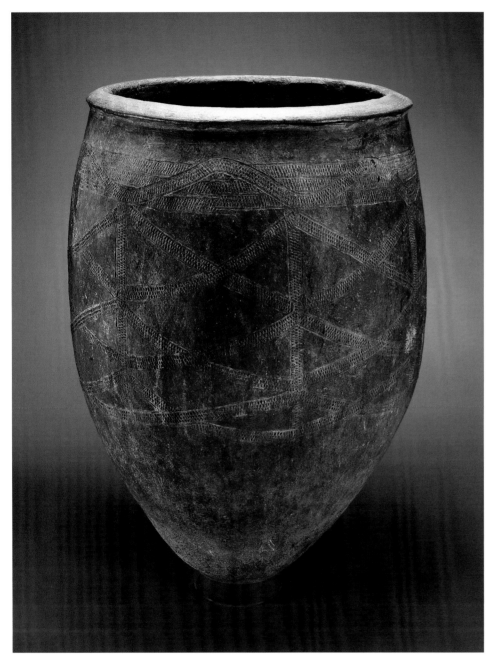

28

STORAGE CONTAINER
Turka; Burkina Faso
Early/mid-20th century
Terracotta
75.6 x 50.8 cm (29¾ x 20 in.)

THE TURKA, GOUIN, AND TUSYAN peoples of
southwest Burkina Faso are closely related to the
Senufo, with whom they share a similar language,
political structure, and system of belief.[1] These
groups can be divided into smaller subgroups, each
with unique variations of culture. The southern
Tusyan, who live predominantly in and around the
town of Toussiana, call themselves the Win, and
jars like this—dark in color and decorated by pat-
terned bands applied by roulette—have at times
been attributed to them.[2] Such vessels are indeed
found in Win homes, where they are often lined
up in two rows and used to store grain and some-
times millet beer.[3] This container has a broad
mouth for easy access and a thick lip to withstand
frequent use. The abrasions on its extremely
narrow base suggest that it was set into the earth
to stand upright. The potter took this into account
in her choice of decoration: she applied the under-
stated, crisscrossing net of roulette-impressed
bands only on the upper two-thirds of the body.

Little is published on pottery production and
trade in southern Burkina Faso. However, Susan
Cooksey, who has conducted fieldwork in the
region, suggested that these pots are likely made
for the Win by Turka potters who sell their wares
at the regional market town of Banfora.[4]

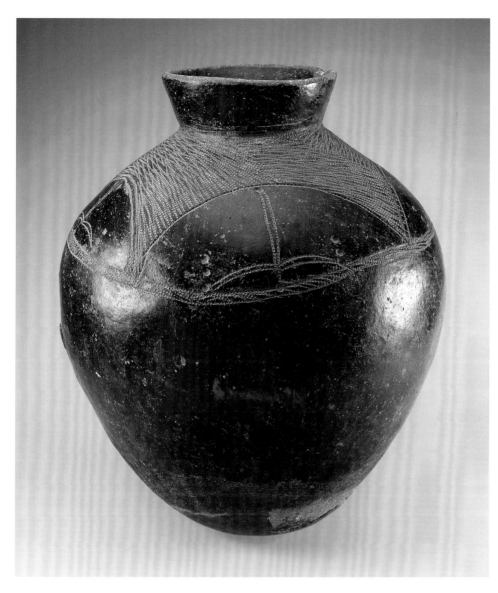

As throughout much of Africa, among the Lobi pottery is practiced by women and is learned through apprenticeship. Potters form the base of a pot by pushing directly into a lump of clay and build up the walls with coils.[3] Using a corncob or fruit peel, they smooth and refine the form, which they then burnish with a flat stone. Impressed patterns are added when the work is leather hard. The Lobi greatly admire well-made vessels for such qualities as "balanced shape and size, flawless work, smooth polishing, uniform coloration, regular and painstaking decoration, a pure ringing tone, [and] functionality."[4] Married women accumulate as many containers as possible, not for use but for display, and keep them stacked in their homes, sometimes with jewelry or cash secreted away inside (see "Pottery and the Home," fig. 1).[5] A talented potter who specializes in the production of the most highly valued containers, including those meant to hold beer and water, can expect to make a good living.

Thin, egg-shaped containers with slightly flared necks are commonly used to store drinking water and are highly esteemed.[6] Like this one, they are impressed across the shoulders with patterns of arcs, triangles, and bands in distinctive combinations that highlight the maker's individuality. The potter begins by outlining the pattern with the sharp edge of a stone, and then fills in areas with a twisted-fiber roulette, a spring, or a notched iron bracelet.[7] Here, irregular lines of closely spaced dots were densely applied to fill in a large zone around the neck. The area's scalloped lower edge joins with a narrow string of lines around the shoulders, defining arched niches. These enclose delicate, linear motifs punctuated by larger dots, which add a more contemplative counterpoint to the embellishment.

29

WATER CONTAINER
(NYONDEDAA OR
NYONNYODAA)

Lobi; Burkina Faso
Early/mid-20th century
Blackened terracotta
45.1 x 36.8 cm (17¾ x 14½ in.)

THE LOBI ARE AMONG the original inhabitants of the region that comprises the junction of Burkina Faso, Côte d'Ivoire, and Ghana. They live in scattered settlements that have come together as communities through a shared connection with a protective spirit.[1] Extended families live and work together, farming the land. Some communities specialize in skilled crafts, chief among them ironworking and pottery, and sell their wares at regional markets.[2]

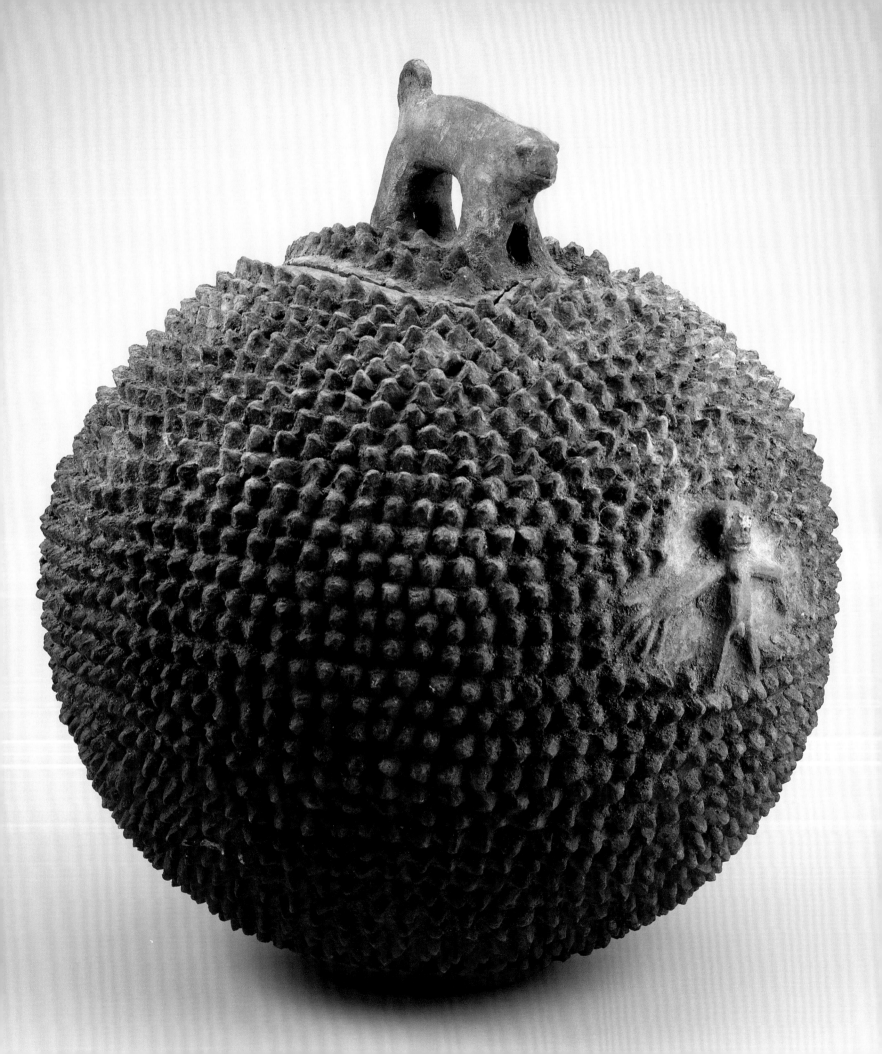

30

ALTAR VESSEL
Gur-speaking peoples, possibly
Lobi; Burkina Faso
Early/mid-20th century
Terracotta
43.2 x 38.1 cm (17 x 15 in.)
The Art Institute of Chicago,
Arnold Crane Fund; Irving Dobkin
Endowment; through prior gift of
Katharine Kuh, 1998.520

31

ALTAR VESSEL
Gur-speaking peoples, possibly
Lobi; Burkina Faso
Early/mid-20th century
Terracotta and sacrificial material
33 x 26.7 cm (13 x 10½ in.)

32

DOUBLE ALTAR VESSEL
Gur-speaking peoples, possibly
Lobi; Burkina Faso
Early/mid-20th century
Terracotta
25.4 x 40.6 cm (10 x 16 in.)

A COMMON COMMITMENT to honoring a protective spirit is the agent that binds families together as communities in the culturally diverse Gur-speaking region of southern Burkina Faso and northern Ghana. These spirits guide life individually and collectively, manifesting their presence through altars that are established within and outside the home. Pottery is found on many altars and is often specially made to be placed there. Only potters who have reached menopause make altar vessels, for it is believed that a woman who does so during her childbearing years risks becoming barren.[1] Moreover, this is the work of only the most masterful practitioners, who are recognized for their skill and understanding of the esoteric rules that govern supernatural interactions.[2]

Altar vessels are usually round bottomed and short necked, and inevitably have a lid that protects the contents from natural and supernatural contamination.[3] Unlike pots made for domestic use, which are ornamented with impressed patterns, ritual containers are painstakingly embellished in high and low relief. Spiky knobs commonly wrap the pot in one, two, or multiple rows, and abstract forms of animals and humans may be

applied to the sides or the top. The spikes that engulf two of the pots shown here (cat. 30–31) are used to decorate pots holding powerful substances and reflect a practice found across west Africa from Mali to Cameroon and even as far east as Tanzania (see "Engaging the World Beyond," fig. 5). Among the Lobi such spikes may symbolize protection against witchcraft, misfortune, and illness; fecundity and fertility; or supernatural protection during initiation.[4] Among the neighboring Senufo they represent the physical manifestations of disease.[5] The differences in the style of these two pots are striking. The spikes on one (cat. 31) are applied in an organic manner that is enhanced by the kaolin and yellow ocher—possibly associated with warding off illness—that coat its surface.[6] The vessel's iconography is complex and includes a snake, turtles, and male and female figures. A small ladle accompanies the vessel, presumably for pouring substances in or out. In contrast, the spikes on the other vessel (cat. 30) line up in tight rows, and the lid is neatly cut from the body in a fashion often used by potters in the region (see cat. 33–34, 45). A chameleon, a symbol of wealth, stands squarely on the lid, and a male figure with arms outspread is placed at center front.[7]

OPPOSITE: 30

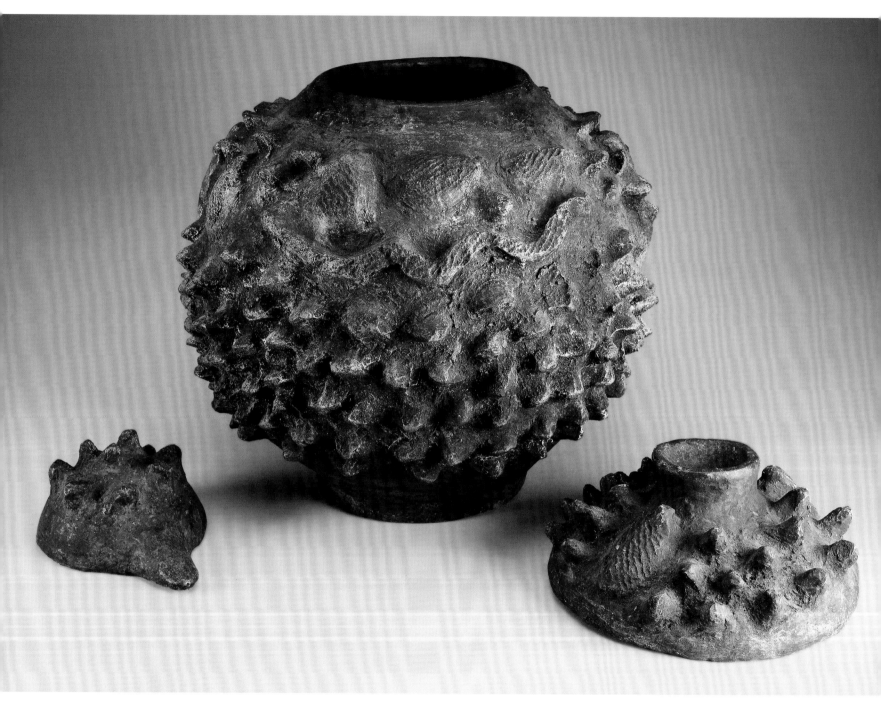

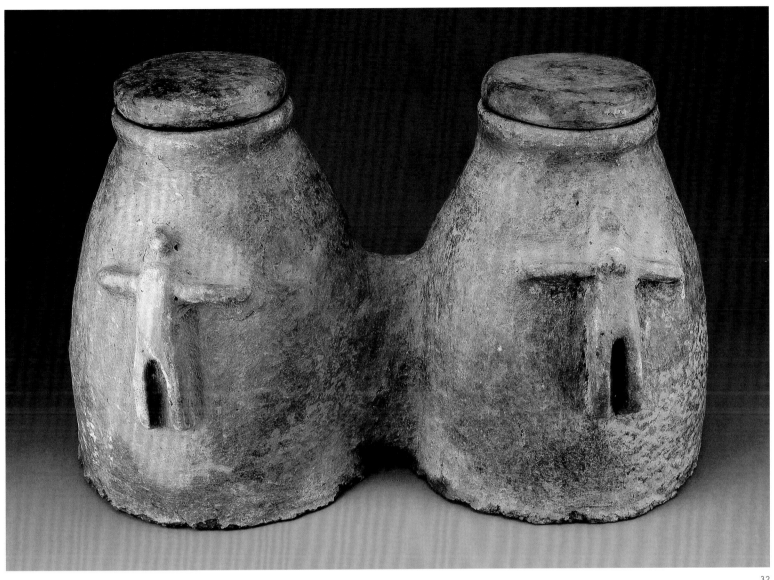

The Lobi make double pots to aid in the treatment of ailing twins.[8] The birth of twins is considered a blessing, and when they become ill it is diagnosed as a supernatural concern that must be addressed to the protective spirit of the father's family. The relatives commission a double pot, which is placed on the father's altar and contains a specially brewed medicine that is used to bathe the twins. According to Klaus Schneider, who has conducted an extensive study of Lobi pottery, double pots are always made with rounded bottoms and without figural embellishment.[9] This example (cat. 32) has a flat bottom and flat lids, and is embellished with a male figure on one pot and a female figure on the other, suggesting that it may come from a closely related, but stylistically independent, tradition.

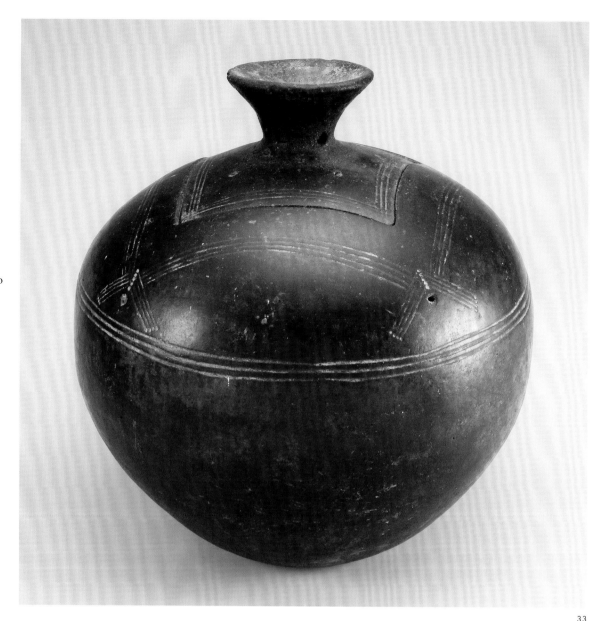

33

CONTAINER FOR VALUABLES

Gur-speaking peoples; Burkina Faso
or Ghana
Early/mid-20th century
Blackened terracotta
34.9 x 31.8 cm (13 ¾ x 12 ½ in.)

34

CONTAINER FOR VALUABLES

Gur-speaking peoples, possibly
Nuna; Burkina Faso
Early/mid-20th century
Blackened terracotta and slip
47.6 x 34.3 cm (18 ¾ x 13 ½ in.)

33

SOUTHEASTERN BURKINA FASO and northern Ghana are home to numerous small, culturally interrelated peoples that speak Gur languages.[1] In Burkina Faso they number among them the Kasena, Lela, Nuna, Nunuma, Sisala, and Winiama, while in Ghana they include the Nankani and those groups known collectively as the Frafra (Gurensi, Nabdam, and Tallensi). These populations are among the original inhabitants of the region, and although they have sometimes shifted their areas of residence, they maintain close ties to the land.[2] They are predominantly farmers and live in tightly composed villages of extended families and related clans.

Among these Gur-speaking peoples, potters use the direct pull method, pushing into a lump of clay to form the pot's base and pulling upward while rotating the mass to form the walls.[3] They then scrape the clay to consolidate it and to perfect the form. Elegant, round-bodied containers such as these, which feature a lid cut seamlessly from the body and a flared topknot that acts as a handle, are made by many Gur-speaking peoples and are intended to hold valuables.[4] On the first container shown here (cat. 33), the widest expanse and the outline of the lid are accentuated by bands of three or four thinly incised lines highlighted with kaolin; this form of decoration is typical

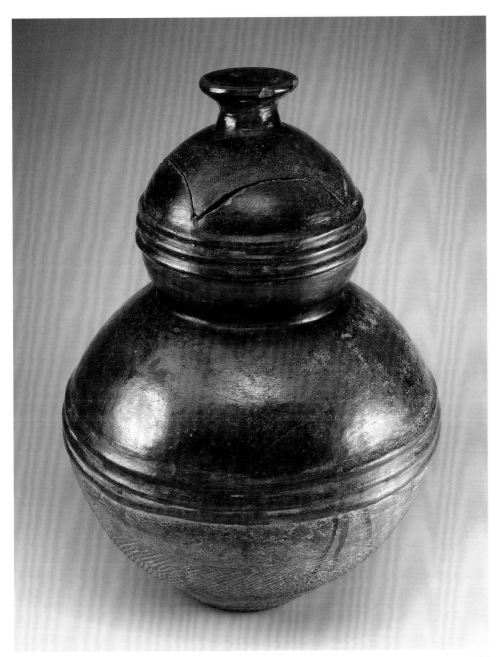

of pots made in northern Ghana and just across the border in Burkina Faso.[5] The second vessel (cat. 34) is more robust in appearance, with two tiers that are each encircled at midpoint by a series of three ridges. A topknot handle and cutaway lid crown the upper tier, and this, along with the upper half of the lower tier, is smoothly burnished and stained with a red slip that has partially blackened. In contrast, the bottom half of the lower tier was consolidated with a roulette or corncob, giving it a textured surface. According to Douglas Dawson, the Nuna specialize in these two-tiered forms (see cat. 45–46.).[6]

While the valuables stored within such containers may include money and jewelry, their worth may also be defined more esoterically. For example, clans, lineages, and individuals possess objects that are treasured for their role in forging a connection with the vital forces of nature. These may include "animal skulls and tails, rings, amulets, bracelets, stools, bottles, and anthropomorphic figures in clay and wood."[7]

34

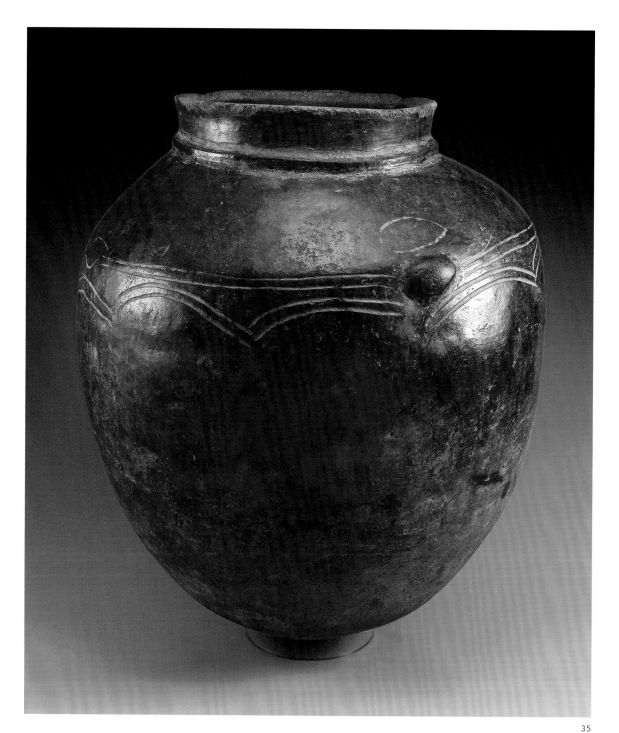

35

STORAGE CONTAINER

Gur-speaking peoples, possibly
Frafra; Ghana or Burkina Faso
Mid-/late 20th century
Terracotta and slip
57.2 x 50.8 cm (22 ½ x 20 in.)

36

CONTAINER, POSSIBLY
FOR WATER

Gur-speaking peoples, possibly
Frafra; Ghana or Burkina Faso
Early/mid-20th century
Blackened terracotta
58.4 x 38.7 cm (23 x 15 ¼ in.)

THE DIRECT PULL TECHNIQUE of pottery making is used by culturally interrelated Gur-speaking peoples such as the Kasena, Lela, Nuna, Nunuma, Sisala, and Winiama in Burkina Faso and the Gurensi, Nabdam, and Tallensi in Ghana, who are collectively called the Frafra. The vessels shown here may be Frafra in origin.[1] Taller than it is wide, drawn in sharply at the shoulders, and with a short neck, the first (cat. 35) is similar in shape to storage containers that were photographed in Nabdam villages in the 1960s.[2] A ring and an arching band have been sketched with quick, easy gestures around the container's shoulders, and a large, raised button marks one side. An arching line, called *yie*, is the most common form of decoration on Frafra pottery, as well as on the walls of Frafra houses.[3] It is associated with the crescent moon and with the grass ropes that bind a thatched roof to the rafters

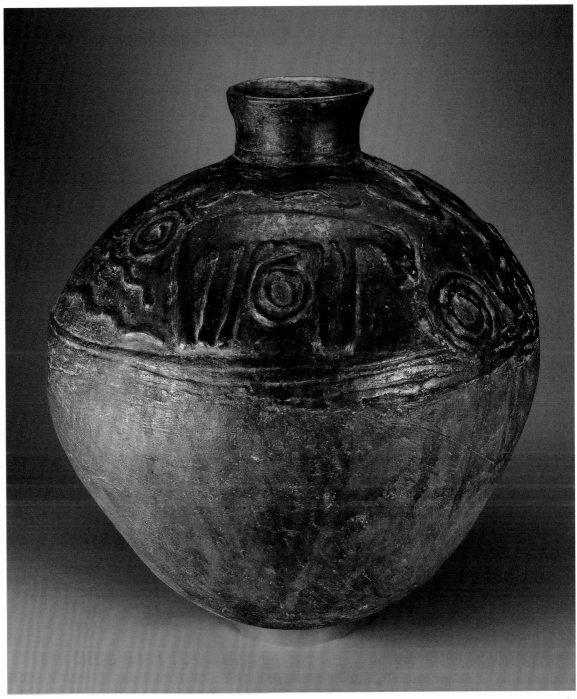

of a house. The pot's dark red color is the result of a coating of slip that was added before firing.

The second pot shown here (cat. 36) was purchased in Burkina Faso but may have come from just across the border in northern Ghana, in the region occupied by the Frafra.[4] Its shape—a round body with a tightly indrawn neck and a flared mouth—is common on both sides of the border.[5] The vessel's large size and narrow neck suggest that it may be a container for carrying or storing water, although its handsome embellishments may indicate a ritual use. Its surface has an almost metallic appearance, and its iconography includes a horse, lizard, and wavy and spiral lines. Horses are longstanding symbols of power and wealth in the region, dating to the fifteenth- and sixteenth-century invasions that heralded the establishment of the Mossi states.

37

STORAGE CONTAINER

Mossi; Burkina Faso
Early/mid-20th century
Terracotta
64.1 x 33.7 cm (25 ¼ x 13 ¼ in.)

38

STORAGE CONTAINER

Kurumba; Burkina Faso
19th/mid-20th century
Terracotta
68 x 51.4 cm (26 ¾ x 20 ¼ in.)

39

STORAGE CONTAINER

Kurumba; Burkina Faso
Early/mid-20th century
Terracotta
77.5 x 44.5 cm (30 ½ x 17 ½ in.)

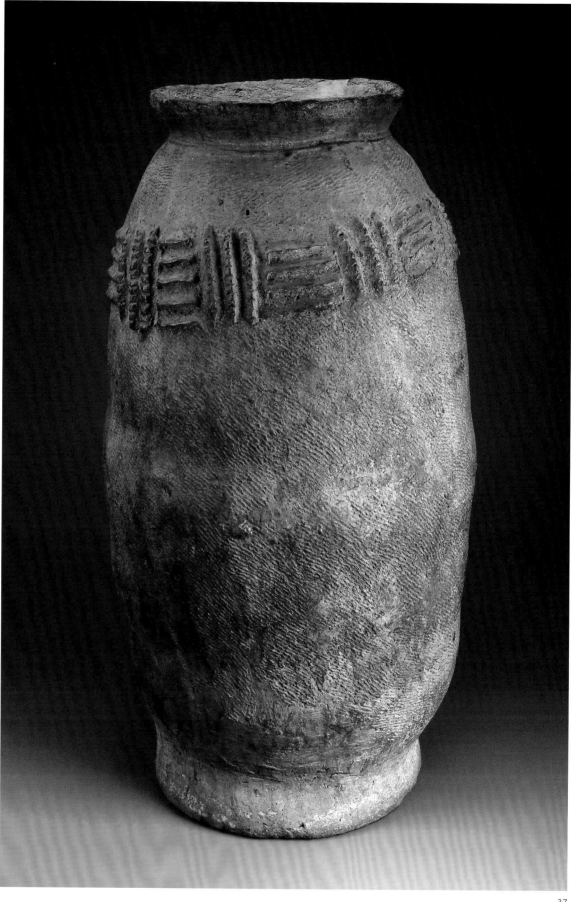

37

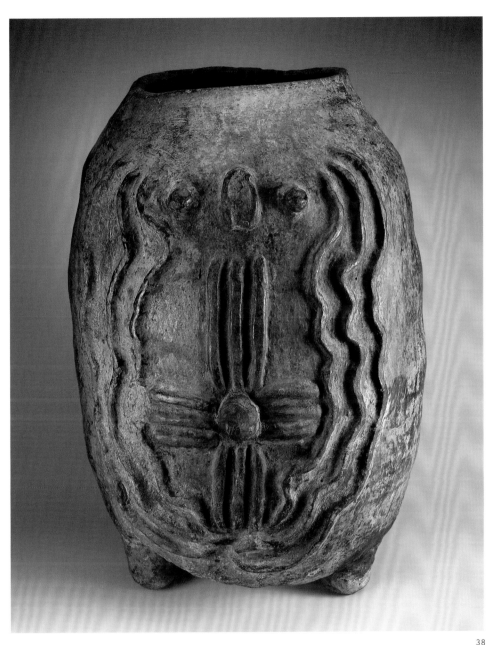

38

also safeguard other dry goods such as peanuts or okra, as well as personal valuables, from clothing and jewelry to money. Such vessels are a visual and conceptual extension of the larger, stationary granaries that are prominent features of the built environment (see "Granaries and Grain Containers"). Both are strongly associated with sustenance, fecundity, and fertility.

These storage containers come from central and northern Burkina Faso, a region that saw the founding of the powerful Mossi States in the fifteenth century.[1] At that time, the invasion of horsemen from northern Ghana changed the political and cultural make up of the area in significant ways. The local populations of Kurumba, Dogon, and Gurmantche were overpowered by their attackers but were not completely subsumed by them; today they continue to possess a sense of ownership over the land and maintain a unique sense of identity on many levels.[2]

The customs and techniques of Mossi pottery vary widely depending on the maker's region and cultural origin. The concave mold technique is used in the northernmost part of Mossi territory, once occupied by the Kurumba and Dogon, where women are potters. It is also used in the southeast, where Mossi men make pottery.[4] The convex mold technique, in contrast, is used by male potters throughout most of the southern Mossi territory and by some female potters in the southwest.[5] The sturdy storage container illustrated here (cat. 37), which is believed to be Mossi, has an engaged foot and walls that have been textured using a twisted-fiber roulette. The vessel's only other embellishment is a meandering band of thick, notched lines that wraps around the shoulder in alternating vertical and horizontal groups.

In contrast to this pot, the two Kurumba storage containers (cat. 38–39) stand on three squat legs. The first (cat. 38) is thick and heavy and bears a bold pattern of raised embellishment that depicts the scarification patterns once commonly applied to the bellies of married women with children.[6]

TALL, CYLINDRICAL STORAGE containers are a regular feature in traditional homes of the arid western Sahel and savanna region. Lined up in rows in the kitchen, they hold the life-sustaining grains—primarily millet, sorghum, and, more recently, corn—that are grown in the short rainy season that lasts from June until September. They

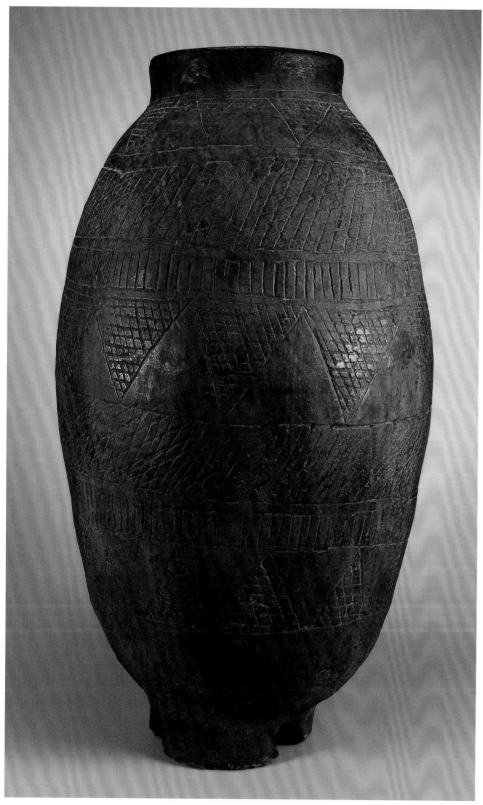

A projecting navel is prominently rendered at center, with lines radiating outward at the four cardinal points. Above, two smaller knobs suggest breasts. These designs are strongly associated with human and agricultural fertility. The second vessel (cat. 39) is etched from neck to feet with a free-hand pattern of bands and triangles that are filled in with hatching and cross-hatching. A related Kurumba example possesses bands of patterning that are impressed in a more regular and compartmentalized fashion.[7] Similar inscribed patterns are also found on a jar from an ancient burial mound at Kouga in Mali.[8]

39

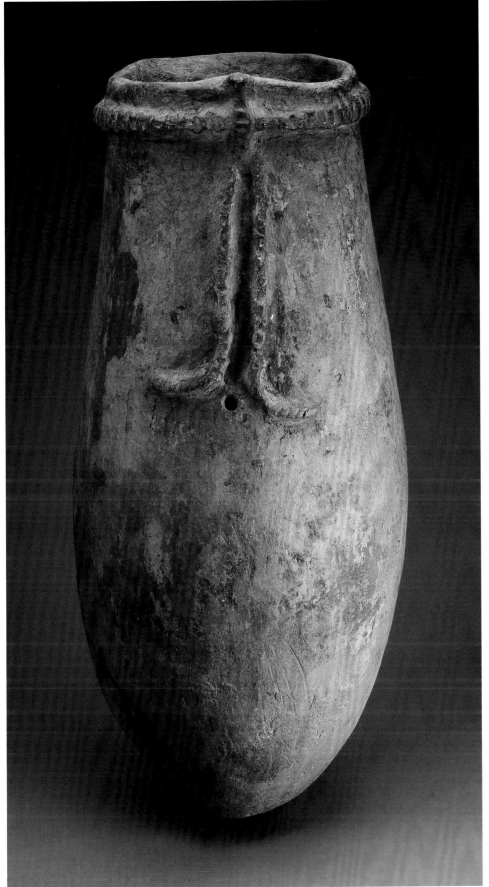

40

STORAGE CONTAINER

Kurumba, Kasena, or Mossi; Burkina Faso
Early/mid-20th century
Terracotta
50.2 x 21 cm (19¾ x 8¼ in.)

41

STORAGE CONTAINER

Kurumba, Kasena, or Mossi; Burkina Faso
Early/mid-20th century
Terracotta
43.2 x 29.9 cm (17 x 11¾ in.)

THESE TWO CONTAINERS, which were probably kept to store valuables, are smaller versions of vessels that are used primarily to preserve grains and dry goods across the western Sahel and savanna (see cat. 37–39). That shown on the following page (cat. 41) has a feminine, subtly undulating shape that is accentuated by its burnished patina and combed texture. In contrast, the form and finish of the one at left (cat. 40) is less refined. With its extremely narrow base, this pot appears quite precarious and would have needed to be set into the ground to stand upright. Its only ornament is a raised ribbon that suggests a simply rendered human figure with long arms that form a band around the pot's mouth and legs that terminate in gentle hooks. Similar ribbonlike embellishments are found on other containers that have been identified as Kurumba and Kasena, peoples living to the north and south of the Mossi heartland.[1] This vessel reportedly stored cowrie shells, once widely used both as currency and as decorations for masquerade costumes.[2]

40

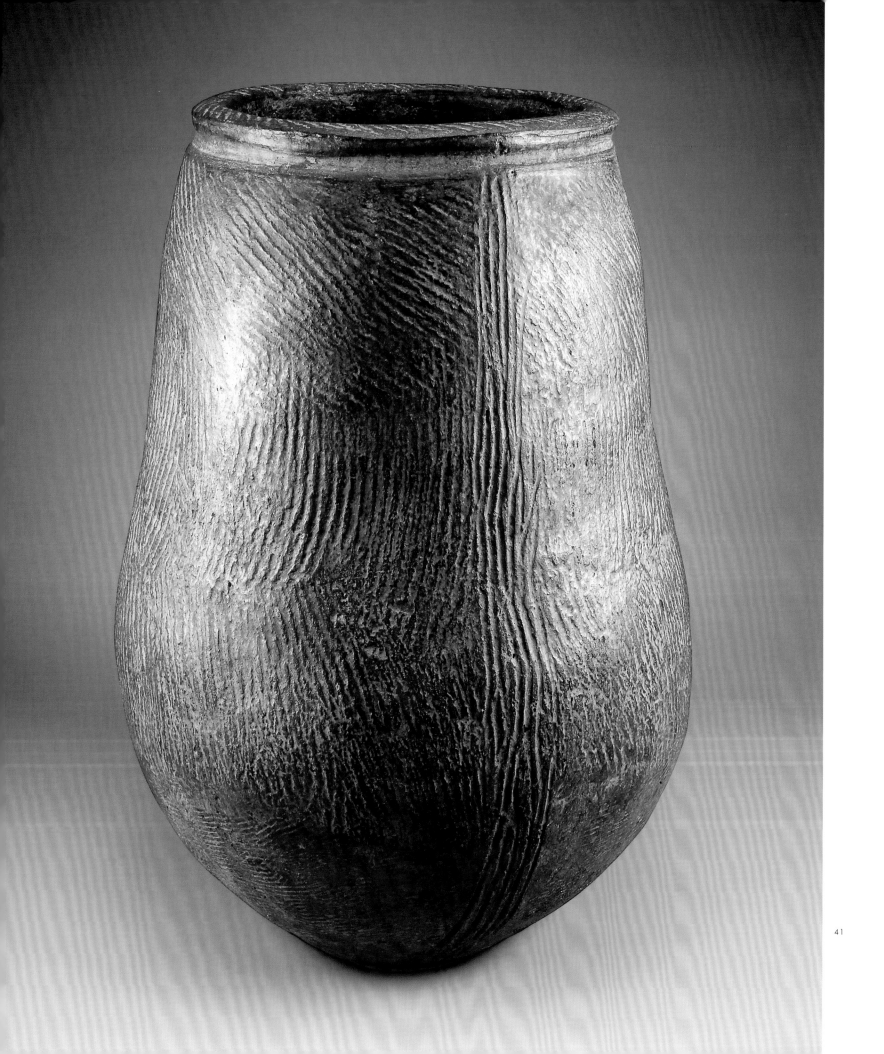

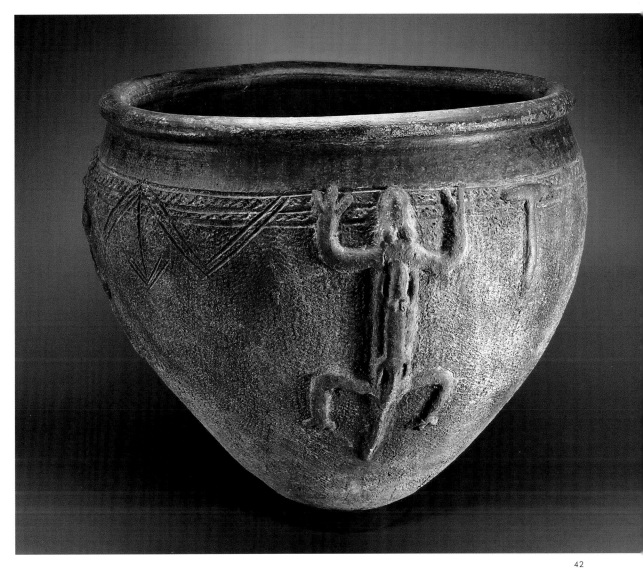

42

STORAGE CONTAINER

Nuna; Burkina Faso
Early/mid-20th century
Terracotta and slip
55.9 x 64.8 cm (22 x 25 ½ in.)

43

STORAGE CONTAINER

Nuna; Burkina Faso
Early/mid-20th century
Terracotta and slip
73.7 x 96.5 cm (29 x 38 in.)

44

STORAGE CONTAINER

Bwa; Burkina Faso
Early/mid-20th century
Terracotta and slip
52.1 x 69.2 cm (20 ½ x 27 ¼ in.)

MASSIVE, WIDE-MOUTHED CONTAINERS with narrow bases—some up to five feet in diameter and weighing several hundred pounds—are made across a wide region of central Mali, Burkina Faso, and northern Ghana.[1] Too big to move easily, these huge pots must be fired individually. Once installed in a courtyard or house they occupy the boundary between furniture, by nature movable, and architecture (see "Granaries and Grain Containers," fig. 1). Women use these vessels for a variety of household purposes, foremost of which is the germinating of millet or guinea-corn by soaking it in water. This is the first step in brewing beer, the sale of which can be an important source of income. Such containers can also be used to store beer, water, or personal possessions.[2]

Two of the containers shown here (cat. 42–43) were made by potters of the Nuna people, one of the numerous, interrelated Gur-speaking groups of southern Burkina Faso. Nuna potters, like many others in the region, use the direct pull method to form a pot's base, utilizing coiling to complete the walls and lip.[3] A bumpy texture, applied by roulette, covers each container up to the broad shoulder, where a narrow band of burnished red slip introduces a thick, rolled lip. The shoulder of the second vessel shown here (cat. 43) is encircled by three raised bands and, on one side, by a series of enigmatic appliquéd images: three staffs (possibly denoting currency) share space with an arrow-shaped motif (perhaps symbolizing women) and the abstract head of a water buffalo,

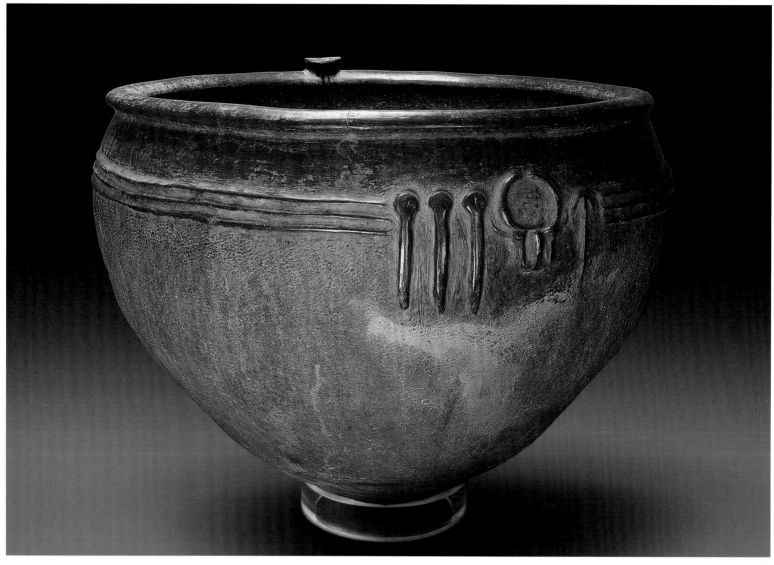

43

which may also be a water buffalo mask.[4] According to scholar Christopher Roy, Nuna masks represent protective spirits that can "provide for the fertility, health, and prosperity of the owners," themes that would be equally appropriate to a grain-storage container.[5] Opposite these motifs, the pot's rim bears a raised knob. The first pot (cat. 42) was embellished with the appliquéd image of a large lizard or crocodile carrying a baby on its back. Another lizard or crocodile graces the opposite side of the container while smaller images of a snake, a turtle, and a T-shaped motif, possibly representing an old form of metal currency lie between.[6] These designs originate at the container's widest expanse, its shoulder, which is further emphasized by etched lines and a brief zigzag on one side, offering an unexpected surprise.

The third vessel pictured here (cat. 44) displays a very different approach to embellishment. Its entire surface is covered with a dark red slip

that was vigorously burnished and mottled with dark fire marks. The maker applied a crisscrossing roulette pattern in a band around the shoulder; below this, soft pitch was used to render two large stick figures, which would have been applied after the work was fired, either by the potter or by a subsequent owner. This container has been attributed to the Bwa, who live west of the Nuna in Burkina Faso and southern Mali.

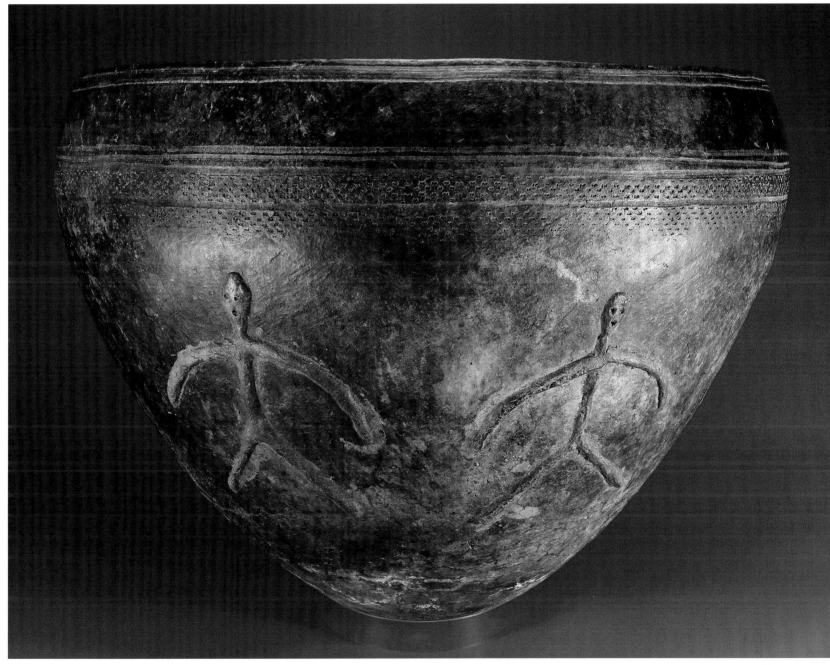

44

45

STORAGE CONTAINER

Nuna; Burkina Faso
Early/mid-20th century
Terracotta and slip
87.6 x 35.6 cm (34½ x 14 in.)

46

STORAGE CONTAINER

Nuna; Burkina Faso
Early/mid-20th century
Terracotta and slip
61 x 61 cm (24 x 24 in.)
The Art Institute of Chicago,
gift of Keith Achepohl, 2003.381

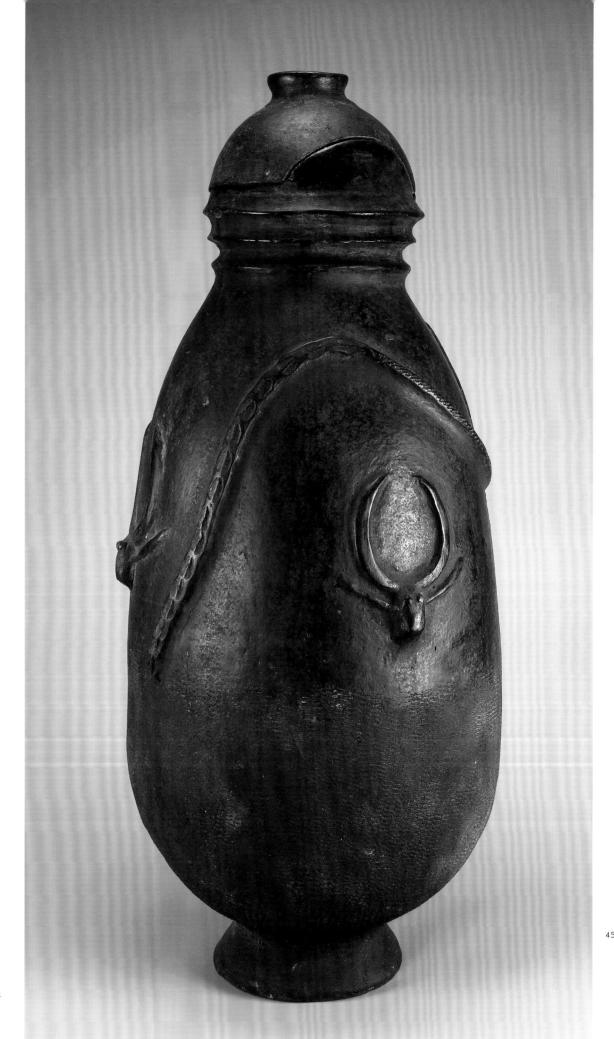

45

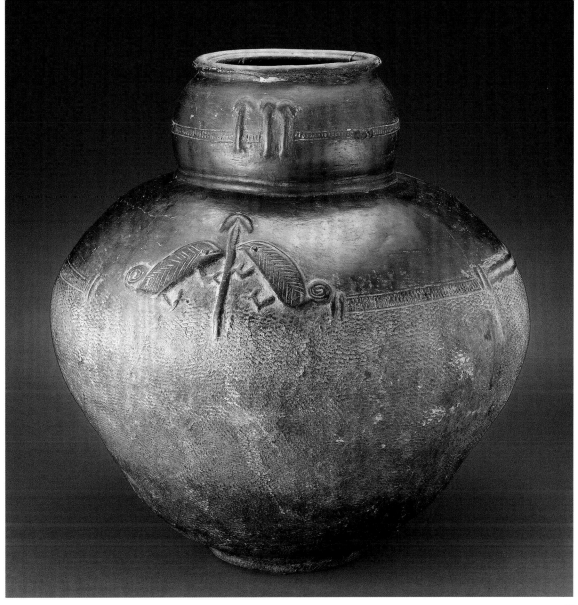

46

Burkina Faso is home to some of the most prolific and vital pottery traditions of the African continent, and large, handsomely formed storage containers are among the region's hallmarks. These two Nuna storage vessels are remarkable for their complex forms. The tall, narrow example (cat. 45) was constructed in several phases. The roulette-textured base was probably formed first; the foot was added next, and finally coils were used to build up the tall walls and ribbed neck. The lid may have been formed separately and attached when the neck was leather hard. The style of seamless, cut-away top seen here can be found on jars, large and small, from across the region (see cat. 33–34).[1] The iconography on this container, which includes tall staffs (possibly representing old metal currency), a snake, and a bush buffalo head, is visible on other

Nuna pottery and is related to prosperity, protection, and fertility (see cat. 42–43).

The plump, double-tiered container (cat. 46) was collected in Dedugou, a town in the Bwa region, but its style and iconography are more closely related to Nuna pottery from an area just southeast of the Bwa. The rough texture of the pot's rouletted lower half sets off the smoothly burnished upper part, with its applied motifs of chameleons, arrow-shaped patterns, and vertical and horizontal lines. Among the Nuna, chameleons are a symbol of change, magical transformation, and human fertility, while the arrow motif may represent women.[2] Themes of regeneration and fecundity are familiar ones for storage containers throughout the region (see "Granaries and Grain Containers").

Pottery and the Body

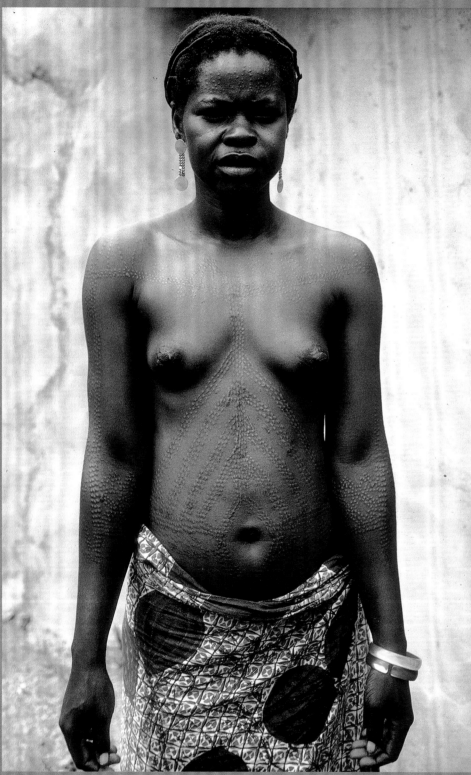

FIG. 1

The elemental associations made between pottery and the human figure are borne out in the words used to name the parts of a vessel—for instance lip, neck, body, and foot. Likewise, throughout Africa the patterns that embellish pots are part of a wider aesthetic and symbolic system that also frequently includes marks on the body. Girls living in the Ga'anda Hills of northeastern Nigeria are traditionally adorned with scarifications applied over a period of years leading up to marriage. Patterns like those on this Yungur woman's body are echoed on baskets, incised gourds, painted granaries, and on figural pots made to be placed on ancestral shrines, like that in the Achepohl collection (cat. 83). Photo by Marla C. Berns, Dirma, Nigeria, 1981.

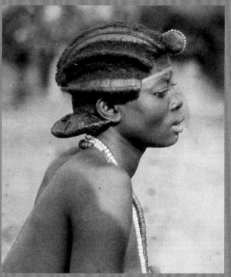

FIG. 2

Figural pottery evokes associations between vessels and the human body in a particularly direct manner and can also serve to document changing fashions in bodily ornamentation. This woman was photographed in the 1930s wearing a type of ridged headdress that is no longer fashionable in the Luba region. A similar style is depicted on a Lunda bottle in the Achephol collection that may date to the same period (cat. 107). Photo by Rev. W. F. P. Burton, Kashololo, Lovoi Highland region, Democratic Republic of the Congo, 1930s.

FIG. 4

Vessels in the form of human figures evoke many complex associations, making them ripe for use on shrines and altars. A potter crafted this figure like an upside-down pot, hollow inside and open at the bottom. Buried to just below the waist and bearing the remains of repeated offerings poured over its head, the figure is part of a Vodun shrine in southern Ghana. Photo by Jan Cocle, Ghana, 1989.

FIG. 3

Abstract patterns, often with magical or protective associations, are found across the arts practiced by the Berber women of North Africa. Tattooing was once foremost among these, although its practice has waned since the late twentieth century. In the Rif Mountains of northeastern Morocco, decorative patterns tend to be linear and understated, like the subtle herringbone motif tattooed on this Zemmour woman's chin and also found on a milk jug or butter churn in the Achepohl collection (cat. 14). Photo by Cynthia Becker, Khemisset, Morocco, 2002.

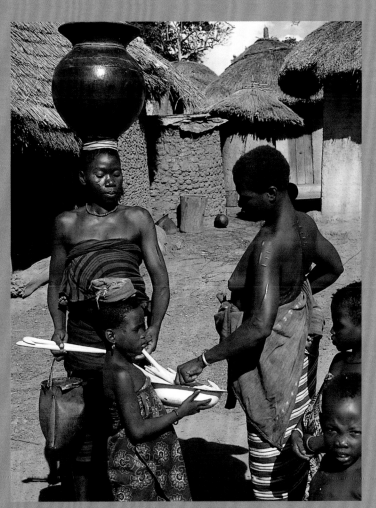

In many parts of Africa girls begin to carry objects on their heads as soon as they start to walk, and the grace, balance, and physical strength that this requires soon indelibly marks their overall carriage and self-presentation. This Senufo woman balances a beautifully formed water jar on her head as if it were an extension of her body, while at the same time carrying a baby on her back and a water bag in one hand. Here she pauses to buy a stirring whisk from a young girl and her mother. The girl has just removed the tray that she holds in her hands from her own head, where it sat propped on the circle of cloth that remains. Photo by Anita Glaze, Poundya, Côte d'Ivoire, 1970.

FIG. 5

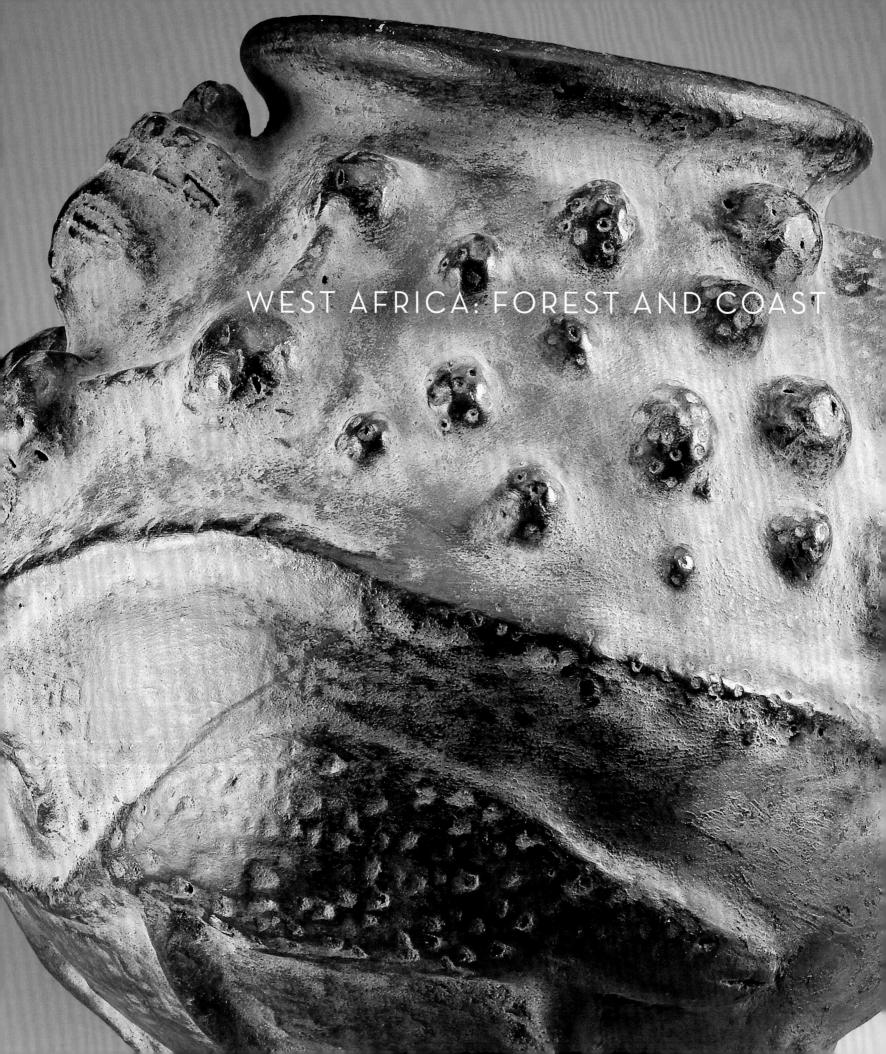

THE SOUTHWARD-FACING COASTLINE of the Atlantic Ocean and the Gulf of Guinea sits only a few degrees above the equator. The region's narrow coastal plane quickly succumbs to what was once tropical rainforest, although its vegetation has been largely transformed by deforestation and cultivation. This dense landscape naturally invited the development of decentralized but interrelated communities. Larger polities with urban centers also developed, however, particularly when their locations allowed for the control of valuable goods. These included the Benin Kingdom (Nigeria); Dahomey (Republic of Benin); and the Asante Confederacy (Ghana).

The majority of potters in the region use the coiling process, a development that may reflect the abundant availability of water.[1] Molding techniques, often used in combination with coiling, are also found, for instance, among some Baatombu and Yoruba potters in Republic of Benin and Nigeria.[2] Other practitioners use the direct pull technique, including the Asante in Ghana; the Fon in Togo and Republic of Benin; and the Gwari and neighboring Nupe in Nigeria.[3]

Relatively little archaeology has taken place along the coast and in the forests of West Africa, making it impossible to firmly date the antiquity of the region's pottery. The exception is central Nigeria, where work has revealed the remains of complex societies with fully formed pottery traditions dating to as early as 500 B.C. The oldest sites, associated with the Nok culture, lie just north of the forest proper, above the confluence of the Niger and Benue rivers.[4] There, potters made containers and sculptures that were traded over one hundred square kilometers. South of the junction lie the ancient cities of Igbo-Ukwu and Ile-Ife. The finds at Igbo-Ukwu, in the region of the Lower Niger, date to the tenth century and afford a glimpse into the hierarchical world of the Nri, an ancestral branch of the present-day Igbo.[5] Excavations have uncovered the sumptuous burial of a powerful leader and a shrinelike cache of luxury goods, including beads, copper-alloy ornaments, and elaborate regalia. Decorated pottery from the site has buttresslike handles, relief imagery, and swirling combed patterns that recall the forms and ornament used on Igbo pottery today. Ile-Ife, the founding city of the Yoruba kingdoms, thrived between the eleventh and fourteenth centuries and is best known for the celebrated cast copper-alloy and fired clay sculptures of idealized human heads representing royal figures.[6] It is likely that potters made such sculptures and were also responsible for creating ritual vessels, some with appliquéd imagery or sculpted, animal-head lids; they also produced a wide assortment of non-ritual containers, often beautifully decorated with combed, roulette, and stamped patterns. A similar coexistence of clay vessels and sculptures is found in many locations across the coastal and forest region of West Africa, including among Akan-speaking peoples such as the Asante, the Fon and related cultures, the Igbo, and the Yoruba.[7]

OPPOSITE: 59 (DETAIL)

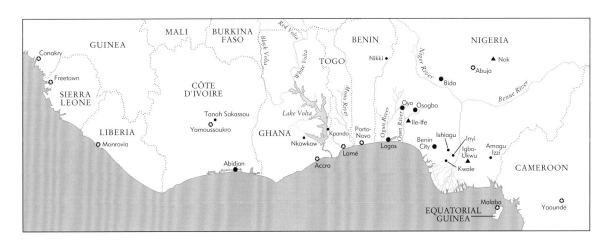

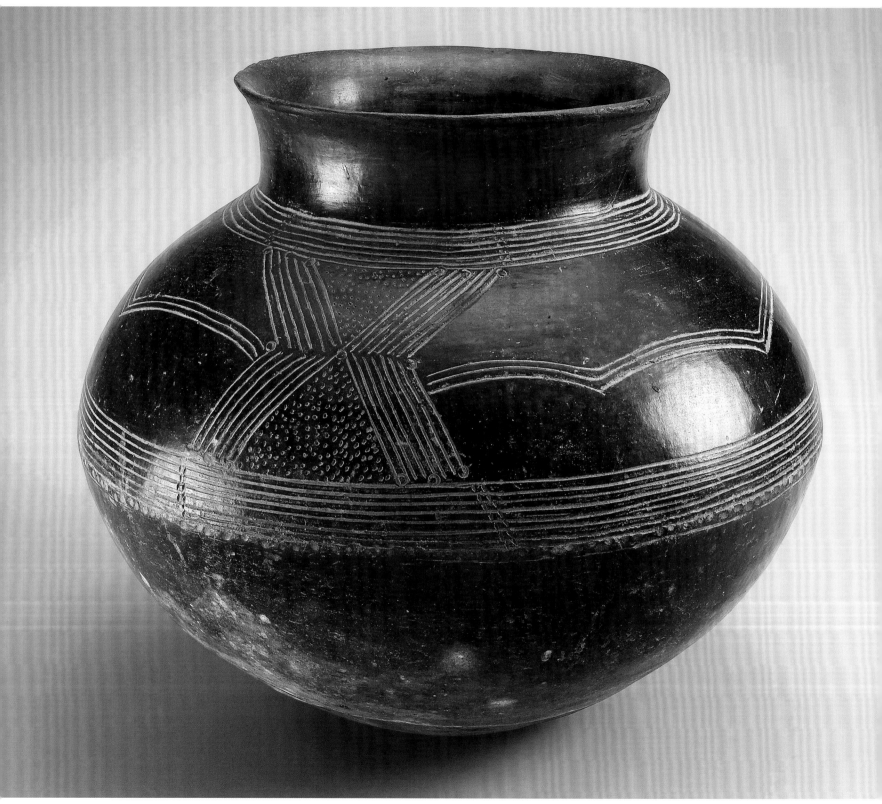

47

WATER CONTAINER

Baule; Tanoh Sakassou,
Côte d'Ivoire
Early/mid-20th century
Blackened terracotta, wash,
and kaolin
33.7 x 39.4 cm (13 ¼ x 15 ½ in.)
The Art Institute of Chicago, gift of
Keith Achepohl, 2004.741

48

BOWL

We; Liberia or Côte d'Ivoire
Early/mid-20th century
Blackened terracotta
27.9 x 40.6 cm (11 x 16 in.)

49

WATER CONTAINER

Possibly Sapa, Mano, or Dan;
Liberia
Early/mid-20th century
Terracotta and wire
39.4 x 49.5 cm (15 ½ x 19 ½ in.)

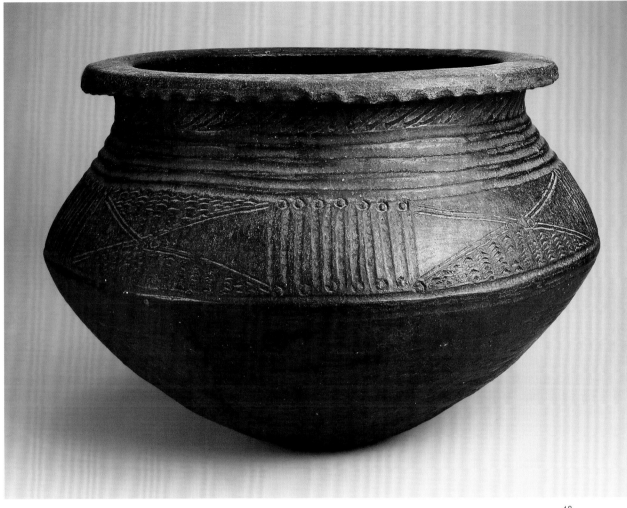

48

Across southern and central Côte d'Ivoire and into Guinea and Liberia, women make dark-colored, wide-bodied pots for a variety of household uses. Potters practice their craft in the midst of their families, and girls acquire their skills by observing and imitating long before receiving any formal instruction. Most potters use the direct pull method to make their wares.[1] They begin a piece by punching and wedging a hole into a lump of clay. They then place this on a makeshift turntable, possibly a shallow wooden bowl or a piece of broken pottery, in order to turn the work more easily as they build it up with coils and perfect its shape. Potters concentrate impressed and appliquéd decoration on a pot's neck and shoulders, usually leaving the lower half smoothly burnished. Works are fired in the open; upon removal the burning hot vessels may be blackened in a reduction firing of sawdust or chaff and dipped or splashed with an herbal wash to make them shiny.

With a round body that narrows to a short, slightly flared neck, the first pot illustrated here (cat. 47) is a handsome example of the jars Baule potters make to hold water. Smoking has given this gracefully formed, thin-walled piece a dark, slightly mottled color, and the potter embellished it with precisely etched lines that are highlighted with kaolin. Tight rings encircle its neck and waist,

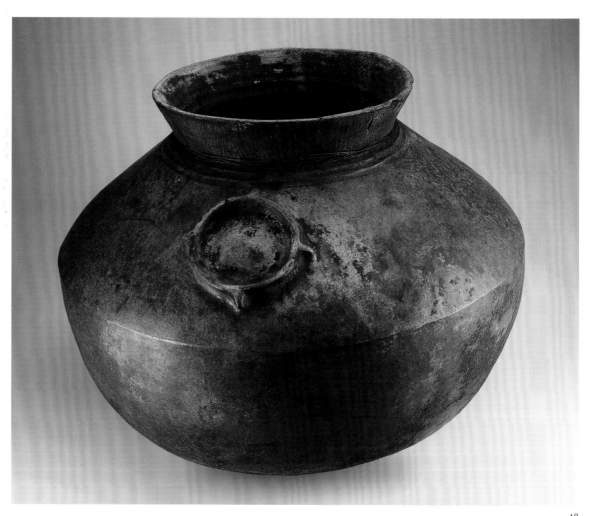

while a scalloped trio of lines dances lightly around the shoulder, meeting at the intersection of a large X. A particularly well made pot such as this one is openly admired and enjoyed for the beauty it brings to a living space.[2]

We (or Guere) potters and their Dan neighbors make wares that are similar in shape to those of the Baule, but with thicker walls and a more robust appearance. These pots are also distinguished by their combination of deeply impressed and more lightly incised patterns, which are created with tools such as bamboo sticks, thin pieces of calabash, and twisted brass rings.[3] The large We bowl shown here (cat. 48) has a round bottom and a sloped upper wall. The potter pressed ridges into the thick,

flattened rim to create a scalloped edge.[4] Wide channels encircle the neck, and succinct patches of circles, lines, and Xs embellish the shoulder.

The exact origins of the third vessel (cat. 49) are unknown, but the large and capacious container, probably intended to hold water, resembles pieces made by Sapa, Mano, and Dan potters in Liberia.[5] The object's grayish tint may be the result of the clay color in the region, which is bluish white when wet.[6] Rings are etched around the inside of the pot's neck and on the outside where the neck meets the body. The only other embellishment is a large, raised circle that is appliquéd on the pot's shoulder; its tabs mark the four cardinal points.

50

COMMEMORATIVE CONTAINER
(ABUSUA KURUWA)

Kwahu; Ghana
Late 19th/early 20th century
Terracotta
35.9 x 16.8 cm (14⅛ x 6⅝ in.)
The Art Institute of Chicago, gift of
Keith Achepohl, 2002.626

51

COMMEMORATIVE CONTAINER
(ABUSUA KURUWA)

Kwahu; Nkawkaw, Ghana
Late 19th/early 20th century
Terracotta and sacrificial material
36.8 x 52.1 cm (14½ x 20½ in.)

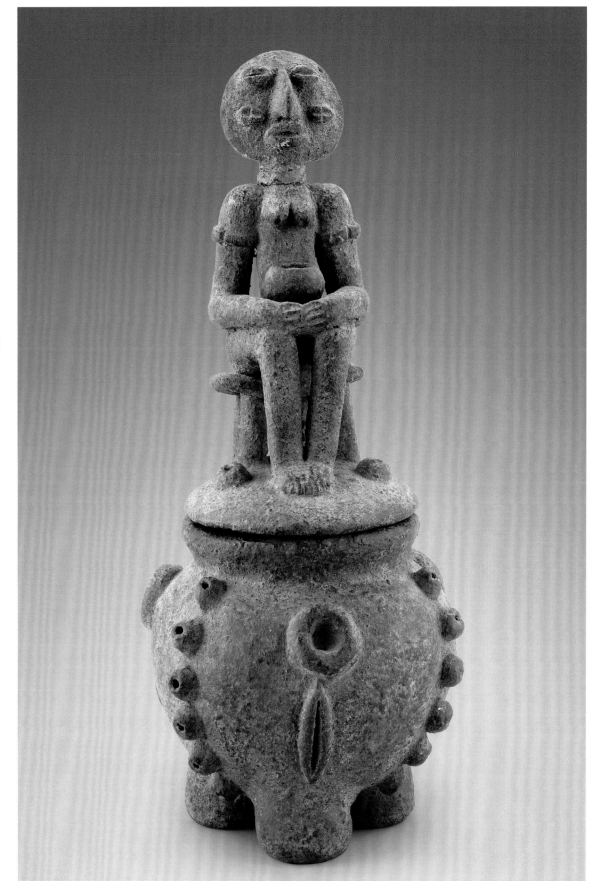

50

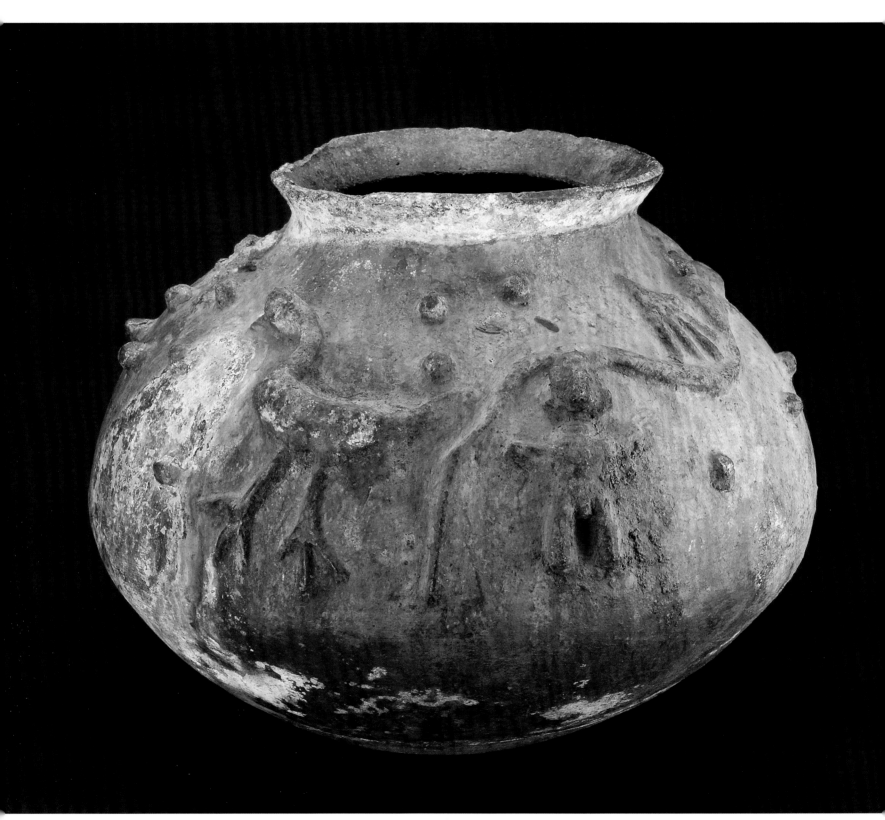

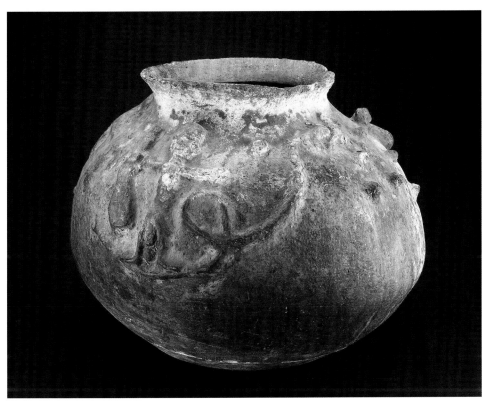

51, ALTERNATE VIEW

An *abusua kuruwa* was displayed during second burial celebrations, when the family of the deceased ate together and offered food to their departed relative. Among the Kwahu the pot stood under a shelter constructed next to a ritual hearth where special food was prepared for the dead.[6] Afterwards it was set, along with the cooking paraphernalia, on the deceased's grave. Hair and nail parings from family members may have been placed into the vessel as a symbol of familial unity.[7] Such pots are also seen on shrines, in royal stool rooms, and even in residential compounds, where they hold drinking water for the ranking elder, reflecting his or her close connection to the ancestors.[8]

The first Kwahu container shown here (cat. 50) demonstrates a sophisticated balance of forms. The small, round vessel that serves as its base stands on three legs and is embellished with circular knobs and cowrie-shaped attachments. The gracefully rendered woman who crowns its lid, perhaps intended to represent the deceased, has the flat-headed form and cowrie-shaped eyes of Kwahu figural sculptures. She sits on a classic Akan-style stool, which underscores her noble status, and holds a small bowl in her hands.

The large commemorative container (cat. 51) reportedly comes from the Kwahu town of Nkawkaw.[9] Its robust form, with flared lip, acutely angled sides, and round bottom, is typical of *kuruwa* that take the form of domestic storage containers.[10] Raised motifs, including two meandering snakes, a long-legged bird, a standing male figure, and a male figure holding a rifle, are applied in an intuitive fashion, animating the surface of the vessel. These probably had proverbial meanings or illustrated necessities, such as a chiefly entourage, that the deceased would need for life as an ancestor. Their simplicity of style and relatively low relief, as well as the pot's crusty surface, suggest significant age.[11]

ACROSS THE AKAN-SPEAKING REGION of what is today primarily Ghana, members of the royal elite were entitled to commission commemorative, funerary figures and vessels.[1] These practices were already well established in the seventeenth century, when early European travelers took note of pottery containers and sculptures on gravesites; they have waned since the second half of the twentieth century.[2] While women are the main makers of domestic pottery in the area, both sexes fashion commemorative containers called *abusua kuruwa*, or family pots.[3] These are found in a variety of styles ranging from simple to complex, reflecting their wide distribution and long-standing importance.[4] These variations are also due in part to the fact that a potter made only a few such vessels during his or her career.[5]

52, 53

PAIR OF SHRINE FIGURES
Ewe, Aja, or Fon; Ghana or Togo
Late 19th/early 20th century
Terracotta
58.4 x 26.7 cm (23 x 10½ in.)
59.7 x 27.3 cm (23 ½ x 10 ¾ in.)

THE EWE, AJA, FON, and other culturally related peoples share a religious practice known as Vodun, a word that is also used to describe the "mysterious forces or powers that govern the world and the lives of those who reside within it."[1] Among the best-known artworks associated with Vodun are sophisticated sculptures in metal made for royal patrons, and wooden sculptures, often unsettling in appearance, that are covered, wrapped, and bound with empowering materials. Pottery, however, also plays an important role in the visual expression of Vodun. Distinctive terracotta vessels and figures are associated with individual deities and prominently displayed in temples and on shrines.[2]

Open at the bottom and hollow within, these impressive figures in the Achepohl collection are essentially upside-down pots and were doubtlessly made by potters. They are heavily stained to the waist with the dripping lines of sacrificial offerings and were probably even partially buried in the ground below that point, as can be seen in a photograph from Southern Ghana of a similar figure in situ (see "Pottery and the Body," fig. 4).[3] Such figures have been described as protective and as representations of ancestors, and they may signify one of the many Vodun that come into being when an important person dies.[4] Why this pair represents two males is unknown, but the pieces' equivalent size, appearance, and indications of use suggest that they were almost certainly made and displayed together. Each is portrayed with an erect penis, a frequent symbol of the deity Legba that may refer more generally to danger, deception, and trickery.[5]

Figures with the same tufted coiffure, but with squatter bodies, have been collected in southern Ghana and are said to have been brought there in the 1930s.[6] Others come from the border between Togo and Republic of Benin.[7] A male and female pair collected in Togo displays similar elongated bodies, flat, truncated arms and hands, and heavy-lidded expressions.[8]

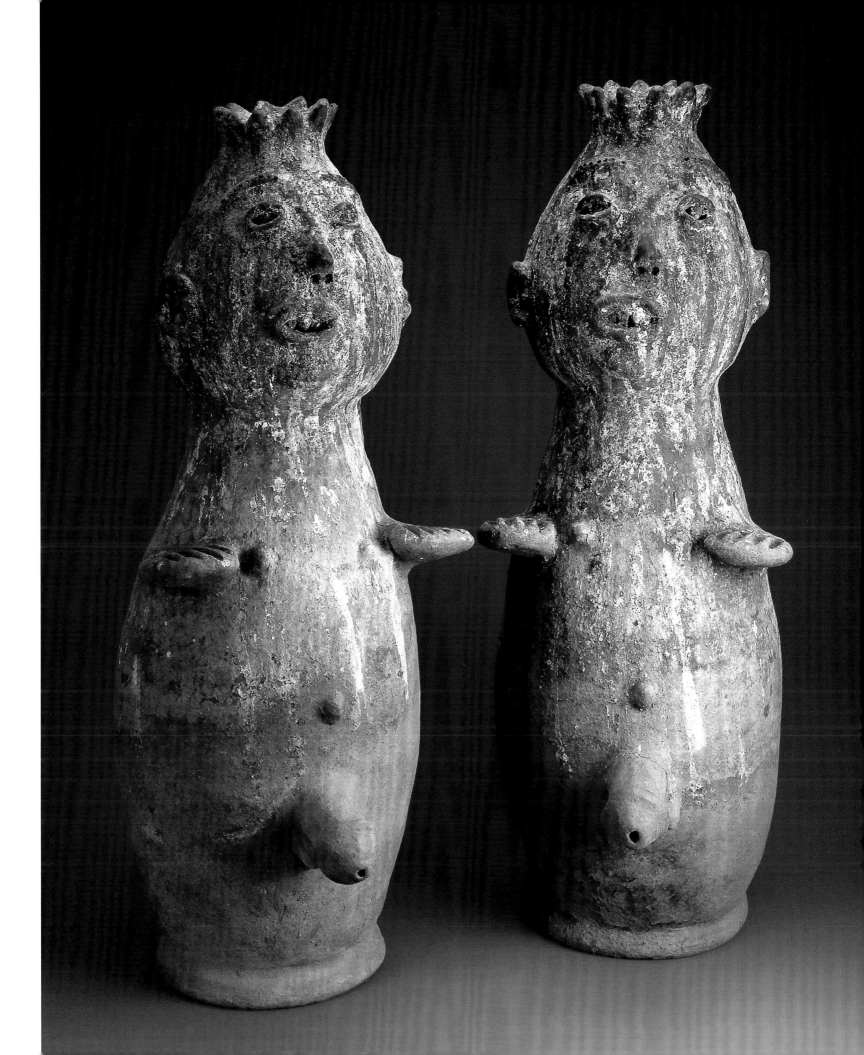

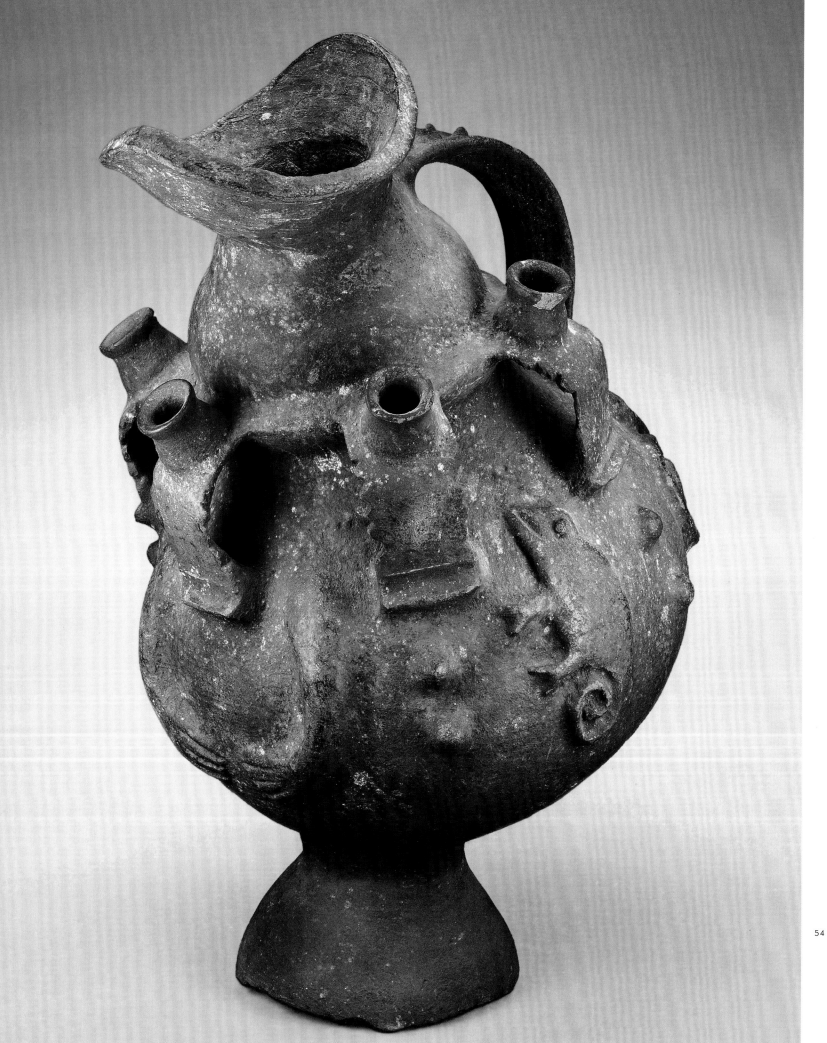

54

SHRINE VESSEL

Ewe or Fon; vicinity of Kpando,
Ghana
Early/mid-20th century
Terracotta
58.4 x 35.6 x 42.6 cm
(23 x 14 x 16 ¾ in.)
The Art Institute of Chicago, Atlan
Ceramic Club Endowment, 2003.76

55

CONTAINER

Undetermined culture; possibly
Ghana, Togo, or Republic of Benin
Mid-/late 20th century
Terracotta
27.9 x 33.7 cm (11 x 13 ¼ in.)

56

CONTAINER

Undetermined culture; possibly
Ghana, Togo, or Republic of Benin
Mid-/late 20th century
Terracotta
25.4 x 27.9 cm (10 x 11 in.)

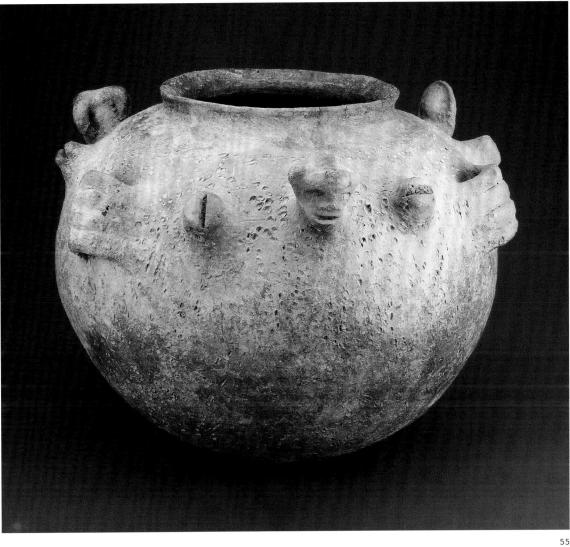

55

THE IMAGINATIVE, ASYMMETRICAL FORM of this shrine vessel (cat. 54) reveals the remarkable skill of the woman who made it. The piece's semispherical foot, rounded body, plump neck, wide spout, arching handle, and openwork arcade around the shoulders are balanced in a bold, confident manner. Human arms lie across the belly of the vessel and when in view transform it into a voluptuous standing figure. Appliquéd images of a chameleon, crocodile, fish, and snake suggest connections with magical, transcendent beings. The object was collected together with several other similarly styled pots and is believed to come from in or near the town of Kpando, in far east-central Ghana, near the Togo border.[1] According to one report, elderly women in the region have stated that such pots are no longer made or used, but were once placed on altars and were associated with very specific symbolic meanings.[2] The Kpando region is home to people of Ewe descent as well as to later immigrants from the Akan-speaking south. The vessel displays stylistic affinities to both pottery traditions, evoking the Ewe in its stacked forms and the Akan in its low-relief imagery.[3]

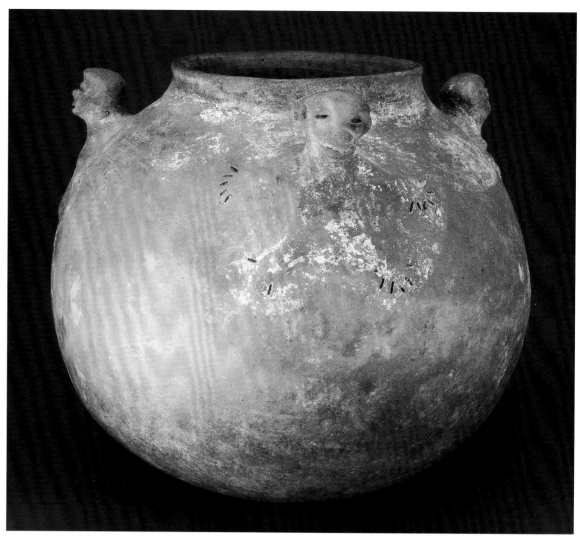

The miniature pots that sit upon the vessel's looping arcade suggest another possible source of inspiration. They are found on small, round-bottomed vessels that are made across southern Ghana, Togo, and Republic of Benin and used in Vodun, the region's predominant religion (see cat. 52–53). In the early twentieth century, two such examples were recorded in the collection of the Linden-Museum, Stuttgart, and identified as Ewe.[4] One bears the raised image of a snake and was described in the inventory card's dated language as a "snake fetish pot."[5] Others made by Adja and Gun potters, who are linguistically and culturally related to the Ewe, bear sculpted representations of chameleons, figures, and snakes; these are associated with various Vodun powers as well as with the water spirit Mami Wata, revered throughout West Africa.[6]

The two other plump-bodied pots shown here may also be from the broad region of the Ewe and their linguistically and culturally related neighbors such as the Adja, Fon, Gen, and Gun. The first (cat. 55) is embellished just below its short neck with three projecting heads, each rendered with a unique coiffure. These are interspersed with smaller, cowrie-shaped knobs and three vertically oriented tubes, each scored with rings, through which cord could be passed to suspend the vessel. Like this piece, the container above (cat. 56) is ornamented with three stylized heads that crane outward from rudimentary, flattened bodies, arms and legs akimbo. Vessels with similar faces are identified as Ewe and Fon, although these comparisons are by no means definitive.[7]

57

JAR (*WÉKÉRU*)
Baatonu (Bariba); Republic of Benin
Early/mid-20th century
Terracotta
41.3 x 36.2 cm (16¼ x 14¼ in.)
The Art Institute of Chicago, gift of
Keith Achepohl, 2002.625

58

SHEA BUTTER JAR (*BWÉERU* OR
WÉKÉ GUMGIA)
Baatonu (Bariba); Republic of Benin
Early/mid-20th century
Terracotta
27.9 x 30.5 cm (11 x 12 in.)

59

JAR (*WÉKÉRU*)
Baatonu (Bariba); Republic of Benin
Early/mid-20th century
Terracotta
27.3 x 26.7 cm (10¾ x 10½ in.)

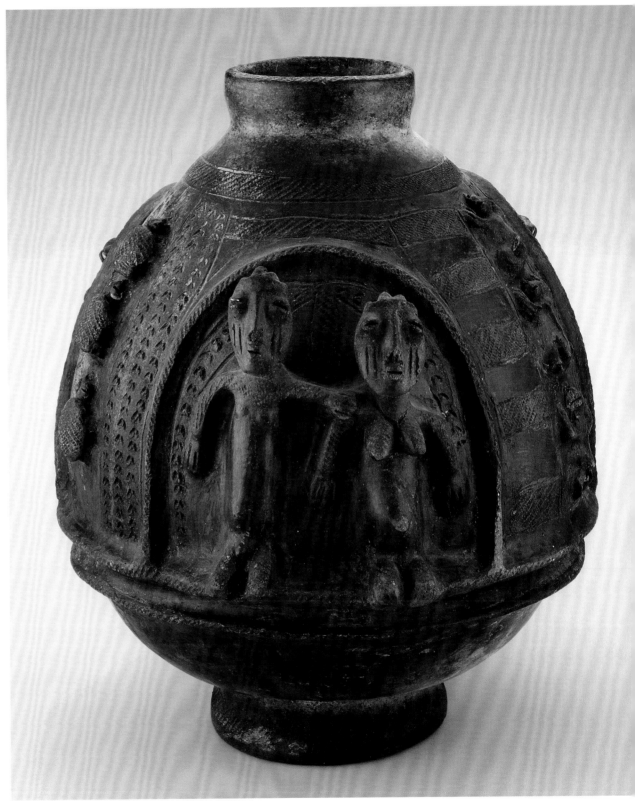

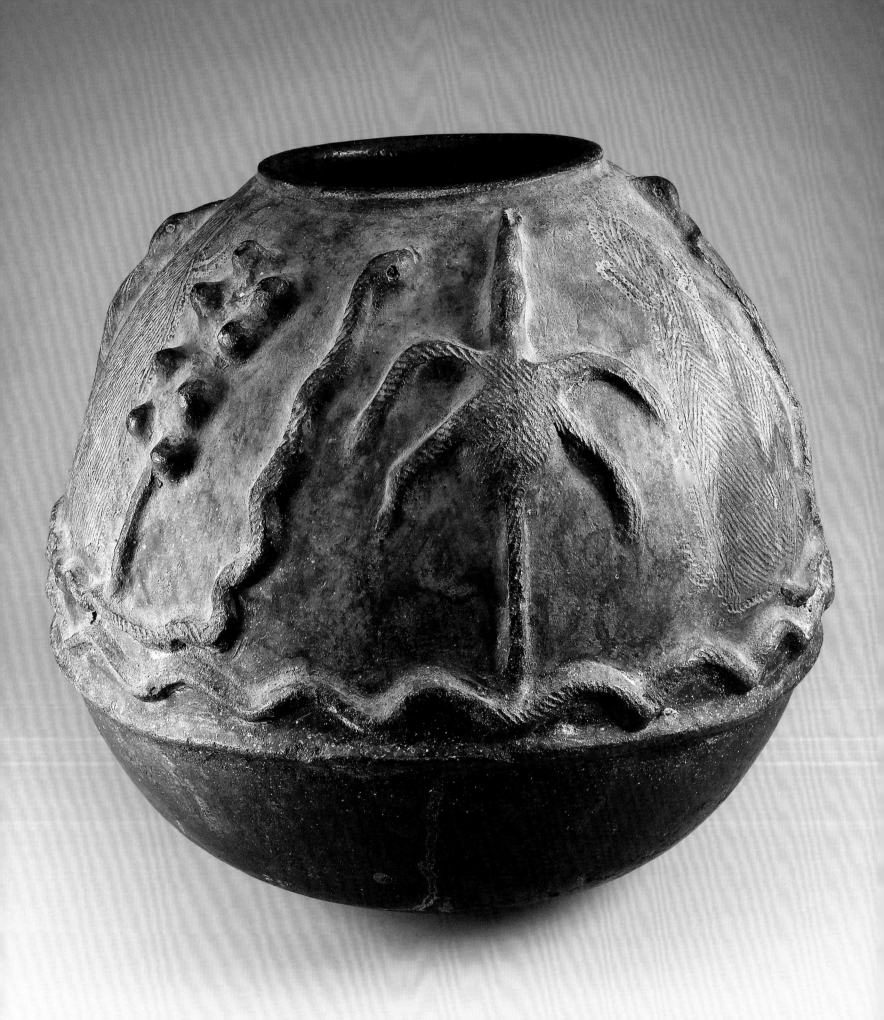

THE BAATONU (PLURAL, BAATOMBU), or Bariba, are the majority population in the ethnically diverse Borgou Province of northeastern Republic of Benin.[1] Their origins are complex, combining a base population associated with hunting, traditional healing, and communion with spirits and ancestors, with a ruling elite called the Wasangari, refugees from the Hausa region of Nigeria who fled Islamic reform in the nineteenth century. Today the Baatombu make a living primarily as subsistence farmers. While their origins are debated, it is clear that they have absorbed many influences from their Yoruba neighbors to the south and southeast, as well as from the Gur-speaking region of Burkina Faso to the northwest and perhaps even from the distant Mande-speaking heartland of central Mali.[2]

Well into the 1950s pottery was central to the domestic life of the Baatombu, and women made a variety of vessels for household and ritual use.[3] By the 1980s, however, much of the pottery intended for daily use was displaced by imported enamelware and few women were choosing ceramics as a

career.[4] Today there continues to be some demand for specialized pottery in rural areas, particularly as a symbolic gift to a young woman about to marry, for ceremonial use by spirit mediums, for preparing or storing traditional medicines, and for making offerings to spirits and ancestors.[5] Although pottery may once have been a hereditary profession that was closely aligned with iron-working in Baatonu thought and practice, today it may just as likely be learned through apprenticeship as passed from mother to daughter.[6]

The potter forms the base of a pot using the convex mold technique. This method is also used by many potters in Burkina Faso, where the Baatonu may have originated, and by the neighboring Yoruba in the region of Oyo.[7] After the pot is removed from the mold, coils are added to complete its form. According to Carolyn Sargent and David Freidel, some Baatombu use the hammer-and-anvil technique instead of coiling to complete their pots, a method also employed by the Songhay, Fula, and Mossi, who may have distant connections with them.[8]

Among the most elaborately adorned Baatombu vessels are large egg-shaped jars with heavily embellished surfaces that combine delicate incising with bold modeling in low or high relief. Some of these, as well as similarly shaped shea-butter-fueled lamps, are decorated with inventive sculptural forms including animals and fully realized figures.[9] Three Baatonu vessels from the Achepohl collection presented here (cat. 57–59) are the work of three potters with markedly different styles.[10] A male and female couple takes pride of place in the arched niche that is the focal point of the first (cat. 57). The figures' stylized faces are expressively rendered with large, slit eyes, long noses, pursed mouths, and prominent scarifications on their cheeks. Similarly modeled figures are found on several other published examples of Baatombu pottery, and their recurrence may suggest a workshop or regional style.[11] On the sides and back of the jar vertical registers hold

58 (DETAIL)

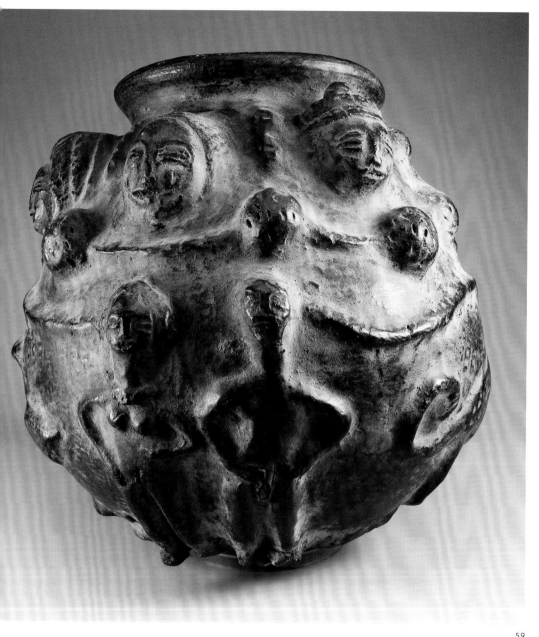

rows of turtles, lizards, and snakes—probably the python—animals that transcend the boundaries of earth and water. Such animals may become associated with the protective spirit of a family or of a spirit medium.[12] Contrasting areas of smooth burnishing and incised pattern further articulate the jar's surface and include evenly spaced horizontal bands that unite the complex decorative program.

Such organizational devices are absent on the other two vessels. The snakes, crocodiles, and lizards that embellish one (cat. 58) have an improvisational quality that is akin to the immediacy of gesture drawing. The jar's yellowish color suggests it was used to store shea butter, which seeps through the porous walls of a terracotta vessel over time, permanently discoloring it. With its multiple domestic uses, including as an ingredient in cooking and medicine and as lamp fuel, shea butter is an ideal symbol of plenty. Baatombu mothers commission jars like this to give to their daughters upon their marriage, filled with shea butter. The animals on this example probably represent the protective spirits of the owner's family.[13]

The third jar of the group (cat. 59; see detail, p. 92) may also have been commissioned as a "butter jar" for a newly married woman.[14] Central to its imagery is a male and female couple—rendered in an elongated style quite different from that of the opening work (cat. 57)—that stands rooted in the swirling sea of imagery enveloping the pot from top to bottom. The heads of a man, wearing a chief's hat, and a woman, wearing a traditional headwrap, float amid the images of a large chameleon, a crocodile, and hemispherical beads, some linked together, possibly referring to the sexually provocative beads that Baatombu women wear around their waists.[15]

59

60

JAR (*WÉKÉRU*)

Baatonu (Bariba); Republic of Benin
Mid-20th century
Terracotta and pigment
34.3 x 27.9 cm (13 ½ x 11 in.)

61

SHEA BUTTER JAR (*BWÉERU* OR
WÉKÉ GUMGIA) OR SHRINE JAR

Baatonu (Bariba); Republic of
Benin; or Yoruba; Nigeria
Late 19th/early 20th century
Terracotta
31.8 x 29.2 cm (12 ½ x 11 ½ in.)

62

SHRINE JAR

Yoruba; Nigeria
Late 19th/early 20th century
Terracotta
27.9 x 36.2 cm (11 x 14 ¼ in.)

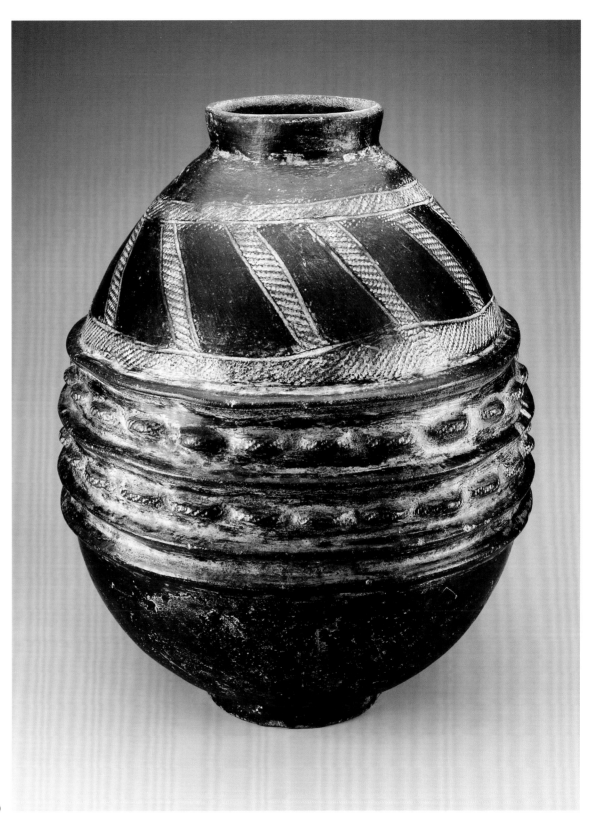

60

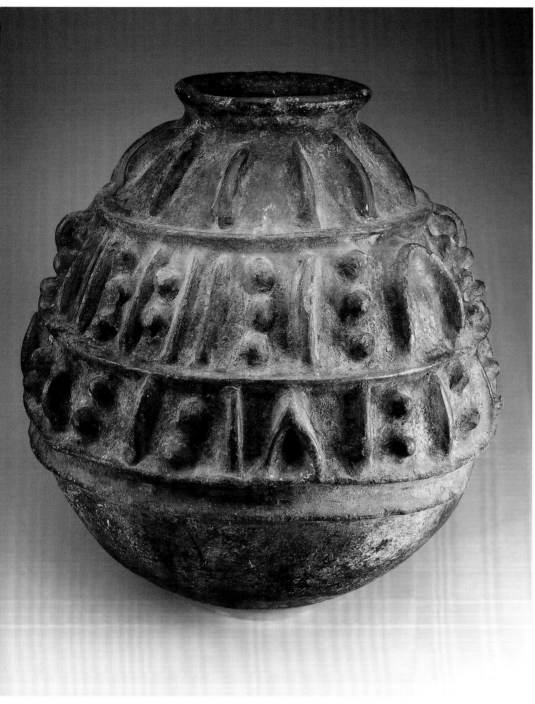

THE BAATONU (PLURAL, BAATOMBU) homeland lies to the northwest of Oyo, the once powerful Yoruba empire, and the two regions share important economic and cultural ties.[1] Today Baatombu and Yoruba often live side-by-side, and potters from the two groups may work in close proximity to each other, making pots that look very similar.[2] The Baatonu and Oyo Yoruba also share similar pottery techniques, using a convex mold to form the base of a pot and then completing it with coils.

The deep reddish black coloring and banded embellishment—here accentuated by a roulette-impressed pattern—of the first jar of this group (cat. 60) are evocative of the artfully dyed and incised calabashes that are widely used by Baatombu for storing valued possessions and ritual objects.[3] This jar may have served the same purpose, or it may have held water, grain, or ritual offerings.

The second vessel of this group (cat. 61) also has the egg-shaped form that is typical of Baatombu jars, and its wishbonelike motif is reminiscent of a tattoo worn by Baatonu women and symbolic of courage.[4] If indeed Baatonu, it is likely that the jar was commissioned by a mother to give to her daughter upon marriage as a blessing for domestic happiness and comfort.[5] Such vessels are presented filled with shea butter, a household staple used in food preparation, as lantern oil, for skin care, and for medicine. The substance actually soaks into the jar and imparts the yellowish stain visible here. Once empty the treasured container could be used to store grain or valuables.

But it is also possible that a Yoruba potter made this piece, with its distinctive pattern of raised bands and dots rendered in strikingly high relief. Maude Wahlman photographed a jar with a similar pattern west of Ile-Ife, in a region historically linked to Oyo.[6] The jar's pattern was said to be derived from Ifa, a form of divination.[7] Set under a tree in the potter's compound, the object formed a shrine dedicated to Olokun, goddess of the sea, where potters could make

61

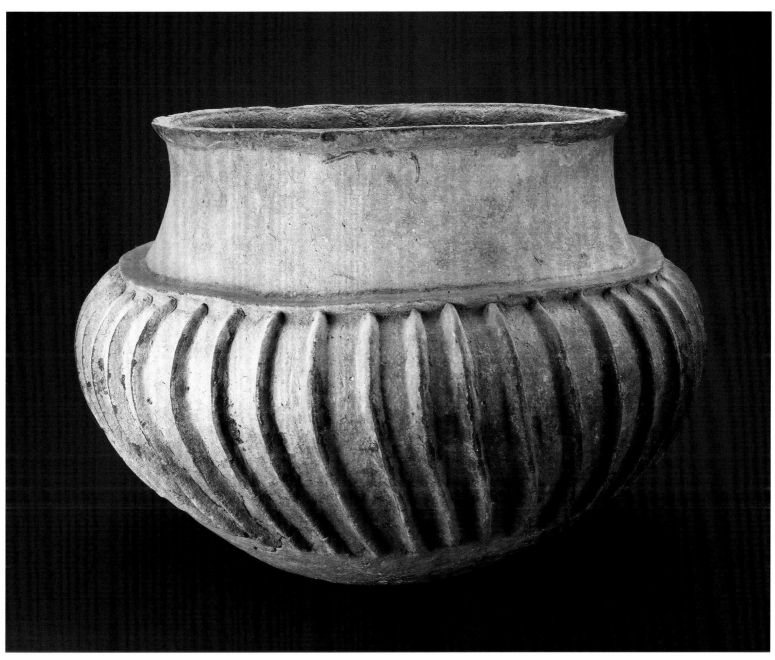

periodic offerings.[8] It was also the site of an annual festival to celebrate the deity, a practice that is followed in other parts of Yorubaland when potters commemorate the deities most closely aligned with pottery.[9] If this is the case, the jar's beautiful patina would be indicative of the occasional application of offerings over years of use.[10]

The elegant, understated shrine vessel that completes this grouping (cat. 62), with its wide mouth and full body that tapers to a soft point at the bottom, is more clearly Yoruba in shape.

The container's subtly bowed neck stands in contrast to its rounded shoulder. A ledge marks the meeting of these two forms, from which sharply rendered ribs descend to define deep channels in rhythmic intervals around the body of the vessel. This handsome pot has no representational imagery to indicate the deity it was made to honor; yet wide-mouthed containers are often found on shrines for Sango, the god of thunder and protector of twins, where they support calabashes that hold sacred objects.[11]

63

OSUN SHRINE JAR
Yoruba; Osogbo or vicinity,
Nigeria
Early/mid-20th century
Terracotta
59.7 x 31.1 cm (23 ½ x 12 ¼ in.)

64

SHRINE JAR
Yoruba; Ekiti, Nigeria
Early/mid-20th century
Terracotta
49.5 x 41.3 cm (19 ½ x 16 ¼ in.)

THE GREAT DIVERSITY OF TECHNIQUES and forms found in Yoruba pottery is a reflection of the localized development of ceramic practices. While construction methods have become widespread over time, styles have been more likely to maintain a local character. Such is the case in and around the town of Osogbo, in the Osun River valley, where potters are known for making tall, cylindrical jars. The handsome example shown here (cat. 63) is one of a group of similarly styled vessels made in Osogbo that may be the work of a single individual.[1] A human face is rendered midway along the jar's neck and bears appliquéd features including large, half-circle ears, elliptical eyes, a broad nose, projecting lips, and thick, vertical lines of scarification on either cheek. Raised bands and impressed and raised dots embellish the remaining surface. Around the face these imply a decorative hat—with the jar's flared lip as its rim—and a schematic beard; they take on a more abstract appearance on the back of the neck and the widened base.

The festival for the goddess Osun, "mother of life-giving waters" and namesake of the river that runs adjacent to Osogbo, dominates the town's religious calendar.[2] Given the local prominence of Osun, it is likely that this jar was made for a shrine dedicated to her. The vessel would have held stones and water from the river. Similar long-necked jars are also made just across the Osun River to the east, in the Ekiti region.[3]

Pottery from the Ekiti region of Yorubaland often features flared rims such as that seen on the large and stately shrine jar illustrated on the facing page (cat. 64). Ekiti potters use a variation of the coiling technique in which they build up the walls and rim of a pot from a hollowed-out, unformed lump of clay.[4] Once they are leather hard, the walls and rim are decorated and further thinned by scraping from the inside. At this stage the walls of a smaller vessel may be gently pushed outward to give the body a rounder form. Finally the piece is inverted and the outside of the base is scraped until it, too, is evenly thin and smooth.

This particular jar takes the form of a domestic container called an *oru*.[5] Its elaborate embellishment is attractively fluid and effortless. Stacks of notched rings circle the shoulders and hips, between which stand rainbows of grooved arcs that imply the unique touch of the potter's fingers. Decorative knobs on opposing sides act as handles, and an enigmatic assortment of raised and incised patterns further enhances the surface. While the container shares some resemblance to pottery found on shrines dedicated to the deity Sango, the context of its original use is uncertain (see "Ceramics in Africa," fig. 14).

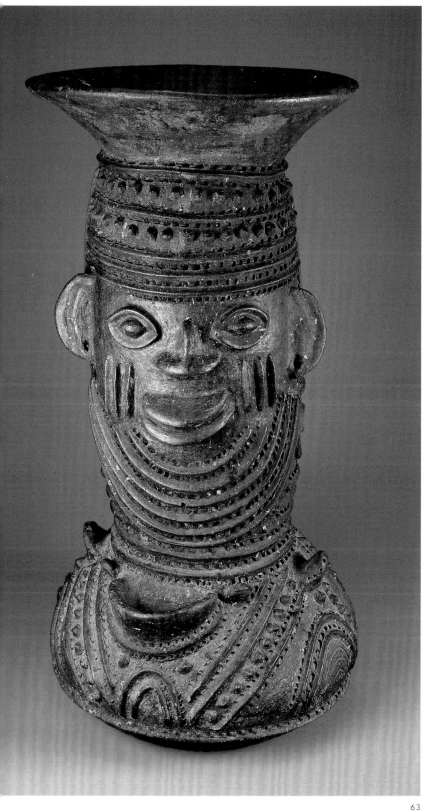

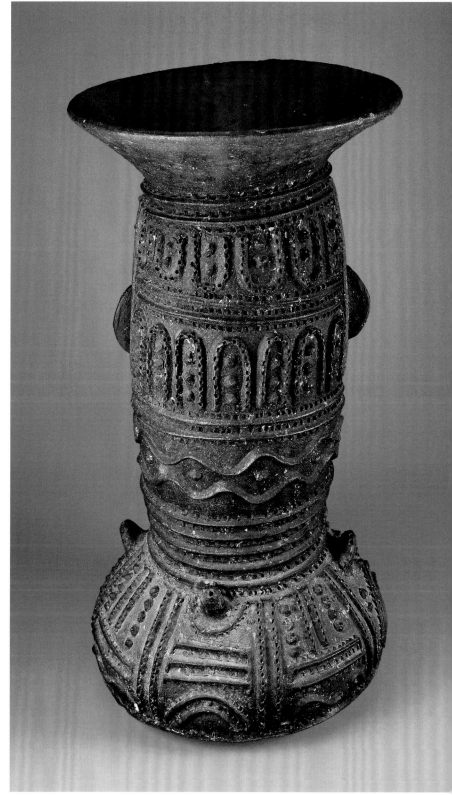

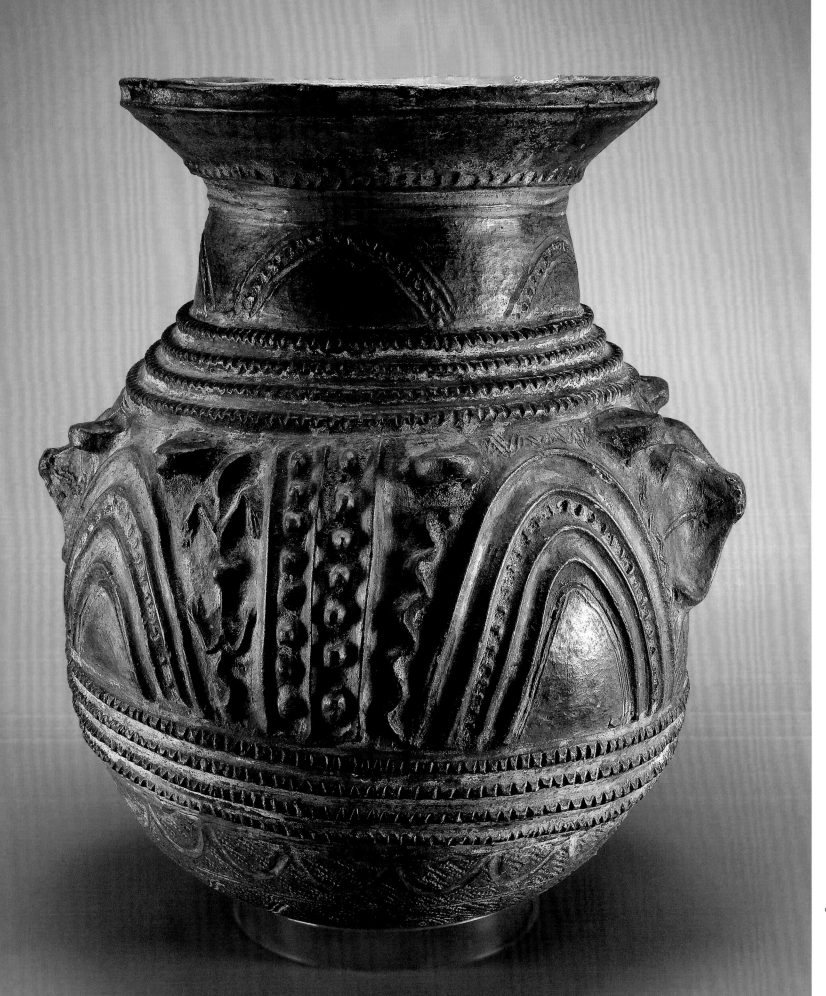

65

WATER OR PALM WINE
CONTAINER (*ITI* OR *UDU*)

Igbo; Ishiagu, Nigeria
Mid-20th century
Terracotta
38.1 x 40.6 cm (15 x 11 ¾ in.)

66

WATER OR PALM WINE
CONTAINER (*ITI* OR *UDU*)

Igbo; probably Ishiagu, Nigeria
Mid-/late 20th century
Terracotta
36.8 x 26.7 cm (14 ½ x 10 ½ in.)

67

TITLE-TAKING VESSEL

Northeastern Igbo; Nigeria
Mid-20th century
Terracotta
39.4 x 40.6 cm (15 ½ x 16 in.)

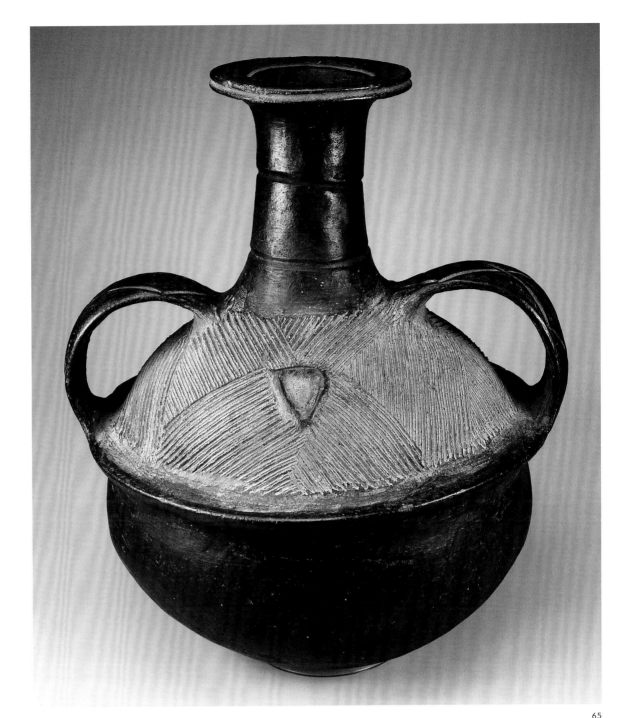

65

IGBO POTTERY HAS BEEN ADMIRED for its inventive variety of forms and embellishments.[1] Women build vessels using the coil method and ornament them with an assortment of rouletting and combing, freehand incising, burnishing, and raised sculptural elements. As throughout much of Africa, they are then allowed to dry and are fired quickly and efficiently in an open bonfire. The origins of modern Igbo ceramics can be traced back to the accomplished vessels found at the tenth-century site of Igbo-Ukwu, which are characterized by deeply incised linear patterns and arching, buttresslike handles that wed neck or rim to body.[2] Contemporary examples include vestiges of these elements, but they also demonstrate the presence of innovation and change over time, including the addition of roulette patterning, a practice not found at Igbo-Ukwu.[3]

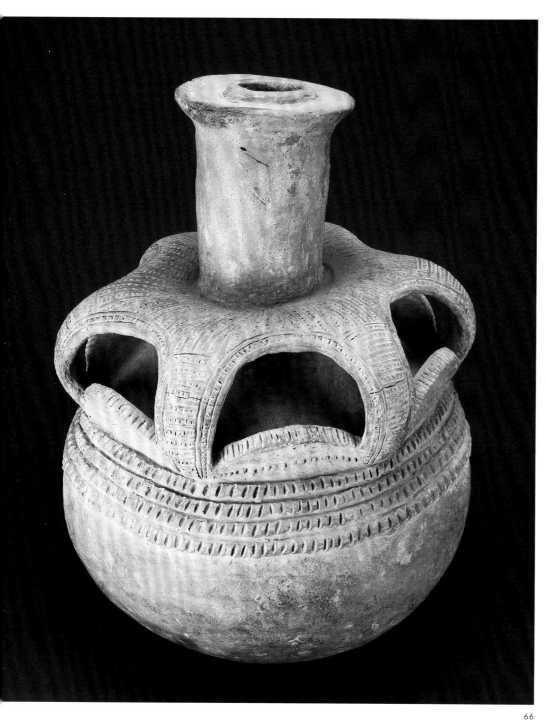

Bottles for water or palm wine like those shown here in the Achepohl collection (cat. 65–66) are a specialty of potters in the towns of Inyi and Ishiagu, which have thrived for generations as centers of full-time ceramic production.[4] Wares imported from the Hausa in the nineteenth century are believed to have originally inspired such objects, colloquially called "coolers," which are now made more widely.[5] The first example (cat. 65) is gracefully proportioned, with a round base, looping handles, a long, tapering neck, and flared lip. Both the bottle's overall shape and the tightly combed lines, which recall Igbo-Ukwu pottery and create a textured panel around the shoulder, suggest that it comes from Ishiagu. Although less refined, the elaborate openwork arcade of handles on the second vessel (cat. 66) is also distinctive to Ishiagu and likewise shows a strong link to forms found at Igbo-Ukwu.[6]

The other container illustrated here (cat. 67) is a handsome example of the kind of large, spherical pot, endowed with a short neck and ornamented with fine lines of combed embellishment, that is used as a symbol of rank by titled Igbo men.[7] A similar piece belonging to Chief Echiagu of Amagu Izzi, in far northeastern Igboland, was photographed in 1983.[8] As here, Chief Echiagu's title-taking vessel is decorated with wide bands that radiate out from the neck to the waist and are interspersed with half circles. On this example, the potter's hand veered slightly with the curvature of the clay wall, adding a dynamic quality to the drawing. Textural contrast abounds, both between the horizontal lines that inscribe the bands and the vertical lines in the half circles, as well as between these areas, the smoothly burnished spaces around them, and the bumpy rouletting on the lower half. It is likely that the container was used to serve palm wine to title-takers, title-holders, and other honored guests during a title-taking ceremony.[9]

66

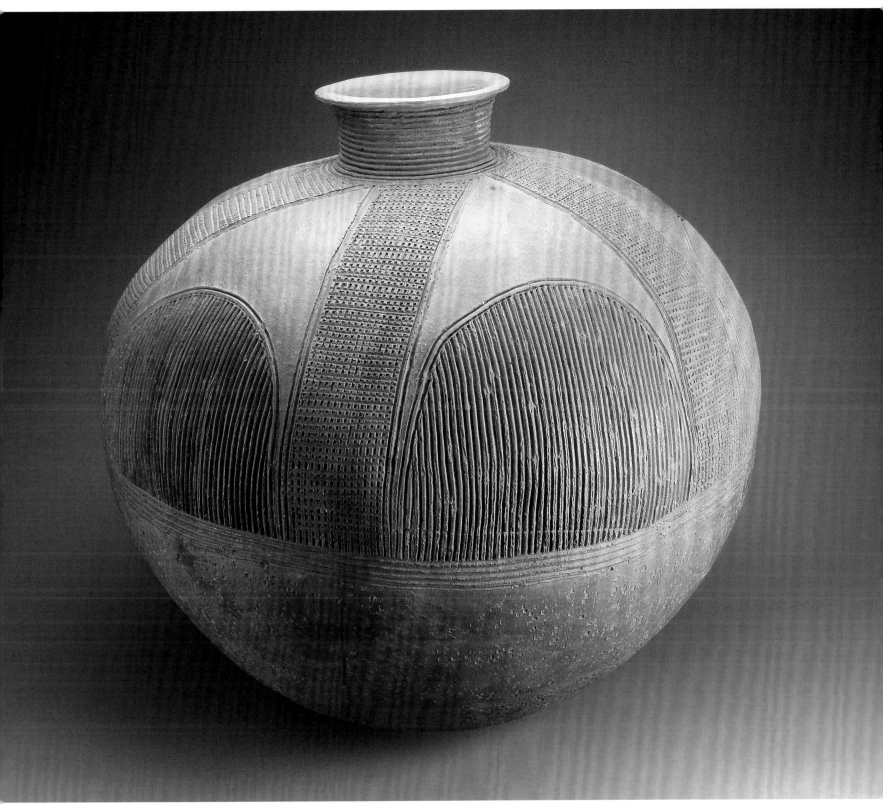

68

WATER CONTAINER
Nupe; Nigeria
Early/mid-20th century
Terracotta
31.8 x 38.1 cm (12 ½ x 15 in.)

69

WATER CONTAINER
Nupe; Nigeria
Early/mid-20th century
Terracotta
30.5 x 35.6 cm (12 x 14 in.)

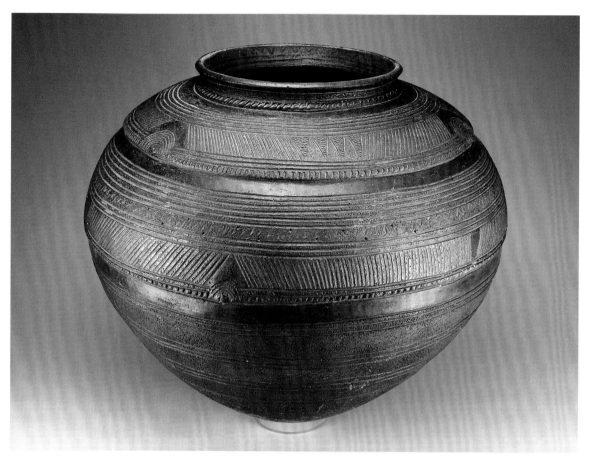

68

NUPE POTTERS USE A CONVEX-MOLD technique to form the base of round-bottomed vessels. In this method they hammer a flat disk of clay over the top of a mold, usually a fired pot, until achieving the desired shape. They then finish the piece with coils if so desired. These two spherical water containers illustrate the myriad, complex variations on form and linear embellishment that Nupe potters have pioneered.

On the first example (cat. 68), the gently sloping lower half transitions into a softly rounded top and terminates in a short rim. Lines defining horizontal bands of various widths encircle the container from top to bottom. Closely spaced diagonal lines articulate the wider of these and are periodically interrupted by small areas of burnishing, some of which are framed by rainbows of arching lines, creating resting points for the eye.

Highly burnished bands, one at the vessel's waist and one midway between the waist and neck, provide welcome breaks in the exhaustive patterning, and a quickly scrawled swagging line adds unexpected visual interest.

On the second pot (cat. 69), the rounding of the lower half slows to a gradual inward slope at midpoint and terminates in a rimless opening. The incised embellishment on this piece is thicker and deeper than its companion's and was applied with a comb. On the upper half of the vessel, two wide bands of pattern are separated by raised lines. The lower of these bands is filled in with zigzag lines, while the upper one has a series of arches that are futher punctuated by raised dots of clay. A similarly embellished vessel is said to have come from the region of Muregi.[1]

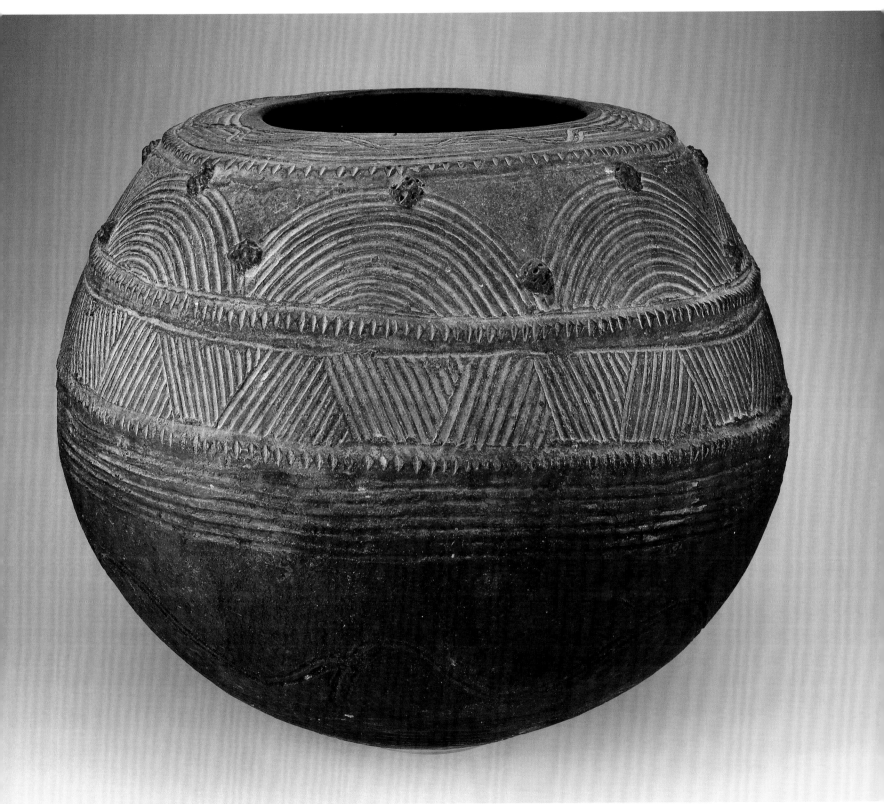

70

WATER OR PALM WINE
CONTAINER

Nupe; Nigeria
Late 19th/early 20th century
Terracotta and metal
38.1 x 29.2 cm (15 x 11 ½ in.)

71

WATER OR PALM WINE
CONTAINER

Nupe; Nigeria
Early/mid-20th century
Terracotta
42.6 x 33 cm (16 ¾ x 13 in.)

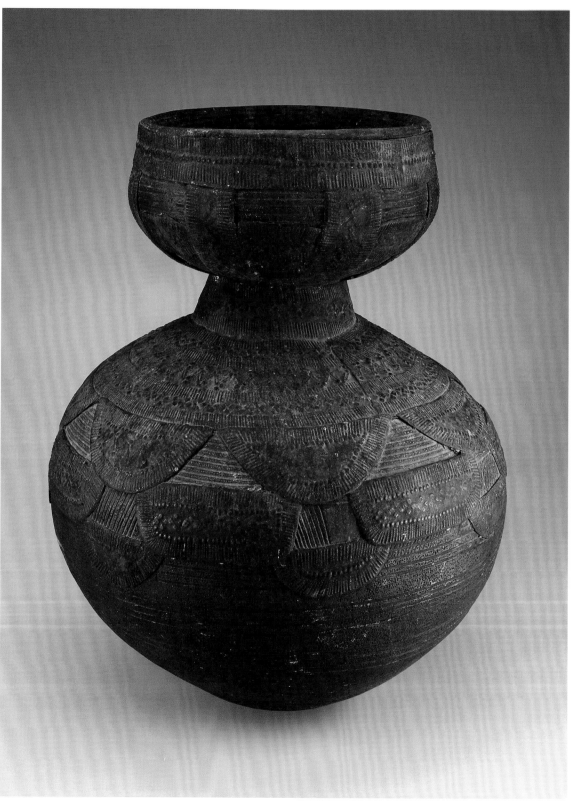

70

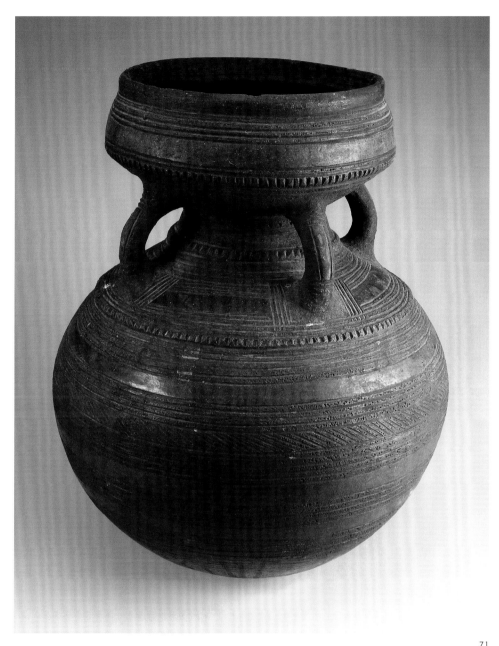

AMONG THE MOST DISTINCTIVE of Nupe pots is the gracefully designed double-tiered container. This type of vessel, which is inspired by the shape of a gourd, is intended for transporting and storing water or palm wine, and it is perfectly designed to accomplish the task.[1] The full belly holds a good amount of liquid, and the narrow neck and funnel-like upper reservoir are ideal for keeping it from sloshing out when the pot is filled or moved. This may explain why such containers were in high demand and widely distributed in the region by Nupe traders.[2]

The potter begins the vessel as she would any round-bottomed pot, forming the base using the convex mold technique.[3] When the clay has dried to leather hardness, she completes the walls of the lower pot using coils. The smaller upper reservoir is molded separately, and when it hardens a hole is cut into its bottom, and it is attached to the lower half with coils that form the neck. Like other Nupe ceramics, these are covered with close-knit, detailed patterns that are applied by burnishing, incising, and roulette work.

In the nineteenth and early twentieth centuries, double-tiered containers were at times made even more elaborate by the addition of hammered brass fittings decorated with delicate repoussé and pointillé designs.[4] On one of the vessels shown here (cat. 70), these encase the upper tier in netlike bands and run in looping scallops around the lower tier's broadest expanse. These fittings were the work of a male brass smith who was commissioned to add them to the pot by a wealthy client. Such vessels, with their layers of rich embellishment, were a conspicuous expression of wealth and prestige that resembled brass containers forged for well-to-do patrons, including the royal family and members of the ruling Fulani elite.[5]

71

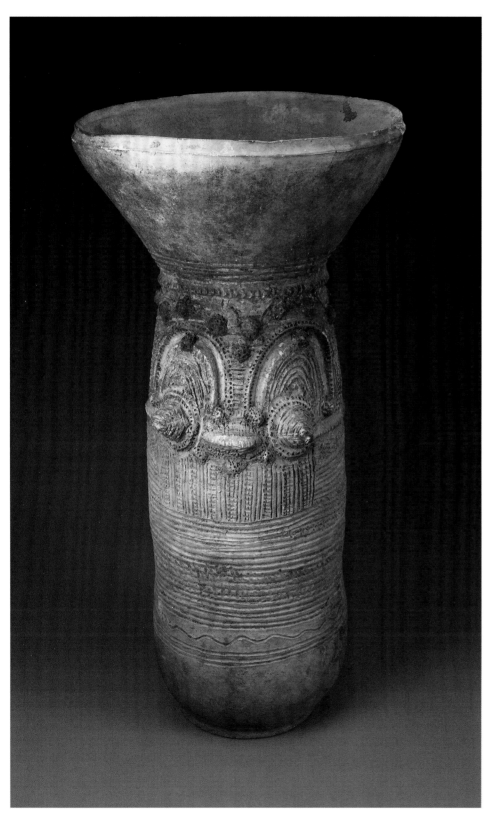

STORAGE CONTAINER *(ETSO)*
Nupe; Nigeria
Early/mid-20th century
Terracotta
62.2 x 31.1 cm (24 ½ x 12 ¼ in.)

AMONG THE NUPE THE SKILLS for making useful, beautiful domestic pottery are passed down from mother to daughter. Specialized family ateliers were once active throughout Nupe country, particularly in the area of Bida, the region's capital.[1] While large pots are fired in the open, more dimunitive ones are placed in a small, roofless, earthen kiln, a technique rarely found in Africa (see "Ceramics in Africa," fig. 11).[2] According to scholars, columnar containers such as this one are typical of ceramics produced in Bida's *Masagá*, or glass worker's quarter.[3] These vessels are likely made with the direct pull method, which Nupe potters use along with the convex mold technique. Such objects appear in two distinct styles.[4] One features a series of broad, flat rings that encircle the trunk from just below the neck to just above the bowl-like base.[5] The other, more delicate style, seen here, features an ornate array of raised and incised marks, and often includes a pair of close-set cones at midpoint, suggestive of breasts.[6]

Columnar containers are used in Nupe homes to store clothing and dry goods. In one abandoned village, such vessels were documented half-buried in the earthen floor, possibly to help in preserving foodstuffs.[7] The pieces are designed so that a round-bottomed pot can be stacked on top of their wide, substantial rims. This helps keep the contents clean and is also an efficient use of space in the tight quarters of a traditional Nupe house.[8] It is for this reason that such containers are sometimes referred to as "pot stands."[9] Formally, this stacking also mirrors the stacked appearance of the carved wooden posts used to support the structure of Nupe homes.[10]

73

WATER CONTAINER
Gwari; Nigeria
Early/mid-20th century
Blackened terracotta
22.9 x 26.7 cm (9 x 10½ in.)

GWARI WOMEN MAKE POTTERY in family groups, with daughters learning from their mothers and continuing their craft when they move to their husbands' compounds.[1] In form and technique Gwari ceramics are related to those of their eastern Nupe neighbors (see cat. 68–72).[2] Potters use the direct pull method, punching down into a lump of clay and then pulling up diagonally with their fingers to form the vessel's sides, adding coils if a larger size is desired. A potter may use a makeshift turntable to help form a small pot; she will fashion a large one, however, by walking steadily backwards around the piece, dragging one foot to maintain her balance and at times changing direction to avoid dizziness.[3]

Water containers such as this small, classic example are plump-bellied with short, slightly narrowed necks and flared lips. They are decorated with incising and roulette patterns that showcase the sure-handed drawing skills of the maker. Gwari potters incise their wares with a blade that cuts neatly through the coarse clay, producing straight or slightly curved lines that contrast with the roundness of the pot.[4] Here a series of horizontal lines encircles the vessel's neck in regular intervals, while vertical bands—alternating between straight and elliptical in shape and between smoothly burnished and rough in texture—embellish its body. On one side the potter rendered a stylized lizard at an impromptu angle, decorating it with crisscrossing lines. The lizard is one of several animal motifs that Gwari potters from the village of Kwale use on a regular basis. This container's dark color results from a solution of locust tree pods that was applied to the red-hot vessel immediately upon its removal from the fire.[5] The coating also helps make the pot watertight.

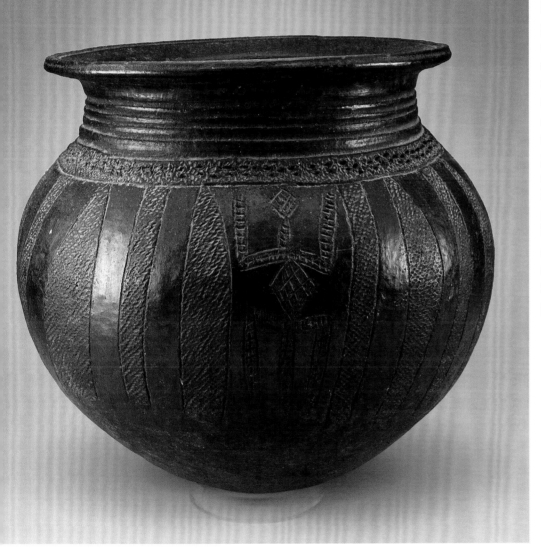

74

STORAGE CONTAINER

Nupe or related tradition; Nigeria
Early/mid-20th century
Terracotta
33.7 x 35.6 cm (13 ¼ x 14 in.)

75

WATER OR PALM WINE
CONTAINER

Nupe or related tradition; Nigeria
Early/mid-20th century
Terracotta
43.2 x 31.8 cm (17 x 12 ½ in.)

THE NUPE MAKE POTTERY in a region that is rich in interrelated ceramic traditions. This may in part explain the great diversity of forms, but it also makes it difficult at times to distinguish the origins of a piece based solely on its style. The storage container pictured here (cat. 74) has a wide, round base and a long, tapered upper body that narrows slightly to a flared mouth. It is designed to hang suspended from the ceiling by a cord, which is passed through the arcade of angled openings located just above its widest point. While the vessel's form and incised embellishment are in some respects reminiscent of Nupe work, it probably comes from a neighboring region between the Niger and Benue rivers.[1] The combed bands of incising that wrap around the upper body combine tightly spaced straight and wavy lines and occasional zigzags in a lively pattern. Over these, the potter drew a series of large graphic motifs suggestive of stick figures.

The bottle illustrated here (cat. 75) may also come from north of the Nupe region.[2] Its body has a distinctive shape, like two bowls set together and joined at midpoint. From this base rises a narrow, columnar neck with a flared mouth. Deep channels of linear incising are drawn over the surface in alternating directions, giving it a dynamic texture.

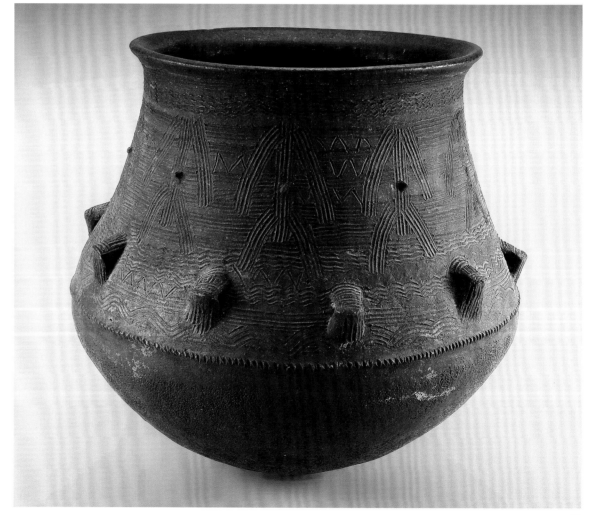

74

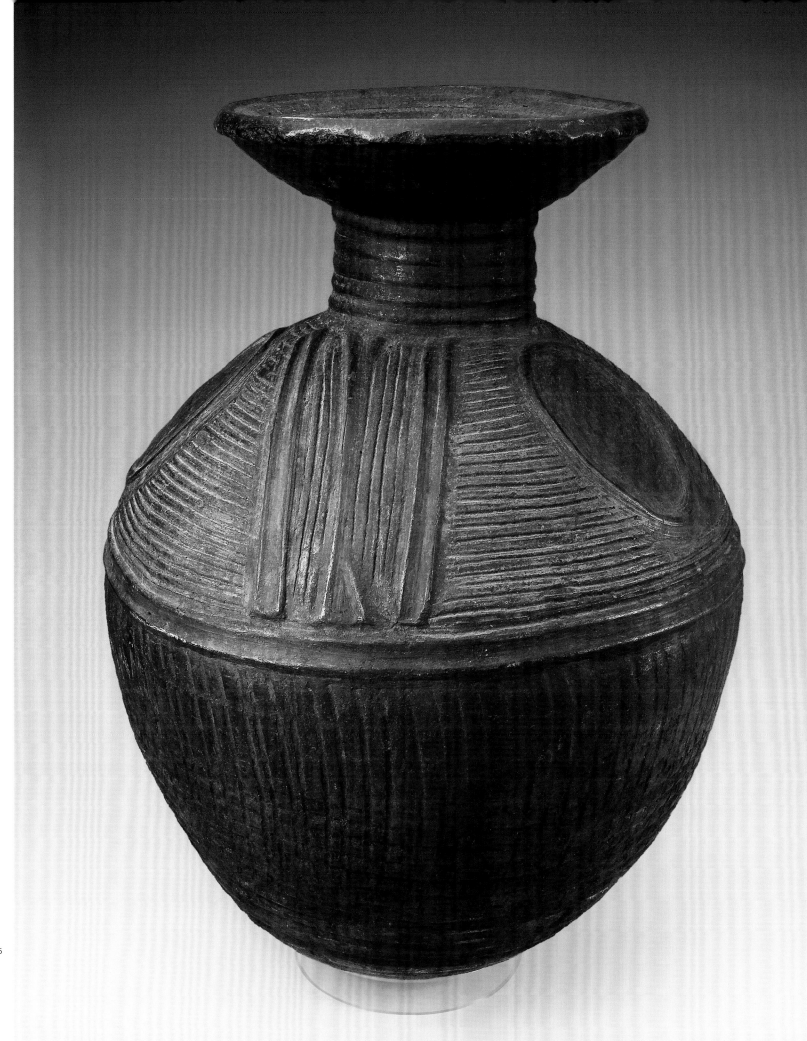

The Potter's Art

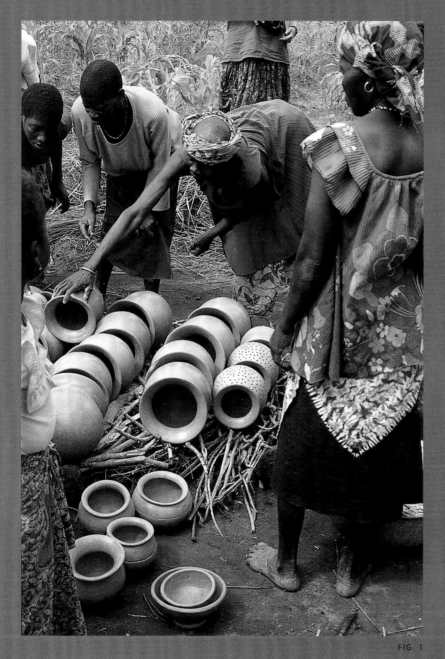

FIG. 1

Stacking pots in preparation for firing is a critical task that requires skill, know-how, and finesse. This Senufo potter begins to carefully arrange wide-mouthed jars by nestling one into the next on a bed of sticks. Once completed the mound will stand several layers high and include over 100 pots. Dry grass will then be piled on top and ignited. Photo by Kathleen Bickford Berzock, Dabakaha, Côte d'Ivoire, 1997.

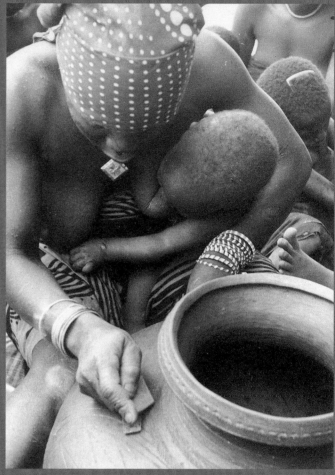

FIG. 2

Makonde water jars are the stage for a potter's most creative work and are highly prized for their elaborately incised and impressed embellishment. Using a flat iron blade, the potter first draws the broad outlines of a pattern and then fills it in with fine hatch marks or impressed triangles. While holding an infant in her lap, this woman uses a fragment of pottery to press a band of small triangles into the neck of a jar. Photo by Margot Dias, Dankali, Mozambique, 1958.

Across much of Africa pottery is learned first through observation and imitation and only later through direct instruction. It takes years of work to attain the skills of a mature potter, and few achieve true mastery. Here, Bamana potter Assa Coulibaly has formed a perfectly proportioned jar with ease and thoughtful focus. In contrast, her granddaughter, whom she supervises, approaches her work more tentatively. Photo by Barbara Frank, Banamba, Mali, 1988.

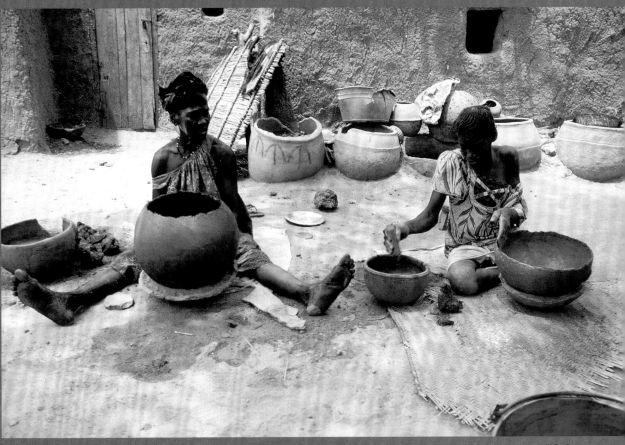

FIG. 3

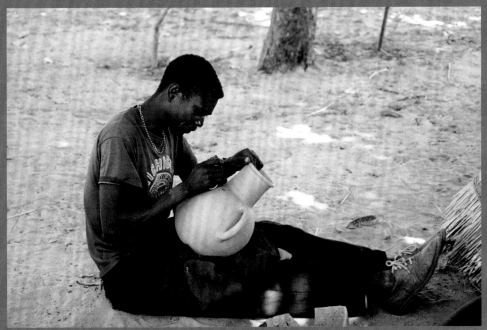

FIG. 4

While the majority of potters in Africa are women, men do practice the craft in some traditions. This potter, named Charles, works along with his brothers in a region of Zambia that is well known for its rich clay deposits and ceramic production by both sexes. Here Charles burnishes a jar with a copper bracelet, which will give it a reddish tone once fired. Photo by Karen Milbourne, Kayeyo, Lukulu district, Western province, Zambia, 1996.

EASTERN NIGERIA AND CAMEROON

A SUCCESSIVE CHAIN of mountain ranges stretches across the borderland between Nigeria, Cameroon, and southern Chad. Although the Mandara Mountains are formidable, their relatively low altitude and the abundant rainfall in the north have made agriculture feasible. Today the region's natural landscape blends with terraced fields formed by industrious farmers. In northeastern Nigeria the mountains recede into sandstone hills that are intersected by the Gongola River, creating a valley to the west of its confluence with the Benue River. In central Cameroon they merge with an area of wooded valleys and fertile plains known as the Grassfields. Amid this rugged terrain three major language families converge—Chadic, Adamawa, and Benue-Congo, which includes

Bantu and related languages. It was from here that the Bantu languages began to spread eastward and southward, ultimately coming to dominate eastern, central, and southern Africa. This linguistic melting pot has given rise to a region of cultural complexity in which pottery holds a central place in the ceremonies that focus and locate spiritual power.[1] The ritual ceramics made and used in the Gongola Valley and Mandara Mountains are related to ancient antecedents in the Lake Chad Basin to the north. These include human figures dating from the eleventh century A.D. and animal figures that date even earlier.[2] Further south along the upper and lower Cross River, pottery also thrived from an early date and was widely traded.

Pottery holds a no-less-vaunted place in the mountains and grasslands of Cameroon. Here large storage containers and smaller serving vessels are important accoutrements for the beer and palm wine that are necessary ingredients of ritual and hospitality (see "Beer and Palm Wine," fig. 5). While everyday pottery was once widely made in the Grassfields region, major centers of production developed to meet the needs of title-holders and rulers. The distinctive techniques and styles of these centers are well documented, but the vibrant and highly inventive pottery traditions of the Mambila, Mfumte, and related peoples to the west of the Grassfields are not. The layers of interconnection among these traditions are intriguing to perceive, but they have yet to be studied in a serious way.

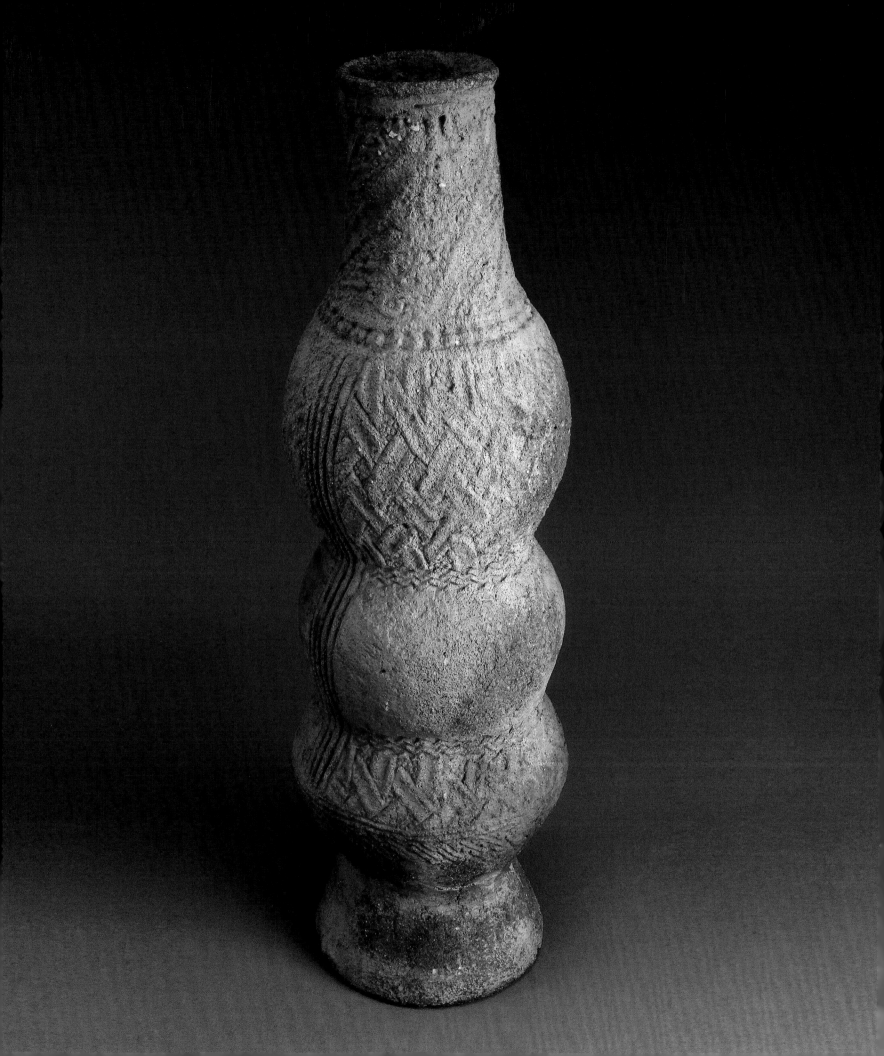

76

CYLINDRICAL VESSEL
Calabar region, Nigeria
10th/13th century
Terracotta
40.6 x 12.7 cm (16 x 5 in.)

THIS ANCIENT BOTTLE is distinctive for its tall undulating form and for the complex interwoven patterns, reminiscent of basketry, that are impressed on its surface. It comes from one of a group of sites in and around the town of Calabar, Nigeria, near the mouth of the Cross River.[1] Archaeological research, although not extensive, points to domestic and ritual activities, some of which may predate the region's longtime inhabitants, the Qua, Efut, and Efik.[2] Contemporary Qua people describe many of the sites as sacred grounds where forebears maintained shrines and performed rituals.[3] Richly ornamented ceramics like this example have been found buried in specially dug pits—possibly graves, storage areas for ritual objects, or pottery workshops—along with round white pebbles, metal blades, ceramic headrests, and a variety of terracotta figures.[4] This latter group are hollow and open on the bottom, closely resembling inverted water containers, and they are artfully embellished and surmounted by modeled heads.

We know little about the making and use of archaeological ceramics from Calabar, and contemporary pottery practices are fading in the lower Cross River area in general.[5] Vessels such as this one, however, can be seen within a broader history of ceramics in southeastern Nigeria. Sophisticated terracotta vessels have been excavated at the tenth-century site of Igbo-Ukwu northwest of Calabar, and fragments of ancient terracotta containers and sculptures are found in the Niger River delta region to the southwest.[6] Farther afield, in the floodplains south of Lake Chad, ancient terracotta figures and other objects have been found in mounds that present inhabitants attribute to a culture known as the Sao. The making of pottery for ritual use continues today among the nearby Igbo, and in northeastern Nigeria and northwestern Cameroon ritual pots, many of them similar in concept to the figures excavated in and around Calabar, are widely produced.

77

CONTAINER FOR RITUAL
HEALING (*ITINATE* OR
KWANDALOWA)

Cham, Mwona, or Longuda; Nigeria
Mid-20th century
Terracotta
16.5 x 16.5 cm (6½ x 6½ in.)

78

CONTAINER FOR RITUAL
HEALING (*ITINATE* OR
KWANDALOWA)

Cham, Mwona, or Longuda; Nigeria
Mid-20th century
Terracotta
18.4 x 17.8 cm (7¼ x 7 in.)

79

CONTAINER FOR RITUAL
HEALING (*ITINATE* OR
KWANDALHA)

Cham, Mwona, or Longuda; Nigeria
Mid-20th century
Terracotta
38.1 x 11.4 cm (15 x 4½ in.)

80

CONTAINER FOR RITUAL
HEALING (*NGWARKANDANGRA*)

Bëna; Nigeria
Mid-20th century
Terracotta
24.1 x 14.6 cm (9½ x 5¾ in.)

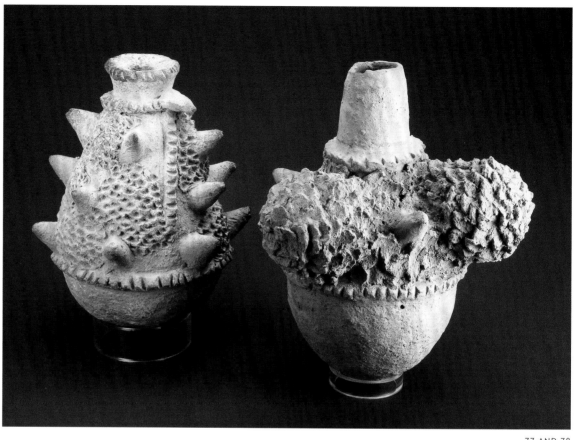

77 AND 78

THE LOWER GONGOLA RIVER valley, a ruggedly hilly region that lies west of the confluence with the Benue River in northeast Nigeria, is home to diverse communities that share historical and at times cultural and linguistic ties. Here elaborately formed and embellished pottery is often used to facilitate interactions with spirits for veneration and healing, with neighbors influencing each other's styles and practices.[1] Among the region's Adamawa-language speakers, including the Cham, Mwona, Longuda, and Bëna, the making of such pottery for curative rituals is particularly highly developed, and pots for this purpose are made in a seemingly endless variety.

The closely related Cham and Mwona and their eastern neighbors the Longuda use pottery in rituals intended to protect against and treat spirit-inflicted maladies, in part by transferring

the illness to a pot in which it can be contained.[2] A diviner prescribes a particular kind of vessel and a potter makes it, first bringing the unformed clay into contact with the patient to begin the process of transferring the illness to the raw material.[3] When the pot is ready, the diviner activates it by applying libations.[4] Once the illness is cured, the container is discarded well away from the community.[5] Among the Cham and Mwona these ritual containers are called *itinate* and are made by men with unique skills and knowledge.[6] Among the Longuda, however, they are called *kwandalha* and the specialists who make them are women.[7]

With their swollen bulges, jagged scales, scabby patches, and sharp points, these containers give graphic form to the pain and discomfort of disease.[8] While their basic forms are often repeated, their uses may vary. The first container presented

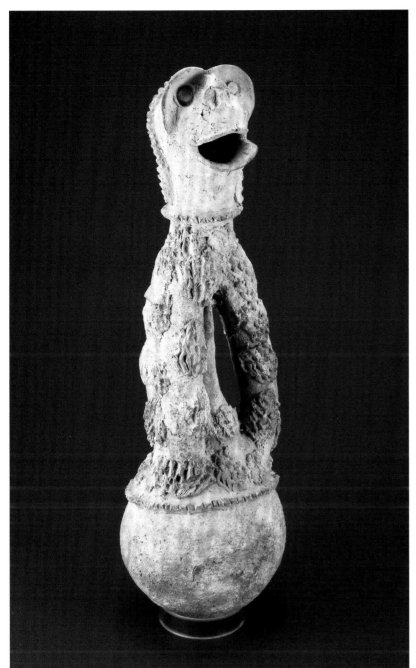

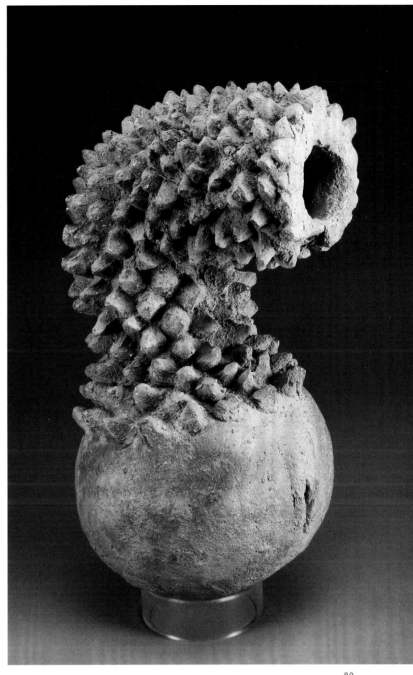

here (cat. 77) was reportedly used to alleviate headaches.[9] Containers like cat. 78 have been said to treat hemorrhoids and related problems as well as chicken pox and other childhood diseases.[10] The highly stylized human form of cat. 79 is particularly evocative: its tripartite trunk, suggesting a torso and arms, is elongated and scabby, and its animated head has an almost anguished expression, with wide upturned eyes and an open mouth.

Among the Bëna, who live east of the Gongola River in the Ga'anda Hills, pots such as cat. 80 are made to contain the spirit called Ngwarkandangra, who is appealed to in rituals to heal skin diseases.[11] These pots have a globular base and a crooked neck that is enveloped in spiky projections, a powerful image of the symptoms that will be eased when the disease is successfully cured.

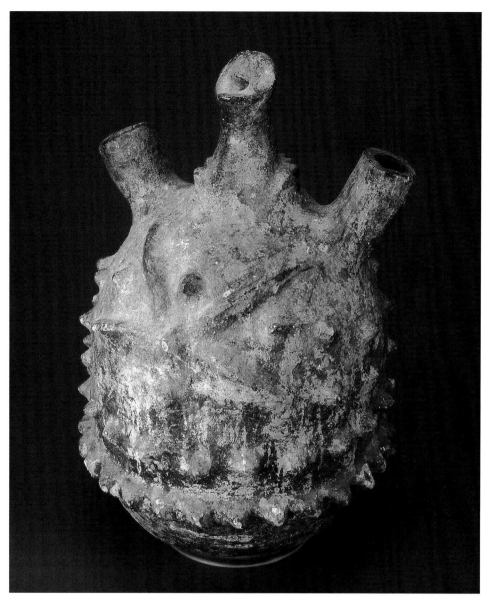

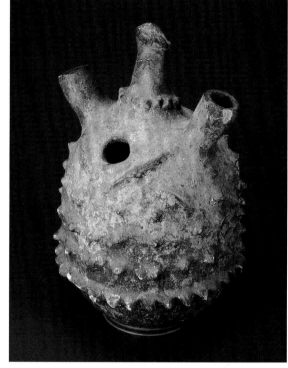

ALTERNATE VIEW

81

RITUAL CONTAINER (*KU'CHAN*)
Jen (Janjo), Bata, or Kwa; Nigeria
Mid-20th century
Terracotta and sacrificial material
30.5 x 18.4 cm (12 x 7¼ in.)

THE ARTIST WHO BUILT THIS ritual pot achieved a striking balance between the round inflated body, the sharp punctuation of the truncated arms, and the elongated neck that narrows to an abbreviated head. Such containers, known as *ku'chan*, are used by the Jen (also called the Janjo), who live west of the Gongola River in the Benue River floodplain, though they may not be made by the Jen.[1] In the 1970s and 1980s Marla Berns noted that Kwa potters were making ritual vessels for Jen patrons, and Karl-Ferdinand Schädler has suggested that similar ones are made by the Bata, who are culturally related to the Jen.[2]

Berns has described the Jen use of *ku'chan*: the pots are placed in the forked branch or at the foot of a tree, which is the marker for a shrine where prayers are made and sacrifices offered. Below the tree lie the collective graves of men who were important community leaders. During annual prayers millet beer is poured into the vessels and ground sprouted corn is splashed over them, attracting the spirits that bring protection and success to hunters and, in the past, to warriors.[3]

RITUAL CONTAINER
Possibly Mafa; Mandara Mountains
region, Nigeria or Cameroon
Early/mid-20th century
Terracotta
42.6 x 25.4 cm (16¾ x 10 in.)

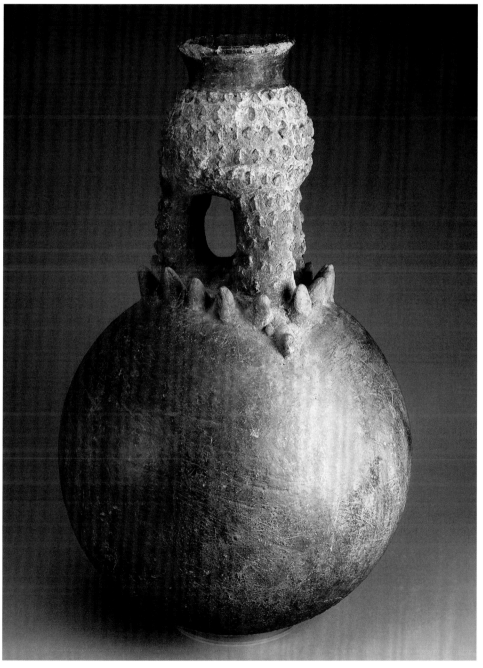

ACROSS THE PLATEAU REGION of eastern Nigeria and western Cameroon, potters make the stacked form of a container atop a container.[1] According to Sylvia Leith-Ross, the Anaguta in Nigeria use such pots to hold a gruel that hunters drink, while the Angas, Rukuba, Tangale, and Tula use them to store beer for ceremonial purposes.[2] Another scholar, Renata Wente-Lukas, has recorded the form among the Bana and Gude in Cameroon on the roof finials of chief's houses.[3]

This container is reportedly Mafa, and Nicholas David has documented a very similar vessel on a Sirak grave, where it honored the spirits of slain enemies.[4] The Mafa, Sirak, and other closely related ethnic groups populate the steep and rocky Mandara Mountains that stretch along the border between eastern Nigeria and west-central Cameroon. Among many Mandara peoples male blacksmiths and their families form a minority hereditary caste within the dominant culture. The wives and daughters of these men often practice pottery, using variations of the hammer and concave anvil technique (see "Ceramics in Africa," fig. 5).[5] While Sirak potters tamp out almost the entire spherical form of a vessel, leaving only the lip or narrow neck to be completed by coiling, Mafa potters use tamping to form the base or lower half of a piece and complete the entire upper portion with coils.[6]

The obvious care taken in the shaping and embellishment of this container leaves no doubt that its significance was beyond the ordinary. The lower tier is beautifully rounded, smoothly burnished, and colored with a red slip—associated by the Mafa with supernatural power and protection—that is marked by a fire cloud at bottom.[7] The upper tier and its three slightly bowed legs are covered to the flared lip with rows of raised pellets, while larger spikes mark the point of transition from one tier to the other.[8] Among the Mafa, Sirak, and related peoples, these embellishments have symbolic significance. Appliquéd pellets on pottery may be associated with threshed millet grains, millet being the primary staple of the region, and more broadly with spiritual protection.[9] Likewise, spikes are a symbol of abundance and success through supernatural means.[10]

83

SPIRIT POT (*MBIRHLEN'NDA*)
Ga'anda; Nigeria
Mid-20th century
Terracotta
59.1 x 35.6 cm (23 ¼ x 14 in.)

THE MANDARA MOUNTAINS, spanning the border between Nigeria and Cameroon, and the Gongola River valley in northeastern Nigeria constitute a melting pot in which various peoples have, over the course of centuries, blended cultural and artistic practices while maintaining distinct ethnic identities. Pottery is a primary form of visual expression throughout this region and it is one dominated by women, who produce an abundance of ceramic wares that function across domestic and ritual domains. Among the area's most aesthetically rich pottery genres is that of figural vessels used either in venerating tutelary and ancestral spirits or in conducting rituals of healing.[1]

The Ga'anda live in the hills east of the Gongola River and its main tributary, the Hawal. Their ancestors migrated to the area from the Mandara Mountains, and they still speak a Chadic language similar to that of their distant relatives to the east. Ga'anda pottery is generally made by women, although in some instances older men may fashion certain sacred vessels.[2] Potters use a coiling technique and richly embellish their wares. Whereas domestic ceramics are patterned with incised and impressed patterns, spirit pots—i.e., sacred containers that become the focus for veneration—are given sculpted features and are embellished with densely applied raised pellets and bands of pattern. The stately round-bodied vessel presented here represents a community guardian called Mbirhlen'nda and is one of the most abundant and elaborate spirit pots made by the Ga'anda.[3] The body and neck of this example evoke the shape of a Ga'anda water container, but this work is crowned by a round head with a projecting O-shaped mouth. Like many Mbirhlen'nda pots, this one is depicted with an axe over the right shoulder and a bow and arrow in the left hand, male tools that underscore the spirit's connection with human endeavors. The pot has characteristic patterns around the head, neck, and shoulders; the bib of impressed horizontal bands, however, is more commonly found on another Ga'anda protective spirit pot called Ngum-Ngumi, a type that is made by men.[4]

Into the mid-twentieth century Mbirhlen'nda pots could be found on Ga'anda family shrines and on larger collective shrines, reflecting the belief that their proximity would encourage the spirit's vigilance.[5] This is also apparent in the placement of Mbirhlen'nda near the center of a shrine, with the pot's open mouth squarely facing the entrance (see "Engaging the World Beyond," fig. 4). Once a year a Mbirhlen'nda pot is removed from its shrine along with other spirit pots, washed inside and out, and filled with specially brewed guinea corn beer as part of a ritual called Xombata, which honors the spirits who promote a fruitful harvest.[6]

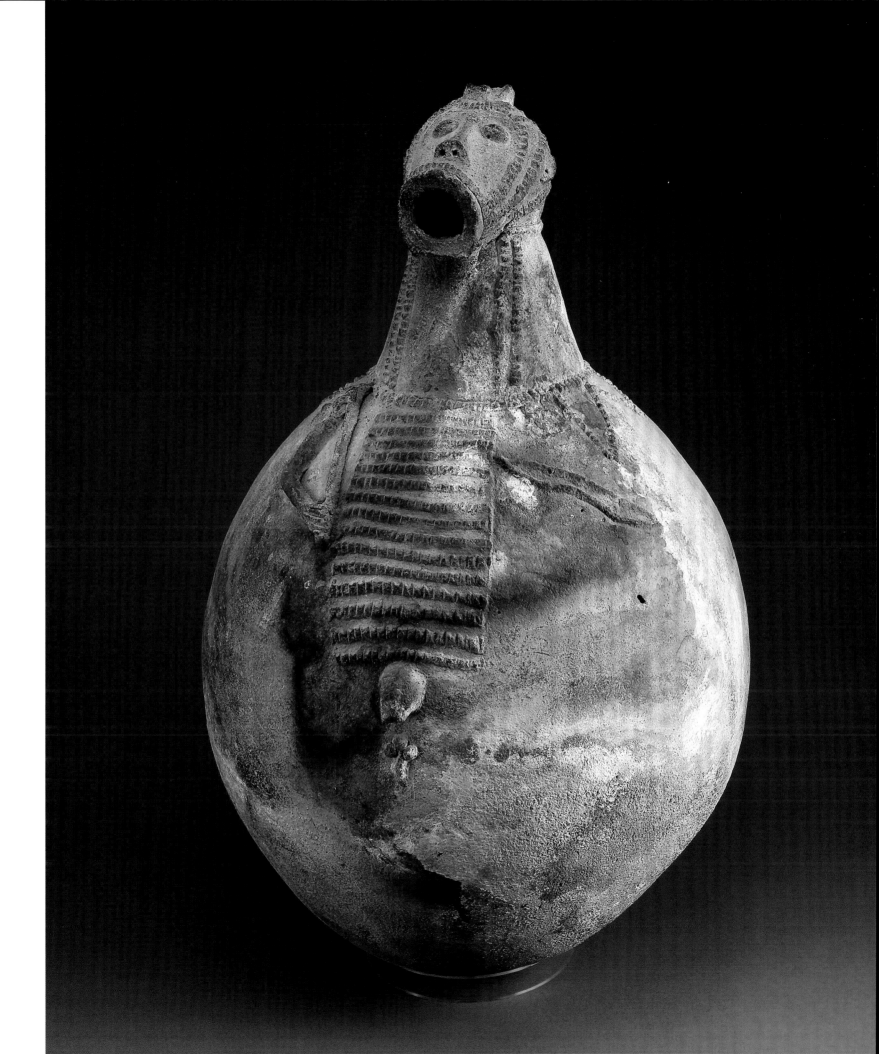

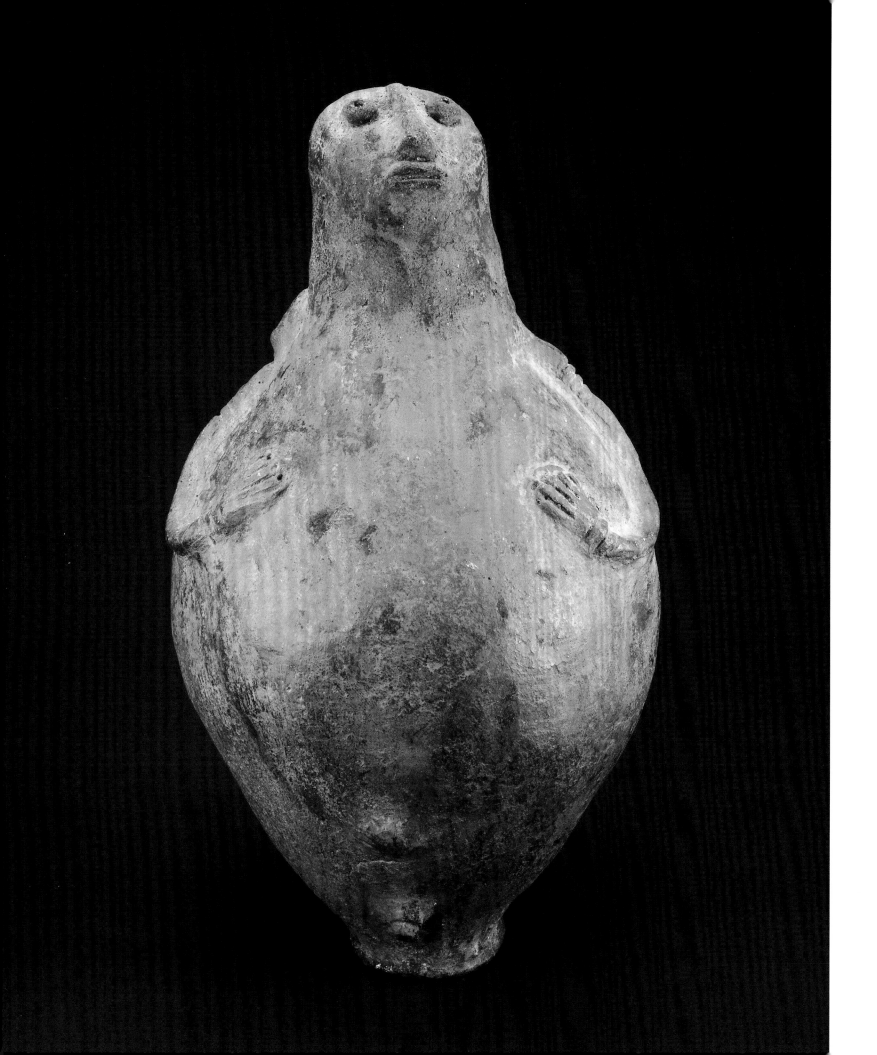

84

FIGURAL VESSEL

Mambila or Mfumte; possibly Mbat, Nigeria or Cameroon
Mid-20th century
Terracotta
39.4 x 22.9 cm (15 ½ x 9 in.)

LIKE THEIR NEIGHBORS in the Mandara Mountains and the Gongola Valley of Nigeria, the Mambila, Mfumte, and related peoples also use figural vessels in ritual. What little information exists on such figures suggests that they function in multiple contexts including practices related to supernatural protection and healing.[1] The example in the Achepohl collection is portrayed with a plump body; thin, bending arms; and hands that rest on the belly.[2] Its narrow base, wide middle, and narrow head convey a sense of buoyancy and its simple features and upturned gaze contribute to its otherworldly character. This style of vessel is made by women potters in the Mambila village of Mbat (in Nigeria) for use in the male secret society called Wankya, which is widespread among the Mambila and the neighboring Mfumte.[3] An opening at the back of the neck gives access to the piece's hollow interior and probably indicates that it represents a male figure, which were considered less dangerous than their female counterpart. While female figures are not removed from cult houses, male ones are periodically used to pour libations of palm wine onto a road in a ritual intended to protect a community against witchcraft.[4] Across the border in Nigeria, Tula potters also make figural vessels with spouts in the back of the neck.[5] These hold beer that is drunk during rituals conducted to bring the living into contact with ancestors who can influence community well-being.[6] David Zeitlyn has noted that the nearby Yamba make small terracotta figurines with holes at the back of the neck into which leaves and other objects may be placed and on which libations may be poured.[7]

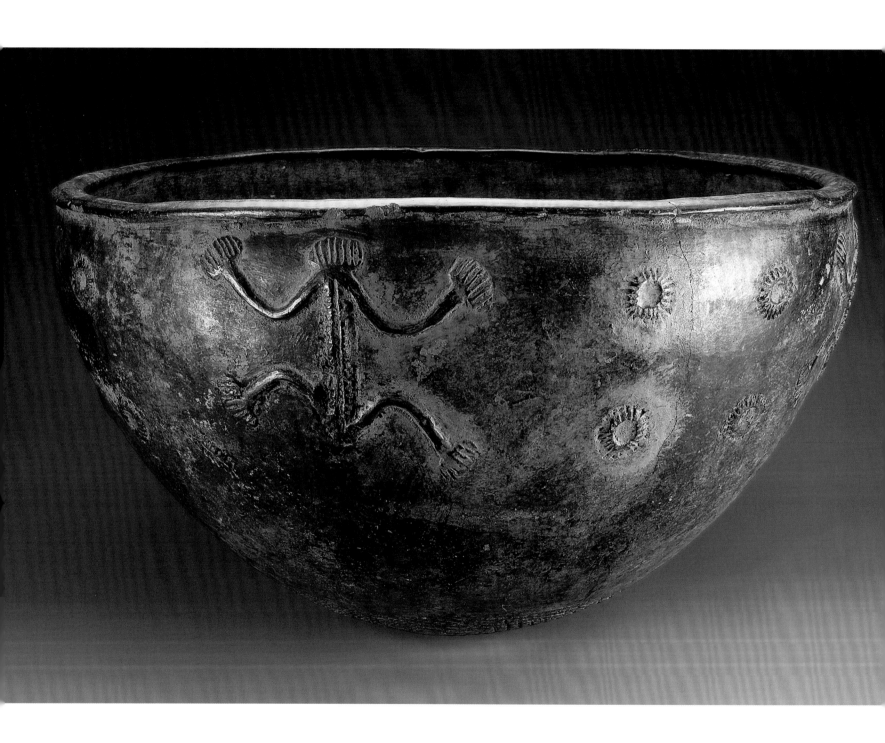

85

BOWL

Mambila; Cameroon
Early/mid-20th century
Terracotta
26.7 x 44.5 cm (10 ½ x 17 ½ in.)

THE BEAUTY OF THIS THIN-WALLED bowl lies in its subtle imperfections—its slightly off-center shape is accentuated by a smooth body and an understated approach to embellishment, and its swaying rim terminates in a thickened lip. Years of use have given the burnished and blackened surface an almost metallic sheen that is heightened by the red camwood rubbed into the crevices around the raised imagery.[1] Prominent among the elements that ornament this vessel is the frog or toad, one of the most ubiquitous animal symbols used in the art of the Mambila Plateau and the neighboring Grassfields. Favorable omens of human fertility and, by extension, of the well-being of the community, these creatures are rendered in a highly schematized and linear fashion, splayed open and invigorated by the notched bar that defines their bodies and the long fringes that signify their feet and heads.[2] Here four circular starbursts are located between each frog or toad to mark the four corners of an implied rectangle. These elemental signs may be interpreted in multiple ways, including as spiders, a motif associated with divination and with the ancestors.[3] The Mambila use large, though generally unembellished, bowls like this one to fry maize that is then ground for making beer.[4] The mother of twins may keep a smaller version to hold palm oil, which the children will lick off her finger each morning before leaving the house.[5]

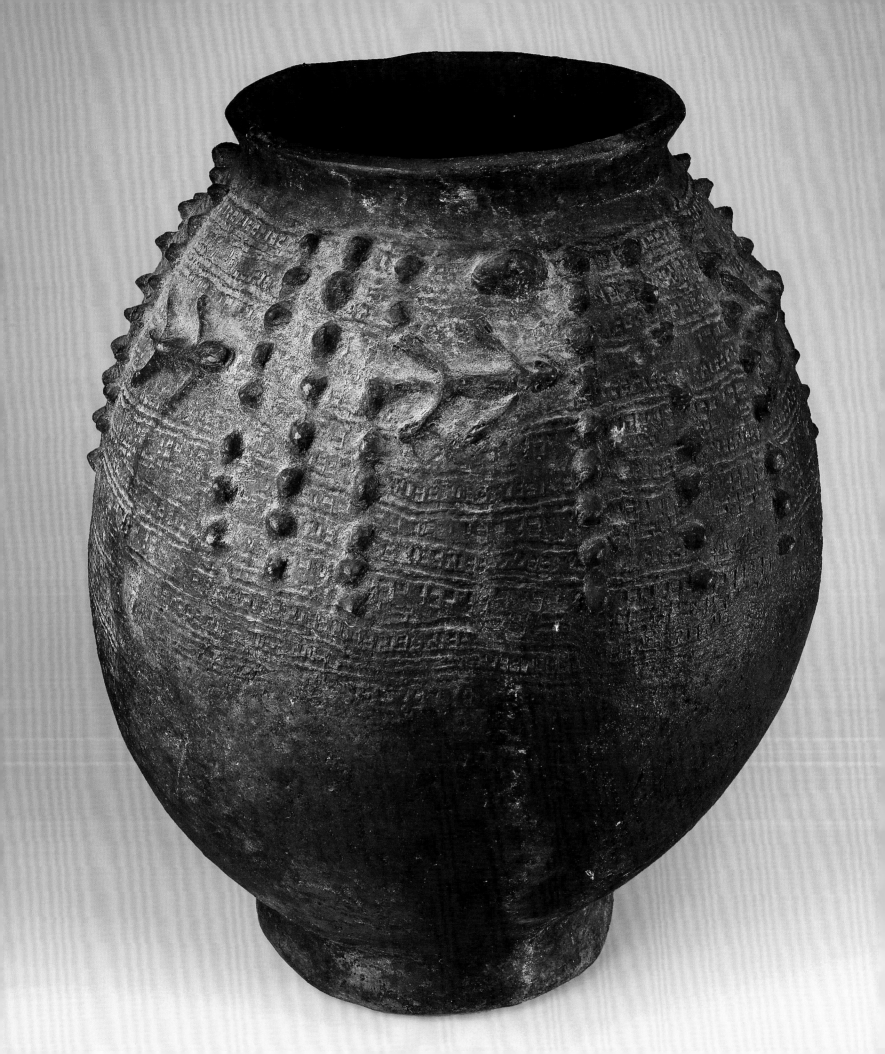

86

PALM WINE CONTAINER

Mfumte; Nigeria or Cameroon
Mid-/late 20th century
Terracotta
40 x 34.3 cm (15 ¾ x 13 ½ in.)

87

PALM WINE CONTAINER

Yamba; possibly Gom, Cameroon
Early/mid-20th century
Terracotta
57.2 x 43.8 cm (22 ½ x 17 ¼ in.)

88

CONTAINER FOR LIQUIDS

Mambila; Lip or vicinity, Cameroon
Early/mid-20th century
Terracotta
55.9 x 52.1 cm (22 x 20 ½ in.)

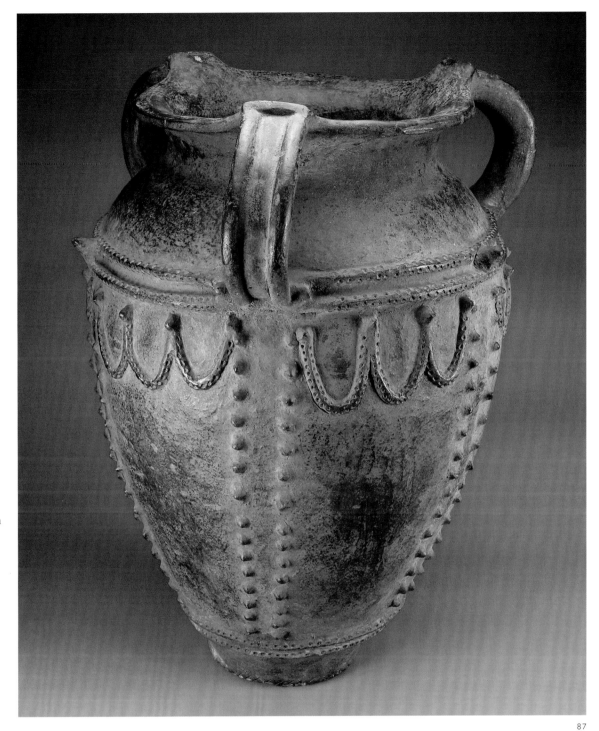

87

OPPOSITE: 86

LITTLE HAS BEEN PUBLISHED ON the pottery of the Mambila, the Mfumte, and neighboring and interrelated peoples such as the Yamba, who live primarily in the highlands of west-central Cameroon and across the border into eastern Nigeria.[1] Potters in this region make large, hand-somely decorated containers for storing and serving palm wine, which is offered as an important expression of hospitality within the family and at larger communal events. They may also perform this function in cult houses, where they would be consecrated through ritual.[2] These and other

pottery vessels are sold in markets, and their trade across considerable distances has promoted the blending of local styles.[3]

The first of the vessels shown here (cat. 86) is typical of the idiosyncratic approach to embellishment that seems to characterize these wares. The form is straightforward with a round foot, oblong body, and short, thick lip. The upper half of the container is covered with bands of roulette-impressed texture. Over this ground vertical rows of raised dots have been applied and interspersed with simply rendered splayed figures of a four-legged creature with a tail. The vessel has been identified as coming from Mfumte, which lies southwest of the Mambila heartland. The missionary and ethnologist Paul Gebauer collected a more ornate version, also with raised dots and figures, that was made in 1936 by the Mfumte potter Naa Jato, whose work was admired for its artistry and widely sought after by wealthy patrons.[4] In 1964 Michael O'Brien also photographed pottery in the region with these same features.[5]

The second pot shown here (cat. 87), probably from the Yamba village of Gom, is an elegant palm wine container that may also be used to store water or grain.[6] Vessels in this distinctive style have oblong bodies that narrow at the neck and flare at the mouth, with multiple handles that loop from lip to shoulder, and raised lines and dots fluidly applied as embellishment.[7] The three sculptural handles—with their deep channels and rounded sides—arc well above the line of the pot's lip and give it an undulating edge. Double lines of carefully applied dots define quadrants around the body of the work, and a notched swag adorns the shoulder.

In the Mambila village of Lip and the surrounding region, simply adorned containers like the elegantly austere example that completes this group (cat. 88) can hold water and the maize flour that is used to make beer.[8] The vessel's overall form is graceful, with a rounded base gently rising to a wide shoulder, then abruptly narrowed at the neck, and slightly flared at the rim. The potter's artistry is evident in the deftly applied embellishment. A raised coil encircles the shoulder like a necklace just above its widest point. From this, other coils extend down the inward sloping sides, each maintaining its integrity and seemingly adhered with a single press of the potter's finger at top. In the neighboring Grassfields, potters make containers closely related in form that hold a variety of liquids including beer and palm wine.[9]

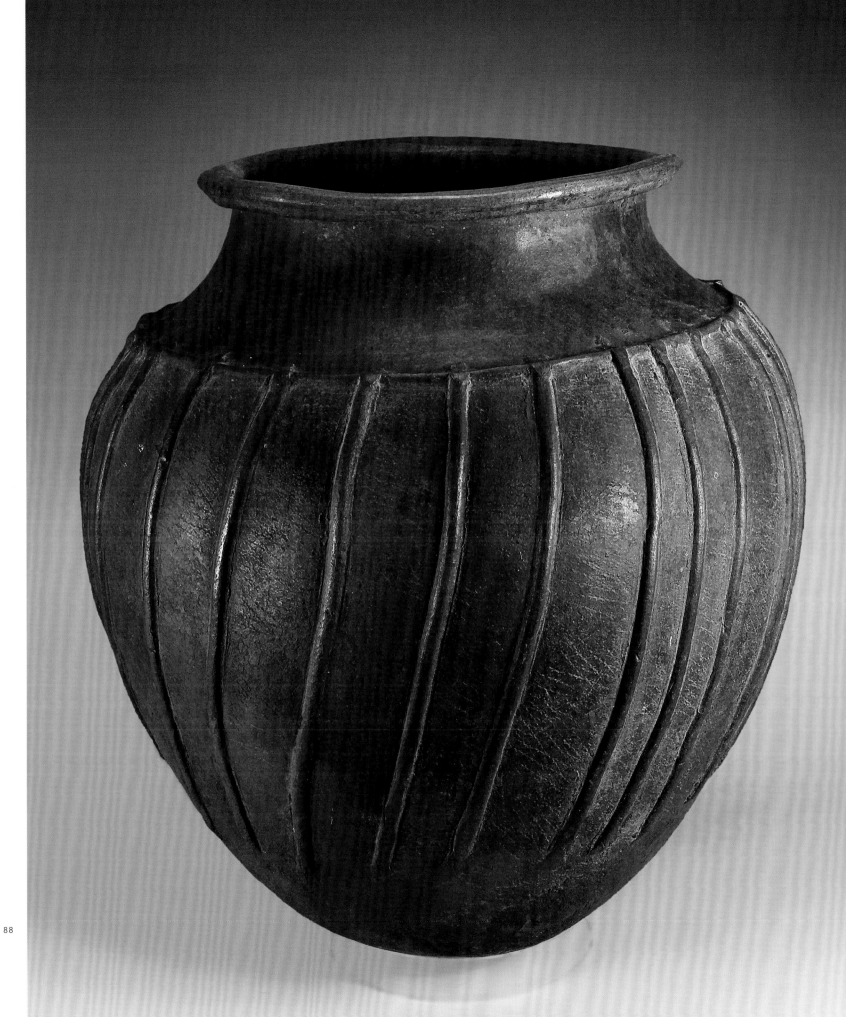

89

BOWL FOR SAUCE OR STEW
(*KU TO*)

Nsei; Cameroon
Early/mid-20th century
Blackened terracotta
12.1 x 14 cm (4 ¾ x 5 ½ in.)

90

CONTAINER, POSSIBLY FOR USE AS AN OIL LAMP

Possibly Nsei; Cameroon
Early/mid-20th century
Blackened terracotta
12.1 x 13.3 cm (4 ¾ x 5 ¼ in.)

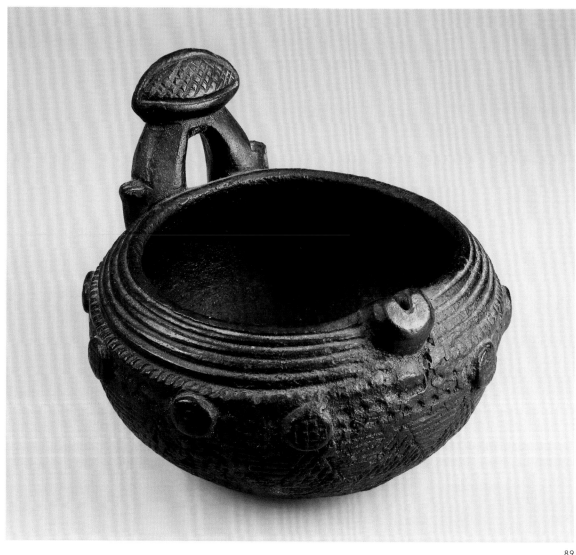

89

THE MOUNTAINOUS GRASSFIELDS REGION of Cameroon is home to highly stratified chiefdoms that are bound together by a history of cultural contact and shared political structures. On the Ndop Plain, in the heart of the Grassfields, pottery is dominated by two production centers, at Babessi and Nsei, also called Bamessing.[1] In Babessi, pottery is the occupation of women, who make thin-walled vessels that are embellished with roulette-impressed patterns and appliquéd motifs.[2] In Nsei both women and men produce ceramics, although certain forms and decorative motifs are restricted to one sex or the other.[3] Potters use both the direct pull and coiling techniques, forming the most elaborate wares with thick walls that allow for deeply incised ornamentation with a variety of carving tools.[4]

Grassfields potters make a variety of small bowls for warming and serving stew, a staple dish that is part of almost every meal. Until recently all men and women had such a bowl, which could vary in form from simple to ostentatious depending on the rank and wealth of the owner. The majority, like the one presented here

(cat. 89), are round bottomed with an inward sloping rim, a looped handle on one end—from which it could be hung when not in use—and, opposite the handle, a projecting stud, evocatively called the navel.[5] In Nsei, where this piece originated, both women and men can make simple versions with or without a handle or navel; only men, however, make the more elaborate versions with representational imagery, raised pedestals, and lids.[6] Although this small bowl is relatively straightforward in its form and decoration, carefully considered details—such as the elliptical topknot and the small buttresses on the handle, the decorative notch in the navel, and the sure-handed incising—give it an accomplished air.

Nsei may also be the place of origin of the compact container that has a small access hole on top and a looping handle on one side (cat. 90). The container's intended function is uncertain. It may have been used as an oil lamp, a pottery form that faded from use beginning in the late 1940s.[7] The rows of deeply incised lines laid out patchwork-style in contrasting directions are certainly suggestive of the reductive style of embellishment practiced by Nsei potters.

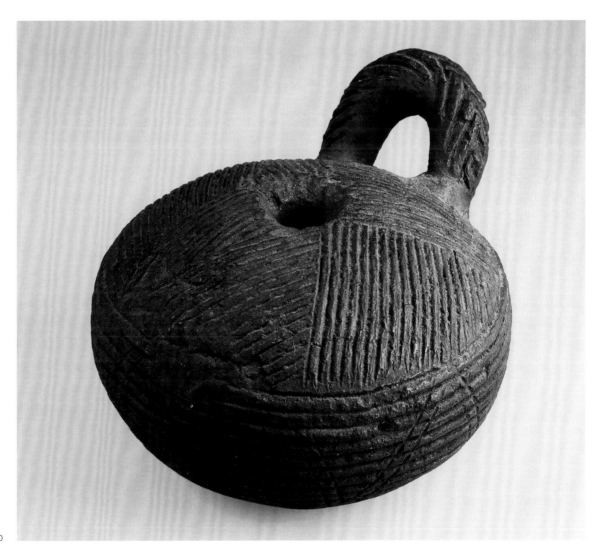

90

91

WATER CONTAINER

Babessi; Cameroon
Early/mid-20th century
Terracotta
40 x 39.4 cm (15 ¾ x 15 ½ in.)

92

MAN'S WASH BASIN (*NTIEKO*)

Babessi; Cameroon
Mid-/late 20th century
Terracotta
26.7 x 45.1 cm (10 ½ x 17 ¾ in.)

93

BOWL OR MAN'S WASH BASIN
(*NTIEKO*)

Babessi; Cameroon
Mid-/late 20th century
Terracotta
18.4 x 47 cm (7 ¼ x 18 ½ in.)

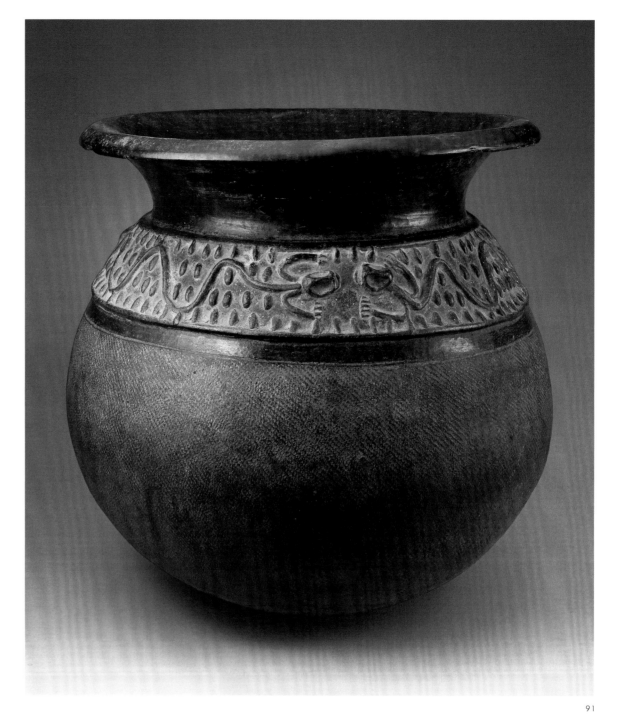

91

THE CLOSELY SITUATED CHIEFDOMS of Babessi and Nsei, longtime centers of pottery production and regional exchange, adapted to changing demands and clienteles during the twentieth century.[1] Despite their proximity to each other, the ceramic traditions of Babessi, where only women make pots, and Nsei, where they are made by both sexes, differ significantly. This distinction is most visible in the way that pots are decorated:

Babessi potters prefer roulette patterns and appliquéd motifs that complement clay's plasticity, while the Nsei primarily use incising techniques to embellish their wares.

A notable example of this can be seen in an elegant old Babessi water container in the Achepohl collection (cat. 91).[2] Its flared lip, narrow neck, and rounded body, which is textured with a small wooden roulette to the shoulder, are ideal for

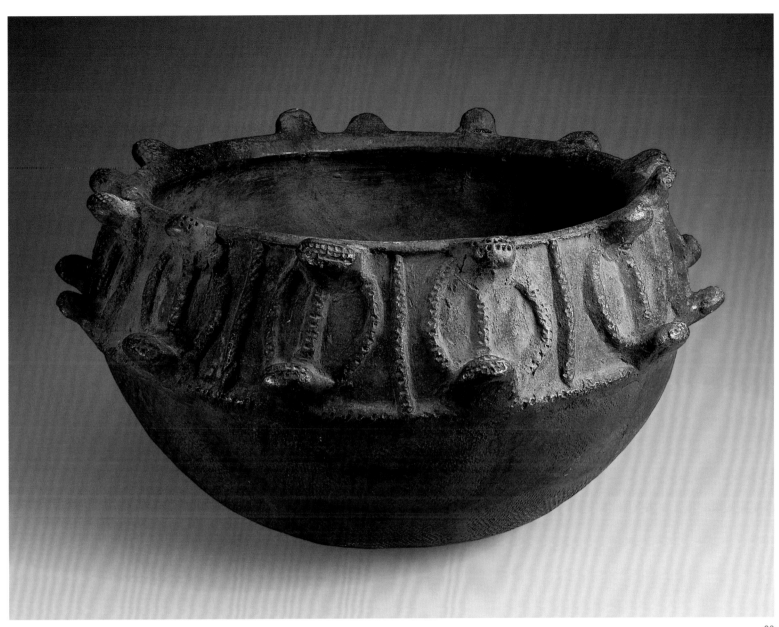

holding liquid without spilling. In the home a man's wash basin—such as cat. 92—would have served as the lid for this vessel, its snug fit symbolizing the marriage union, especially as the water pot is itself associated with women and fertility.[3] In a photograph taken by Hans-Joachim Koloss in the chiefdom of Oku, a similarly shaped container is seen being used to prepare medicines (see "Engaging the World Beyond," fig. 2). A raised band encircles the pot's shoulder on which gracefully meandering serpents trace a waving line, a motif often found on water containers from Babessi.[4] The serpents are here rendered with

front legs, leaving their exact nature ambiguous. While this image is identified as a snake in many parts of the Grassfields, in Babessi it is also associated with a lizard.[5]

The market for Babessi pottery tends to be local and conservative in its preferences. In response to this, area potters continue to make wares, such as the man's wash basin, which are no longer used in more urban areas.[6] While the majority of potters in Babessi make fairly ordinary pots to be marketed by small-scale traders in neighboring chiefdoms, those from the chief's lineage work on commission, creating specialty

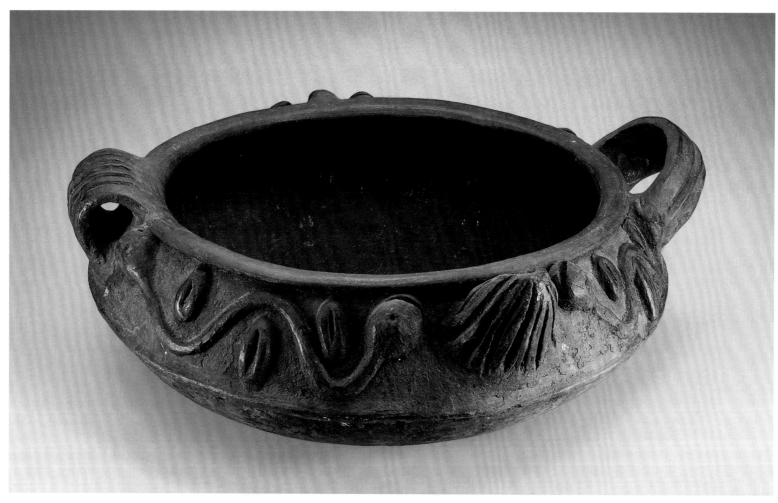

vessels that are embellished with variations on long-established human- and animal-inspired designs.[7] In classic Babessi style, the lower portion of the first basin (cat. 92) has a roulette-applied texture, and its sloped upper wall is ornamented with a repetitive pattern that is formed using coils and clumps of clay. The motif, an abstraction based on the human figure, is stippled with small holes that have been applied with a dried reed, a popular decorative technique in Babessi.[8]

 The third vessel in this grouping (cat. 93) was also probably meant to function as a man's

wash basin, although its form resembles a sauce or soup bowl, with a hook opposite its navel, a projecting stud that is here shaped like a spout. Handles are attached on either side of the bowl, one looping laterally and the other vertically, and it is embellished with stylized cowrie shells and meandering snakes, a frequent combination of motifs associated with royalty and wealth.[9] Again, in his exhaustive study of Oku, Koloss illustrated a similar bowl being used as a wash basin during the ritual cleansing of boys as part of a burial ceremony.[10]

94

CONTAINER FOR PALM WINE

Nsei; Cameroon
Mid-/late 20th century
Terracotta
43.8 x 40.6 cm (17 ¼ x 16 in.)

95

PITCHER FOR PALM WINE
(*MBA MOLU*)

Probably made by Martin Fombah
(born c. 1950)
Nsei; Cameroon
Late 20th century
Blackened terracotta
30.5 x 20.3 cm (12 x 8 in.)

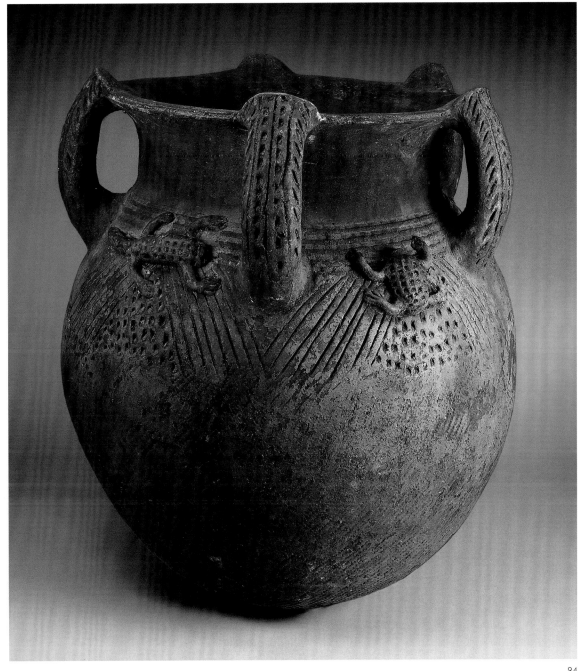

94

PALM WINE IS AMONG AFRICA's oldest and most widespread alcoholic beverages, and it is intimately tied to social and religious life across the continent's forest regions (see "Beer and Palm Wine," figs. 1–2). The sweet juice used to ferment palm wine can be obtained from the stalk of a felled tree or from the immature male flowers or stem of a living one.[1] In the Cameroon Grassfields the sharing of palm wine is an important gesture of hospitality and an indelible part of court and regulatory society ritual. As Hans-Joachim Koloss stated in his definitive study of the chiefdom of Oku, "Eating *njemte* and drinking palm wine mutually during these rituals is not only understood as communion with the ancestors, it is also a confirmation of the unity and friendship among the participants."[2] Reflecting this level of integration and importance, Grassfields potters spend a considerable amount of time making containers for serving and drinking palm wine.

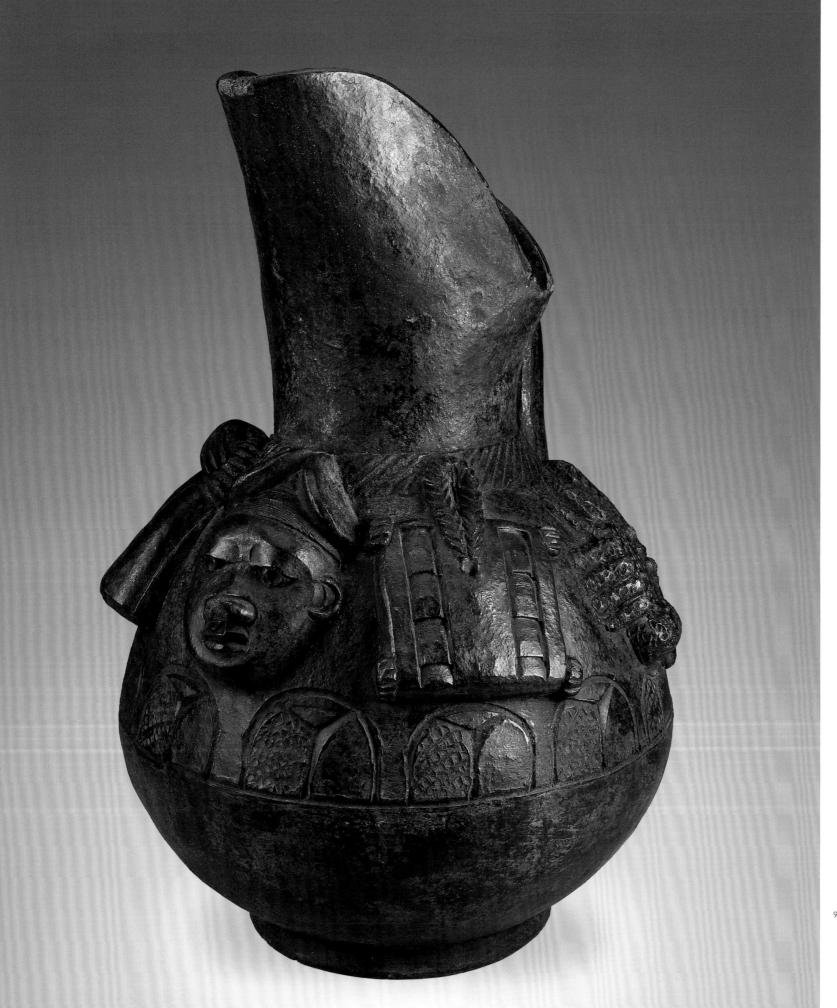

The elaborate form and animal imagery of the large palm container shown here (cat. 94) identify it as a pot of some status, possibly intended for the palace regulatory society. Nsei palm wine containers are often designed with an arcade of looped handles that can become a platform for a potter's innovation.[3] Here the loops rise above the plane of the vessel's lip in an unusual fashion. Palm wine may readily be transferred from such a communal pot into smaller pitchers or jugs for serving. Until recently each Nsei title-holder had a pitcher of his own for this purpose.[4] Palm wine pitchers from Nsei are differentiated from those made in the competing pottery center of Babessi by their steeply pitched spouts.[5] In Nsei only men make such pitchers, and only men embellish pottery with representations of humans and animals.[6]

The pitcher in the Achepohl collection (cat. 95) is in the style of potter Martin Fombah and was probably made in the 1980s or 1990s (see "Ceramics in Africa," fig. 13).[7] Fombah is from a prominent family of Nsei potters, and he is known for his innovative approach to traditional ceramic forms.[8] His works cater to a new elite in Nsei that wishes to reinforce its economic success through overt displays of wealth, including pottery, intended for show instead of ritual use. Like much of Fombah's output, this pitcher brings new sculptural emphasis to traditional symbols of power, status, and authority. A man's head, crowned by the distinctive two-lobed prestige hat of Grassfields' chiefs and title-holders, sits squarely at front. To the right is a gun and an arm holding a double gong, a musi-

cal instrument strongly associated with kingship and court ritual.[9] To the left are a lizard, a scorpion, and a bag with a looped handle. Bags made of woven raffia palm fiber were once widely used to carry personal items, and today they continue to be used to hold sacred objects.[10] This image may represent a specific Nsei-style bag—with rows of individual pockets for holding ritual substances—that is used only by members of the palace regulatory society.[11]

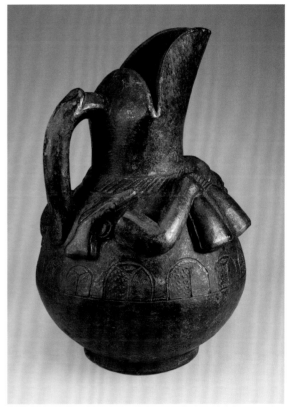

95, ALTERNATE VIEW

Engaging the World Beyond

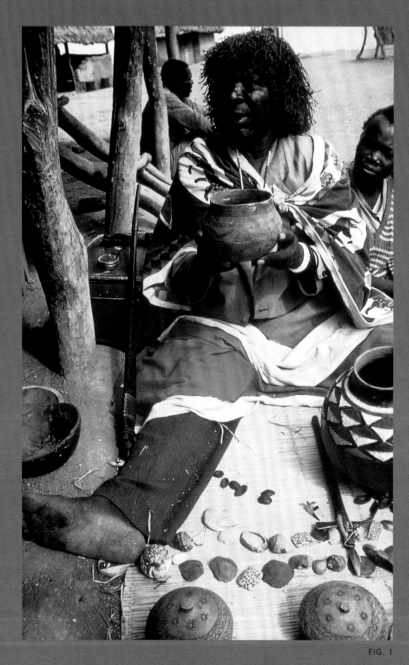

FIG. 1

Dr. Mabvongere is a diviner-herbalist who specializes in treating illness through a combination of ritual and medicine. His kit includes a water pot painted in bright enamel hues. While such painted embellishment appeals to many people, particularly those with a taste for the modern, it is said by some to limit a pot's application to nonritual use. Photo by William J. Dewey, Chipinge district, Zimbabwe, 1994.

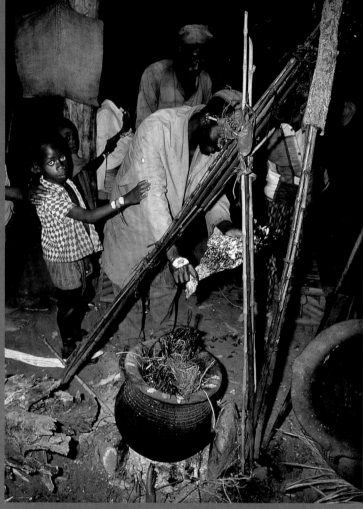

FIG. 2

In the Cameroon Grassfields kingdom of Oku, the military society called Samba is renowned for its powerful medicines that enhance strength, heal the ill, promote fertility, and ensure the passage of the souls to the otherworld. This Samba member is sacrificing a chicken over medicinal herbs that are being roasted in a large water vessel. Military societies were once an important means of defense throughout the Grassfields kingdoms, and while their strategic function has waned, they remain active social and ritual organizations. Photo by Hans-Joachim Koloss, Elak, Oku Kingdom, Cameroon, 1977.

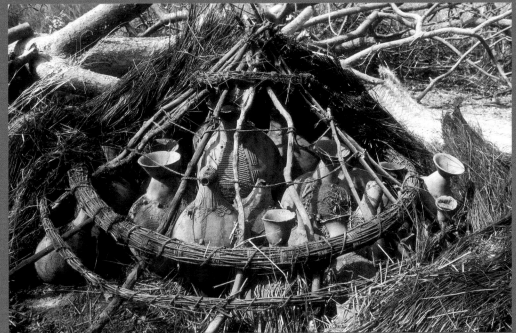

FIG. 4

Around the town of Dingai in northeastern Nigeria, the Bëna and Ga'anda live in close proximity and have influenced one another culturally and artistically. For instance, both peoples make similar figural vessels that are placed on shrines to contain and honor spirits and ancestors. Many of those on this Bëna shrine are identical to those made by the Ga'anda. They include, at center, a large headless pot with an elaborately textured bib, which represents one spirit being, and in front a figural pot with an open mouth, which represents another. Although the Ga'anda pot in the Achepohl collection (cat. 83) is of the latter type, it is somewhat unusual in that the artist has drawn iconic elements from both. Photo by Marla C. Berns, Dingai, Nigeria, 1981.

FIG. 3

Delicate ceramic bottles for holding water, palm wine, or oil are made throughout Central Africa. They are prized possessions and are reserved for special occasions. Here a Teke chief uses one to pour a libation of palm wine in honor of the ancestors at the unveiling of an agricultural development project. Photo by Henny Weima, Democratic Republic of the Congo, 1980.

This imposing jar for supernaturally charged, protective medicines stands in the courtyard of the Kpeenbele Senufo potters of Katiorokpo village. The vessel's base takes the form of a washing pot, but its large size, rows of jutting bumps, and sealed top clearly declare its special status. Among the Senufo only a widow can make such a sacred and power-filled container. This example was made by potter Mbakoro Danyö'o. Photo by Anita Glaze, Katiorokpo, Côte d'Ivoire, 1970.

FIG. 5

THE CONGO BASIN, dominated by the sweeping arc of the great Congo River and its network of snaking tributaries, embraces and largely defines the region of Central Africa. The equator bisects this area, and the dense forest that is fed by its constant temperatures, high humidity, and abundant rainfall has kept populations relatively small. To the south the forest dissolves into plateaus of grassy savanna that are intersected by more fertile river valleys. As early as 1000 B.C., waves of migration from what is today western Nigeria and Cameroon brought Bantu language speakers into the Congo Basin, immigrants who gradually settled, began farming, and mingled with existing populations. These newcomers carried with them ironworking and pottery technologies, laying the foundation upon which these practices have developed and become differentiated over time.

To the north the equatorial rainforest likewise gradually gives way to grass-filled savanna. This region, which is dominated by the Ubangi and Uele rivers, is less densely populated than its counterpart to the south with the exception of the eastern portion. Here three major language families—the Ubangi or Adamawa-Eastern, Bantu, and Eastern Central Sudanic—have intersected, signaling a linguistic and cultural melting pot that is reflected in the area's artistic heritage.

Central Africa is a vast and culturally complex region, and its pottery reveals an impressive diversity of forms, techniques, and cultural practices. Whether the need is for simple vessels for everyday use or finely formed and embellished luxury wares, pottery is generally the occupation of women. One exception to this is in the northwestern region of the Democratic Republic of the Congo, where, among the Zande, men often make pottery. Likewise, in the lower Congo River region and among the Lwena and Chokwe in Angola, men make figurative wares, while in many parts of Central Africa—notably among the Luba and related peoples this is the domain of the women. A small bottle used to hold alcohol, oil, or water is a widespread Central African pottery form that is rarely found in other parts of the continent. Often highly esteemed and reserved for special occasions, such objects are showcases for the virtuosity and inventiveness of the potters who made them.

OPPOSITE: 101 (DETAIL)

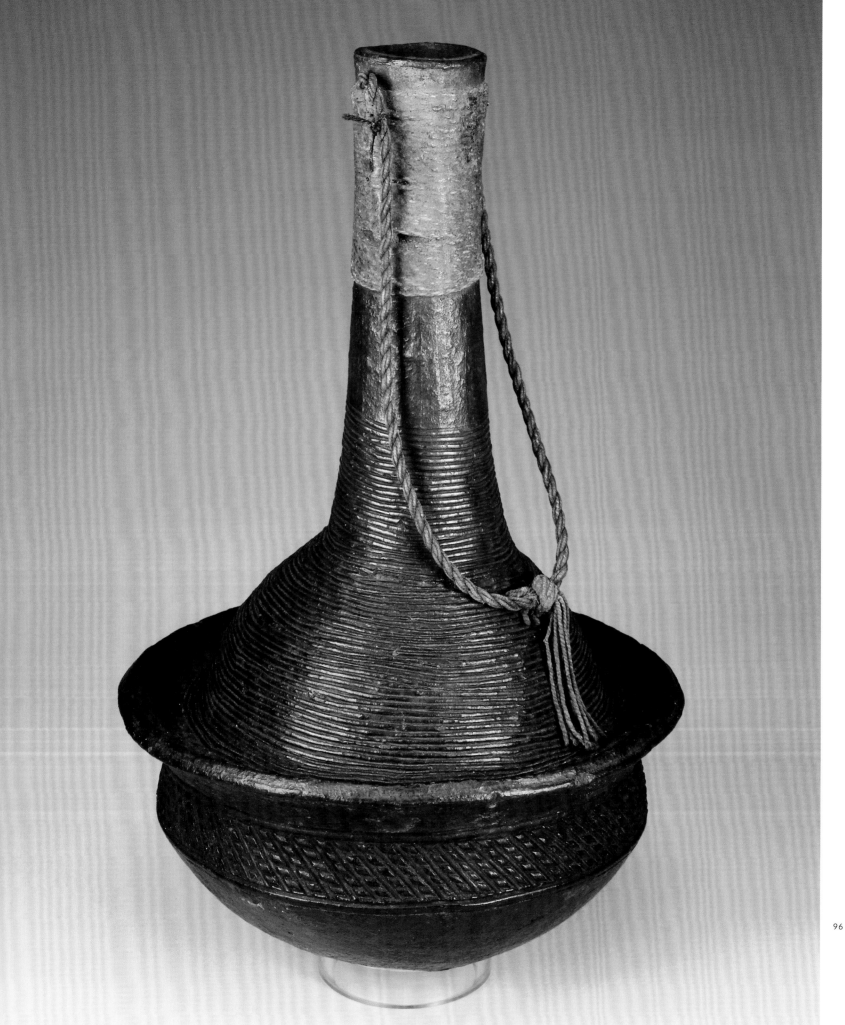

96

BOTTLE

Buma or Sengele; Democratic
Republic of the Congo
Late 19th/early 20th century
Terracotta
21 x 14 cm (8 ¼ x 5 ½ in.)

97

BOTTLE

Teke; Republic of Congo
Early/mid-20th century
Terracotta
29.9 x 21.6 cm (11 ¾ x 8 ½ in.)

98

BOTTLE

Ambundu or Chokwe; Democratic
Republic of the Congo or Angola
Late 19th/early 20th century
Terracotta
21 x 17.8 cm (8 ¼ x 7 in.)

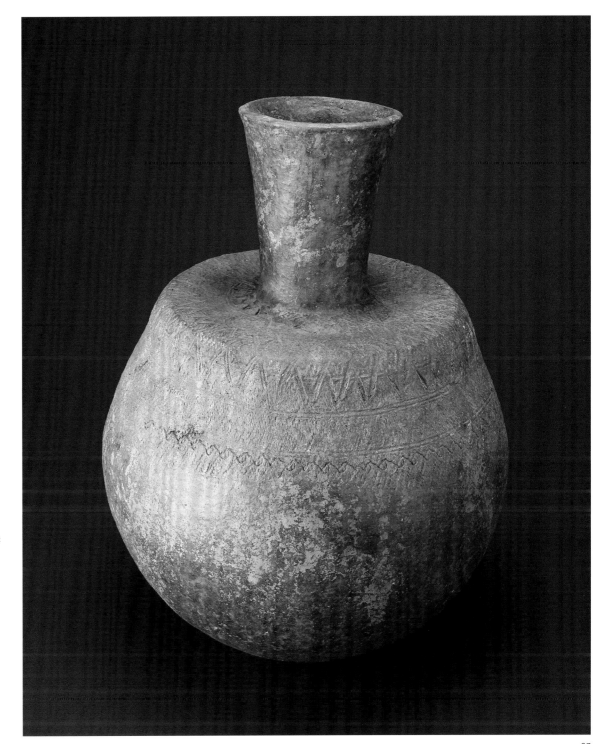

97

OFTEN HIGHLY INVENTIVE in their forms, small bottles are made by potters throughout Central Africa for holding liquids such as beer, oil, water, or palm wine. Such pieces are often treasured personal possessions and are therefore appropriate for use in honoring ancestors, whether through the pouring of libations on special occasions or by placing them on shrines or graves (see "Engaging the World Beyond," fig. 3).[1] These exquisite examples are believed to date to the late nineteenth or early twentieth century.

The delicate bottle shown on the facing page (cat. 96) comes from the region of the Kwa River, west of Lake Mai-Ndombe, and may be Buma

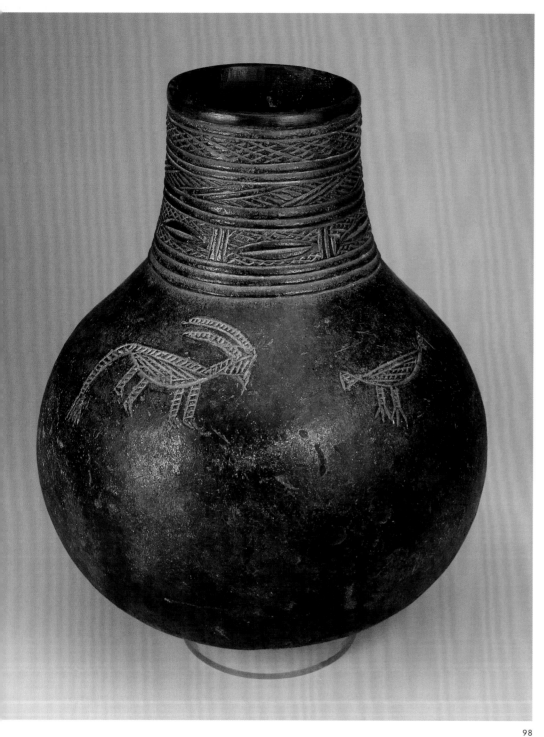

98

or Sengele.[2] The vessel's base takes the shape of a small bowl with a flared rim and a diagonal roulette pattern around the waist. The potter formed this section first, pressing clay into a mold and adding coils to finish it.[3] The round-bodied, long-necked bottle that appears to sit within this bowl was formed later, also using coils. As is typical of bottles from this region, the surface has been painstakingly incised with thin cords almost halfway up the neck.[4] Mirroring this, the upper half of the neck is tightly wrapped with a thin strand of twisted fiber to which a long looping handle is attached.

The second bottle (cat. 97) comes from the Teke-dominated region north of the mouth of the Congo River in what is today the Republic of Congo. Bottles with similarly squat bodies and funnel-shaped necks are found among the Teke as well as among such Kongo-speaking neighbors as the Kunyi.[5] The flat shoulder of this work is an unusual feature that gives it a strongly geometric silhouette. Just below the shoulder, the body was embellished with several bands of roulette pattern over which the potter quickly inscribed a zigzag line above and a scalloped line below. Teke potters usually use a mold to build the lower part of a vessel and sometimes make closed forms such as bottles by joining two such pieces together; they then add coils to create the neck.[6]

With its organic, gourdlike shape, the third vessel presented here (cat. 98) may have been fashioned by a Chokwe potter in Angola or may be Ambundu, from the Kongo-speaking region further north.[7] The maker's steady and confident hand rendered tightly etched bands of pattern around the bottle's neck and charming depictions of animals, including an antelope and a bird, around the shoulder.

99

STORAGE CONTAINER
(MULONDO)

Songye; Democratic Republic
of the Congo
Early/mid-20th century
Terracotta
48.9 x 45.1 cm (19 ¼ x 17 ¾ in.)

100

STORAGE CONTAINER
(MULONDO)

Songye; Democratic Republic
of the Congo
Mid-20th century
Terracotta
48.9 x 45.1 cm (19 ¼ x 17 ¾ in.)
The Art Institute of Chicago,
African and Amerindian Art
Purchase Fund, 1995.149

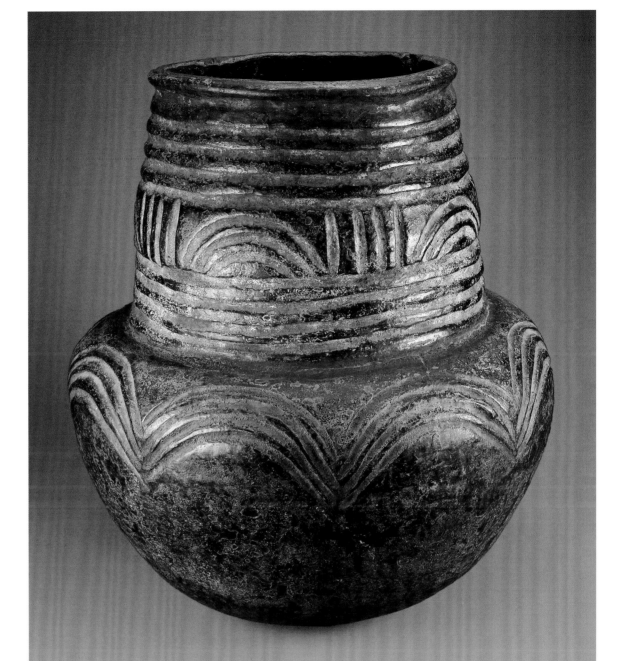

99

WRITING IN 1905 AND 1906, the German ethnographer Leo Frobenius praised Songye pottery, attributing to it a "plainly astonishing beauty and a copious but measurable abundance of forms."[1] Indeed, Frobenius recorded over two hundred different types of Songye pots, many of which were variations on the tall-necked storage container.[2] These two containers demonstrate the stylistic variations-on-a-theme that characterize Songye pottery: both are embellished in a charac- teristically robust style, with deeply incised lines that emphasize the neck and shoulders. The chain of arches around the shoulders of the one illus- trated above (cat. 99) have a bouncing spontaneity, whereas on the other (cat. 100) they appear more tightly controlled, as do the grooves around the neck. In keeping with this, the rounded arches at mid-neck on the former (see also p. 10) have been squared off on the latter. According to Frobenius, much of this kind of embellishment is added to a

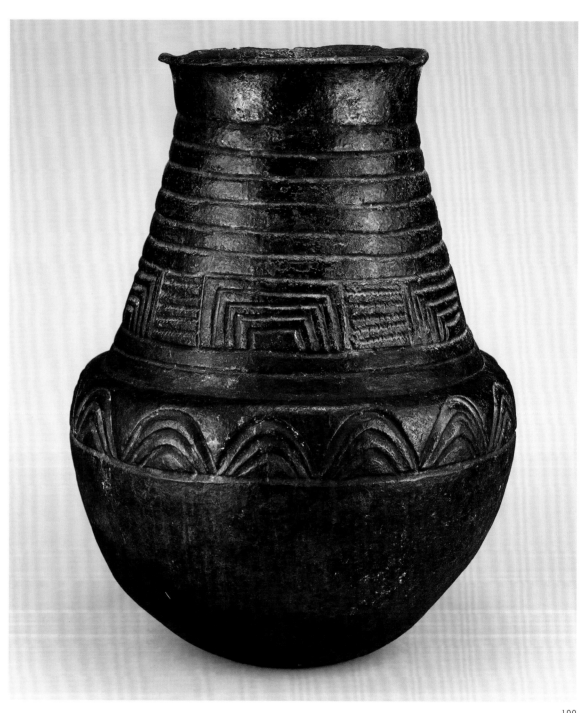

pot when it is still wet, while finer details are incised after it is leather hard.[3] The surfaces of both containers are overlaid with a dense, crusty coating interrupted by areas of high sheen that suggest age and use. A dry yellow substance coats the interior base and lower walls of the second (cat. 100), perhaps to help make it watertight.

101

BOTTLE

Yacoma; Democratic Republic of
the Congo
Early/mid-20th century
Terracotta and pigment
27.9 x 20.3 cm (11 x 8 in.)
The Art Institute of Chicago, gift
of Keith Achepohl, 2004.743

102

BOTTLE

Mangbetu or Zande; Democratic
Republic of the Congo
Early/mid-20th century
Terracotta
26.7 x 17.8 cm (10½ x 7 in.)

103

BOTTLE

Zande or Barambo; Democratic
Republic of the Congo
Early/mid-20th century
Terracotta
30.5 x 20.3 cm (12 x 8 in.)
The Art Institute of Chicago,
Edward E. Ayer Endowment in
memory of Charles L. Hutchinson,
2003.77

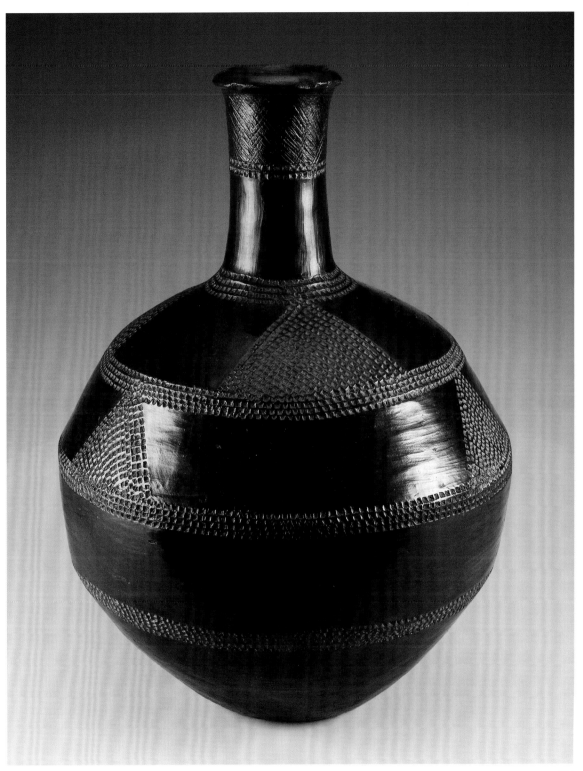

101

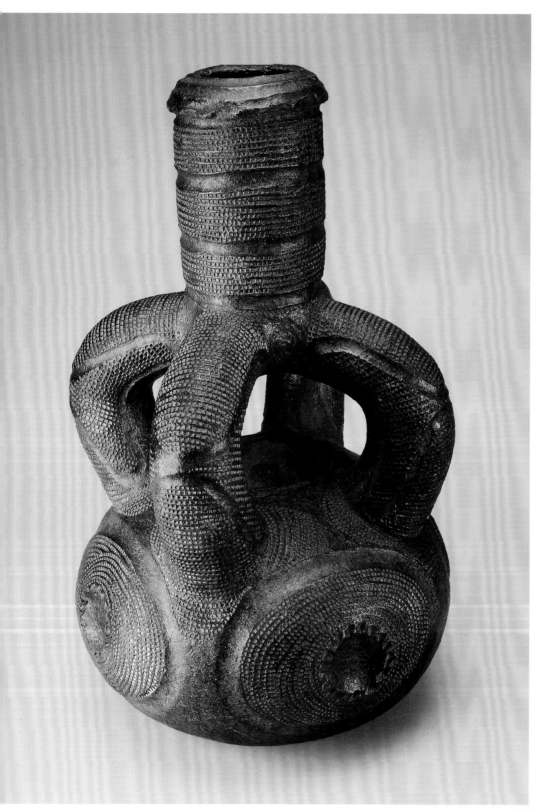

102

THE UELE RIVER LIES NORTH of the Congo
River and intersects with it by way of the Ubangi.
Here dense forest gradually gives way to more
open savanna, granting farmers access to rich
resources for making ironwork and pottery, which
they have exploited since at least 2300 B.C.[1]

The homeland of the Yacoma people lies near
the confluence of the Uele and Ubangi rivers, and
they have taken advantage of this locale by actively
engaging in river trade, which flourished in the
late nineteenth and early twentieth centuries and
included fine pottery.[2] The artistry of the first
bottle presented here (cat. 101) lies in its well-
honed angles, each accentuated by textured
embellishment. These sharp shifts seem to defy
the medium of clay, which more naturally accom-
modates gentle transitions and rounded forms.
Complementing its crisp shape, the highly bur-
nished surface stands in high contrast to the red
and white pigments that were rubbed into its
stippled bands and triangles. Yacoma potters have
explored variations on this theme, as other pub-
lished examples—including a bottle that is cinched
slightly at the waist and a ball-shaped pitcher with
a handle and spout—readily demonstrate.[3]

Further east along the Uele River the central-
ized chiefdoms of the Mangbetu and Zande arose
in the eighteenth century, and their influence cast
a wide net.[4] Among the Mangbetu and the closely
related Barambo, pottery is typically practiced by
women, while among the Zande it is men who
control its production.[5] Despite this, beginning
in the late nineteenth century growing similarities
between Mangbetu, Zande, and Barambo pottery
reflect the spread of styles, potters, and their wares
during a period of intensifying cultural contact.[6]
Ornate bottles for storing beer, oil, water, and
wine were made as luxury items for rulers and the
wealthy elite, and, increasingly in the early twen-
tieth century, for European travelers.[7] The spheri-
cal base of the example in the Achepohl collection
(cat. 102) is ingeniously joined to the neck by four
arcing tubes and is embellished by circular motifs

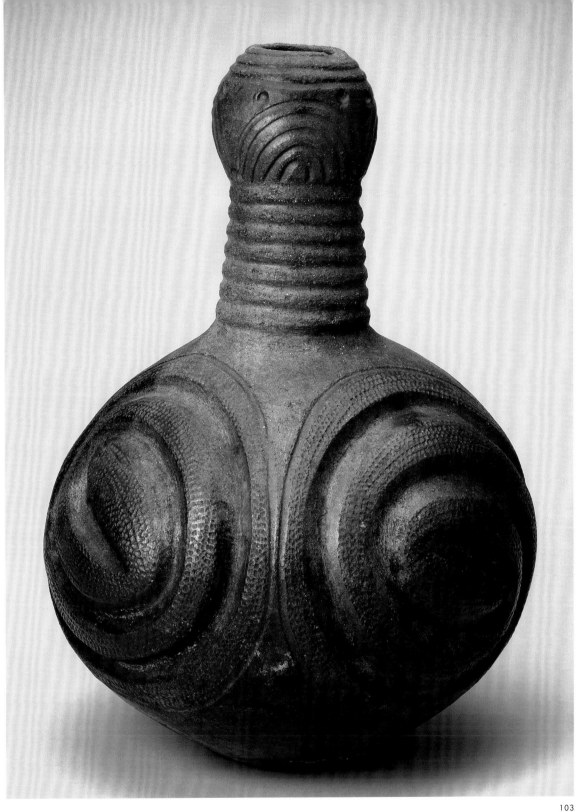

of broad, indented lines with areas of roulette-impressed pattern, a combination widely used by Mangbetu potters.[8] The deeply inscribed, swirling pattern that encircles the body of the bottle above (cat. 103) is found on Barambo and Mangbetu pottery from the early twentieth century, although it likely originated with the Barambo.[9] The maker skillfully gauged the thickness of the bottle's walls, making them substantial enough to accommodate the depth of carving without rendering the vessel overly heavy.[10] A slightly metallic sheen and several fire clouds further enhance its appearance.

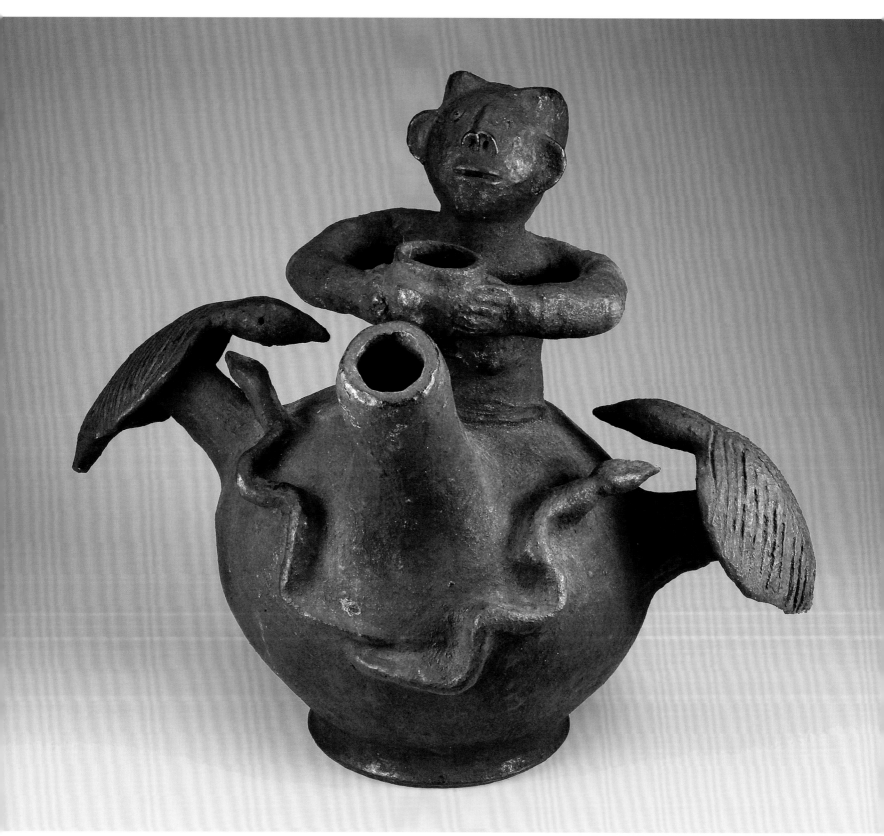

104

FIGURAL JUG

Zela, Kaonde, or Lomotwa;
Democratic Republic of the Congo
or Zambia
Mid-/late 20th century
Terracotta
31.8 x 35.6 x 25.4 cm
(12 ½ x 14 x 10 in.)

105

FIGURAL BOTTLE

Possibly Zela; Democratic Republic
of the Congo
Mid-/late 20th century
Terracotta
31.8 x 35.6 cm (12 ½ x 14 in.)

106

FIGURAL BOTTLE

Possibly Zela; Democratic Republic
of the Congo
Mid-/late 20th century
Terracotta
28.6 x 19.7 cm (11 ¼ x 7 ¾ in.)

107

FIGURAL BOTTLE

Lunda or Luba; Democratic
Republic of the Congo or Zambia
Mid-/late 20th century
Terracotta
38.7 x 21.6 cm (15 ¼ x 8 ½ in.)

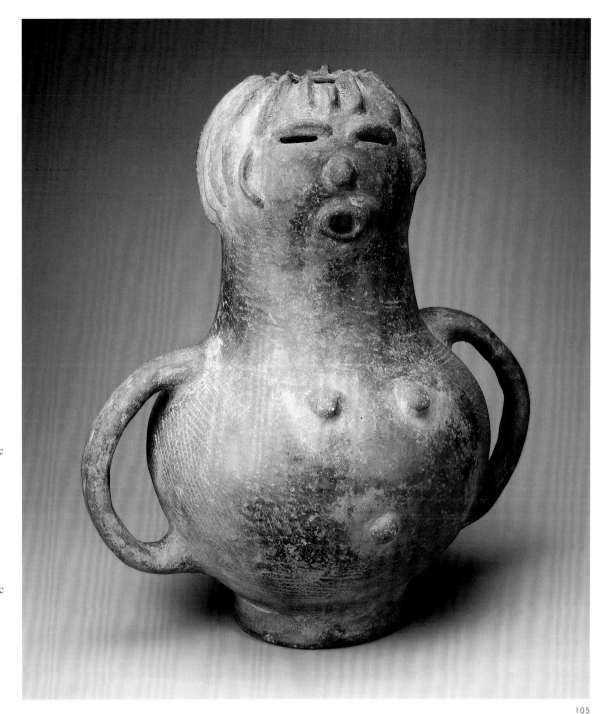

105

IN THE EIGHTEENTH AND NINETEENTH centuries the Luba kingdom grew in strength and influence, dominating a large region centered on the resource-rich Upemba Depression, lying along the Lualaba River in south-central Democratic Republic of the Congo. People living in areas peripheral to the Luba blended with them in various ways, emulating them, adopting their practices, and adapting to their increasing power in a dynamic fashion.[1] The Kaonde, Lomotwa, Lunda, and Zela all live in the outer reaches of the Luba kingdom, and their pottery reflects the regional influence of Luba ceramics as well as its broader cultural diversity.

Decorative spouted jugs like the one shown here (cat. 104) are widely made by potters in the Luba region.[2] With its highly sculptural form and almost freestanding imagery, this piece was clearly

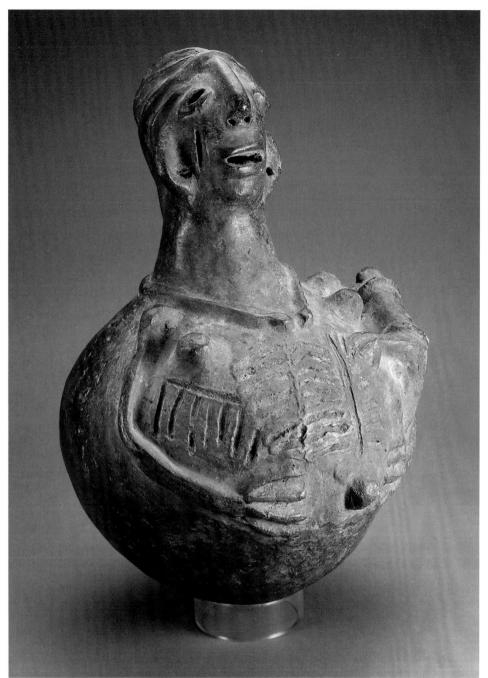

106

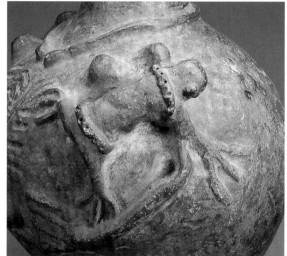

modeled in high relief on its body and a female figure holding a bowl, in this case in the form of a removable stopper, at top.[3] The other comparable work, which was collected in the Lomotwa area, bears the form of a woman's head rendered on its handle in a closely related style.[4] The repetition of the image of a woman holding a bowl is striking and may be a reference to divination. Among Luba and Luba-related peoples, royal diviners use gourds in various ways during their sacred rituals.[5] Many also own a figure of a woman holding a bowl sculpted in wood. These so-called bowl figures have curative powers and are seen by some to represent the wife of a possessing spirit.[6]

The other bottles presented here have been fully given over to the human form. Two of them—one depicting a round-bodied figure with her hands on her hips (cat. 105), the other a woman holding a highly stylized baby in her left arm (cat. 106)—have a fluid and animated sculptural style that is believed to be Zela. The third (cat. 107), with its large, beautifully sculpted head, conveys a greater stylistic formality and is probably Luba or Lunda. Its sculptural hairstyle resembles a crested headdress photographed by the missionary Rev. W. F. P. Burton in the 1930s (see "Pottery and the Body," fig. 2). Such vessels usually hold water or alcohol, whether palm wine, home-brewed beer, or even distilled liquor.[7] They may also be used to pour libations in honor of ancestors or may be placed on shrines or graves.[8]

not meant for daily use. The prominent upper torso of a female figure, wearing a crested coiffure and holding a bowl in her hands, tops the vessel. She is flanked on either side by birds that perch on raised posts well out from the pot's body. Two similar spouted jugs bearing the modeled figures of women with crested coiffures have been published. One has been identified as Zela, and like this jug has a snake and other creatures

108

BOTTLE *(ENSUMBI)*

Nyoro or related peoples; Uganda
Mid-/late 20th century
Terracotta
21 x 17.8 cm (8 ¼ x 7 in.)
The Art Institute of Chicago, gift of
Keith Achepohl, 2003.383

109

BOTTLE *(ENSUMBI)*

Nyoro or related peoples; Uganda
Mid-/late 20th century
Terracotta
27.9 x 17.2 cm (11 x 6 ¾ in.)
The Art Institute of Chicago, gift of
Keith Achepohl, 2003.382

110

BOTTLE *(ENSUMBI)*

Nyoro or related peoples; Uganda
Mid-/late 20th century
Terracotta
21.6 x 16.5 cm (8 ½ x 6 ½ in.)
The Art Institute of Chicago, gift of
Keith Achepohl, 2003.384

THESE THREE DELICATE, gourd-shaped bottles demonstrate a sensitive approach to form, proportion, and decoration. The second two (cat. 109–10) appear to be by the same hand, while the first (cat. 108) differs from them in its embellishment and in the addition of a foot. Writing in the 1950s, Margaret Trowell stated that such works were made in Uganda among several related cultures, but were the specialty of the Nyoro, Toro, and Ganda.[1] Among these groups such finely crafted pottery has long been the province of men.[2] These bottles are coil built with extremely thin walls, much like those of gourds, and are colored a dark brownish black either by smoking, as was likely here, or by rubbing with graphite.[3] While the footed bottle was decorated by hand with carefully etched meandering lines, the other two vessels were embellished with precisely placed roulette patterns of small dots. In the past, such textured ornamentation might have been accentuated by rubbing it with white or red clay.[4]

The use of gourd bottles, well documented in the region, undoubtedly inspired the creation of ceramic examples like these. Trowell described the Nyoro as particularly focused on the aesthetic quality of the gourds they used as containers, noting that they "take special pride in the appearance of their gourds, and although they rarely decorate them, rejoice in the most perfectly shaped vessel polished to a rich red-brown."[5] Both gourds and gourd-shaped ceramic bottles fulfill the same purpose of carrying beer or drinking water.[6] Trowell reported that the ceramic versions were true luxury goods, used by the wealthy elite and also made for sale to tourists.[7]

Beer and Palm Wine

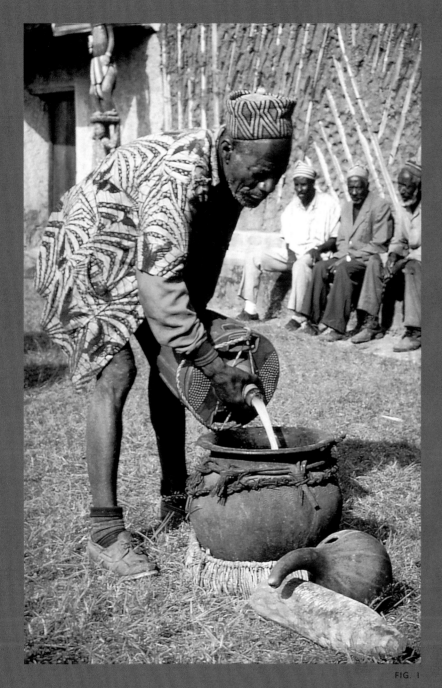

FIG. 1

Palm wine is the preeminent offering made to ancestors in the Grassfields kingdoms of Cameroon. Babey Lemba, an elder of the royal lineage of Oku, pours palm wine from a metal container into a ceramic vessel while reciting a prayer to his ancestors, informing them of the resolution of a conflict in the family. "I have united the rest of the family," he intones. "The aim is that when people live in unity they have success. Bless the whole family." Photo by Hans-Joachim Koloss, Oku, Cameroon, 1998.

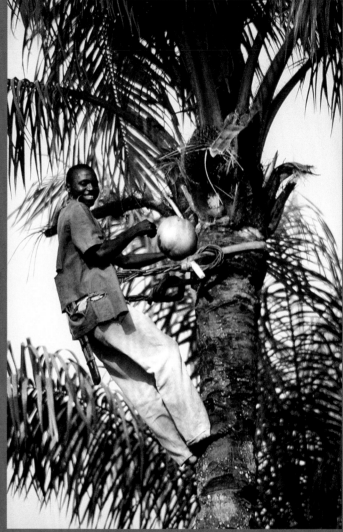

FIG. 2

When the sugary sap from a palm tree is exposed to microorganisms in the air, it ferments, producing a mildly intoxicating beverage. Palm wine may be tapped from a felled tree or directly from a standing tree. This Nigerian tapper, named Goddy, mounts a tree using a harness, tapping the wine into a calabash container. In Nigeria, palm wine from a standing tree, called "up wine," is considered preferable to the sweeter wine from a felled tree, called "down wine." Photo by Amanda Carlson, Alok, Ikom Local Government, Cross River state, Nigeria, 1996.

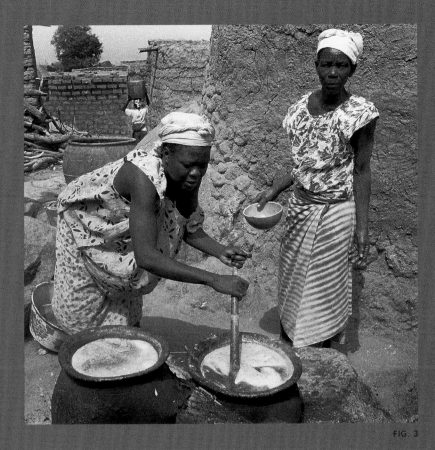

FIG. 3

Across Africa beer is brewed from a variety of grains including maize, millet, and sorghum. The work, which is usually done by women, is labor intensive and takes from several days to as many as two weeks. Grains are soaked and left to sprout in large jars like that in the background of this photo. Next they are ground into malted flour, mixed with liquid, boiled, and fermented. Here two Bobo women oversee the beer they are boiling. Photo by John Watson, Koro, Burkina Faso, 1996.

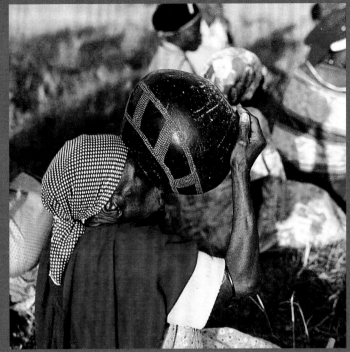

FIG. 4

Among the Zulu, home-brewed beer is the preferred food of the ancestors and is an indispensable part of celebrations marking life's milestones, including birth, marriage, and death. At weddings the bride and groom's families share beer as a symbol of their newly forged connection. Pots for serving and drinking beer, like that used by this guest, are blackened and embellished with textured patterns. Blackening attracts the ancestors, whose presence and blessing are desired. Photo by Jean Morris, KwaZulu-Natal, South Africa, 1960/74.

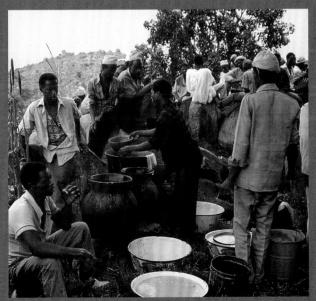

FIG. 5

In the Mandara Mountains between Nigeria and Cameroon, home-brewed sorghum beer is an essential component of social ritual. Its presentation is a gesture of hospitality and, as a favorite drink of the ancestors, a symbol of connection with generations past. Here members of the Sukur Young Farmers' Society heat the beer offered to them by the elders whose fields they have finished cultivating. Brewed by the elders' wives, the beer was transported in the enamel basins seen in the foreground and then transferred into ceramic containers. Photo by Nic David, Mandara Archaeological Project, Sukur, Nigeria, 1992.

EASTERN AND SOUTHERN AFRICA

THE VAST REGION OF EASTERN Africa stretches westward from the coast across the Rift Valley to the Great Lakes—Victoria, Tanganyika, and Malawi—and southward from the headwaters of the Nile to the floodplains of the Zambezi River, where this area merges physically and culturally with southern Africa. This extraordinary region presents tremendous geographic diversity including massive lakes, high mountains, fertile plateaus, and arid savanna. Its populations witnessed the earliest stirrings of humankind some two and one half million years ago, and they demonstrate an equally diverse mix of cultures that reflect the shifting of people through time. Predominant are speakers of Nilo-Saharan and Bantu languages—some pastoralists and others agriculturalists—who migrated across the region over the course of the first millennium A.D. and slightly before, bringing with them pottery practices that still exercise influence throughout the region today. South of the Zambezi River, the high plateaus of southern Africa are broken by areas of forest and desert. Beginning in the fourth century A.D., Bantu-speaking farmers with pottery and ironworking skills made their first appearance in the region, merging with and displacing the indigenous hunters and gatherers.[1]

While no single trait unifies the pottery of eastern and southern Africa, several broad themes have developed across parts of the region. Beginning in A.D. 800, for example, roulette-impressed decoration, widely associated with Nilotic-speaking populations, began to take hold around the Great Lakes, and today, the creative application of roulette patterns continues to give pottery from this area a distinctive appearance.[2] Similarly, in northwestern Tanzania pottery used in sacred healing practices—whether to hold medicines or to embody spirits—is frequently embellished with spiky projections. This practice may be seen as part of a much broader association between pottery spikes and medicine that can be traced across the mid-section of the African continent. Finally, throughout much of southern Africa, some of the finest pottery is crafted specifically for the storage, serving, and drinking of home-brewed beer (see "Beer and Palm Wine").

OPPOSITE: 123 (DETAIL)

175

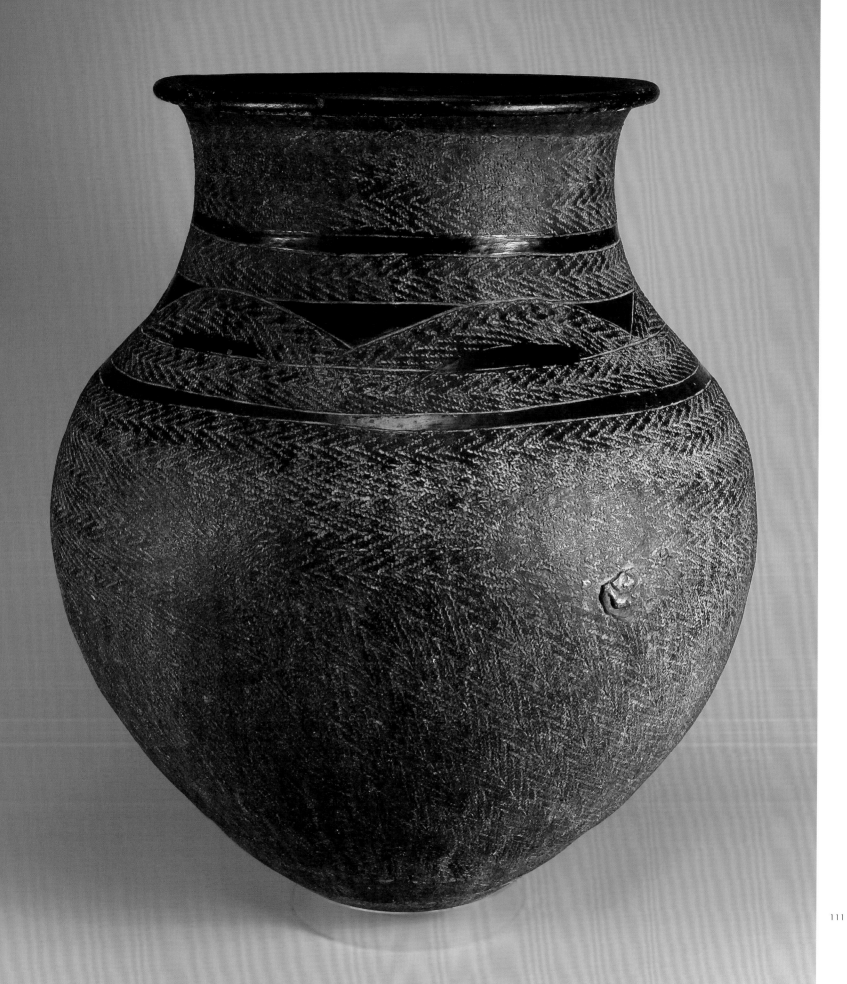

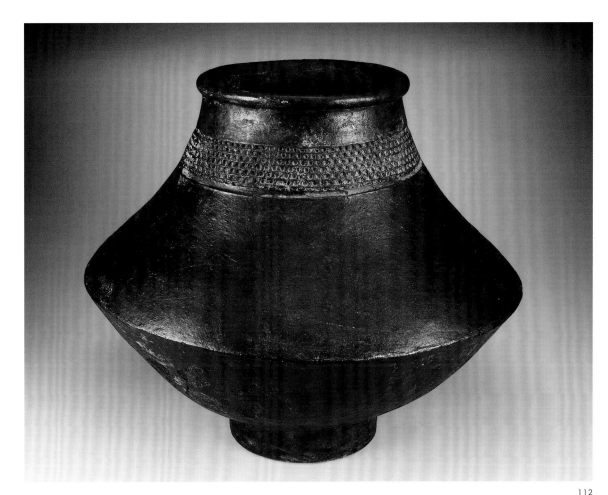

112

111

CONTAINER

Unidentified culture; Kenya,
Sudan, or Uganda
Mid-/late 20th century
Terracotta and pigment
68.6 x 57.2 cm (27 x 22½ in.)

112

CONTAINER

Unidentified culture; Kenya,
Sudan, or Uganda
Mid-/late 20th century
Terracotta
26.7 x 31.8 cm (10½ x 12½ in.)

THE GREAT LAKES REGION of eastern Africa, which contains the massive Lake Victoria as well as many smaller bodies of water, is a cultural melting pot that includes Nilotic- and Bantu-speaking peoples. Ancient roulette-decorated pottery, dating as early as A.D. 800, has been found in the region and is widely associated with the Nilotic populations.[1] Today, roulette work is still the most common form of pottery decoration in the region.

Large containers such as the one shown here (cat. 111) began to appear on the Western art market in 2001 and are sometimes identified as created by the Luo.[2] As a group these vessels have gracefully undulating shapes that move easily from a wide mouth to a slightly more narrow neck, bowing out again at the middle and then gradually narrowing to a small, rounded base. The containers are covered with a richly textured herringbone pattern of careful roulette work crisply applied in bands. This textured surface is offset at the shoulders and neck by patterns of highly burnished ribbons and alternating triangles tinted with brown and dark red slip. The great similarities in shape, proportion, and embellishment of these vessels make it likely that they were produced within the same localized community of potters.[3] This sizeable example is believed to come from Sudan, which is not part of the Luo heartland. Luo potters in Kenya, however, do create containers of similar shape, although with more narrow necks, as do the Vuma of Uganda.[4] They generally employ this type for storing or brewing beer.

The smaller jar (cat. 112) is also believed to come from the Great Lakes region, where vessels of similar size and related shape are commonly used to store milk and other liquids.[5] This piece has a narrow mouth and flares dramatically to a sharply defined edge two-thirds of the way down the form. The base is hemispherical and terminates in an attached foot. A roulette band encircles the neck, below which a large, very lightly incised flower petal pattern is offered as a surprise to the person who looks closely.

113

MEDICINE CONTAINER
(NKHOBA)

Unidentified culture; northeast
Tanzania
Early/mid-20th century
Terracotta
14 x 12.1 cm (5 ½ x 4 ¾ in.)

114

RITUAL CONTAINER

Possibly Kisi or Pare; Tanzania
Early/mid-20th century
Terracotta and glass beads
24.1 x 17.8 cm (9 ½ x 7 in.)

115

RITUAL CONTAINER

Possibly Tanzania
Early/mid-20th century
Terracotta and pigment
21.6 x 16.5 cm (8 ½ x 6 ½ in.)

113

SMALL POTTERY CONTAINERS and figurines are among the ritual objects made throughout north-eastern Tanzania for use in sacred practices, called *ughanga*, that are important in healing physical and psychological afflictions and misfortunes. *Ughanga* is, in fact, a multifaceted and adaptive institution that pervades much of society in north-eastern Tanzania,[1] and *ughanga* objects such as these receptacles hold medicines and in some cases embody spirits that can be called upon to aid in treatment. The medicines are made by traditional healers, called *waghanga*, who are expert herbalists and the keepers of cultural knowledge, history, and custom.[2] They may administer their mixtures in a straightforward fashion or in conjunction with prayer, with the singing and dancing of spirit songs, and in ritual performances that unite all of these facets and allow the healer to engage with spirits and ancestors.[3]

The smallest of the three containers shown here (cat. 113) is powerful in its rudimentary form. The small hole at its top was probably once

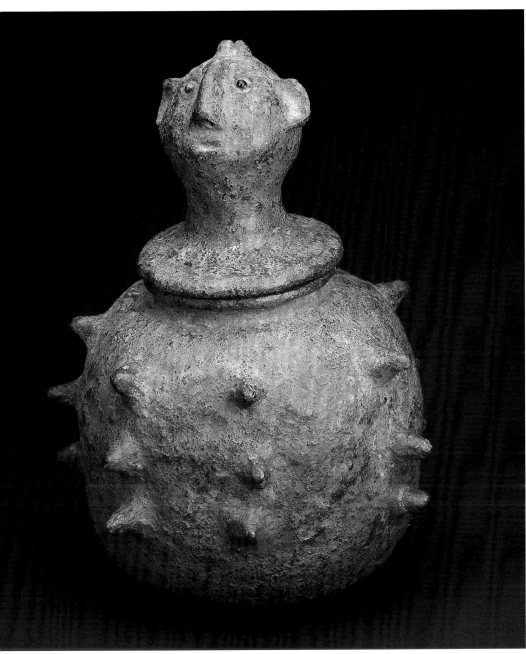

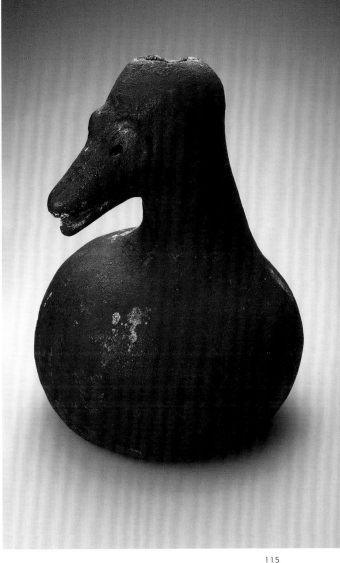

114

115

plugged with a wooden stopper. In the second container (cat. 114) this basic template is given a more sophisticated, anthropomorphized form. The human head that completes the vessel has the long nose, crested coiffure, round ears, and piercing eyes that typify figures made by the Kisi or Pare. The black-bead eyes, in particular, likely indicate that the figure was associated with a particularly powerful category of spirits that are symbolized by the color black.[4]

New forms of *ughanga* objects are continually being invented, while old forms pass out of use.[5] Nonetheless, the monkey or birdlike face on the third example (cat. 115) is idiosyncratic, although its round base and entry hole at top are consistent with healing objects from northeastern Tanzania.

116

BEER STORAGE CONTAINER
(INDEKO)

Ikombe Kisi; Tanzania
Late 20th century
Terracotta and pigment
20.3 x 34.3 cm (8 x 13½ in.)

THE NYAKYUSA, who live just north of Lake Malawi, and the northern Kisi, who reside along the lake's eastern shore, share a closely related history that includes very similar pottery techniques and an overlapping repertoire of forms.[1] Pots are built by hand from slightly sandy, light gray-brown clay; no grog is added to strengthen their composition, which makes them challenging to fire successfully.[2] Once they are leather hard, a gray slip is applied inside and out and the exterior is burnished to a high gloss. Pots are then fired in a shallow pit with both wood and grass or leaves.[3]

Girls learn these techniques of pottery making from female relatives first through informal observation and then, by age seven or eight, through direct instruction.[4] By age ten, they are already starting to master some of the basic shapes, though they continue to learn more complex forms well into adulthood. Despite the effect of such tightly knit communities of potters in producing highly localized ceramic styles, increasing commercialization has led to some homogenization in the region.[5] This has been particularly true for the basic cooking pots that are the staple product of Nyakyusa and Kisi potters. In contrast, the thin-walled and exactingly burnished beer storage containers continue to reflect wider variations in style.[6]

The carinated form of this beer container is particularly elegant, with its slightly thickened lip, sharp-edged transition at midpoint, and rounded bottom. The vessel's overall shape is complemented by the arching pattern, in burnt red slip, that encircles its shoulder. This slip, which also highlights the lip of the piece, is applied in sweeping, calligraphic gestures that leave linear brush marks in their wake. This style of painted embellishment is applied to beer storage pots and other small vessels made in the Kisi village of Ikombe. Called *mahena*, it is one of the distinctive qualities that differentiate Ikombe ceramics from others in the region.[7] Black now covers the lower half of this piece and once disguised the painted pattern above almost completely. It is uncertain why or how the black was added to the pot, and other published examples from Ikombe do not share this characteristic.[8]

Containers from other parts of the region demonstrate a contrasting approach to form and ornamentation.[9] While they maintain the overall wide and squat character of Ikombe examples, they do not have the distinctive, sharp-edged transition at midpoint. Some also bear a vertical ribbed texture, applied during burnishing, that begins several inches below the mouth and stands in sharp contrast to the smooth surface of Ikombe beer containers.

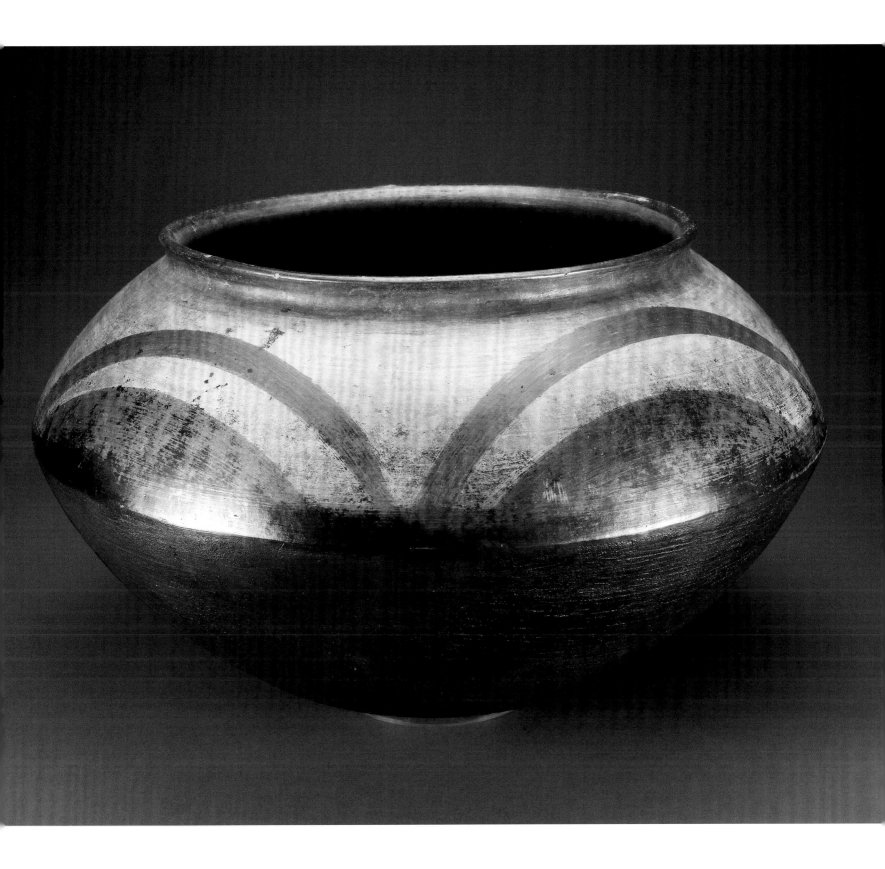

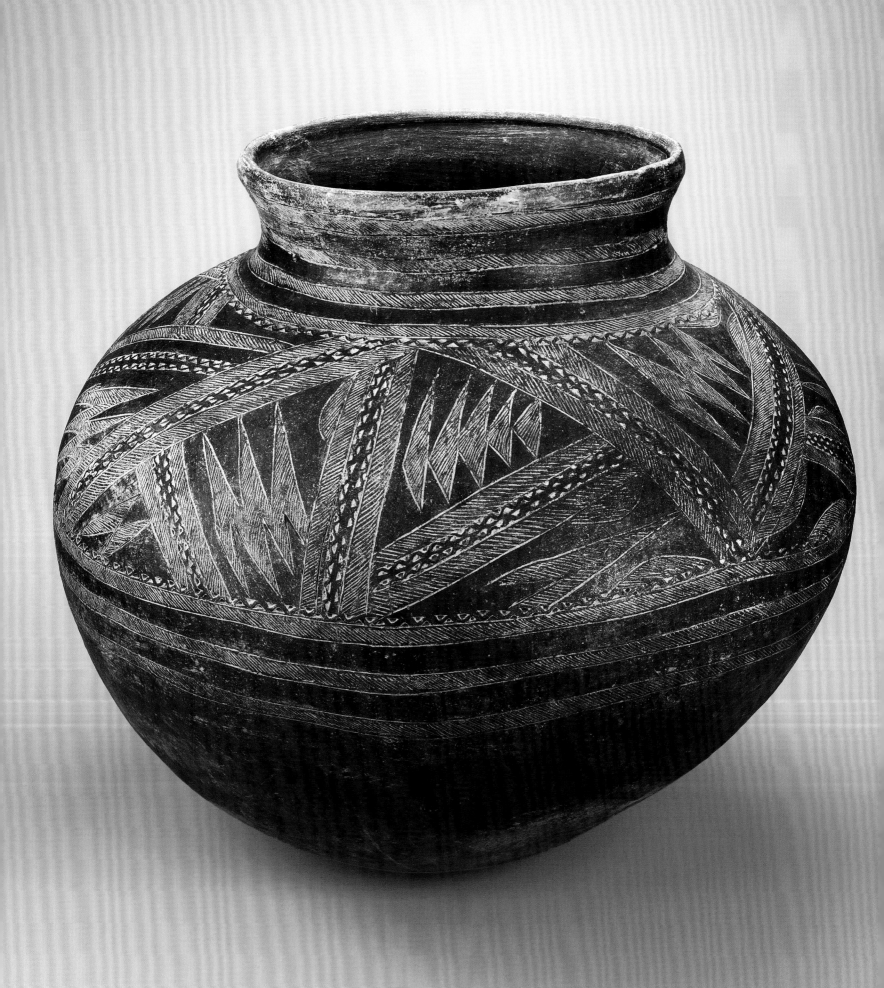

117

WATER CONTAINER
(CHILONGO CHAKUMUTO)

Makonde; Mozambique
Mid-/late 20th century
Terracotta and kaolin
58.4 x 63.5 cm (23 x 25 in.)
The Art Institute of Chicago,
restricted gift of Mrs. Stanley M.
Freehling, 2001.150

THE MAKONDE OF NORTHERN MOZAMBIQUE are known for their large, intricately ornamented pottery jars, and while these are increasingly being supplanted today by other, less-fragile containers, some people still prefer them for transporting and storing water (see "Pottery and the Home," fig. 3).[1] Hence, these handsome vessels continue to be made for domestic use, and their beauty has also led to their production for the commercial art market. Writing in 1961, Margot Dias reported that large versions were widely used by women, while smaller ones were made for pubescent girls just beginning to take on adult responsibilities.[2] Made on commission, such vessels were among the most treasured possessions of Makonde women, and their importance was expressed by their extended lives: when a pot became too worn for carrying water, it could be converted into a storage receptacle for dry goods such as beans, corn, and millet.[3] Later it might also be placed on a woman's grave.[4]

The water jar is the Makonde potter's favored stage for virtuoso expressions of creativity, such that no two pots ever receive the same overall design.[5] After a piece has been built up of coils and then smoothed, shaped, and left to dry for several hours, it is painted with a mica-rich wash of earth, charcoal, and water, which gives it a distinctive, speckled gray-black color.[6] Once this colored wash has been absorbed, the potter burnishes the surface with a stone until it is hard and smooth. At this point the water pot is ready to be meticulously embellished with incised designs.

The Makonde word for drawing on pottery, *nkova*, is the same word they use for tattooing, once a widespread practice with important ritual significance, and many visual similarities exist between these two art forms.[7] The potter marks the outlines of the pattern—a combination of straight and curved bands, zigzags, triangles, and semicircles—and then fills it in with light hatch marks, punctured lines, or more deeply impressed triangles (see "The Potter's Art," fig. 2). Another woman may sometimes assist her in this lengthy process.[8] Finally, after firing it in the open, the maker may accentuate the designs by rubbing kaolin into them.

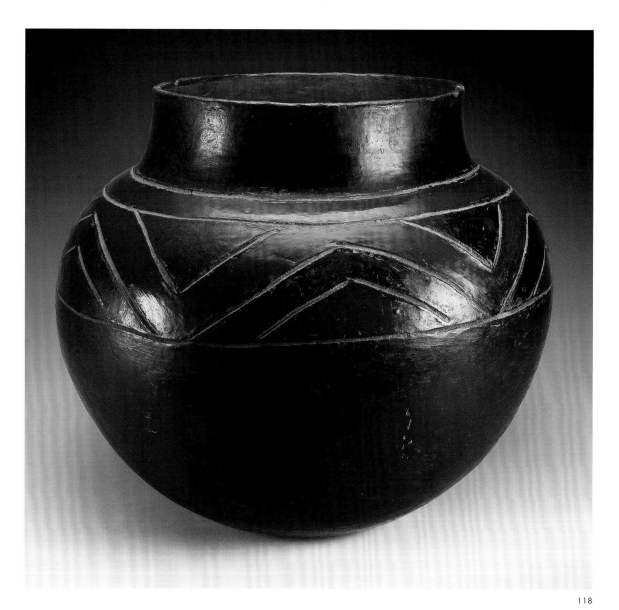

118

**CONTAINER FOR WATER
OR BEER**

Shona; Zimbabwe or Mozambique
Mid-/late 20th century
Terracotta and enamel paint
36.8 x 42.6 cm (14 ½ x 16 ¾ in.)

119

**CONTAINER FOR WATER OR
BEER** (INONGO)

Gwembe Tonga; Zambia
Mid-/late 20th century
Terracotta and pigment
39.4 x 41.3 cm (15 ½ x 16 ¼ in.)

118

THE RURAL SHONA EARN their living from farming, herding cattle, and practicing specialized crafts that can be pursued in the winter months when fields are fallow. While men may become blacksmiths, carpenters, or woodworkers to supplement their family's income, women can learn to make baskets, bark cloth blankets, or pottery for household use and sale.

Potters produce vessels in standard sizes and shapes for various uses including carrying and storing water; cooking, storing, and serving food and beer; drinking beer and water; and eating. Small pieces may be modeled from a single lump of clay, though bigger ones often require the addition of extra coils to build them to sufficient size. A potter forms the upper portion of each work

first, including any burnishing and incising she may wish to give it.[1] After this part has dried to the hardness of leather, the pot is turned over and the bottom is formed using coils (see "Ceramics in Africa," fig. 7.)

Although cooking vessels are usually left unembellished, Shona storage containers are often burnished to a high sheen, and potters sometimes rub them with graphite powder to achieve a metallic luster. They then ornament the pots around the shoulder with bold geometric patterns, most frequently simple crosshatched bands or large triangles in alternating black and ocher.[2] By the early 1960s, some potters had also begun to use enamel or oil-based paint on their wares in place of more traditional pigments.[3] The glossy

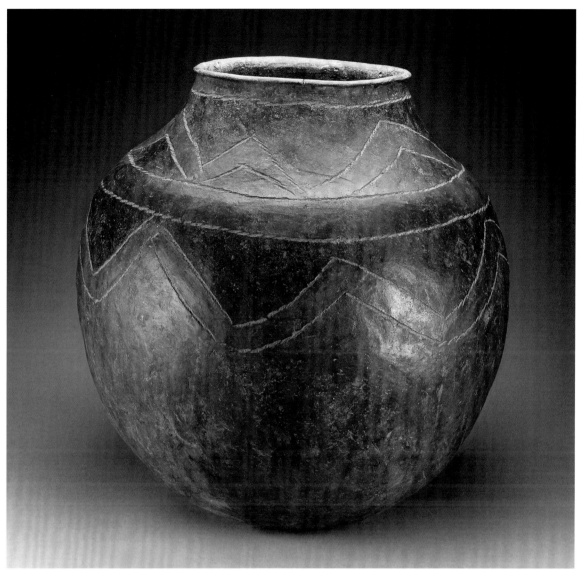

119

red and black paints that embellish the Shona water container illustrated here (cat. 118), for example, evoke the traditional graphite and ocher palette. The straightforward pattern of alternating red and black zigzags and triangles is beautifully proportioned to the size of the pot and is outlined with a wide, confidently drawn groove. The thin red ring painted around the pot's inner lip is a subtle finishing touch.

The Tonga live to the east of the Shona in Zambia's Gwembe Valley and share with them pottery techniques.[4] Particularly gifted Tonga potters are specialists who attribute their talents to selection by an ancestor who was also a skilled practitioner.[5] Like many in Africa, they focus a great deal of attention on making water containers such as the one shown here (cat. 119). These vessels must be well formed, thin walled, and symmetrical so that they can be borne atop the head while filled with several gallons of water.[6] Because they are among the most public of pots, attention is also devoted to embellishment. Here a design of large triangles and zigzag bands emphasizes the muscular proportions of the vessel's short neck and shoulders. The incised lines have been rendered quickly and at times they skip along the clay in a staccato rhythm. The potter has rubbed a deep red pigment, probably iron-rich hematite, on alternating sections to enhance the warm, yellowish orange of the body.[7]

120

WATER BOTTLE

Lozi or Mbunda; Zambia
Mid-20th century
Terracotta and pigment
36.8 x 22.9 cm (14 ½ x 9 in.)

121

WATER BOTTLE

Lozi or Mbunda; Zambia
Mid-20th century
Terracotta and pigment
35.6 x 28.6 cm (14 x 11 ¼ in.)

THE REGION OF PRESENT-DAY ZAMBIA, in south-central Africa, has been a nexus of trade and migration for centuries. A flow of people, practices, and goods has resulted in a cultural overlap and blending that are reflected in the form and function of the arts, including pottery. This integration is particularly true along the northern Zambezi River in western Zambia, where waves of migration from the west, northwest, and south significantly changed the region's ethnic makeup in the eighteenth and nineteenth centuries.

During the late nineteenth century, it was also along the northern Zambezi River in Barotseland that King Lewanika united the dominant Lozi population with other diverse minority communities including the Mbunda and Tonga.[1] A skilled and visionary leader, Lewanika carefully positioned his kingdom to be successful politically and economically in the difficult period that led to colonial rule. Among his actions were the promotion and sale of art to European clients.[2] As part of this initiative, the king forged an agreement with a representative of the American Museum of Natural History, New York, which brought that institution more than 4,000 objects between 1906 and 1918, including baskets, ivory hairpins, wooden masks, and pottery.[3] He also worked closely with representatives of

the British South Africa Company, which likewise purchased a variety of goods—including ceramics—that eventually found their way into museum collections.[4]

One of the water bottles in the Achepohl collection (cat. 120) shares some of the classic characteristics of the pottery made during Lewanika's reign. These include, most notably, a highly distinctive flared lip; a two-toned palette of yellow-orange and red-orange that is generously marked by dark flashes from firing; and the stacking of shapes—here in the form of multiple cones—to create an inventive, towerlike structure. The inclusion of leafy stems on the neck may suggest that this piece was made in the mid-twentieth century, when a delicate, botanical style was in fashion.[5] The work was brought to the United States in the mid-1990s by an American missionary and his Mbunda wife, who reported that it had been made by an Mbunda potter.[6]

With its rounded lip, somber palette, and precisely composed decoration, a second example (cat. 121) shows a more austere approach to form and embellishment. Bottles such as this are traded into Zambia's northwest province, where they are called "African refrigerators" for their excellent ability to keep water cool by slow evaporation through the porous ceramic.[7]

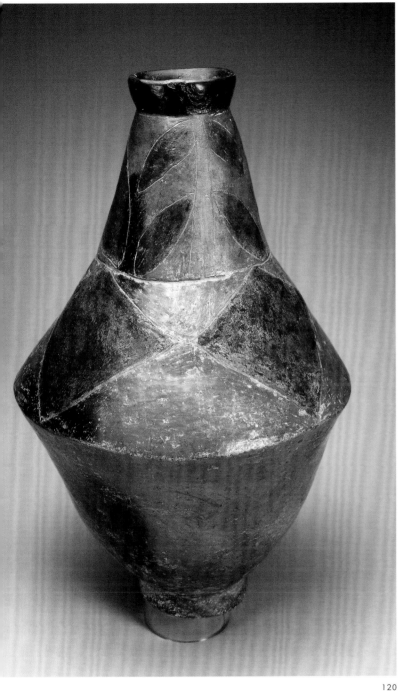

120

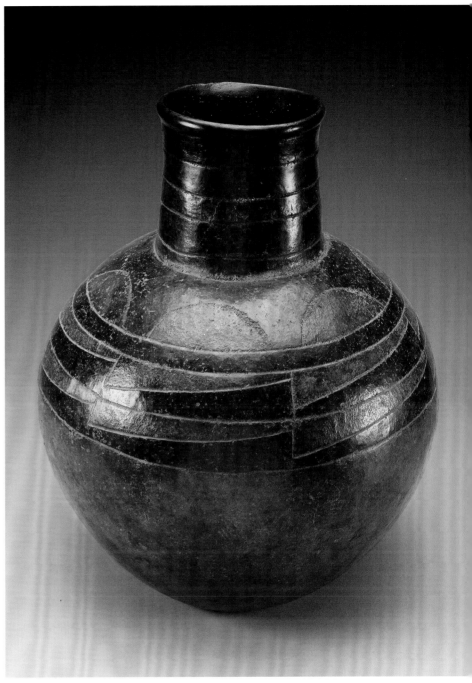

121

122

VESSEL FOR SERVING BEER
(IZIKHAMBA)

Zulu; Kranskop or vicinity,
KwaZulu-Natal, South Africa
Early/mid-20th century
Blackened terracotta
48.3 x 50.8 cm (19 x 20 in.)
The Art Institute of Chicago,
Charles R. and Janice Feldstein
Endowment, 2003.78

123

VESSEL FOR SERVING BEER
(IZIKHAMBA)

Zulu; KwaZulu-Natal, South Africa
Mid-20th century
Blackened terracotta
27.3 x 26.7 cm (10 ¾ x 10 ½ in.)

124

VESSEL FOR SERVING BEER
(IZIKHAMBA)

Zulu; KwaZulu-Natal, South Africa
Mid-20th century
Blackened terracotta
21.6 x 26.7 cm (8 ½ x 10 ½ in.)

125

VESSEL FOR SERVING BEER
(IZIKHAMBA)

Zulu; Hlabisa region,
KwaZulu-Natal, South Africa
Mid-20th century
Blackened terracotta
24.1 x 29.2 cm (9 ½ x 11 ½ in.)

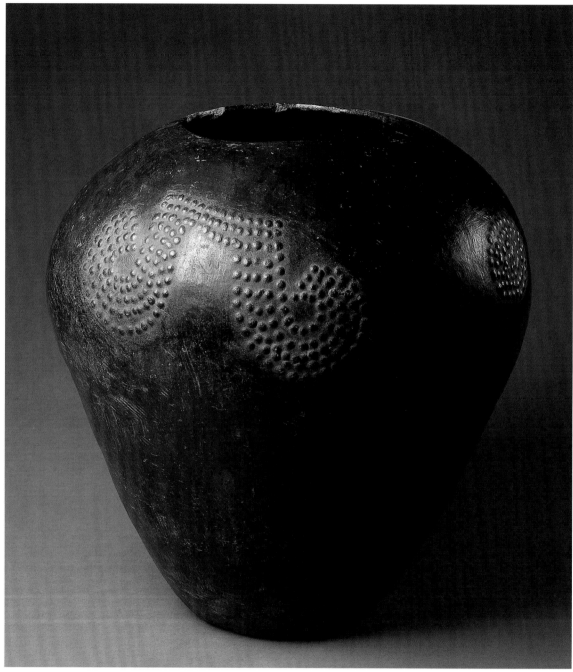

122

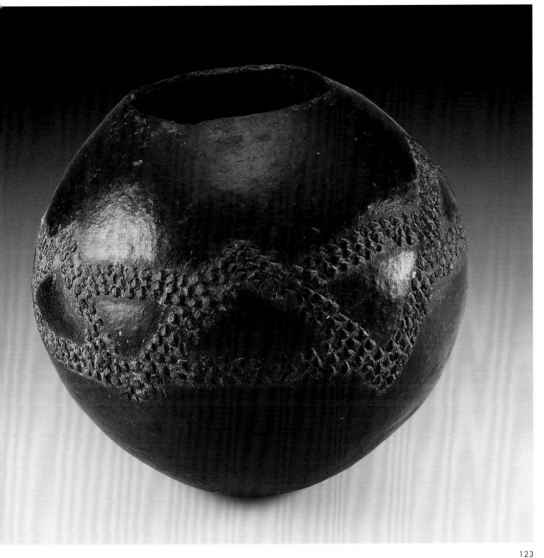

123

the earth—which is both the resting place of the ancestors and the provider of nourishment for the living—is perceived as feminine. The earth also supplies the clay that women use to make pots.[3] Vessels are made for a variety of domestic needs, including the preparation and serving of food and drink, and many of these purposes have important ritual dimensions. Supreme among them is the brewing and serving of beer (see "Beer and Palm Wine").

Sorghum beer, called *utshwala*, has been produced in the Zulu region for at least as long as pottery has.[4] It is considered the food of the ancestors, who are drawn to its smell from first brewing to full flower.[5] For this reason, numerous rules and prohibitions guide its making, storing, serving, and drinking.[6] The beverage's popularity increased in the nineteenth century as crops became more plentiful, and its significance as a social lubricant that could promote solidarity within a community also expanded.[7] Today, homemade beer made from sorghum and other grains continues to be an essential part of Zulu ritual and social life, and ceramic pots have remained the favored container.[8]

Pots for brewing and storing beer are large, unembellished, and made of coarse clay. These vessels are kept in the dark, far back reaches of the house, in the sacred and private area called *umsamo* that is visited by one's ancestors (see "Pottery and the Home," fig. 4).[9] The more public containers for serving and drinking beer, like these, are made from finer clay and are blackened in a smoky reduction firing of grass or dung. Blackening signifies the association of

AMONG THE ZULU, pottery is a specialized art form practiced by skilled women who make wares for family use and for sale.[1] Archaeology has revealed ceramic traditions in the region that date to the first century B.C., and Nguni-speaking ancestors of the Zulu are believed to have begun making pottery in the early second millennium A.D.[2] Not surprisingly given its historic importance, pottery has symbolic dimensions that are expressed both covertly and overtly in Zulu culture. According to Zulu mythology, for example,

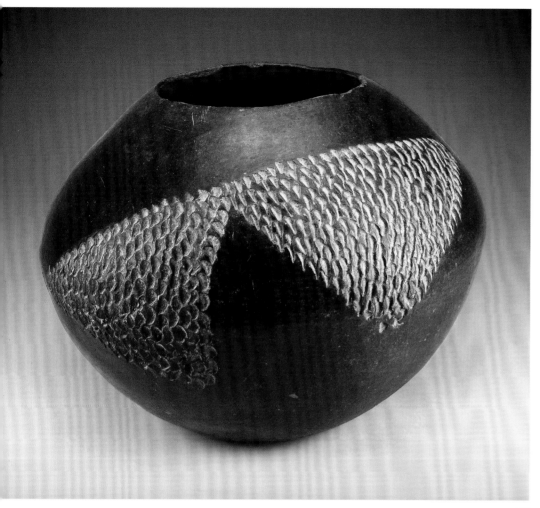

124

parts, this example is lipless, thin-walled, and smoothly burnished, although its broad shoulders, sloping sides, and narrow base give it a more substantial presence.

Zulu potters use a variety of patterns to ornament beer vessels, the textures of which stand in strong contrast to the pots' highly burnished surfaces. Patterns often run in a chain around the shoulders of a pot or take the form of large shapes placed in a pleasingly off-balanced manner across the belly. Among the oldest forms of decoration is the application of clusters of raised welts, known as *amasumpa* or "warts" (see cat. 122–23). *Amasumpa* were used to embellish pots as early as the beginning of the nineteenth century,[12] and it is likely that the welts were originally a royal prerogative and a symbol of wealth and royal patronage that gradually grew to have wider use.[13] Certainly they bear resemblance to the scarifications that enhanced the bodies of young women into the mid-nineteenth century, and they may symbolically allude to the number of cattle given by a groom to his bride's family or more broadly to the large herds of cattle that composed an extended family's wealth.[14] In southern Africa, cattle and beer are both linked to communicating with and commemorating one's ancestors.[15] The double-hooked motif on the largest *izikhamba* (cat. 122), suggestive of a cow's horns, underscores this association.

One of the beer pots in the Achepohl collection (cat. 124) illustrates another widespread decorative technique in which small semicircular indentations are pressed into the clay in tight rows that define a geometric shape or band.[16] Here the marks are crisply executed and inscribe two large triangles extending point-to-point at an angle across the body of the vessel. Potters in the Hlabisa region use a comb to inscribe thin, closely spaced lines.[17] On another example (cat. 125), these form a textured panel around the pot's body that is intersected by a smooth zigzag band at the shoulders.

the pots with the ancestors and creates an environment that is more accessible to them.[10] Serving beer to family and guests, therefore, is a meaningful gesture of hospitality and spiritual connection that is enhanced by the use of beautiful containers. The *ukhamba* (singular, *izikhamba*), or serving pots, used at most gatherings are medium sized (see cat. 123–25). They are attractively round with an unornamented lip, and the most accomplished pieces have very thin, evenly worked walls and a smooth, glossy surface.[11] Wealthy households with the means to host larger gatherings may own a much bigger *izikhamba* such as the one shown here (cat. 122). Like its smaller counter-

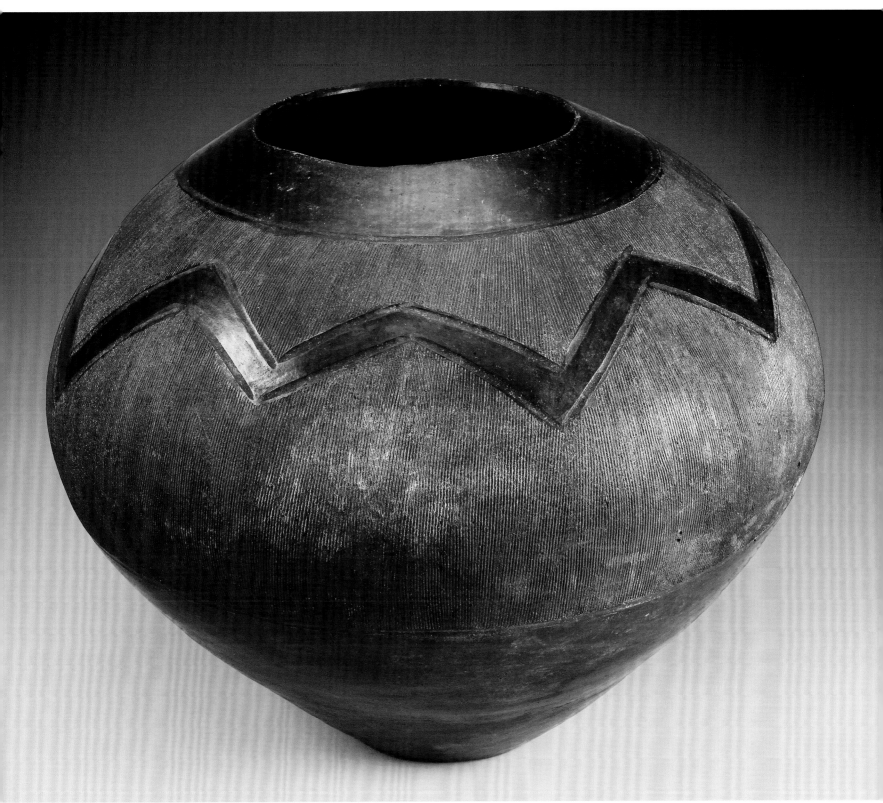

NOTES

CERAMICS IN AFRICA, PP. 17–30.

1. Roy (2000c, p. 143) considered this point in his comparative study of African pottery techniques.

2. Garlake 1995, p. 33.

3. Garlake 1995, p. 33.

4. Russman 1995, p. 43.

5. Desmedt 1991, p. 163.

6. The site of Kwale in Kenya, which dates between the first and fourth centuries A.D., revealed an abundance of Bantu-influenced pottery, while Kivinja, spanning roughly the same time period, contained this early style as well as the later triangular incised ware; see Kusimba 1999, pp. 90–91.

7. Davison 1995b, p. 182.

8. See, for instance, Sterner and David 1991; Herbert 1993; Frank 1994; Frank 1998.

9. Frank 1998, p. 153; Herbert 1993, p. 200.

10. See, for instance, Sterner and David 1991; Herbert 1993; Frank 1994; Frank 1998.

11. According to the Senufo scholar Anita Glaze (personal communication, May 2005), the ancient, core blacksmith artisan group in the central Senufo region are the Fonobele, whose wives specialize in mat and basket making, while potters belong to the Kpeenbele artisan group and intermarry with brass casters.

12. See, for instance, McIntosh and McIntosh 1988; McIntosh and McIntosh 1993.

13. Childs and de Maret 1996, p. 51.

14. Davison (1995a, pp. 194–95) speculated that these materials may have been used in initiation rituals.

15. Berns 1993 cogently and convincingly argued this point.

16. For instance, according to Roy (1987, pp. 55–57), Mossi women in the north and Mossi men in the south use the concave mold technique, whereas Mossi women in the southwest use the convex mold technique.

17. Aronson 1984, pp. 123, 127–29.

18. Berns (1993, pp. 135–36) argued that this does not fully explain why women dominate pottery production in Africa, since men who are farmers are equally available for this work during the dry season, when pottery is most often produced, and are less likely to be called away from their work by other household tasks.

19. Aronson (1984, p. 129) made this point for pottery.

20. Herbert 1993, pp. 206–16.

21. Herbert 1993, p. 216.

22. Various authors have summarized these processes. For the Mande-speaking region, see, for instance, Frank 1998; for West Africa, see Roy 2000c; for an overall summary that draws on examples primarily from central and southern Africa, see Krause 1997.

23. Frank 1998, p. 79.

24. Barley 1994, p. 21; Krause 1997, pp. 117–18. Krause went in to note that secondary clays—those that have been removed from their place of origin by wind, water, or ice, thereby picking up impurities that modify their texture and particle size—require a lower firing temperature. This is important to pottery technology in Africa, where clay is traditionally fired at low temperatures.

25. Frank 1998, pp. 79, 81.

26. Forni 2000–2001, pp. 100–101.

27. Krause 1997, p. 118; Roy 2000c, p. 124.

28. The wheel is used only in North Africa, and primarily in urban areas. Christopher Roy conducted a cross-cultural comparison of pottery making techniques in West Africa and provided detailed summaries of these techniques; see Roy 2000a, 2000c, and 2003. Alain Gallay, Eric Huysecom, and Anne Mayor encountered the same techniques in their comparative study of pottery in the region of the Inland Niger Delta; see Gallay, Huysecom, and Mayor 1996 and 1998.

29. This technique has been given several names. Frank (1998, pp. 95, 97), for instance, called it "paddle and anvil"; Gallay, Huysecom, and Mayor (1996, p. 48; 1998, p. 16) called it "pounding in concave form"; Roy (2000c, pp. 130–31) referred to it as the "concave mold technique"; and Sterner and David (2003, pp. 5–9) labeled it "tamper and concave anvil."

30. Lindahl and Matenga 1995, pp. 30–31.

31. Fatunsin (1992, pp. 23–26) called this the "direct method."

32. Forni (2000–2001, pp. 104–05, 118, 137, 150–51) described and illustrated this technique.

33. Soper 1985, p. 30.

34. For the Yoruba, see Wahlman 1972, pp. 326–27; for the Hausa, see Nicholson 1929, pp. 47–48; for the Mossi, see Roy 1987, pp. 56–59.

35. See Roy 2000c, p. 139.

36. Roy (2000c, pp. 139–40, 141–43) offered an excellent summary of these processes and their ramifications.

37. For a summary of roulette decoration in Africa, see Soper 1985.

38. Roy 2000a, p. 2.

39. Many authors have pointed out the folly of trying to draw firm distinctions between sacred and secular pottery in Africa. See, for instance, Spindel 1989, p. 66; Herbert 1993, p. 205; Argenti 1999, p. 2.

40. Vogel 1997, p. 116

41. See Berns 1989b; Berns 1990.

42. Berns 1990 explored this idea with specific reference to the Yungur.

43. David, Sterner, and Gavua 1988, p. 366.

ANCIENT CIVILIZATIONS OF THE NIGER BEND, PP. 32–33.

1. For more on the geographical and cultural history of the Niger River, see Musée national des arts d'Afrique et d'Océanie 1993.

2. See, for instance, McIntosh and McIntosh 1988; McIntosh and McIntosh 1993; McIntosh 2000.

3. McIntosh and McIntosh 1988, p. 151.

4. Gado 1993, pp. 365–74.

5. Gado 1993, p. 374.

CAT. 1, PP. 34–35.

1. McIntosh and McIntosh (1988, pp. 150–51) discussed the urban character of the region and the widespread production of pottery.

2. McIntosh and McIntosh 1988, p. 151; McIntosh and McIntosh 1993, pp. 631–32; LaViolette 2000, p. 58.

3. Berns 1993 argued succinctly that ceramic sculpture was likely made by women potters.

4. This head is similar in style to that on a kneeling female figure with bumps illustrated in Schädler 1985, pp. 24–25. While these works possibly represent a regional style, this cannot be proven since neither was scientifically excavated.

5. McIntosh and McIntosh 1979, p. 53.

6. Such vessels are sometimes referred to as incense pots; for a summary of such vessels, see de Grunne 1983, pp. 27; 65, cat. 55–57.

7. McIntosh and McIntosh 1979, p. 52; McIntosh and McIntosh 1980a, p. 14; de Grunne 1980, p. 14.

8. Masson-Detourbet 1953, p. 100, fig. 3.

CAT. 2–4, PP. 36–37.

1. For a similar example, see de Grunne 1983, p. 69, cat. 64.

2. See McIntosh 1995, pls. 6–13, for variations on the twisted-cord roulette pattern and other roulette patterns commonly found at Jenné-Jeno.

3. For other examples of pottery from the region with similar ornamentation, see Stössel 1984, pp. 223–24, pl. 85; and Dawson 2001, n.pag.

4. McIntosh and McIntosh 1980b, p. 117.

CAT. 5–8, PP. 38–40.

1. McIntosh and McIntosh 1980a, p. 11; McIntosh and McIntosh 1981, p. 15.

2. Finer, thinner-walled pottery at Jenné-Jeno results from finer grog being used in the clay body; see McIntosh 1995, p. 162; LaViolette 2000, p. 58.

3. For three examples believed to be in the Bankoni style, see Garrard 1995, p. 495, fig. 6.41.

4. For a discussion of the possible belief systems of the Middle Niger, see McIntosh and McIntosh 1988; the authors also discussed the homogenization of the region over time, as seen through material remains such as pottery.

5. Szumowski 1957, pp. 234–38; 246, pl. 7, fig. 10; de Grunne 1983, pp. 75; 93, fig. 74.

6. Szumowski 1957, pp. 234–35.

7. McIntosh 1995, p. 144.

8. See McIntosh and McIntosh 1980b, pp. 122, 125; McIntosh 1995, pp. 135–36.

CAT. 9–10, P. 41.

1. Bedaux and Raimbault 1993, p. 276.

2. For similar bottles which are believed to come from the "Tumuli Region between Timbuktu and Lake Debo," see de Grunne 1983, p. 14, no. 14; for flat-shouldered examples, see pp. 38–40, nos. 13–15; for round-bottomed ones, see p. 15, no. 1; 32, no. 2. For a round-bottomed bottle excavated at El Oualadji, see Bedaux and Raimbault 1993, p. 278, fig. 5, no. 2. A description of bottles from the site of Killi can be found in Desplanges 1903, p. 162. Bottles similar in shape but with roulette work on the lower half have been excavated at Jenné-Jeno; for a brief description, see McIntosh and McIntosh 1980b, p. 216, fig. 15.

3. Bedaux and Raimbault 1993, p. 279.

4. McIntosh and McIntosh 1988, pp. 147, 153.

CAT. 11–12, P. 42.

1. McIntosh and McIntosh 1988, p. 151; McIntosh and McIntosh 1986, pp. 312–13.

2. Bedaux and Raimbault 1993, p. 279.

3. For Killi, see Bedaux and Raimbault 1993, p. 278, fig. 5.1; for Gourma-Rharous, see McIntosh and McIntosh 1986, p. 312, fig. 11, right.

CAT. 13, P. 43.

1. Gado 1993, pp. 368–69.

2. Gado 1993, pp. 368–69.

3. Gado 1993, pp. 366–67.

BERBER NORTH AFRICA, PP. 46–47.

1. D'Ucel 1932, p. 27.

CAT. 14, PP. 48–49.

1. Martinez-Servier 1998, p. 384. Herber (1946, p. 88) suggested that Berber women from Bhalil make pots in autumn because the weather is cooler at that time.

2. In Egypt it is men who make such jugs using a potter's wheel; see Henein 1992 and 1997.

3. This idea developed in discussion with Douglas Dawson.

4. Phillips 1995, p. 565.

5. Jereb 1995, p. 115.

6. Jereb 1995, p. 116.

CAT. 15, P. 50.

1. Marie-France Vivier, personal communication, July 2004

2. Amamra 2003, p. 28.

3. For a summary of the pottery process see Van Gennep 1911, pp. 628–49.

4. Saïd 2003, p. 33, Vivier 1995, p. 564.

5. For a succinct description of geometric design in Algerian pottery, see Balfet 1957, pp. 16–17.

6. Van Gennep 1911, p. 28

7. Vivier 2003, pp. 15–17; Amamra 2003, p. 29; Bynon 1984, pp. 138–39.

CAT. 16, P. 51.

1. Jamieson 2000, p. 54.

2. Bliss 1998, pp. 191–92; Jamieson 2000, p. 56.

3. Bliss 1998, p. 192; Nessim Henry Henein, personal communication, Sept. 2004.

WEST AFRICA: SAHEL AND SAVANNA, PP. 54–55.

1. Frank 1998, p. 8.

2. For a cogent summary of the Islamicization of West Africa, see Bravmann 1974.

CAT. 17, PP. 56–57.

1. Nicholson (1929) discussed the various forms of pots made by men and women in Sokoto, Nigeria; Krieger (1961) emphasized the role of men in making pottery in Anka, Nigeria; and Dupuis and Echard (1971) described the exclusive role of women in making pottery in the Ader region of Niger.

2. See Nicholson 1929 and Krieger 1961 for descriptions of this process.

3. See, for instance, Heathcote 1977, p. 41; O'Brien 1989, p. 17; Rammage et al. 1980, p. 21; and Leith-Ross 1970, p. 18.

4. Nicholson (1929, p. 47) noted that a roulette pattern impressed just below the neck is a standard form of decoration on Hausa pottery from Sokoto.

5. Nicholson 1929, p. 47; Krieger 1961, p. 365.

6. Douglas Dawson, personal communication, Nov. 2002.

7. Leith-Ross (1970, p. 23, figs. 362–63) illustrated two smaller water containers with similar shapes but different approaches to embellishment; Stössel (1984, p. 297, fig. 235) published another related vessel, with a shorter and wider neck, that is identified as a storage container.

CAT. 18–19, PP. 58–59.

1. Alternative spellings include *Djerma* and *Zarma*.

2. See Gallay, Huysecom, and Mayor 1998, p. 43, for a summary of Songhay (Sonraï) pottery techniques; Etienne-Nugue and Saley (1987, p. 101) remarked on the widespread use of molds for making pottery in Niger, but without specific reference to the Jerma; Anquetil (1977, pp. 39–40) noted the close ties between Songhay and Jerma craft techniques.

3. Anquetil 1977, pp. 39–40.

4. Etienne-Nugue and Saley 1987, p. 103

5. Gardi 1970, p. 112.

6. Stössel 1984, p. 299, fig. 241.

CAT. 20–21, PP. 60–61.

1. Gallay 1991–92, p. 29.

2. Frank 1998, p. 43.

3. LaViolette 2000, p. 59.

4. Like the Bamana, the Bozo speak a Mande language. They are widely considered to be the original inhabitants of the Inland Niger Delta region.

5. Gallay, Huysecom, and Mayor 1996, p. 30; Gallay, Huysecom, and Mayor (1998, 23) called this pottery tradition "Bozo-Somono" based on the fact that Somono potters speak the Bozo language; the authors further remarked that people of Bozo ethnicity do not make pottery.

6. For a description of Somono pottery techniques, see Gallay, Huysecom, and Mayor 1998, pp. 24–30, pl. 7–8; LaViolette 2000, pp. 61–70.

7. Gallay, Huysecom, and Mayor (1998, p. 25) described this as a version of the concave mold technique, whereas LaViolette (2000, p. 64) argued that the saucer acts only as a holder.

8. Bedaux et al. 1978 and 1994, cited in Gallay, Huysecom, and Mayor 1998, p. 25.

9. Anne Mayor, personal communication, Mar. 2005.

10. Dawson (2001, n. pag.) identified this work as a Bozo lamp but noted its similarity to Somono pottery.

11. Frank 1998, p. 33.

12. Gallay, Huysecom, and Mayor (1998, p. 26, fig. 13, pl. 8, nos. 40, 42) illustrated these tools and techniques.

13. Anne Mayor, personal communication, Mar. 2005; LaViolette (2000, pp. 64–65) reported the same shift in practice in the region of Jenne; Frank 1998, p. 33.

CAT. 22, PP. 62–63.

1. Dawson 2003, pp. 200–21.

2. Gallay, Huysecom, and Mayor 1996, p. 30; Gallay, Huysecom, and Mayor 1998, p. 23.

3. For examples see Gallay, Huysecom, and Mayor 1996, pp. 87–93.

CAT. 23, PP. 64–65.

1. See, for instance, de Grunne 1980, p. 89, fig. 116, p. 110, fig. 127; de Grunne 1983, p. 65, no. 56.

2. Frank 1998, p. 9. The Fula are also referred to as Fulani or Peul.

3. McIntosh and McIntosh 1982, pp. 406–407.

4. Stössel 1981b, p. 17.

5. Lids with loops are not unknown in the Inland Niger Delta. Gallay, Huysecom, and Mayor (1998, p. 29, fig. 16, no. 5) illustrated a Bozo lid with a similar shape but with two intersecting loops, rather than the single loop seen here.

6. Frank 1998, p. 34, fig. 26.

7. Frank 1998, p. 34, fig. 27.

8. Frank 1998, p. 33.

CAT. 24–26, PP. 66–68.

1. For more on the status of artists in Mande society, see Conrad and Frank 1995; Frank 1998; McNaughton 1988.

2. Frank 1998, pp. 125, 130–33.

3. Frank 1998, pp. 132–33.

4. See Frank 1998, pp. 83–89, for a description of this process; Gallay, Huysecom, and Mayor (1998, pp. 46–57) defined three regional variants of Bamana pottery.

5. Frank 1998, pp. 83–84

6. Frank 1998, p. 29.

7. Frank 1998, pp. 21, 33.

8. Frank 1998, p. 19.

9. Frank 1998, pp. 92–94.

10. Douglas Dawson, personal communication, spring 2003.

CAT. 27, P. 69.

1. Glaze 1981, p. 5; Anita Glaze (personal communication, May 2005) noted that the wives of Senufo blacksmiths specialize in making mats and baskets. This is in contrast to Mande blacksmiths, whose wives are potters.

2. Glaze 1981, p. 34.

3. Anita Glaze, personal communication, May 2005.

4. This is also true for Tyedunbele potters; Frank 1998, pp. 94–97. For a description of Kpeenbele Senufo pottery techniques, see Spindel 1989, pp. 69–71.

5. Spindel 1989, p. 69.

6. Anita Glaze, personal communication, May 2005.

7. Stössel 1984, pp. 245–47, figs. 128–29, 131–32. Several are identified as coming from the village of Diamankani.

CAT. 28, P. 70.

1. Roy 1987, p. 360; scholars also refer to the Tusyan as *Tusyâ* and *Toussain*.

2. Haselberger (1969, pp. 225, 228) illustrated several related jars that are identified as Gouin (figs. 25–27), Tourka (fig. 28), Tiefo (fig. 31), and Toussian (figs. 34, 36). See also Dawson 2005, p. 12.

3. Susan Cooksey, personal communication, Apr. 2005.

4. Susan Cooksey, personal communication, Apr. 2005.

CAT. 29, P. 71.

1. Schneider 1997, p. 111.

2. Schneider (1990, p. 49) observed that craft specialization and interdependency are part of the local economy, offering the example of Lobi potters who sell pots to their Birifor neighbors, who in turn specialize in making baskets and mats. This may explain why some pots in this style have been anecdotally attributed to the Kasena; Douglas Dawson, personal communication, summer 2001.

3. Roy (1987, pp. 52–33) called this method "direct pull"; Schneider 1997, p. 112; for a comprehensive description of pottery making techniques, see Schneider 1990, pp. 72–99, pls. 2–6.

4. Schneider 1990, p. 49; Schneider 1997, pp. 111–12.

5. Schneider 1990, p. 148: Schneider 1997, p. 112.

6. Schneider 1990, pp. 101, 108, fig. 8.

7. Schneider 1990 illustrated these tools (p. 98, figs. 1–5) and the techniques for using them (pl. 2).

CAT. 30–32, PP. 72–75.

1. Schneider (1990, p. 169; 1997, p. 114) discussed this in reference to the Lobi. Spindel (1989, p. 72) discussed it in reference to the neighboring Senufo.

2. Schneider 1990, pp. 170–71; Schneider 1997, p. 112.

3. Schneider (1990, pp. 171–72; 1997, p. 114) outlined these criteria for the Lobi, but the same is true among other Gur-speaking people.

4. Schneider 1990, p. 173; Schneider 1997, p. 114.

5. Spindel 1989, p. 72.

6. Schneider 1997, p. 114.

7. Schneider (1990, pp. 176–78; 1997, p. 114), who produced the most comprehensive study of Lobi pottery, did not discuss the significance of human figures on altar pots; he did, however, address freestanding clay figures made by men, which represent supernatural helpers for *thila*.

8. Schneider (1990, pp. 175; 185, fig. 83) described double altar vessels for twins.

9. Klaus Schneider, personal communication, May 2005.

CAT. 33–34, PP. 76–77.

1. These people are often collectively referred to as "gurunsi," a name given them by the politically dominant Mossi; this term, however, is considered pejorative by many; see Roy 1987, p. 204.

2. Roy 1987, p. 209.

3. Roy 1987, p. 52.

4. See, for instance, Haselberger 1969, p. 225, no. 10; K.-F. Schädler 1997, p. 91, fig. 130; Dawson 2001, n. pag.; Dawson 2005, p. 22.

5. Bourdier and Minh-Ha Trinh illustrated a pot with similar embellishment in an eastern Kasena home (1985, p. 157, pl. 72; the pot is seen on the lower right); Fred Smith, personal communication, Apr. 2005.

6. Dawson 2005, p. 22.

7. Roy 1987, p. 212.

CAT. 35–36, PP. 78–79.

1. Fred Smith, personal communication, Apr. 2005.

2. Archer 1971, p. 55 right, p. 56 upper right.

3. Smith 1989, p. 63.

4. Douglas Dawson, personal communication, summer 2001.

5. Haselberger (1969, pp. 225; 228, fig. 8; 237, fig. 20) illustrated several pots with this shape from the Kasena region of Burkina Faso.

CAT. 37–39, PP. 80–82.

1. For a summary of Mossi history and society, see Roy 1987, pp. 91–96.

2. Roy 1987, p. 93.

3. Roy 1989, p. 254.

4. Roy 1989, pp. 256, 262.

5. Roy 1987, p. 57; Roy 1989, p. 256.

6. For comparative examples, see Roy 1987, p. 58, fig. 23; Musée national des Arts d'Afrique et d'Océanie 1993, p. 561, fig. 153; Anderson Gallery 1996, p. 12, fig. 47; Dawson 2001, n.p.; Dawson 2005, p. 16.

7. Musée national des Arts d'Afrique et d'Océanie 1993, p. 561, fig. 155.

8. Musée national des Arts d'Afrique et d'Océanie 1993, p. 279, fig. 7.

CAT. 40–41, PP. 83–84.

1. Musée national des Arts d'Afrique et d'Océanie 1993, p. 561, fig. 154; Anderson Gallery 1996, p. 12, fig. 43.

2. Douglas Dawson, personal communication, 2004; Roy 1987, p. 259.

CAT. 42–44, PP. 85–87.

1. Dawson 2005, p. 24. See Bourdier and Minh-Ha Trinh 1985 for excellent photographs of such pots in context, and Roy 2005 for video of such pots during beer brewing.

2. Bourdier and Minh-Ha Trinh 1985, pp. 57, 20.

3. Roy 1987, p. 53.

4. Dawson 2001, n.p.

5. Roy 1987, pp. 219–21.

6. Dawson 2005, p. 24.

CAT. 45–46, PP. 88–89.

1. See Anderson Gallery 1996, p. 12, fig. 43, for a tall container, reputedly Kasena, with a similar treatment of the lid.

2. Roy 1987, p. 223; Dawson 2001, n.p.

WEST AFRICA: FOREST AND COAST, PP. 92–93.

1. Roy 2000c, p. 125.

2. Roy 2000c, p. 125.

3. Roy 2000c, p. 132.

4. For more on Nok, see Fagg 1977 and Fagg 1994.

5. For more on Igbo-Ukwu, see Shaw 1970.

6. For more on Ife, see Willet 1967 and Drewal, Pemberton, and Abiodun 1989.

7. Berns 1993, p. 136–37.

CAT. 47–49, PP. 94–96.

1. See, for instance, Etienne-Nugue and Laget 1985, pp. 92–94; Soppelsa 2000, pp. 216–18; Schwab 1947, pp. 131–33.

2. Vogel 1997 provided a sensitive exploration of Baule concepts of looking at art.

3. Fischer and Himmelheber (1984, figs. 157–62) illustrated this process.

4. Similar bowls, identified as Guere (an alternate name for the We), are illustrated in Etienne-Nugue and Laget 1985, p. 108, fig. 3. Dan examples appear in Fischer and Himmelheber 1984, pp. 160–65, pls. 189–93.

5. Schwab (1947, figs. 61a, 63c) illustrated large Sapo (called Sapa) water pots of a similar shape; in the same publication, fig. 62d illustrates Mano examples and fig. 63h illustrates a Dan (called Gio) example.

6. Schwab 1947, p. 131.

CAT. 50–51, PP. 97–99.

1. Preston 1981, p. 83.

2. Cole and Ross 1977, p. 118–19; Sieber 1972, p. 174.

3. Rattray (1927, p. 301) stated that only men can make anthropomorphic or zoomorphic pottery; this was contradicted by Sieber 1972, p. 178; Cole and Ross 1977, p. 122; and McLeod 1981, p. 157. Cole and Ross (1977, p. 119) translated *abusua kuruwa* as "family pot" or "clan pot"; McLeod (1981, p. 157) translated it as "the cup of the matrilineage."

4. Cole and Ross 1977, p. 122.

5. See Sieber 1972, p. 179, which refers specifically to Kwahu potters.

6. This is described in Sieber 1972, pp. 178–79.

7. Rattray 1927, pp. 164–65.

8. Sieber 1972, p. 178; Cole and Ross 1977, p. 120; McLeod (1981, pp. 157–58) suggested that in some cases in the recent past, commemorative pottery may have been placed on shrines or in stool rooms for safekeeping.

9. Dawson (2001, n. pag.) referred to the town as Inkuoka. This is probably a transliteration of Nkawkaw, pronounced "In-kor-kor," a major Kwahu trading town; Nii Quarcoopome, personal communication, Feb. 2005.

10. Preston 1981, p. 83; Cole and Ross 1977, pp. 119–20.

11. Nii Quarcoopome, personal communication, Feb. 2005.

CAT. 52–53, PP. 100–101.

1. Blier 1995, p. 4.

2. Blier 1995, p. 259.

3. Hübner 1996, pl. 6.

4. Hübner 1996, pp. 36, figs. 32, 34–35; 50–52; Suzanne Blier, personal communication, Feb. 2005.

5. Blier 1995, p. 150.

6. Hübner 1996, pp. 21, pl. 6; 36, figs. 32, 35; 50–52.

7. K.-F. Schädler 1997, p. 190.

8. Hübner 1996, pp. 52; 136, fig. 34.

CAT. 54–56, PP. 102–04.

1. Douglas Dawson, personal communication, 2001. For two more examples from the group, see Dawson 2001, pp. 42–45.

2. Dawson 2001, p. 42.

3. This observation was informed by Doran Ross, personal communication, July 2003.

4. These are identified by inventory numbers 14053 (accessioned in 1900) and 103417 (accessioned in 1917).

5. According to Nii Quarcoopome (personal communication, Feb. 2005), pots with miniature cups are made for a snake cult that stretches from southeast Ghana into Togo and Republic of Benin.

6. See, for instance, Hübner 1996, pp. 130–34, figs. 1, 3, 10–11, 20, 26–27.

7. See, for instance, Stössel 1984, pp. 32–47; 283, fig. 209; 284, fig. 211.

CAT. 57–59, PP. 105–08.

1. Lombard 1965, pp. 42–43; in the literature the Baatombu are more commonly referred to by the Yoruba term *Bariba*.

2. Lombard 1965, pp 42–43; Sous-Commission Nationale de linguistique Baatonu 1986, pp. 14–17.

3. Sargent and Freidel 1986, p. 182.

4. Sargent and Freidel 1986, pp. 183, 185.

5. Ryan Smith, personal communication, Dec. 2004 and Mar. 2005.

6. Writing in 1957, Lombard (1965, pp. 19–20) remarked on the similarity between the beliefs and traditions that govern Baatombu pottery and ironworking and described the skills as strictly passed from mother to daughter. In contrast N. Schädler (1997, p. 148) noted a conversation with Baatonu potter Bélégou Seydou in which she observed that ironworking is an inherited specialization while pottery is learned through apprenticeship.

7. Lombard (1957, pp. 17–18) described the use of the convex mold technique by the Baatombu. For the distribution of the convex mold technique, see Frank 1998, p. 97. For the technique and its use by the Yoruba, see Wahlman 1972, pp. 314–30.

8. Sargent and Freidel 1986, p. 183; for its use among the Songhay, Fula, and Mossi, see Frank 1998; see Roy 2003 for a demonstration of the technique in conjunction with the convex mold technique among the Mossi.

9. Such pottery was praised by Lombard 1957, p. 19.

10. Some of these may at one time have had lids, as does an example in the Afrika Museum, Berg en Dal, in the Netherlands (Grootaers and Eisenburger 2002, p. 272).

11. See Vidal 1992, p. 14; N. Schädler 1997, p. 149, fig. 252; Grootaers and Eisenburger 2002, p. 273.

12. Ryan Smith, personal communication, Mar. 2005.

13. Ryan Smith, personal communication, Mar. 2005.

14. Ryan Smith, personal communication, Mar. 2005.

15. Ryan Smith, personal communication, Mar. 2005.

CAT. 60–62, PP. 109–111.

1. Lombard 1965, p. 42.

2. The Baatombu potter Bélégou Seydou described receiving guidance and training from a Yoruba potter (N. Schädler 1997, p. 148).

3. Lombard 1957, p. 20.

4. According to Ryan Smith, the symbol represents the Baatombu concept *woru goru*, which can be translated as courage; personal communication, Mar. 2005.

5. Thanks are due to Ryan Smith for a description of marriage jars; personal communication, Mar. 2005.

6. Wahlman 1972, p. 329, fig. 21.

7. Wahlman 1972, p. 329, fig. 21

8. A similar shrine is illustrated in Fatunsin 1992, p. 10, pl. 2.

9. Wahlman 1972, pp. 328–30; Fatunsin 1992, pp. 9–15; according to Fatunsin (p. 9) female deities are most often venerated by potters and include Ìyámòpó, Osun, Olokun, Imòle Ìréfín, and Ayavi.

10. Offerings to the deities associated with pottery include fried maize flour, steamed bean flour with or without oil, honey, yam porridge, oil, and water (Fatunsin 1992, pp. 10–13).

11. This observation was informed by John Pemberton III, personal communication, Feb. 2005.

CAT. 63–64, PP. 112–14.

1. Douglas Dawson, personal communication, Feb. 2005.

2. Pemberton 1989, p. 166–67.

3. Wahlman (1972, p. 334, fig. 27) illustrated a faceless example with a narrower neck that was intended for an Osun shrine in the Ekiti town of Ara. Ojo (1982, pp. 187–88; 205, pl. 9b) reproduced a squatter version with a face that was placed on a shrine dedicated to Oko, god of the farm. Pemberton (1989, p. 167) observed that Oko and Osun are both *orisa funfun*, or deities of whiteness.

4. Fatunsin (1992, pp. 23–26) called this the "direct method."

5. David Doris, personal communication, Feb. 2005.

CAT. 65–67, PP. 115–17.

1. Leith-Ross 1970, p. 146; Picton and Fagg 1970, p. 31; Cole and Aniakor 1984, pp. 78, 82.

2. For more on Igbo-Ukwu, see Shaw 1970.

3. Shaw 1970, p. 207.

4. Leith-Ross 1970, pp. 146; 150, fig. 452; Cole and Aniakor 1984, p. 80; Nicolls 1987, pp. 30–32.

5. Nicolls 1987, pp. 70, 99.

6. Christopher Slogar (personal communication, Jan. 2004) reported seeing pottery like this for sale near Ishiagu in northwest Igboland.

7. Cole and Aniakor 1984, p. 81.

8. Cole and Aniakor 1984, p. 81, fig. 148.

9. Herbert Cole, personal communication, Jan. 2005.

CAT. 68–69, PP. 118–19.

1. Martin, Féau, and Joubert 1997, p. 300, fig. 333.

CAT. 70–71, PP. 120–21.

1. Stössel 1981a, p. 48.

2. Stössel 1981a, p. 48.

3. Perani (1995, p. 523) described the making of a double-tiered pot.

4. Perani 1995, p. 523.

5. Perani 1995, p. 523.

CAT. 72, P. 122.

1. Leith-Ross 1970, p. 101.

2. Vernon-Jackson 1960, p. 58. Nicholson (1934, p. 90) recorded only kiln-firing in Bida. He also described the use of kilns by Nupe in Sokoto, Nigeria (1929, pp. 47–48).

3. Vernon-Jackson 1960, p. 58; Stössel 1981a, p. 24.

4. Cardew (1970, p. 10) reported the use of the direct pull method by Nupe potters. Nicholson (1929, pp. 71–72) described Nupe potters in Bida using the convex mold technique exclusively.

5. See, for instance, Stössel 1981a, pp. 38–41, figs. 1–11.

6. See, for instance, Stössel 1981a, pp. 45–46, figs. 19–20; and N. Schädler 1997, p. 262. They also bear a certain formal resemblance to Yoruba shrine pots such as cat. 102.

7. Stössel (1981a, p. 37) suggested that this may mean they were used to store medicines, although he does not elaborate upon this hypothesis.

8. See Leith-Ross (1970, p. 106) for an illustration of a model Nupe home interior with pottery from the Jos Museum.

9. See, for instance, Perani and Smith 1998, p. 156; K.-F. Schädler 1985, p. 169; K.-F. Schadler 1997, pp. 262–63; Stössel 1984, pp. 300–301.

10. Anderson Gallery 1996, p. 11.

CAT. 73, P. 123.

1. Bandler and Bandler 1977, p. 26.

2. Leith-Ross 1970, p. 95; Perani 1995, p. 523; Perani and Smith 1998, pp. 156–57.

3. Bandler and Bandler 1977, p. 29; Cardew 1969, p. 88.

4. Cardew 1969, p. 88.

5. Cardew 1969, p. 30.

CAT. 74–75, PP. 124–25.

1. Stössel (1981a, pp. 89; 91, fig. 3) published a similarly embellished container without an attribution.

2. Stössel (1981a, p. 90, fig. 1) published a similar vessel that he suggested was from from Eggan. Cardew (1969, pl. 3) illustrated an example that he said came from Gwazunu.

EASTERN NIGERIA AND CAMEROON, PP. 128–29

1. Berns 2000, p. 53.

2. Connah 1976, p. 339.

CAT. 76, PP. 130–31.

1. A variety of forms from the region are illustrated in K.-F. Schädler 1997, pp. 249–50, figs. 484–89; fig. 487 has a similar undulating form and the same impressed interwoven pattern as this vessel.

2. For an overview of the sites and their contents see Ekpo 1982; the suggestion that these may be pre-Qua sites is alluded to in Ekpo 1977, p. 36. More recent excavations by Ekpo Eyo have revealed related finds on Efut and Efik lands as well; Museum for African Art 2001, pp. 15–17; Christopher Slogar, personal communications, 2003 and 2004.

3. Ekpo 1984, p. 58.

4. Ekpo 1984, p. 58; Museum for African Art 2001, p. 15.

5. Ekpo 1984, p. 60.

6. For more on Igbo-Ukwu, see Shaw 1970; a brief reference to ancient terracottas from the lower Cross River can be found in Anderson and Peek 2002, pp. 45–46, fig. 1.18.

CAT. 77–80, PP. 132–33.

1. Berns 1989b, pp. 50–51.

2. Meek 1931, p. 352; Berns 2000, pp. 62–63.

3. Berns 2000, pp. 62–63.

4. According to Hare 1983, pp. 8–9, the blood of a rooster was most often used, although water from a sacred pool was applied in some instances.

5. Berns 2000, p. 62.

6. Hare 1983, p. 8.

7. Meek (1931, p. 351) used the term *kwandalowa*, while Berns (2000, p. 63) used the alternate spelling *kwandalha*.

8. Berns 2000, p. 62.

9. Hare 1983, p. 12, fig. 2.

10. Hare 1983, p. 11, fig. 1; Berns 1989a, p. 35.

11. Berns 1989b, p. 54.

CAT. 81, P. 134.

1. For a comparative example, see K.-F. Schädler 1997, p. 270, fig. 523.

2. Berns 2000, p. 61; K.-F. Schädler 1997, p. 270.

3. Berns 2000, p. 60.

CAT. 82, P. 135.

1. Marla C. Berns, personal communication, 2005.

2. Leith-Ross 1970, pp. 54, fig. 259; 55–56, figs. 622, 793; 85–87, fig. 994; 125–29, fig. 411; 133–36, fig. 640.

3. Wente-Lukas 1977, pp. 13–14, 16, figs. 8–9.

4. Douglas Dawson was told that pots like this were Matakam (an alternate term for Mafa), from Chad; personal communication, spring 2003. This information is confusing, as the Mafa home-land does not stretch as far east as Chad. For two related pots from this group, see Dawson 2005, pp. 64–67. For the Sirak example, see David 1990.

5. Sterner and David (2003, pp. 5–9) described this technique, which they refer to as "tamper and concave anvil," and its use in the Mandara Mountains.

6. Sterner and David 2003, pp. 5–9.

7. David, Sterner, and Gavua 1988, p. 371–72.

8. According to Nicholas David the pellets on the upper tier are typical of the region; personal communication, Dec. 2004. Cone-shaped spikes similar to those on the lower tier appear on a Mafa jug illustrated by LaVergne 1944, p. 90.

9. David, Sterner, and Gavua 1988, pp. 373–75.

10. David, Sterner, and Gavua 1988, pp. 375–77.

CAT. 83, PP. 136–37.

1. Berns 1989b, p. 50.

2. Berns 1986, p. 60.

3. Berns 1986, pp. 64–66.

4. Mark C. Berns, personal communication, Feb. 2005; see also Berns 1986, pp. 64–66, and Berns 1989b, pp. 51–52.

5. Berns 1989b, p. 52.

6. Berns 1986, pp. 139–42.

CAT. 84, PP. 138–39

1. Zeitlyn 1994, p. 40; Zeitlyn 1997, p. 233.

2. Comparative vessels are illustrated in Kennesaw State College 1989, p. 21, fig. 47; Zeitlyn 1997, p. 234; Grootaers and Eisenburger 2002, p. 305.

3. Fr. Hermann Gufler, personal communication, May 2005.

4. Fr. Hermann Gufler, personal communication, May 2005.

5. See Berns 2000, pp. 59–60, fig. 9.

6. Berns 2000, pp. 59–60, fig. 9.

7. Zeitlyn 1997, p. 233.

CAT. 85, PP. 140–41

1. Argenti (1999, pp. 18–19) described the practice of rubbing camwood and oil on the surface of some pots.

2. Northern (1984, p. 50) discussed frog symbolism in the neighboring Grassfields. Similarly abstracted frog motifs are seen on a jug in the collection of the Field Museum, Chicago, collected in 1914 and reportedly from the southern Bamileke region (Northern 1984, p. 114, fig. 42) and on a large wine container illustrated by Dawson 2001 (n. pag.) and identified as Bamileke or Mambila.

3. The widespread use of the spider motif in the neighboring Grassfields is discussed by Northern 1984, p. 49.

4. Fr. Hermann Gufler, personal communication, Mar. 2005.

5. Fr. Hermann Gufler, personal communication, Mar. 2005.

CAT. 86–88, PP. 142–45.

1. The Yamba are also sometimes referred to as the Kaka.

2. Fr. Hermann Gufler, personal communication, May 2005.

3. David Zeitlyn, personal communication, Mar. 2005.

4. Gebauer 1979, pp. 266–68, fig. P138; Dawson 2005, p. 70.

5. Thanks are due David Zeitlyn for making me aware of these images.

6. Fr. Hermann Gufler, personal communication, May 2005.

7. For another example, see Dawson 2001, n.p.

8. Fr. Hermann Gufler and Genesis Ghasi, personal communication, Mar. 2005.

9. Argenti (1999, p. 7) noted that in the Grassfields undecorated pots are not restricted in use to palm wine; he also illustrated a maize beer pot with this general shape; Argenti 1999, p. 29, fig. 18.

CAT. 89–90, PP. 146–47.

1. Forni 2000–2001, p. 56.

2. Argenti 1999, pp. 13–15; Forni 2000–2001, pp. 97–130.

3. Argenti 1999, pp. 5–10; Forni 2000–2001, pp. 131–63.

4. Knöpfli 1997, pp. 56–57.

5. Knöpfli 1997, p. 57; Argenti 1999, p. 5.

6. Argenti 1999, p. 25, figs. 3–6.

7. Knöpfli (1997, p. 59) has speculated on the form of Grassfields oil lamps; Nicolas Argenti and Silvia Forni, personal communications, Mar. 2005.

CAT. 91–93, P9. 148–50.

1. Argenti (1999) and Forni (2000–2001) considered pottery making in these centers.

2. Argenti (1999, p. 35, fig. 45) and Edelman (1989, pp. 34–35, fig. 27) described this form as a water container; Knöpfli (1997, p. 74, fig. 24) illustrated a similar jar that he identified as a palm wine container.

3. Argenti 1999, pp. 18–19.

4. Argenti 1999, p. 19.

5. Argenti 1999, p. 20.

6. Argenti 1999, p. 14.

7. Argenti 1999, p. 13.

8. Argenti 1999, pp. 15; 41, fig. 68.

9. For a discussion of the snake motif, see Northern 1984, pp. 46–47; for references to cowries, see Northern 1984, p. 103.

10. Koloss 2000, p. 341, fig. 276.

CAT. 94–95, PP. 151–53.

1. Desmedt 1991, p. 102.

2. Koloss 2000, p. 101; *njemte* is a food made primarily from guinea corn (p. 58).

3. See, for instance, Argenti 1999, pp. 54–55, pls. 26–28.

4. Argenti 1999, p. 6.

5. For a comparison of pitchers from Nsei and Babessi, see Argenti 1999, p. 34, figs. 42 and 43.

6. Argenti 1999, pp. 7; 34, fig. 42.

7. Thanks to Silvia Forni for information on Martin Fombah; personal communication, Mar. 2005.

8. Forni 2000–2001, pp. 167–68.

9. According to Argenti 1999, p. 13, the double gong motif is popular among Bamessing potters, but is not used in Babessi.

10. Gebauer 1979, pp. 110, 279–91; figs. P149–P160; 359–60, figs. M71–M78; see Koloss 2000, pp. 403–04, figs. 386–87, for examples of bags like this used during rituals.

11. Knöpfli 1997, pp. 88; 94, fig. 8 left.

CENTRAL AFRICA, PP. 156–57.

CAT. 96–98, PP. 158–60.

1. Marc Felix, personal communication, Nov. 2004; Weima (1986, p. 43) displayed a photograph of a chief pouring libations with such a ceramic bottle.

2. Marc Felix, personal communication, Nov. 2004; Maes (1937, pp. 29–33, fig. 18) described pottery techniques in this region and illustrated three examples.

3. Maes 1937, p. 30.

4. Maes 1937, pp. 32–33.

5. Marc Felix (personal communication, Nov. 2004) has seen such bottles used by Kongo and Teke peoples in the region. Felix, Meur, and Batulukisi (1995, p. 136, fig. 3) identified this bottle as Kunyi and presented a schematic drawing of it; see Reunion des musées nationaux 1998, p. 82, fig. 69, for a comparative example identified as Teke.

6. Maes 1937, pp. 24, 26, 28; Reunion des musées nationaux 1998, p. 63.

7. Marc Felix, personal communication, Nov. 2004.

CAT. 99–100, PP. 161–62.

1. Frobenius 1990, p. 97.

2. Frobenius (1990, p. 97) indicated that such containers are used to hold water; Marc Felix (personal communication, Dec. 2004) reported seeing them used to store flour.

3. Frobenius 1990, p. 98.

CAT. 101–03, PP. 163–65.

1. Vansina 1990, pp. 71, 75.

2. Stössel 1984, p. 131, fig. 109.

3. See Stössel 1984, p. 131, fig. 109; Polfliet 1987b, p. 25, fig. 9.

4. Vansina 1990, pp. 81–87.

5. Schildkrout and Keim 1990, p. 112.

6. Schildkrout and Keim 1990, p. 109; Schildkrout, Hellman, and Keim 1989, p. 38.

7. Schildkrout and Keim 1990, p. 111, fig. 6.14.

8. Schildkrout and Keim 1990, p. 110, fig. 6.12.

9. Schildkrout, Hellman, and Keim 1989, pp. 43–44, fig. 10.

10. Dawson 2003, p. 98.

CAT. 104–07, PP. 166–69.

1. Roberts and Roberts 1996, p. 20

2. Roberts (1995, p. 292, fig. 4.65) noted that a group of anthropomorphic and zoomorphic ceramics from the Luba region date from the late nineteenth and early twentieth century.

3. Polfliet 1987a, pp. 13; 38, fig. 12.

4. Polfliet 1987a, pp. 13; 34, fig. 10.

5. Roberts and Roberts 1996, pp. 194–204.

6. Roberts and Roberts 1996, p. 204.

7. Marc Felix, personal communication, Nov. 2004. He also provided information on the use of such bottles.

CAT. 108–10, PP. 170–71.

1. Trowell and Wachsmann 1953, p. 120.

2. According to Roscoe (1923, p. 15) both men and women made pottery for everyday use, but only men made high-quality pottery for the king and the wealthy elite. Trowell (1941, p. 19) stated that pottery is "predominantly a male occupation" and noted (Trowell and Wachsmann 1953, p. 117) "strong taboos against women approaching the clay-pits, or passing when pots are being built or fired."

3. Roscoe (1923, p. 227) suggested that graphite was used to color only pottery made for the king; Trowell did not make this distinction (1941, p. 64; Trowell and Wachsmann 1953, p. 118).

4. Trowell and Wachsmann 1953, p. 29.

5. Trowell and Wachsmann 1953, p. 105.

6. Trowell and Wachsmann 1953, p. 119.

7. Trowell 1941, p. 59.

EASTERN AND SOUTHERN AFRICA, PP. 174–75.

1. Whitelaw 1998, p. 4.

2. Soper 1985; Desmedt 1991.

CAT. 111–12, PP. 176–77.

1. See, for instance, Desmedt 1991, pp. 161–96; Soper 1985, pp. 48–49.

2. For similar examples, see Dawson 2003, pp. 90–91; Vogel 2004, p. 82, cat. 71.

3. Herbich and Dietler (1989, pp. 29, 38) pointed out that such attributes characterize the work of different communities of potters within the Luo area.

4. Michael Dietler, personal communication, Nov. 2004. For an example of a Luo container, see Herbich and Dietler 1989, pp. 30–31, fig. 3.3c. For Vuma examples, see Jensen 1969, p. 99, fig. 32.5; Stössel 1984, pp. 366–67, fig. 378.

5. I am speaking here of pots with narrow mouths that gradually bell to their widest dimension well below midpoint. For an example of a Vuma pot without an attached foot, see, for instance, Jensen 1969, pp. 78; 99, fig. 32.6. Michael Dietler (personal communication, Nov. 2004) also related seeing vessels with a shape much like this made by Kuria potters in South Nyanza, Kenya. Sieber (1980, p. 177) published a wooden milk container from Uganda also with this shape believed to be Hima.

CAT. 113–15, PP. 178–79.

1. For an in-depth study of ughanga and its related arts, see Thompson 1999a.

2. Thompson 1999a, p. 88; Thompson 1999b, p. 1.

3. Thompson 1999a, pp. 88–89.

4. Thompson 1999a, p. 105; Barbara Thompson, personal communication, Mar. 2003.

5. Thompson 1999a, p. 104.

CAT. 116, PP. 180–81.

1. Waane (1976, p. 5) noted that the Ikombe Kisi were gradually becoming integrated with the Nyakyusa and were differentiated from other Kisi peoples living to the south.

2. Waane 1976, p. 34.

3. Waane 1976, p. 22.

4. Waane 1976, p. 10.

5. Waane 1976, p. 30.

6. The Kisi word for pot is indeko. Waane (1976, p. 20) gave the word kifuna (plural vifuna) to vessels of this shape. Others, however, claim that kifuna refers only to a similarly shaped beer container made of knotted fiber; Knut Felberg, personal communication, Jan. 2005.

7. Waane 1976, pp. 20–21.

8. See Waane 1976, p. 49, no. 7; Kirknaes 1982, fig. 17.

9. For two examples identified as Nyakyusa, see, for instance, Dawson 1999, p. 64; Ginzberg 2000, p. 93.

CAT. 117, PP. 182–83.

1. Zachary Kingdon (personal communication, Dec. 2004) suggested that some people prefer to cook in pottery jars because food tastes better prepared this way. Taste is also a likely reason why some people may prefer to continue using a pottery water jar.

2. Dias 1961, p. 99.

3. Dias 1961, p. 102.

4. Dias 1961, p. 106.

5. Dias 1961, p. 119.

6. Dias (1961, pp. 108–23) described and illustrated the step involved in Makonde pottery making.

7. Dias 1961, p. 116; for a discussion of Makonde tattooing, see Schneider 1973, pp. 28–31.

8. Dias 1961, p. 119.

CAT. 118–19, PP. 184–85.

1. Lindahl and Matenga 1995, pp. 30–31.

2. Lawton 1967, pp. 8, 231, 280; Lindahl and Matenga 1995, pp. 32–33.

3. Lawton 1967, pp. 8, 231, 253; Lindahl and Matenga 1995, pp. 32–33.

4. For a description of Tonga pottery techniques, see Reynolds 1968, pp. 144–52.

5. Reynolds 1968, p. 142; Choma Museum and Crafts Centre Trust 2004, p. 2. According to Dewey (1986, p. 67), Shona potters rarely attribute their skills to an ancestor, although this is common among men who are blacksmiths and woodworkers.

6. Reynolds 1968, 154.

7. Bert Witkamp, personal communication, Nov. 2004.

CAT. 120–21, PP. 186–87.

1. But for a brief interval during 1884 and 1885, Lewanika reigned from 1878 until his death in 1916.

2. For a fascinating in-depth study of this topic, see Milbourne 2003.

3. Milbourne 2003, p. 5, and Appendix A, p. 404.

4. Milbourne 2003, p. 57, fig. 10; Barley 1994, p. 34; Sieber 1980, p. 258.

5. Milbourne 2003, p. 201.

6. Douglas Dawson, personal communication, Aug. 2004.

7. Elisabeth Cameron, personal communication, Nov. 2004.

CAT. 122–25, PP. 188–91.

1. Kennedy 1978, p. 3

2. Whitelaw 1998, p. 4.

3. Reusch 1998, pp. 19–20.

4. De Haas 1998, p. 13.

5. De Haas 1998, p. 15.

6. De Haas 1998, p. 15; Reusch 1998, pp. 25–26.

7. De Haas 1998, pp. 13–15.

8. Reusch 1998, pp. 24, 26.

9. Armstrong and Calder 1996, pp. 107–108; Kennedy 1993, p. 226; Reusch 1998, pp. 15, 27 28.

10. Armstrong and Calder 1996, p. 109; Reusch 1998, p. 26.

11. Kennedy 1993, pp. 232–34.

12. Whitelaw 1998, p. 8.

13. Phillips 1995, p. 221.

14. Kennedy 1993, p. 230; Phillips 1995, p. 221; Klopper 1989, p. 36.

15. Klopper 1989, p. 36.

16. Kennedy 1993, p. 231.

17. Gary Van Wyk, personal communication, Aug. 2003.

BIBLIOGRAPHY

Amamra, Aïcha Aziza. 2003. La poterie algérienne. In *Algérie: Mémoire de femmes au fil des doigts*, edited by Béatrice Riottot-El Habib and Marie-France Vivier, pp. 27–30. Paris-Musées.

Anderson Gallery, Drake University. 1996. *Earthen Vessels: Central and West African Works of Fired Clay*. Essay by Phillip Chen. Anderson Gallery, Drake University.

Anderson, Martha G., and Philip M. Peek. 2002. *Ways of the Rivers: Arts and Environment of the Niger Delta*. UCLA Fowler Museum of Cultural History.

Anquetil, Jacques. 1977. *Niger*. L'Artisanat créateur. Agence de coopération culturelle et technique.

Archer, Ian. 1971. Nabdam Compounds, Northern Ghana. In *Shelter in Africa*, edited by Paul Oliver, pp. 46–57. Praeger Publishers.

Argenti, Nicolas. 1999. *Is This How I Looked When I First Got Here? Pottery and Practice in the Cameroon Grassfields*. Occasional Papers, no. 132. British Museum.

Armstrong, Juliet, and Ian Calder. 1996. Traditional Zulu Pottery. In *Zulu Treasures: Of Kings and Commoners, A Celebration of the Material Culture of the Zulu People*, pp. 107–14. KwaZulu Cultural Museum and the Local History Museums, South Africa.

Aronson, Lisa. 1984. Women in the Arts. In *African Women South of the Sahara*, edited by Margaret Jean Hay and Sharon Stichter, pp. 119–38. Longman.

Balfet, Hélène. 1957. *Les Poteries modelées d'Algérie dans les collections du Musée du Bardo*. Ministère de l'Algérie, Imprimerie Officielle.

Bandler, Jane, and Donald Bandler. 1977. The Pottery of Ushafa. *African Arts* 10, no. 3, pp. 26–31.

Barley, Nigel. 1994. *Smashing Pots: Works of Clay from Africa*. Smithsonian Institution Press.

Bedaux, Rogier M. A., and Michel Raimbault. 1993. Les grandes provinces de la céramique au Mali. In *Musée national des arts d'Afrique et d'Océanie 1993*, pp. 273–93.

Bedaux, Rogier M. A., et al. 1978. *Recherches archéologiques dans le delta intérieur du Niger*. Walters.

Bedaux, Rogier M. A., and J. D. van der Waals. 1994. *Djenné: Une Ville millénaire au Mali*. Rijksmuseum voor Volkenkunde, Leiden.

Berns, Marla C. 1986. Art and History in the Lower Gongola Valley, Northeastern Nigeria. Ph.D. diss., University of California, Los Angeles.

———. 1989a. Ceramic Arts in Africa. *African Arts* 22, no. 2, pp. 32–37, 101–02.

———. 1989b. Ceramic Clues: Art History in the Gongola Valley. *African Arts* 22, no. 2, pp. 48–59, 102–03.

———. 1990. Pots as People: Yungur Ancestral Portraits. *African Arts* 23, no. 3, pp. 50–60, 102.

———. 1993. Art, History, and Gender: Women and Clay in West Africa. *African Archaeological Review* 11, pp. 129–48.

———. 2000. Containing Power: Ceramics and Ritual Practice in Northeastern Nigeria. In Roy 2000b, pp. 53–76.

Blier, Suzanne Preston. 1995. *African Vodun: Art, Psychology, and Power*. University of Chicago Press.

Bliss, Frank. 1998. *Artisanat et artisanat d'art dans les oasis du désert occidental Egyptien*. Rüdiger Köppe Verlag.

Bourdier, Jean-Paul, and T. Minh-Ha Trinh. 1985. *African Spaces: Designs for Living in Upper Volta*. Africana Publishing Company.

Bravmann, René A. 1974. *Islam and Tribal Art in West Africa*. Cambridge University Press.

Bynon, James. 1984. Berber Women's Pottery: Is the Decoration Motivated? In *Earthenware in Asia and Africa*, edited by John Picton. Colloquies on Art and Archaeology in Asia, no. 12. University of London, Percival David Foundation of Chinese Art and School of Oriental and African Studies.

Cardew, Michael. 1969. *Pioneer Pottery*. Longmans.

———. 1970. Introduction: Pottery Techniques in Nigeria. In Sylvia Leith-Ross, *Nigerian Pottery*, pp. 9–13. Ibadan University Press of the Department of Antiquities.

Childs, S. Terry, and Pierre de Maret. 1996. Re/Constructing Luba Pasts. In Roberts and Roberts 1996, pp. 49–59.

Cole, Herbert M., and Doran H. Ross. 1977. *The Arts of Ghana*. Museum of Cultural History, University of California, Los Angeles.

Cole, Herbert M., and Chike C. Aniakor. 1984. *Igbo Arts: Community and Cosmos*. Museum of Cultural History, University of California, Los Angeles.

Connah, Graham 1976. The Diama Sequence in the Prehistoric Chronology of the Lake Chad Region of Nigeria. *Journal of African History* 18, no. 3, pp. 321–52.

Conrad, David C., and Barbara E. Frank. 1995. *Status and Identity in West Africa: Nyamakalaw of Mande*. Indiana University Press.

Choma Museum and Crafts Centre Trust. 2004. Tonga Crafts and People. http://www.catgen.net/cmcc/EN/100003.html.

David, Nicholas. 1990. *Vessels of the Spirits: Pots and People in North Cameroon*. Videorecording. University of Calgary, Department of Communications Media.

David, Nicholas, Judy Sterner, and Kodzo Gavua. 1988. Why Pots are Decorated. *Current Anthropology* 29, no. 3, pp. 365–89.

Davison, Patricia. 1995a. Lydenburg Head. In Phillips 1995, pp. 194–95.

———. 1995b. Southern Africa. In Phillips 1995, pp. 179–85.

Dawson, Douglas. 1993. *African Ceramics: Ancient and Historic Earthenware Vessels*. Douglas Dawson Gallery.

———. 1999. Revelations of the African Potter. *American Craft* 59, no. 5, pp. 64–69.

———. 2001. *Of the Earth: Ancient and Historic African Ceramics*. Douglas Dawson Gallery.

———. 2003. *The Art of African Clay: Ancient and Historic African Ceramics*. Douglas Dawson Gallery.

———. 2005. *The Potter's Hand: Historic African Ceramics*. Douglas Dawson Gallery.

De Haas, Mary. 1998. Beer. In *Ubumba: Aspects of Indigenous Ceramics in KwaZulu-Natal*, edited by Brendan Bell and Ian Calder, pp. 13–17, 124–29, 141–47. Tatham Art Gallery, Pietermaritzburg.

Desmedt, Christiane. 1991. Poteries anciennes décorées à la roulette dans la Région des Grands Lacs. *African Archaeological Review* 9, pp. 161–96.

Desplagnes, Louis. 1903. Etude sur les tumuli du Killi dans la région de Goundam. *Anthropologie* 14, pp. 151–72.

Dewey, William J. 1986. Shona Male and Female Artistry. *African Arts* 19, no. 3, pp. 64–67, 84.

Dias, Margot. 1961. Makonde-Topferei. *Baessler-Archiv* n.s. 9, no. 1, pp. 95–126.

Drewal, Henry John, John Pemberton III, and Rowland Abiodun. 1989. *Yoruba: Nine Centuries of African Art and Thought*. Center for African Art and Harry N. Abrams.

D'Ucel, Jeanne. 1932. *Berber Art: An Introduction*. University of Oklahoma Press.

Dupuis, Annie, and Nicole Echard. 1971. La Poterie Traditionnelle Hausa de l'Ader, Rep. Du Niger. *Journal de la Societé des Africanists* 41, no. 1, pp. 7–34.

Edelman, Nancy W., ed. 1989. *Guide de l'art camerounais du Musée Monastère Bénédictin Mont Fébé, Yaoundé*. Les Bénédictins du Monastère Mont Fébé.

Ekpo, V. I. 1977. New Archaeological Materials from Calabar, Nigeria. *Nigerian Field* 42, no. 4, pp. 36–38.

———. 1982. New Archaeological Sites in the Lower Cross River Region. *Nigerian Field* 47, no. 1–3, pp. 45–51.

———. 1984. Qua Terracotta Sculptures. *African Arts* 18, no. 1, pp. 58–60, 96.

Etienne-Nugue, Jocelyne, and Elisabeth Laget. 1985. *Artisanats traditionnels Côte d'Ivoire*. Institut culturel africain.

Etienne-Nugue, Jocelyne, and Mahamane Saley. 1987. *Artisanats traditionnels Niger*. Institut culturel africain.

Fagg, Angela. 1994. Thoughts on Nok. *African Arts* 27, no. 3, pp. 79–83, 103.

Fagg, Bernard. 1977. *Nok Terracottas*. Ethnographica for the National Museum, Lagos.

Fatunsin, Antonia K. 1992. *Yoruba Pottery*. National Commission for Museums and Monuments, Lagos.

Felix, Marc Leo, Charles Meur, and Niangi Batulukisi. 1995. *Art et Kongos: Les Peuples Kongophones et leur sculpture Biteki bia Bakongo*, vol. 1, *Les Kongo du Nord*. Zaïre Basin Art History Research Center, Brussels.

Fischer, Eberhard, and Hans Himmelheber. 1984. *The Arts of the Dan in West Africa*. Museum Rietberg.

Forni, Silvia. 2000–2001. *Molding Culture: Pottery and Traditions in the Ndop Plain (North West Province-Cameroon)*. Universita' degli Studi di Tornio, Dipartimento di scienze Antropologiche, Archeologiche e Storico Territoriali, Dottorato di Ricerca in Antropologica Culturale ed Etnologia.

Frank, Barbara E. 1994. More than Wives and Mothers: The Artistry of Mande Potters. *African Arts* 27, no. 4, pp. 26–37, 93–94.

———. 1998. *Mande Potters and Leatherworkers: Art and Heritage in West Africa*. Smithsonian Institution Press.

Frobenius, Leo. 1990. *Ethnographische Notizen aus den Jahren 1905 und 1906*, vol. 4, *Kanyok, Luba, Songye, Tetela, Songo Meno/Nkutu*. Franz Steiner Verlag.

Gado, Boubé. 1993. Un 'village des morts' à Bura en République du Niger. Un site méthodiquement fouillé fournit d'irremplaçables informations. In Musée national des arts d'Afrique et d'Océanie 1993, pp. 365–77.

Gallay, Alain. 1991–92. Traditions céramiques et ethnies dans le delta intérieur du Niger (Mali). *Bulletin du Centre Genevoise d'Anthropologie* 3, pp. 23–46.

Gallay, Alain, Eric Huysecom, and Anne Mayor. 1996. *Hier et Aujourd'hui: Des Poteries et des femmes, Céramiques traditionnelles du Mali*. Département d'anthropologie et d'écologie, Université de Genève.

———. 1998. *Peuples et céramiques du delta intérieur du Niger (Mali): Un Bilan de cinq années de missions (1988–1993)*. Verlag Philipp von Zabern.

Gardi, René. 1970. *Artisans africains*. Editions Sequoia.

Garlake, Peter. 1995. The African Past. In Phillips 1995, pp. 31–37.

Garrard, Timothy F. 1995. Djenne Terracottas. In Phillips 1995, pp. 488–95.

Gebauer, Paul. 1979. *Art of Cameroon*. Portland Art Museum and Metropolitan Museum of Art.

Ginzberg, Marc. 2000. *African Forms*. Skira.

Glaze, Anita J. 1981. *Art and Death in a Senufo Village*. Indiana University Press.

Grootaers, Jan-Lodewijk and Ineke Eisenburger. 2002. *Forms of Wonderment: The History and Collections of the Afrika Museum, Berg en Dal*. 2 vols. Afrika Museum.

Grunne, Bernard de. 1980. *Ancient Terracottas from West Africa (Terres cuites anciennes de l'Ouest africain)*. Institut supérieur d'archéologie et d'histoire de l'art, Louvain-la-Neuve.

———. 1983. *La poterie ancienne du Mali : quelques remarques préliminaires*. Galerie Biedermann.

Hare, John N. 1983. *Itinate and Kwandalowa: Ritual Pottery of the Cham, Mwana and Longuda Peoples of Nigeria*. Ethnographica.

Haselberger, Herta. 1969. Bemerkungen zum Kunsthandwerk in der Republik Haute Volta: Gourounsi und Altvölker des äussersten Südwesterns. *Zeitschrift für Ethnologie* 94, no. 2, pp. 171–246.

Heathcote, David. 1977. *The Arts of the Hausa*. University of Chicago Press.

Henein, Nessim Henry. 1992. *Poteries et proverbs d'Egypte*. Institut français d'archéologie orientale du Caire.

———. 1997. *Poterie et potiers d'Al-Qasr, oasis de Dakhla*. Institut français d'archéologie orientale du Caire.

Herber, Joseph. 1946. Notes sur les poteries de Bhalil. *Hespéris: Archives Berbères et bulletin de l'institut des hautes études marocaines* 33, pp. 83–92.

Herbert, Eugenia. 1993. *Iron, Gender, and Power : Rituals of Transformation in African Societies*. Indiana University Press.

Herbich, Ingrid, and Michael Dietler. 1989. River-Lake Nilotic: Luo. In *Kenyan Pots and Potters*, edited by Jane Barbour and Simiyu Wandibba, pp. 27–40. Oxford University Press.

Hübner, Irene. 1996. *Geest en Kracht: Vodun uit West-Afrika*. Afrika Museum, Berg en Dal.

Huysecom, Eric, and Anne Mayor. 1993. Les Traditions céramiques du delta intérieur du Niger: Present et passé. In Musée national des arts d'Afrique et d'Océanie 1993, pp. 297–313.

Jamieson, Andrew. 2000. Ancient Pots and Modern Potters of Egypt. *Ceramics Technical* 10, pp. 54–59.

Jensen, Jurgen. 1969. Töpferei und Töpferwaren auf Buvuma (Uganda). *Baessler-Archiv* n.s. 17, pp. 53–100.

Jereb, James F. 1995. *Arts and Crafts of Morocco*. Chronicle Books.

Kennedy, Carolee. 1978. *The Art and Material Culture of the Zulu-Speaking Peoples*. Pamphlet Series, vol. 1, no. 3. UCLA Museum of Cultural History.

————. 1993. Art, Architecture, and Material Culture of the Zulu Kingdom. Ph.D. diss., University of California, Los Angeles.

Kennesaw State College, The Art Gallery. 1989. *Cameroon Art: Selections from the Collection of Robert Arnett*. Kennesaw State College, The Art Gallery.

Kirknaes, Jesper. 1982. *A Collection of Arts and Crafts from Tanzania*. Villadsen and Christensen for HANDICO.

Klopper, Sandra. 1989. The Art of Traditionalists in Zululand-Natal. In *Catalogue: Ten Years of Collecting (1979–1989)*, edited by David Hammond-Tooke and Anitra Nettleton, pp. 32–38. University of the Witwatersrand.

Knöpfli, Hans. 1997. *Crafts and Technologies: Some Traditional Craftsmen of the Western Grasslands of Cameroon*. Occasional Papers, no. 107. British Museum.

Koloss, Hans-Joachim. 2000. *World-View and Society in Oku (Cameroon)*. Verlag von Dietrich Reimer.

Krause, Richard A. 1997. Pottery Manufacture. In *Encyclopedia of Precolonial Africa: Archaeology, History, Languages, Cultures, and Environments*, edited by Joseph O. Vogel, pp. 115–24. AltaMira Press.

Krieger, Kurt. 1961. Töpferei der Hausa. In *Beiträge zur Völkerforschung*, edited by Dietrich Drost and Wolfgang König, pp. 362–68. 2 vols. Akademie-Verlag.

Kusimba, Chapurukha M. 1999. *The Rise and Fall of Swahili States*. AltaMira Press.

LaVergne, Georges. 1944. *Nord Cameroun: Les Matakam*. Reedited and reprinted 1990. L'Imprimerie Roquebrunoise.

LaViolette, Adria. 2000. *Ethno-Archaeology in Jenné, Mali: Craft and Status among Smiths, Potters and Masons*. BAR International Series 838, Cambridge Monographs in African Archaeology 49. Archaeopress.

Lawton, A. C. 1967. Bantu Pottery of Southern Africa. *Annals of the South African Museum* 49, part 1, pp. 1–440.

Leith-Ross, Sylvia. 1970. *Nigeria Pottery*. Ibadan University Press of the Department of Antiquities, Lagos.

Lindahl, Anders, and Edward Matenga. 1995. *Present and Past: Ceramics and Homesteads, An Ethnoarchaeological Project in the Buhera District, Zimbabwe*. Studies in African Archaeology 2, Uppsala.

Lombard, J. 1957. Aperçu sur la technologie et l'artisanat Bariba. *Etudes Dahoméennes*, no. 18, pp. 7–60. Institut Français d'Afrique Noire, Porto-Novo, Dahomey.

————. 1965. *Structures de type "féodal" en Afrique Noire: Etudes des dynamismes internes et des relations sociales chez les Bariba du Dahomey*. Mouton and Company.

Maes, J. 1937. Poterie au Lac Leopold II. *Artes Africanae*, no. 9, pp. 20–43.

Martin, Jean-Hubert, Etienne Féau, and Hélène Joubert. 1997. *Arts du Nigeria, Collection du musée des Arts d'Afrique et d'Océanie*. Reunion des musées nationaux.

Martinez-Servier, Nicole. 1998. La Poterie. In *Splendeurs du Maroc*, pp. 372–385. Musée royal de l'Afrique centrale, Tervuren, and Plume.

Masson-Detourbet, A. 1953. Terres cuites de Mopti (Soudan). *Notes Africaines*, no. 60, pp. 100–102.

McIntosh, Roderick. 2000. Clustered Cities of the Middle Niger. In *Africa's Urban Past*, edited by David M. Anderson and Richard Rathbone, pp. 19–35. Heinemann.

McIntosh, Susan Keech, ed. 1995. *Excavations at Jenné-Jeno, Hambarketolo, and Kaniana (Inland Niger Delta, Mali), the 1981 Season*. University of California Press.

McIntosh, Roderick, and Susan Keech McIntosh. 1979. Terracotta Statuettes from Mali. *African Arts* 12, no. 2, pp. 51–53.

————. 1980a. Jenné-Jeno: An Ancient African City. *Archaeology* 33, no. 1, pp. 8–14.

————. 1980b. *Prehistoric Investigations in the Region of Jenne, Mali: A Study in the Development of Urbanism in the Sahel*, part 1, *Archaeological and Historical Background and the Excavations at Jenne-Jeno*. BAR International Series 89(i), Cambridge Monographs in African Archaeology 2.

————. 1981. The Inland Niger Delta before the Empire of Mali: Evidence from Jenne-Jeno. *Journal of African History* 22, pp. 1–22.

————. 1982. Finding West Africa's Oldest City. *National Geographic*, September, pp. 396–418.

————. 1986. Archaeological Renconnaissance in the Region of Timbuktu, Mali. *National Geographic Research* 2, no. 3, pp. 302–19.

————. 1988. From Siécles Obscurs to revolutionary centuries on the Middle Niger. *World Archaeology* 20, no. 1, pp.141–65.

————. 1993. Cities without Citadels: Understanding Urban Origins along the Middle Niger. In *The Archaeology of Africa: Food, Metals, and Towns*, edited by Thurston Shaw, Paul Sinclair, Bassey Andah, and Alex Okpoko, pp. 622–41. Routledge.

McLeod, Malcolm. 1981. *The Asante*. British Museum Publications.

McNaughton, Patrick R. 1988. *The Mande Blacksmiths: Knowledge, Power, and Art in West Africa*. Indiana University Press.

Meek, C.K. 1931. *Tribal Studies in Northern Nigeria*. 2 vols. K. Paul, Trench, Trubner.

Milbourne, Karen Elizabeth. 2003. Diplomacy in Motion: Art, Pageantry, and the Politics of Creativity in Barotseland. Ph.D. diss., University of Iowa.

Musée national des arts d'Afrique et d'Océanie. 1993. *Vallées du Niger*. Editions de la Réunion des musées nationaux.

Museum for African Art. 2001. *Addendum to African Forms*. Museum for African Art.

Nicholson, W. E. 1929. The Potters of Sokoto, N. Nigeria. *Man* 29, no. 34, pp. 45–50.

————. 1934. Brief Notes on Pottery at Abuja and Kuta, Niger Province. *Man* 34, pp. 70–71.

Nicolls, Andrea Joyce. 1987. Igbo Pottery Traditions in the Light of Historical Antecedents and Present-Day Realities. Ph.D. diss., Indiana University.

————. 2000. Local Pottery and Urban Ceramic Traditions in Certain Igbo Areas. In Roy 2000b, pp. 129–48.

Northern, Tamara. 1984. *The Art of Cameroon*. Smithsonian Institution.

O'Brien, Michael. 1989. *Nigerian Pottery in an African Context*. Aberystwyth Arts Centre.

Ojo, J. R. O. 1982. Yoruba Ritual Pottery. In *Earthenware in Asia and Africa*, edited by John Picton, pp. 181–207. Colloquies on Art and Archaeology in Asia, no. 12. University of London, School of Oriental and African Studies.

Pemberton III, John. 1989. The Oyo Empire. In *Yoruba: Nine Centuries of Art and Thought*, edited by Allen Wardwell, pp. 146–87.

Perani, Judy. 1995. Gourd-shaped Vessel. In Phillips 1995, p. 523.

Perani, Judith, and Fred T. Smith. 1998. *The Visual Arts of Africa: Gender, Power, and Life Cycle Rituals*. Prentice Hall.

Phillips, Tom, ed. 1995. *Africa: The Art of a Continent*. Royal Academy of Arts and Prestel Verlag.

Picton, John, and William Fagg. 1970. *The Potter's Art in Africa: Catalogue of an Exhibition*. British Museum Publications.

Polfliet, Leo. 1987a. *Anthropomorphic Terracotta Vessels of Zaïre*. Galerie Fred Jahn, Munich.

————. 1987b. *Traditional Zaïrian Pottery*. Galerie Fred Jahn, Munich.

Preston, George Nelson. 1981. Funerary Vessel (*Kurowa*). In *For Spirits and Kings: African Art from the Paul and Ruth Tishman Collection*, edited by Susan Vogel. Metropolitan Museum of Art and Harry N. Abrams.

Rammage, Alix, et al. 1980. *Ashanti and Hausa Pottery*. Pottery Cultures Project, School of Art Education, Birmingham Polytechnic.

Rattray, R. S. 1927. *Religion and Art in Ashanti*. Clarendon Press.

Réunion des musées nationaux. 1998. *Batéké: Peintres et Sculpteurs d'Afrique Centrale*. Editions de la Réunion des musées nationaux.

Reusch, Dieter. 1998. Imbiza kayibil' ingenambheki: The Social Life of Pots. In *Ubumba: Aspects of Indigenous Ceramics in KwaZulu-Natal*, edited by Brendan Bell and Ian Calder, pp. 19–40, 120–28, 141–47. Tatham Art Gallery, Pietermaritzburg.

Reynolds, Barrie. 1968. *The Material Culture of the Peoples of the Gwembe Valley*. Kariba Studies, vol. 3. Manchester University Press for the National Museums of Zambia.

Roberts, Mary Nooter. 1995. Pot. In Phillips 1995, p. 292.

Roberts, Mary Nooter, and Allen F. Roberts, eds. 1996. *Memory: Luba Art and the Making of History*. Museum for African Art and Prestel Verlag.

Roscoe, John. 1923. *The Bakitara and Banyoro*. Cambridge University Press.

Roy, Christopher D. 1987. *Art of the Upper Volta Rivers*. Alain and Francoise Chaffin, Meudon.

———. 1989. Mossi Pottery Forming and Firing. In *Man Does Not Go Naked: Textilien und Handwerk aus afrikanischen und anderen Ländern*, pp. 253–64. Ethnologisches Seminar der Universität und Museum für Völkerkunde, Basel.

———. 2000a. Introduction. In Roy 2000b, pp. 1–28.

———, ed. 2000b. *Clay and Fire: Pottery in Africa*. Iowa Studies in African Art: The Stanley Conferences at The University of Iowa, vol. 4. School of Art and Art History, University of Iowa.

———. 2000c. West African Pottery Forming and Firing. In *Mundus Africanus: Ethnologische Streifzüge durch sieben Jahrtausende afrikanischer Geschichte*, pp. 123–45. Festschrift für Karl-Ferdinand Schaedler. Verlag Marie Leidorf.

———. 2003. *African Pottery Techniques* (DVD).

———. 2005. *Brewing Millet Beer in Africa* (DVD).

Russman, Edna R. 1995. Ancient Egypt and Nubia. In Phillips 1995, pp. 51.

Saïd, Claude. 2003. La poterie algérienne. In *Algérie: Mémoire de femmes au fil des doigts*, pp. 31–35. Paris-Musée.

Sargent, Carolyn F., and David A. Freidel. 1986. From Clay to Metal: Culture Change and Container Usage among the Bariba of Northern Benin, West Africa. *African Archaeological Review* 4, pp. 177–95.

Schädler, Natalie. 1997. Potters Are Not Born: A Portrait of the Bariba Potter Bélégui Seydou. In K.-F. Schädler 1997, pp. 148–49.

Schädler, Karl-Ferdinand. 1985. *Ceramics from Black-Africa and Ancient America: The Hans Wolf Collection, Zurich*. Editions Primart.

———. 1997. *Earth and Ore: 2500 Years of African Art in Terra-cotta and Metal*. Panterra Verlag.

Schildkrout, Enid, Jill Hellman, and Curtis A. Keim. 1989. Mangbetu Pottery: Tradition and Innovation in Northeast Zaire. *African Arts* 22, no. 2, pp. 38–47, 102–03.

Schildkrout, Enid, and Curtis A. Keim. 1990. *African Reflections: Art from Northeastern Zaire*. University of Washington Press and American Museum of Natural History.

Schneider, Betty. 1973. Body Decoration in Mozambique. *African Arts* 6, no. 2, pp. 26–31, 88.

Schneider, Klaus. 1990. *Handwerk und Materialisierte Kultur der Lobi in Burkina Faso*. Franz Steiner Verlag.

———. 1997. Ceramics and Brass of the Lobi in Burkina Faso. In Schädler 1997, pp. 111–14.

Schwab, George. 1947. *Tribes of the Liberian Hinterland*. Edited with additional material by George W. Harley. Peabody Museum of Archaeology and Ethnology.

Shaw, Thurstan. 1970. *Igbo-Ukwu: An Account of Archaeological Discoveries in Eastern Nigeria*. 2 vols. Northwestern University Press.

Sieber, Roy. 1972. Kwahu Terracottas, Oral Traditions, and Ghanaian History. In *African Art and Leadership*, edited by Douglas Fraser and Herbert M. Cole, pp. 173–83. University of Wisconsin Press.

———. 1980. *African Furniture and Household Objects*. American Federation for the Arts and Indiana University Press.

Slye, Jonathon. 1977. Mwona Figurines. *African Arts* 10, no. 4, p. 23.

Smith, Fred T. 1989. Earth, Vessels, and Harmony among the Gurensi. *African Arts* 22, no. 2, pp. 60–65, 103.

Soper, Robert. 1985. Roulette Decoration of African Pottery: Technical Considerations, Dating and Distributions. *African Archaeological Review* 3, pp. 29–51.

Soppelsa, Robert T. 2000. A Comparison of Baule and Senufo Pottery Techniques and Forms. In Roy 2000b.

Sous-Commission Nationale de linguistique Baatonu. 1986. *Table Ronde sur les origines de la Gaani: Fête traditionnelle des Baatombu (Bariba)*. Sous-Commission Nationale de linguistique Baatonu, Cotonou, Benin.

Spindel, Carol. 1989. Kpeenbele Senufo Potters. *African Arts* 22, no. 2, pp. 66–73, 103.

Sterner, Judy, and Nicholas David. 1991. Gender and Caste in the Mandara Highlands: Northeastern Nigeria and Northern Cameroon. *Ethnology* 30, no. 4, pp. 355–69.

———. 2003. Action on Matter: The History of the Uniquely African Tamper and Concave Anvil Pot-Forming Technique. *Journal of African Archaeology* 1, no. 1, pp. 3–38.

Stössel, Arnulf. 1981a. *Nupe, Kakanda, Basa-Nge: Gefässkeramik aus Zentral-Nigeria*. Galerie Biedermann and Fred Jahn, Munich.

———. 1981b. *Keramik aus Westafrika: Einführung in Herstellung und Gebrauch*. Galerie Biedermann and Fred Jahn, Munich.

———. 1984. *Afrikanische Keramik: Traditionelle Handwerkskunst südlich der Sahara*. Hirmer Verlag.

Szumowski, G. 1957. Fouilles au Nord du Macina et dans la region de Ségou. *Bulletin de l'IFAN* 19, no. 1–2, pp. 224–58.

Thompson, Barbara. 1999a. Kiuza Mpheho (Return of the Winds): The Arts of Healing among the Shambaa Peoples of Tanzania. Ph.D. diss., University of Iowa.

———. 1999b. Shambaa Ughanga: Converging Presences in the Embodiment of Tradition, Transformation, and Redefinition. *Mots Pluriels*, no. 12, *www.arts.uwa.edu.au/MotsPluriels/MP1299bt.html*.

Trowell, Margaret. 1941. Some Royal Craftsmen of Buganda. *Uganda Journal* 8, no. 2.

Trowell, Margaret, and K. P. Wachsmann. 1953. *Tribal Crafts of Uganda*. Oxford University Press.

Van Gennep, A. 1911. *Etudes d'ethnographie algérienne: Les Soufflets algériens, les poteries Kabyles, le tissage aux cartons, l'art decoratif*. E. Leroux.

Vansina, Jan. 1990. Reconstructing the Past. In Schildkrout and Keim 1990, pp. 69–87.

Vernon-Jackson, Hugh. 1960. Craft Work in Bida. *Africa* 30, no. 1, pp. 51–61.

Vidal, Frédéric. 1992. Les Bariba. *Arts d'Afrique Noire* 83, pp. 12–14.

Vivier, Marie-France. 2003. La symbolique dans l'art populaire Algérien. In *Algérie, Mémoire de femmes au fil des doigts*. Somogy Editions D'Art and Paris-Musées.

Vogel, Jerome. 2004. African Ceramics. In *Material Difference*, edited by Frank Herremann, pp. 78–93. Museum for African Art.

Vogel, Susan Mullin. 1997. *Baule: Africa Art/Western Eyes*. Yale University Press.

Waane, S. A. C. 1976. *Pottery Making Traditions of the Ikombe Kisi of Kyela District*. Occasional Paper no. 4. National Museum of Tanzania.

Wahlman, Maude. 1972. Yoruba Pottery-Making Techniques. *Baessler-Archiv*, n.s. 20, pp. 313–46.

Weima, Henny. 1986. *Une Vie Nouvelle au Zaire*. Hanns-Seidel-Stiftung.

Wente-Lukas, Renate. 1977. *Die Materielle Kultur der Nicht-Islamischen Ethnien von Nordkamerun und Nordostnigeria*. Franz Steiner Verlag.

Whitelaw, Gavin. 1998. Twenty One Centuries of Ceramics in KwaZulu-Natal. In *Ubumba: Aspects of Indigenous Ceramics in KwaZulu-Natal*, edited by Brendan Bell and Ian Calder, pp. 3–12, 119–20, 141–47. Tatham Art Gallery, Pietermaritzburg.

Willet, Frank. 1967. *Ife in the History of West African Sculpture*. McGraw-Hill.

Zeitlyn, David. 1994. Mambila Figurines and Masquerades: Problems of Interpretation. *African Arts* 27, no. 4, pp. 38–47, 94.

———. 1997. Les Mambila. In *Arts du Nigeria: Collection du musée des Arts d'Afrique et d'Océanie*. Réunion des musées nationaux.